Focus

ALSO BY MICHAEL GROSS

Model: The Ugly Business of Beautiful Women

*My Generation: Fifty Years of Sex, Drugs, Rock, Revolution,
Glamour, Greed, Valor, Faith, and Silicon Chips*

Genuine Authentic: The Real Life of Ralph Lauren

740 Park: The Story of the World's Richest Apartment Building

*Rogues' Gallery: The Secret History of the Moguls and
the Money That Made the Metropolitan Museum*

Unreal Estate: Money, Ambition, and the Lust for Land in Los Angeles

*House of Outrageous Fortune:
Fifteen Central Park West, the World's Most Powerful Address*

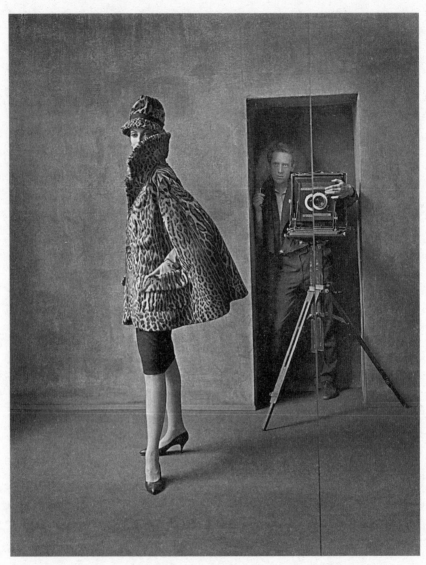

Las Meninas, Carmen Dell'Orefice and Melvin Sokolsky, 1960. (MELVIN SOKOLSKY)

FOCUS

The Secret, Sexy, Sometimes Sordid
World of Fashion Photographers

MICHAEL GROSS

ATRIA BOOKS

NEW YORK • LONDON • TORONTO • SYDNEY • NEW DELHI

ATRIA BOOKS

An Imprint of Simon & Schuster, Inc.
1230 Avenue of the Americas
New York, NY 10020

First Atria Books hardcover edition July 2016

ATRIA BOOKS and colophon are trademarks of Simon & Schuster, Inc.

For information about special discounts for bulk purchases,
please contact Simon & Schuster Special Sales at 1-866-506-1949
or business@simonandschuster.com.

The Simon & Schuster Speakers Bureau can bring authors to your
live event. For more information or to book an event contact the
Simon & Schuster Speakers Bureau at 1-866-248-3049
or visit our website at www.simonspeakers.com.

Manufactured in the United States of America

10 9 8 7 6 5 4 3 2 1

Library of Congress Cataloging-in-Publication Data

Name: Gross, Michael [date]– author.
Title: Focus : the secret, sexy, sometimes sordid world of fashion
 photographers / by Michael Gross.
Description: New York : Atria Books, [2016]
Identifiers: LCCN 2015046283
Subjects: LCSH: Fashion photographers—Biography. | Fashion
 photographers—Conduct of life. | Models (Persons)—Biography. | Fashion
 photography—History. | Fashion merchandising—Social aspects.
Classification: LCC TR139 .G76 2016 (print) | LCC TR139 (ebook) | DDC
 770.92/2—dc23
LC record available at http://lccn.loc.gov/2015045564

ISBN 978-1-4767-6346-0
ISBN 978-1-4767-6348-4 (ebook)

*For Norman Parkinson, who gave me my first fashion photo;
Richard Avedon, who suggested I write a book about the models
who appear in them; and Barbara Hodes, who inspired me to
turn the camera on the people who make them.*

*Here is what other people have and you haven't;
here is where some go but never you. Here is your
lovely land of never, and you may dream of it, but
that's all.*

—DAWN POWELL

CONTENTS

Part 2: Experience 79

In which the third great fashion photographer, Bert Stern, rises from nothing into the pantheon at Liberman and Diana Vreeland's *Vogue*, and along with Jerry Schatzberg, Mel Sokolsky, Bill Helburn, and three stroppy working-class oinks from England, Terence Donovan, Brian Duffy, and David Bailey, make fashion photography a virile profession, costarring the women who love them: Ali MacGraw, Faye Dunaway, Jean Shrimpton, Catherine Deneuve, Donna Mitchell, Dorothy McGowan, and Simone d'Aillencourt.

Part 3: Indulgence 167

In which Europe storms the magazine world, led by an international pack of lensmen called the French Mob, from the lesser-known Pierre Houlès and Claude Guillaumin to the international stars Gilles Bensimon, Patrick Demarchelier, Mike Reinhardt, Uli Rose, and Arthur Elgort. Men who love women, they're a perfect fit for the new, more realistic fashions of the seventies, and the commercialized magazines that sell them. But beneath the pretty surface are dangerous currents, captured by Helmut Newton, Guy Bourdin, and Deborah Turbeville. And Bill King and Francesco Scavullo throw down a gauntlet before Avedon, the King of Fashion Photography.

Part 4: Decadence 221

In which things get more than a little crazy; half-naked teenage girls high on beauty, cocaine, and freedom prowl the halls of Italian hotels; Gilles Bensimon rises above the rest of the French Mob and becomes known as the biggest dick in fashion; Chris von Wangenheim blurs the line between fantasy and reality; and Richard Avedon reinvents himself in the tight space between Brooke Shields and her Calvins.

Part 5: Domination *261*

In which magazines cede the high ground to advertisers; Calvin Klein and Ralph Lauren emerge as Medicis and Bruce Weber as their Leonardo and Michelangelo; AIDS lays low a generation; Bill King dies in a blaze of enmity; and a French art director, Fabien Baron, and an Italian editor, Franca Sozzani, rise and summon the ghosts of Alexey Brodovitch and Carmel Snow.

Part 6: Disruption *311*

In which a Jewish Cherokee named Steven Meisel takes over fashion; Anna Wintour takes over *Vogue* and then the entire edifice of commercial fashion; the cutting edge stretches from London to Barneys New York; grunge may be ghastly but comes to rule the world; Corinne Day and Kate Moss make fashion real again; and Carine Roitfeld, Tom Ford, and Mario Testino counterattack with a stiff dose of glamour; at least until digital photography and impossible images sign the death warrant for the golden age of girls on film.

Epilogue: Return to Terrytown *352*

In which the father-son tag team of Bob and Terry Richardson terrorize, provoke, transgress, and scorch the earth, setting the stage for fashion photography's next visions.

The half century from 1947 to 1997 was fashion photography's glory days. Hundreds of photographers were published in major magazines around the world, but only a few dozen did work that was truly memorable. And only a handful of those were transformational or symbolic of the profession as a whole. So, just as a magazine spread of eight or ten photos has to be edited down from hundreds or thousands of images, I've chosen a small cast of characters to tell the large story of this mass art form in a comprehensible way. Others may—and surely will—disagree with the edit. So be it. This is not a work of criticism. It does not try to be encyclopedic, either.

I have focused on photographers who were unavoidable, who changed the conversation, who lived the life of fashion photography to its fullest, but also ones whom I am drawn to and whose stories were somehow accessible, whether because they were willing to speak about themselves or because firsthand witnesses were willing to speak about their careers. All this means that dozens of great talents—Man Ray, Cecil Beaton, Norman Parkinson, Frank Horvat, Gleb Derujinsky, William Helburn, Peter Beard, Barry Lategan, William Klein, Gosta Peterson, Denis Piel, Andrea Blanch, Steven Klein, Ellen von Unwerth, Pamela Hanson, Peter Lindbergh, Juergen Teller, Paolo Roversi, and Sarah Moon, to name but a few—are given short shrift in the pages that follow. That doesn't lessen the impact or quality of their work.*

My choice of Richard Avedon over Irving Penn to stand for the fifties

*The business started small, then exploded in the sixties and seventies, when many more photographers emerged. For the sake of narrative clarity, I've had to leave many of them out, but some of their stories—along with source citations for this entire book—can be found on my website, www.mgross.com. I encourage interested readers to visit.

illustrates all my criteria. Even though Penn, a restrained, monkish technician, was equally talented, the hyperenthusiast Avedon's fashion photographs were game changers. Penn's choice to remain aloof, while Avedon chased fashion over more than five decades, made the latter a more attractive subject. I'd also spoken to Avedon but never to Penn—and Penn's son was less than eager to return phone calls. My personal preference for Avedon's work sealed the deal. Fortunately, I'd saved every note of every conversation I ever had with Avedon, so he often speaks for himself in the pages that follow.

As I started my research, I revisited files I'd compiled over the last three-plus decades and got a surprise. They contained a wealth of unpublished material, notably extensive interviews with photographers living and dead. The spine of the Bert Stern section of this book, for instance, is a lengthy interview he gave me in 1994, most of it previously unpublished.*

Focus opens and closes with Bob and Terry Richardson, father and son photographers, one who worked in the sixties and seventies, the other, very much of the present. I interviewed Bob. Though I've met and spoken to Terry several times, he, like most currently working fashion-magazine photographers, stylists, and editors, refused to give an interview. Their reasons for saying no may be as varied as their styles and personalities, but my reporting experience leads me to believe that fear of repercussions in a backbiting, already insecure world now under existential threat is behind those refusals. That said, one longtime Condé Nast editor commented, "The people now have nothing to say, so maybe it's better that they don't talk."

I'll leave that for the future to decide. If this book begins to explain how we got from Richard Avedon to Terry Richardson, it will have done the job I set out to do. "The electronic age arrived and the whole thing changed," says Jean-Jacques Naudet, the longtime editor of *Photo* magazine in France. "Models and photographers were the top,

*Interviews conducted by the author—whether for this book or in the past (for the 1995 book, *Model*, or various newspapers and magazines)—are not included in the source notes.

stars. Not anymore. Now you don't recognize them." And fashion photographs, once indispensable documents of fleeting moments, became all-too-easily-manipulated artifacts of a time of fleeting truth.

It's a shame that some disdain today's fashion lensmen and -women as anonymous and fungible; only time will tell if some will emerge as the Avedon and Meisel of this century. Regardless, they won't, can't, be the same as those who came before them. The business they're in has changed—and demanded change—as photography evolved from a difficult and technical art mastered by a precious few to a digital and democratic medium accessible to anyone. Something's been lost for sure, but something new is surely coming in the age of Pinterest, Instagram, Snapchat. We'll have to wait to see. This is the story of what was.

Introduction

WELCOME TO TERRYTOWN

People will always have strong opinions about challenging images.

—TERRY RICHARDSON

For a brief, bizarre moment, in 2013, fashion was Terrytown. Nineteen years after Terry Richardson published his first harshly lit, seemingly styleless, yet appealingly candid point-and-shoot-snapshot-style fashion photographs, a decade after he was consecrated as "the irreverent New Yorker who changed photography forever" at his first big gallery show, and mere months after the *New York Times* Style section profiled him as the "naughty knave of fashion's court," all eyes in that world were on the gangling, grungy, distinctly unglamorous forty-eight-year old.

He was easy to spot. His visual identifiers were many and, taken together, iconic: a lumberjack shirt, heavily tattooed arms, receding hairline, mutton-chop sideburns, handlebar mustache, aviator glasses, and a double thumbs-up gesture framing a shit-faced grin. The last might have been inspired by another attribute he often included in photos of himself (he's been called, not quite accurately, the inventor of the selfie): a preternaturally large penis.

Though this visually astute imagician presents himself as a walking cartoon, Richardson also embodies half a century of fashion photography; his father, Bob, had been a supernova in the field, before quitting it, a victim of schizophrenia compounded by years of drug abuse. His son, it appeared, was living the life his tragic father had thrown away, though ruling a far different fashion photography universe, one under assault from all sides.

In the middle of the first decade of the twenty-first century, digital photography flooded the world with imagery. The Internet had taken a

once elite art form and made it instantly accessible to everyone. Digital culture had wreaked havoc on the print-media ecosystem, making glossy newsstand magazines, the primary medium for fashion photos for almost a century, endangered if not quite extinct. Notoriety had similarly trumped beauty, turning models, long the faces of fashion, into second-tier signifiers of style. Huge corporate conglomerates had taken over the fashion business—both at its high and low ends—making its imagery fungible and leaving the surviving mass-circulation magazines timorous about offending anyone who might adversely affect advertising revenue. The prime directive of fashion photography—*Astonish me!*—a phrase attributed to the estimable midcentury art director Alexey Brodovitch, was becoming ever harder to fulfill in a world in which everything was recycled or pastiche.

Somehow, Terry Richardson rose above all that. He was an astonishment.

That year, Richardson added a stunning array of credits to his résumé. He shot ads for a fragrance by Isaac Mizrahi; a chain of gyms; H&M; Dolce & Gabbana; Procter & Gamble; Ann Taylor; couture and shoe lines; Esprit; Target; Bulgari (featuring former French first lady Carla Bruni Sarkozy); the luxury jeweler David Webb; Valentino-brand accessories (which he photographed, quite cleverly, on his own hands and heavily tattooed arms); the Kardashian Kollection; and a fashion website. He also created photos for Christian Dior's couture runway show and *Harper's Bazaar* and *Numéro* magazines; made several breastcentric, career-making videos for the voluptuous model Kate Upton; made tabloid headlines by dating Audrey Gelman, a beauty half his age who was not only the spokesperson for Manhattan borough president Scott Stringer, but also a best friend of Lena Dunham's. Dunham would loosely base on Gelman the character of Marnie in Dunham's new HBO sitcom *Girls*. And he shot a raft of celebrities: Georgia May Jagger, Scarlett Johansson, Cameron Diaz, Kate Moss, and Miranda Kerr among them.

Then, Richardson made another video, this one for Miley Cyrus, the performing daughter of country music star Billy Ray Cyrus, who was determined to shed her clean-cut child-star image and remake herself as a sexually charged twenty-first-century pop princess. Richardson directed the video for her song "Wrecking Ball." It opens with a beauty shot of Cyrus, a tear dripping from one eye as she starts singing about frustrated love,

then it segues to the tattooed twenty-year-old in white scanties, faux-fellating a sledgehammer, then sitting naked atop the wrecking ball of the title, flashing bits of bum and breasts as it swings back and forth, smashing the concrete-block set, and finally writhing and rending her barely there clothing atop the wreckage. The video ends with a credit card reading, "Directed by Terry Richardson," the letter *i* in his last name dotted with a childish *x*.

Shortly after it was released in September 2013, garnering 19.3 million views on YouTube within twenty-four hours of its release, a hurricane of controversy blew into Terrytown. It lifted the newly sexed-up Cyrus's profile; the song became her first No. 1 hit. But it seemed to have the opposite effect for Richardson, whose image morphed from mischievous imp to malevolent pervert. The acidic drip-drip-drip of accusations and opprobrium was so relentless that the website *Styleite* published a post entitled "A Horrifying Timeline of Terry Richardson Allegations, from Trash Cans to Tampon Tea." A Google search for Richardson misbehavior yielded more than eighty-two thousand hits. Success is a bitch.

The timeline began with a 2004 description of a woman (an assistant who would later become Richardson's girlfriend and in fall 2015 get pregnant with twins by him) who'd been photographed fellating Richardson while sitting in a trash can wearing a tiara reading *slut* in rhinestones. Call me mama!

Sexual harassment claims were first aired—albeit without mention of Richardson's name—in 2009, when a working model told a documentarian that she was asked to give a top photographer a hand job at a go-see, or audition. "He likes it when you squeeze it real hard and twist it," she was told. The next year, model Rie Rasmussen berated Richardson at a party, angry that he'd run photographs of her alongside others "of naked underage girls in his creepy coffee table [book]," *Styleite* said.

Soon, a college student named Jamie Peck came forward to tell how an assistant of Richardson's had invited her to his studio to model. "I was like, 'Yeah, sure, awesome,'" says Peck, who "didn't think to ask" what she'd be posing for. Two sessions with Richardson followed. She doesn't remember the first but later recognized herself in two photos showing her in sexual situations with the photographer. "I don't know what I was thinking" when she returned, she says. "I had stars in my eyes and he hadn't crossed a line yet." Peck grew wary when he suggested making tea with her used tampon. Then,

he exposed "his terrifying penis" to her. "I must have said something about finals," Peck would later write of the moment, "because he told me, 'If you make me come, you get an A.' So I did! Pretty fast, I might add. His assistant handed me a towel." Five years later, she concludes, "It was a caricature of what parents fear when they send their girls to New York."

At the same event where Peck met Richardson, Sarah Hilker, an aspiring seventeen-year-old model, refused to sign a model release and ran from his makeshift studio when she "saw him shooting some obviously inebriated chick straddling a full naked erect guy" while the photographer had "one hand on the camera, the other hand" on himself. That year, the blog *Jezebel* branded him "the world's most f—ked up fashion photographer."

Perhaps the most damning account of Richardson's behavior came from an anonymous poster on the Reddit Web community, who later came forward to identify herself as Charlotte Waters, a former model who'd posed nude for art classes, but discovered her limits stretched to the breaking point when she showed up for a shoot at Richardson's studio. She wrote that she was directed to take Richardson's penis from his pants. Though "never once initiated by me . . . it became sexual act after sexual act, everything you can think of . . . everything slow so his assistant could photograph. . . . I was completely a sex puppet."

Richardson allegedly photographed the splatter of his orgasm. Afterward, Waters supposedly spoke to the police; reports differ as to whether she was told the charges wouldn't stick or she simply didn't press the matter. Richardson responded to her claims in a letter that was printed by a gossip column, claiming he'd ignored the first wave of charges against him because responding would constitute a betrayal of his work and his character. But when the claims resurfaced, "they seemed especially vicious and distorted," he wrote, and felt like "an emotionally charged witch hunt," which he blamed on the anarchy and anonymity of the Internet (the same venue where his studio staff often posted nude photos of models taken in his studio on a website called *Terry's Diary*). He continued: although the "hate-filled and libelous tales" were but rumors and lies, they required a response.

Like his East Village milieu, he wrote, his work "was gritty, transgressive," and "shocking," a far cry from "the well-lit, polished fashion images of the time." He claimed such work had never before been seen, but then compared

himself to the photographers Robert Mapplethorpe and Helmut Newton. He felt his work "explored the beauty, rawness, and humor that sexuality entails" and was produced in collaboration "with consenting adult women who were fully aware of the nature of the work, and as is typical with any project, everyone signed releases." He insisted he never traded work for sexual favors, always respected his models, and implied that some of them had the equivalent of morning-after regrets, resulting in "revisionist history" that fed "the ongoing quest for controversy-generated page views," and "sloppy journalism" that did "a disservice not only to the spirit of artistic endeavor, but most importantly, to the real victims of exploitation and abuse.

"People will always have strong opinions about challenging images, and the dichotomy of sex is that it is both the most natural and universal of human behaviors and also one of the most sensitive and divisive," he ended. "I value the discourse that arises from this. I can only hope for this discourse to be informed by fact, so that whether you love my work or hate it, you give it, and me, the benefit of the truth." Presumably, he meant the benefit of the doubt.

He didn't get it from everyone. A *Vogue* spokesman announced the magazine had no plans "to work with him in the future." That he was under contract to American *Vogue*'s bitter rival, *Bazaar*, likely assuaged any sense of loss at *Vogue*. But Richardson must have felt a loss over the near-simultaneous defections of several clients, including H&M and Target.

He hired a powerful entertainment-business public relations firm with a specialty in reputational damage control. One of its managing directors was present at his 2012 interview with Styles of the *Times*. Though he'd spurned most other requests for interviews (including for this book), the firm then arranged for him to pose and be interviewed for a cover story in *New York* magazine. A day after *Jezebel* revealed that that story was in the works, another woman, a writer and stylist identified only as Anna, came forward to say that in 2008 she'd been lured to a shoot at Richardson's studio, where she ended up crawling on the floor while Richardson jabbed himself "into my face." *Styleite* concluded its recounting of these Richardson outrages with the hope that fewer celebrities would pose for him and more magazines would realize "his simple flash setup really isn't worth the day rate."

Terry was on the June 16, 2014, cover of *New York*, advertising a story somewhat less pointed than the headline that accompanied it: "Is Terry

Richardson an Artist or a Predator?" Despite his PR firm's feeling that it was positive for him, it set off another round of criticism of its misrepresentations and omissions. So there was no victory lap for Richardson. He was as notably absent from fashion during the rest of 2014 as he'd been omnipresent the year before. *Styleite*'s wish seemed to be coming true.

When Miley Cyrus's "Wrecking Ball" won Video of the Year at the 2014 MTV Video Music Awards, the music star decided against giving an acceptance speech, which would have required she thank her director. Instead, she sat silently beside the stage while a young man accepted her award for her and gave a brief speech about homeless youth. Richardson did not attend and did not win the award for Best Direction, either, which went to a relatively forgettable hip-hop video. Cyrus's "team knew" she couldn't thank him, says someone quite close to Richardson, "so they had to do something else."

Though *Harper's Bazaar* would still be publishing Richardson in March 2016, his highest-profile remaining magazine outlet wasn't saying if it had renewed his contract. Executives at *Bazaar* and its owner, the Hearst Corporation, didn't respond to a question about their intentions.

By the end of 2014, *Terry's Diary*—his face to the world—was looking more like a Home for Old Celebrities than the home of the hottest fashion lens on the planet. At the end of the year, the only A-list star whose picture was posted there was Jared Leto. Otherwise, the cast of characters was a motley crew of past-their-prime-time players and B-listers: Chuck Zito, Mason Reese, and Tony Orlando.

The King of Selfies seemed reduced to a panhandler at the door of the party. And the only nude or seminude women on the site—long among its prime attractions—were on billboards for sex clubs (signage has long been a Richardson photographic sideline) and a reproduced spread from a Brazilian nudie magazine.

Late in 2015, Miley Cyrus would return for a sexually charged, all-nude shoot for *Candy* magazine. That just didn't shock anymore.

For most fashion photographers, their peak of creativity lasts seven to ten years. Then, they either quit or start repeating themselves. Terry Richardson's fame had hit not only that limit but also another he imposed on himself with his—to be kind—gritty, transgressive behavior.

Fashion doesn't look back; it moves on. So it had already gone looking for the *next* Terry Richardson and found at least one photographer whose work resembled his, but without the ick factor that finally overwhelmed the novelty and, yes, it needs to be said, honesty of his pre-2013 work. She was a UCLA graduate named Hadley Hudson, whom some art directors call "the female Terry Richardson," thanks mostly to her raw flash-lit, documentary-style photographs of models and style icons in their own clothes and their own homes.

"The dream has changed," says Jeff Poe, co-owner of the Blum & Poe gallery in Los Angeles, for whom Hudson worked as a student. "Fashion photography has been, historically, about seduction and yet, removal. The way Hadley does it, it's almost attainable. It's doing what you want to do, and that's what Hadley represents. Terry Richardson was doing that, too, with his simple flash and his immediacy. She does it in a female way that retains a respect for the subject. Terry has to be the subject, and by doing that, it became about him and not the fashion. That's the problem with the whole world now. Everybody wants to be a fucking star. It's become egalitarian. Hadley foresaw the ubiquity of the image and became part of the change."

On a Sunday afternoon in fall 2014, Hudson was in East Williamsburg, near the Brooklyn-Queens border, shooting a model in a raw loft space for *Vice*, the same influential youth cult magazine that championed Terry Richardson's early work.

To choose her latest subject, Hudson had held a go-see at a Manhattan modeling agency. A series of young male and female models paraded through a small white room with a white leather sofa, each proffering tablet computers full of sample photographs or, in a few cases, old-fashioned physical portfolios. They ran the gamut of experience. "A lot of them live with their parents," Hudson says. "I look for people with their own place."

Toward the end of the hour, a model named Rain walked in. Tall and well built, broad shouldered but boyish, short haired and wearing a yellow jacket and a newsboy cap, Rain removed a jacket, revealing large womanly breasts, and explained that she modeled both as a man and a woman. She told Hudson she lived in an old industrial building that'd been converted into artists' lofts. "Everyone drinks pretentious coffee, eats organic food, and wears H&M," she said. She was nonmonogamous, dated both men and women,

performed live as a monologist, and was then on a cable TV show called *Living Different*, about women who defy stereotypes. She was the show's androgyne. It paid the bills, she said.

Hudson flipped through Rain's book, pausing at a shot of her in underwear. The photographer who had taken it told her, "I want to shoot you as a gay boy," Rain said.

Hudson was intrigued—and a few days later, their shoot began with some of that pretentious coffee and a long, seemingly aimless conversation at Rain's dining room table designed to put the model at ease and give Hudson insight into her character. "This industry really does send a weird message," Rain said, "that you can afford the things we're wearing."

Hudson probed Rain's bio and learned that she came from Vermont, had grown up on a farm, and moved to Colorado, where she had worked as a smoke jumper, fighting fires, and found she could pass as male. "A classic model story," she joked. Then, she earned a degree in genetic engineering from the University of California at Berkeley, where, at a football game, she met a model who said she could be one, too. When Rain demurred, saying models were pretentious and didn't eat, the model offered a bet on the game; if Rain lost, she'd have to go to a casting for a Calvin Klein underwear show.

"They thought I was a dude," Rain told Hudson, until she was asked to take off her shirt. Rain laughed. "I let them deal with my enlarged pecs." She was hired to walk in the show—albeit wearing a shirt. "I identify as nongender."

"What does that mean?" Hudson asked.

"I let people figure it out for themselves. Some people think I'm transitioning, some think I'm a lesbian, some think I'm straight and *very* high fashion. I'd sure as shit be a dude to get a job, but when the *Titanic* starts sinking? Dude, women and children first!"

Though she'd appeared in Chanel campaigns, Rain preferred H&M. "Soon, people won't care anymore. Just buy what's cheap and looks good."

"Do you *like* fashion?" Hudson wondered.

"I love fashion in the sense that you can choose what you wear. I don't like the standards fashion has for what's beautiful."

"Compassion is missing in fashion."

"That's why your project seems important," Rain replied, deadpan. "It could help raise living standards."

The conversation swerved to Hudson's story. She'd attended high school in San Francisco, where she studied photography on a whim and was encouraged by a teacher she was still close to, to study art. She'd entered UCLA at age seventeen. Her plan to earn a master's degree in London was deferred by a pregnancy, marriage to a German, a move to Germany, and raising a child. Soon, her marriage broke up and she was broke and barely hanging on in the former East Berlin. A one-hour photo shop was next to her apartment and it goaded her. "If you're supposed to be doing something, things come together to help you." She picked up her camera again, shooting the odd press photo for musicians and, in 2002, was asked by Peaches, an electronic musician and performance artist she'd photographed the year before for *Spin* magazine, to shoot the cover of a new record. It showed the singer in a fake thick beard and smudged mascara. "If you do something interesting, someone will see it," Hudson said. "After shooting Peaches, things took off."

After an hour and a half of coffee and talk, the foreplay was over and Hudson asked, "Where's your room?"

"What are you after? What are you in the mood for photography-wise?"

"People in their natural environment. The space that's the most you. This'll be the easiest photo shoot you've ever done."

While the pair prowled the loft, their talk turned to clothes. "I want you to be comfortable," said Hudson. "Do one male and one female outfit. Whatever that means for you."

"Let my imagination run wild?"

"Yeah."

"Be like a model? Or a person?"

"Both!" Hudson grinned.

So, as she readied a Canon 7D, a 35 mm digital camera, Rain rummaged through a bag of clothes, finally suggesting she wear men's underwear, a tight top to show her breasts, "and hairy legs." When she emerged, it was her turn to grin as Hudson's eyes strafed Rain's rather large breasts. "I don't bind. It's not good for you. It's all about positive. It's confusing to a lot of people, but not the lesbians." A pause. "My agency says, no nips and no clit."

It was Hudson's turn to deadpan. "We can work with that."

They decided to shoot Rain standing on her bed first. "We're good to go," Hudson said. "Feel free to be yourself—or not."

She began shooting and Rain asked, "Am I supposed to be natural or posing?"

"Look over here. Perfect. Did you have to learn to model? Or were you a natural?"

"I had to learn the difference between men and women. To be like a dude, I'll do this, strong." Rain struck an I-don't-give-a-fuck pose against the wall behind her. Then she smoothly elongated her neck, her body, her legs, and one arm climbed the wall. "With women, everything has to be loooong and sexy."

Hudson was intrigued, shooting faster. "Do it again." For a moment, she was David Bailey, and Veruschka was looming above her, doing the semi-sexual dance that's often the subtext of fashion photographs.

"Dudes can be, like, supercomfortable." Rain grabbed the crotch of her shorts.

"You're a really good observer."

Rain stuck her nose in her armpit, then looked up with a perplexed male stare. "God, I'm just thinking so hard. There's not a lot of vulnerability." She morphed back into a woman, turning her head and arcing her chest. "You never face the camera straight on. You want your assets out there."

"Give me a few modeling faces. I want to see your signature look."

"Let me see." Rain laughed, then dipped her chin to shoot Hudson a sullen stare from under her prominent eyebrows.

"Deep, yet off-putting." Hudson suggested a change into lingerie with a man's jacket over it. "You pick, whatever your favorite is."

Rain returned, revealing a knife scar across her belly. Seeing Hudson spot it, she smirked. "I dated the wrong woman."

She took off her top; beneath was a gray bra. Hudson asked for a matching bottom, but when Rain waved a black thong instead, the photographer bobbed her head. "Yup!"

Back in the bedroom, Rain wedged herself into a brick corner. The light was fading in the late afternoon, but for the moment it was moody and atmospheric—and Hudson shot even faster. "Now, if you want, play with your female side. It's funny how fashion wants you to project a cold sexuality."

"The duck face, I call it. But technically, I'm kind of an anomaly, so I do what I want. I'll ask what they want; they're paying for it. But if not, I'll do what I want."

Hudson chuckled. It sounded like encouragement. Then she moved Rain

out into the middle of her big living room for one last shot, walking straight toward the camera. "That's good, do it again."

"Do you want angry?"

"I love it." Hudson took the jacket off Rain's shoulders.

"Stripping me? Typical. 'I'll just hold your jacket. I'll just hold your bra.'"

"Are you freezing? But you're a model. It's your job."

"Fashion is to die for—a pair of shoes." Rain smiled again. "Do you want one of me sitting on the toilet?"

But the shoot was over and Hudson was staring intently at the screen on the rear of her camera, flicking her way through the pictures she'd taken. "Perfect." She didn't look up. "I am superhappy."

Like Hollywood directors, fashion photographers, the Svengalis who shoot editorial and advertising images of clothing and mold and elevate the stunners who star in them, are figures in the shadows who make those in front of their cameras glow like members of some special, enlightened tribe. But the world they inhabit has striking contrasts: it appears beautiful, but just beneath the pretty surface, like the images they create, the reality can be murkier, often decadent and sometimes downright ugly.

Though they occupy an apparently superficial milieu, fashion photographers have become deeply influential figures. Fashion hawks clothes, accessories, and cosmetics through the work of the image merchants who manipulate compelling beauties—be they models, actresses, or, more recently, mere celebrities—in pictures (as well as in their real lives). But it also conveys a complex, ever-evolving psychology and social ambience, a commercial fiction that goes by the name *lifestyle* and has the proven ability to influence behavior and alter social norms. Its critics have blamed fashion and the images that sell it for everything from anorexia to heroin addiction.

Focus is about fashion photographers and their field, not about fashion photographs themselves. It will not tell the whole story of photography, which was born in Europe at the end of the first third of the nineteenth century, or try to encompass the panorama of the century after the 1840s, when the first photos showing the latest fashions were taken in Europe. By 1880, more than a dozen

fashion journals were being published in the United States. The first magazine to mix words and photographs of clothing was *La Mode Practique* in 1892.

Traditionally, the primary venues for fashion photographs have been periodicals, glossy magazines in particular, and advertisements commissioned by fashion manufacturers. An aspiring fashion photographer often begins a career by shooting "tests" of similarly aspiring models or friends, which are used as calling cards to gain the attention of, and assignments from, art directors and photo editors at magazines. These assignments pay little, but give a photographer priceless exposure. Photo credits in magazines lead to more lucrative advertising assignments.

That double helix is the ladder photographers climb from anonymity to success and wealth—particularly if they are among the handful of shooters who work for big brands. Magazine editors and stylists are charged with choosing clothes and collaborating with photographers as to how those clothes will be photographed. But they also collaborate with fashion brands in ways—accepting gifts and moonlight styling jobs—that violate the traditional boundaries of journalism. And they work alongside large staffs of marketing and publishing executives, some of them also called editors, whose primary job is to keep advertisers happy.

An open secret in the business is that magazines often dole out "pages" and "credits" based on the purchase of advertising pages, and that photographers regularly shoot "musts," garments chosen by major advertisers. But accepting these compromises has compensations. Powerful magazine editors and stylists have long functioned as de facto agents for photographers, recommending them to advertisers for high-paying jobs as a perquisite offsetting meager editorial payments and limited creative freedom.

"I give a job to you and you work for my magazine for free," an executive of a top Italian fashion brand explains. "It's a little mafia. Condé Nast pays almost zero, they make the photographers pay for the stylists and the location, but they guarantee campaigns." Top editors style those campaigns on their days off "at half price and then get twelve pages [by the same photographer] for free. Nobody's innocent."

In recent years, the relationship between fashion and journalism has become an even more tangled web as powerful art directors have been allowed to simultaneously run magazines and independent agencies producing fash-

ion advertisements, and publishing companies have let fashion editors, even editors in chief, moonlight as stylists for the same advertisers whose goods they "report" on in their magazines. Even before the Internet began blowing the most basic assumptions and definitions of media to the four winds, the distinction between fashion journalism and fashion commerce had effectively disappeared. It is no great stretch to say that fashion journalism has always been an oxymoron—and grows more oxymoronic by the day.

The art of fashion photography has always been compromised by the marketplace. But oddly, the primary font of creativity in the field is not always in the allegedly pure waters of editorial photography. Editors have long placed limits on the wilder expressions of their camera-carrying artists. *Harper's Bazaar* editor Nancy White, one of the last of the fashion ladies who always wore hat and gloves, saw objectionable sex all over the place—and fought her contributors tooth and nail to keep it from the pages of her magazine (which was known, at least until her genteel era passed, as "the" *Bazaar*). Ultimately more damaging than such personal preference is the commercial injunction that the manufacturer's dress (and the income streams that flow from it) is more valuable than all but a very few photographers' creative visions. But when that rule becomes the universal norm, as it did during the recessionary 1980s, when advertising revenues dropped sharply and publishers panicked and grew wary of giving any offense, some fashion brands took the creative lead and became the prime movers behind the art. Though they profess to be selling "image," not garments, and thus elevate the photos they commission, ultimately it is all, always, still, about moving fashion products from factory to store to consumer.

Addicted to visuals that grab attention, fashion constantly raises (or, some might say, lowers) the bar, pushing the limits of taste to re-create the thrill of its last fix, the higher high that comes from pushing past any taboos still standing. It signals, reflects, and sometimes even leads social and behavioral shifts, including the changing place of women in society and the workplace, and their steady progress from wives, mothers, and objects (whether domestic or aesthetic) to active participants in public life; and the social ferment of the 1960s, evolving sexual mores, the drug culture, and hedonism of the 1970s, the materialism and resurgence of tradition of the 1980s, the renaissance of decadence and the "heroin chic" of the 1990s, and the corporatization of fashion and society in recent years.

Hadley Hudson has entered a field much diminished from the one Terry Richardson found when he started taking professional pictures twenty years ago. Some hint it's facing extinction. "The whole thing has changed," says Jean-Jacques Naudet, who edited *Photo* magazine in France and *American Photo* in the United States for almost four decades. "The electronic age arrived. Street photography. Now, anyone can take a photograph. Photography has changed so drastically, you can't comprehend it."

Naudet offers numerical proof of his contention that only fine art photography matters at the moment—not fashion. While the value of certain vintage fashion prints is rising in the marketplace—a copy of Avedon's *Dovima with Elephants* from 1955 sold at auction for a record, just under $1.152 million in 2010—"the value of a published picture is less and less," says Naudet, who estimates that a photo that might have earned $80,000 from a publisher a decade ago will now bring in no more than $12,000. Ten years ago, he continues, top fashion photographers could make $5 million to $7 million a year. "Now? I don't know," Naudet says glumly. "All those photographers who had huge contracts are less flamboyant now. Fashion photographers and models were at the top; they were stars, celebrities. Not anymore." Reality television and social media celebrities have replaced them.

Naudet's mournful notes are played often by fashion photography professionals and aficionados. Like other analog-age art forms, from music to books, the fashion photo does seem endangered. Odds are this is just what fashion folk call a *moment*, a passage to another place, not an end. But this moment does seem like a pause, if not for the whole story of fashion imagery, then at least for the golden era, when the form came to full flower, when fashion photographers were more than chroniclers of pleats, drapes, and hemlines, when they seemed to grasp the most evanescent art form ever invented, imbuing it with meaning and importance, giving permanence to passing fancy, plumbing the rich, hidden depths of superficiality.

If a picture is truly worth a thousand words, and *Dovima with Elephants* more than a million dollars, then *Focus* hopes to fix fashion photography's moment, frame it, and display it, so others may recall the years when light, lenses, emulsion, lissome women, and the latest looks combined with envy and ego, ambition and avarice, lucre and lust, to make magic.

It isn't gone. It's just different. These were its glory days.

INNOCENCE

Aberdeen, Aberdeen, doesn't it make you want to cry?

—DIANA VREELAND

Chapter 1

"A WITNESS"

A chilly rain was falling on November 6, 1989, when several generations of New York's fashion and social elite gathered in the medieval-sculpture hall of the Metropolitan Museum of Art for a memorial celebrating Diana Vreeland, the fashion editor, curator, and quintessence of self-creation.

Jacqueline Kennedy Onassis, for whom Vreeland was a fashion godmother, and Lauren Bacall, who'd been discovered by her, both arrived alone. Dorinda Dixon Ryan, known as D.D., who'd worked under Vreeland at *Harper's Bazaar*, was seated next to Carolyne Roehm, one among many fashion designers in attendance. Mica Ertegun and Chessy Rayner, the society decorators, sat with Reinaldo Herrera, holder of the Spanish title Marqués of Torre Casa, whose family estate in Venezuela, built in 1590, is said to be the oldest continuously inhabited home in the Western Hemisphere.

One of Vreeland's sons delivered a eulogy, as did socialite C. Z. Guest; Pierre Bergé, the business partner of Yves Saint Laurent; Oscar de la Renta, the society dressmaker; Philippe de Montebello, then the museum's director and Vreeland's final boss when she ran its Costume Institute; and George Plimpton, who cowrote her memoir, *D.V.* But the afternoon's most telling fashion moment came in between Montebello and Plimpton, when photographer Richard Avedon, who'd worked with Vreeland from the start of his career, took the stage.

Avedon was a giant in fashion and society, an insider and an iconoclast, a trenchant critic of the very worlds that had made him a star, arguably the most celebrated photographer of the twentieth century. Never one to mince words or spare the feelings of others ("Oh, Dick, Dick, Dick is such a dick," a junior fashion editor once said), he used his eulogy as a gun aimed at Vreeland's latest successor at *Vogue*, Anna Wintour.

Though he never once mentioned her name, he sought to wound Wintour, who'd arrived at the memorial with her bosses, the heads of Condé Nast Publications, S. I. "Si" Newhouse Jr., the company's chairman, and Alexander Liberman, its editorial director. Just a year earlier, they'd let Wintour replace Avedon as the photographer of *Vogue*'s covers. Only a few in the audience knew that Avedon had actually shot a cover for the November 1988 issue, Wintour's first as editor in chief of *Vogue*, and that no one had bothered to alert him that Wintour had replaced it with a picture by the much-younger Peter Lindbergh. Avedon only found out when the printed issue arrived at his studio.

He never shot for *Vogue* again.

A year later, Avedon served up his revenge dressed in a tribute to the woman he'd sometimes refer to as his "crazy aunt" Diana. Avedon recalled their first meeting in 1945 when he was twenty-two and fresh out of the merchant marine. Carmel Snow was about to make true his short lifetime's dream of taking photographs for *Harper's Bazaar*, the magazine she edited that he'd first encountered as the son of a Fifth Avenue fashion retailer. Newspaper and magazine stories about the Vreeland memorial would linger on in Avedon's recollections of their first meeting, how he watched her stick a pin into both a dress and the model wearing it, "who let out a little scream," he remembered. Vreeland turned to him for the very first time and said, "Aberdeen, Aberdeen, doesn't it make you want to cry?"

It did, he went on, but not because he loved the dress or appreciated the mangling of his name. He went back to Carmel Snow and said, "I can't work with that woman." Snow replied that he would, "and I did," Avedon continued, "to my enormous benefit, for almost forty years."

But that charming opening anecdote was nothing compared to what followed. Avedon extolled Vreeland's virtues, "the amazing gallop of her imagination," her preternatural understanding of what women would want to wear, her "sense of humor so large, so generous, she was ever ready to make a joke of herself," and the diligence that made her "the hardest-working person I've ever known. . . .

"I am here as a witness," Avedon concluded. "Diana lived for imagination ruled by discipline, and created a totally new profession. Vreeland invented the fashion editor. Before her, it was society ladies who put hats on other so-

ciety ladies. Now, it's promotion ladies who compete with other promotion ladies. No one has equaled her—not nearly. And the form has died with her. It's just *staggering* how lost her standards are to the fashion world."

Sitting at the front of the audience between her two bosses, wearing a Chanel suit that mixed Vreeland's signature color, red, with the black of mourning, the haughty Wintour, her eyes hidden behind sunglasses, gave no hint that she knew Avedon was speaking to her. But even though he saw her ascendance as a sign of the fashion Apocalypse, it's unlikely that even the prescient Avedon could have foreseen all the other, related forces then taking shape that would, in little more than a decade, fundamentally alter the role—fashion photographer—that he'd not only mastered but embodied.

Chapter 2

WOMEN WEARING CLOTHES ON FILM

Richard Avedon's métier had one thing in common with the fashion photography that preceded it: it was still about women wearing clothes on film. Most of the pioneers of the field were born during the Belle Epoque, the end of the nineteenth century, when photography and photographic reproduction were being refined.

In the early twentieth century, fashion photography emerged, but constrained by commerce, rudimentary technology, and social norms, it was either stiff and formal or romantic and artificial, elegant but sexless, lacking both psychological depth and social or historical commentary. Its two most imposing early practitioners were a Balkan baron, Adolph de Meyer, who started shooting for *Vogue* in 1913 and became its first contract photographer at $100 per week, and his successor, Edward Steichen, who took over as chief photographer of Condé Nast, the publisher of *Vogue* and *Vanity Fair*, in 1923.

The company was named for its New York–born founder, Nast, a shy, unexceptional-looking little man with a pince-nez who had come to New York in 1897 to sell ads for a little magazine and earned enough money that by 1905 he started thinking of buying one of his own. Already more than a dozen in America covered fashion, among them *Harper's Bazar* (the third *a* in the second word of its name would be added in 1929). It was founded in 1867 by the same siblings who started a book publisher, Harper & Brothers, and its aim was in its subtitle, "Repository of Fashion, Pleasure and Instruction." *Vogue* was positioned as the most elite of the fashion magazines from its founding in 1892. But fashion was only one of *Vogue*'s concerns; it

covered all the pursuits of its leisure-class backers and their families, the .01 percent of their day.

In 1912, *Harper's Bazar* was sold to William Randolph Hearst, one of the richest and most powerful Americans, who would inspire Orson Welles's movie *Citizen Kane*. Briefly, *Bazar* outsold *Vogue*, but under Nast, the latter became the nation's leading fashion magazine and, for the next two decades, a trendsetter in the use of photography.

Meyer stayed at *Vogue* (which became an international brand in 1916 with the launch of a British edition) for seven years, until Hearst lured him to the *Bazar* in 1920 with the promise of a fifteen-year contract at a higher salary, and work in Paris. Meyer's defection started a war between Hearst and Condé Nast that would continue into the next century. *Vogue's* then editor, Edna Woolman Chase, would later write that Hearst's modus operandi when poaching talent was to offer "money often beyond their worth and beyond what Condé was able to pay."

After Steichen replaced Meyer, he discovered he had an invaluable ally, Carmel Snow, *Vogue's* fashion editor, who "had a policy that a photographer should have whatever he required, and no questions asked." Snow would have a far longer and arguably larger impact on the field than the great photographer did. Steichen, who claimed authorship of "the first serious fashion photographs ever made," would close his New York studio in 1938 when, he wrote, "fashion photography had become a routine, and routines are stifling. . . . I had lost interest [in both fashion and advertising work] because I no longer found the work challenging; it was too easy."

That remark prefigures a comment, attributed to the notable art director Alexey Brodovitch, that stands as a warning to all fashion photographers: "The creative life of a commercial photographer is like the life of a butterfly. Very seldom do we see a photographer who continues to be really productive for more than eight or ten years."

Condé Nast also opened French, Spanish, and German editions of *Vogue*. The art director of the latter, a Ukrainian-born Turk named Dr. Mehemed Fehmy Agha, would soon move to New York to oversee all of Nast's magazines and modernize them with bold typography and strong layouts that emphasized large photographs, some running off the pages in what is called full bleed or floating frameless in theretofore unprecedented amounts of

white space. The redesign reflected the visual revolution set off at a 1925 exposition in Paris of modern decorative and industrial arts, the show that launched the moderne movement.

The revamped *Vogue* delighted fashion editor Carmel Snow, who was also a champion of avant-garde art and design. Born in Ireland to a well-to-do family, she started her career working for her mother's New York dressmaking salon, where she got an education in style, which Snow experienced firsthand, traveling with her mother to see the Parisian haute couture. When she shared her impressions of one season with a fashion journalist, Carmel was rewarded with an introduction to Edna Woolman Chase, the prim, dowdy Quaker who'd been at *Vogue* since 1895, and its editor since 1914. Chase took Snow to Nast, and in 1920 he offered her a job as an assistant editor at the magazine.

Chase viewed the socially desirable and clearly brilliant newcomer as a threat, but Nast was smitten by her, ensuring that career-enhancing opportunities—such as working on Steichen's first fashion shoot, conducted in Nast's Park Avenue apartment—came her way. "Steichen and I immediately clicked," Snow recalled. Promotions to fashion editor and, in 1929, editor of American *Vogue* followed (Chase still reigned as the super-editor of all four editions), so Snow was well placed to learn from Agha when he arrived, even though she found the portly, monocled art director "as inscrutable as a cup of black coffee."

Despite Snow's approval of Agha's attempts to modernize the look of *Vogue* and its operations, its photographers—including Cecil Beaton, Beaton's champion, George Hoyningen-Huené, and Huené's protégé, Horst Paul Albert Bohrmann, who styled himself Horst P. Horst, were still stuck in studios. Fortunately for fashion photography, Carmel Snow was not stuck at *Vogue*. Tired of being Edna Chase's subordinate, and of being second-guessed by her, Snow left *Vogue* to become fashion editor at the *Bazaar* in 1932 and was ever after "considered a traitor by many *Vogue* partisans." Her decision to jump ship ended a brief spell of peace between the rival fashion magazines. She explained it by claiming that mid-Depression, she was sure Nast would be happy to save her salary—which Hearst had matched. Condé Nast, like many of his fellow Americans, had lost his fortune in the stock market crash of 1929, was millions of dollars

in debt, and had lost control of his company to Goldman Sachs, the investment bank.

At the *Bazaar*, Snow began gathering a team to help her freshen up a magazine she thought "dull and monotonous . . . muddy and drab." Among her early hires was a Hungarian news and sports photographer, Martin Munkácsi (born Márton Mermelstein), whom Steichen admired and Snow referred to as Munky. William Randolph Hearst's mistress, the actress Marion Davies, griped that he was "just a snapshot photographer," but Snow insisted, the first of many times she would disregard her new boss's wishes, to the great benefit of their magazine. Snow thought Munkácsi might fill her "instinctive craving to get some fresh air in the book," as professionals refer to magazines, and asked him to reshoot a bathing suit feature originally done in a studio. The photographer didn't speak English, but managed to communicate that he wanted the model to run toward the camera. When the resulting photo appeared in the December 1933 *Bazaar*, it was, Snow would later boast, "the first action photograph made *for fashion*."

In fact, it wasn't. In a perverse irony, female photographers have rarely succeeded in fashion and even the exceptions have been overshadowed, reflecting a social pathology that extends well beyond fashion. Ever since Hoyningen-Huené and Horst, the fashion in fashion photographers has swung back and forth between gay and straight men. Though there have always been significant women photographers, the curious fact is that women's clothing is typically photographed by men. So it's perhaps unsurprising that the work of a woman who began taking action fashion photos before Munkácsi would be downplayed if not forgotten. She was also taking those photographs for *Vogue*—not the *Bazaar*.

Antoinette Wood Frissell, better known as Toni, had been a typical hire when she first came to *Vogue* as a caption writer in 1930, a society girl from a family of adventurers, and a childhood playmate of Condé Nast's daughter. After several years working as an actress, she was introduced to a neighbor, Edna Chase, who hired her with the admonition "Tomorrow you had better wear a hat to the office. No woman is really well turned out without a hat."

Toni's spell in the *Vogue* office was brief; she wasn't much of a copywriter

and was fired, likely due to that same decline in Condé Nast's fortunes that Carmel Snow had used to justify her leap to the *Bazaar*. But after Toni's brother died in a shipwreck, and their mother fell ill, she pulled out a Rolleiflex camera her brother had given her and distracted herself by mastering it. "I thought, why not take pictures out of doors," she would recall in an unpublished memoir.* "Why do all the fashions have to be photographed in a studio." She learned to use the camera with "past-due worthless film," then bought new film and asked friends—local society beauties—to pose during her summer vacation.

"I blew a few of these pictures up to show to *Vogue* on my return," she wrote. Carmel Snow, then still at *Vogue*, approved. "Toni, you're an original girl," she said. "Perhaps you should take up photography." Agha, too, encouraged Toni. "I have a feeling in my Turkish bones that drawings of fashion pictures are on the way out and photographs in," he said. "Bring me your pictures." She did, but *Vogue* didn't bite until she sold several to Hearst's *Town & Country*. Then *Vogue* "immediately resummoned me and began to give me assignments to do outdoor fashion photographs." The following year, just after Snow departed, *Vogue* put Toni under contract.

Vogue was no nirvana for photographers. By the middle thirties, photographers had begun to chafe under Nast's strict regime, which still favored formality. The introduction of cameras that had faster shutter speeds and were smaller, lighter, easier to use, such as the 35 mm Leica, first sold in 1925, led to the creation of newsmagazines such as Lucien Vogel's *Vu* in France in 1928 and *Life* in New York in 1936. Their pictures, "instantaneous, emblematic, capturing a moment frozen in time," in the words of Condé Nast's biographer Caroline Seebohm, introduced photography to the mass market, and over the next five years Nast finally began edging *Vogue* away from its reliance on the stiff studio shot. But by then, the center of gravity of fashion photography had moved to the *Bazaar*.

Its rise began with Munkácsi. By 1936, Munky claimed to be the world's best-paid fashion photographer, making $100,000 a year—he'd soon buy a penthouse triplex in Tudor City and an estate on Long Island's posh North

*The manuscript of Frissell's memoir was shared with the author by her grandson Montgomery Brookfield and his wife, Eileen.

Shore, in which he hung paintings by Rubens and Tintoretto. But he was divorced in 1939, a daughter died of leukemia, he suffered a heart attack in 1943, his career suffered, and in 1947, the *Bazaar* dropped his contract. He declared bankruptcy in 1960, showing debts of more than $30,000 against assets of merely $30, and when he died of a heart attack in 1963 at sixty-seven, his ex-wife found him in a virtually empty apartment with only a half-eaten tin of spaghetti in his refrigerator.

In 1934, Snow visited Rockefeller Center to see an exhibition of a Russian émigré graphic designer. The day before it opened, Snow walked through, she recalled, "and I saw a fresh, new conception of layout technique that struck me like a revelation. . . . Within ten minutes I had asked Brodovitch to have cocktails with me, and that evening I signed him to a provisional contract as art director." It was provisional not just because she needed Hearst's approval to hire Alexey Brodovitch, but also because "I wasn't yet the editor!" So Snow asked Brodovitch to make a "dummy," a book of sample layouts, then traveled to one of Hearst's castles, in Wales, to talk her extremely conservative boss into hiring her avant-garde find.

Alexey Brodovitch was born in a hunting lodge near the Finnish border outside St. Petersburg, Russia, in 1898. His mother was an amateur painter, his Polish father a sportsman, hunter, and military psychiatrist who ran a Moscow hospital for prisoners of the Russo-Japanese War. Before he turned ten, Alexey photographed wounded Japanese prisoners under his father's care. A child of wealthy property-holders in an aristocratic society, Alexey was sent to good schools and spent winters on the Côte d'Azur. His parents tried to shield him from the ferment in prerevolutionary Russia, but "Brodovitch was to be marked forever by the time of great sociopolitical transformation when change of one sort or another was the oxygen of public life," wrote his biographer, Kerry William Purcell.

The Brodovitch family wanted Alexey to enter the Imperial Art Academy, but in 1914, the sixteen-year-old ran away to fight in World War I. Dragged home by his father, he was sent to officers' school, emerged a cavalry officer, and ultimately attained the rank of captain. During the Civil War after the

Russian Revolution, Brodovitch served with the royalist White Army and was wounded in battle against the Bolsheviks, hospitalized in the Caucasus Mountains, and eventually retreated south with thousands of refugees. He met his future wife, Nina, a nurse volunteer, during that retreat.

The couple ended up in Novorossiysk, where he reunited with his brother and father, who was captain of a ship that took them to Constantinople, where his mother appeared. They eventually reached Paris, and Alexey and Nina married and lived in a "cheap, dirty room in a brothel" in Montparnasse, a center of Russian emigrant life. Brodovitch painted backdrops—he called it "executing décor"—designed by Picasso, Derain, and Matisse for the Ballets Russes, and went on to design advertisements, textiles for designers such as Patou and Poiret, and layouts for French magazines. He also designed jewelry and china, tried his hand at architecture and decorating, and immersed himself in the great art movements of the period—constructivism, surrealism, art deco—and in 1924, after winning a poster-design competition in which he beat Pablo Picasso, among others, he focused on graphic design, synthesizing "the various modernist strands" of experimental art and design "into a unified approach" that made his studio, L'Atelier A.B., preeminent in Paris. He moved to Philadelphia in 1930 to teach advertising.

In 1934 after Snow lured him to *Harper's Bazaar*, he helped Hearst's moribund fashion magazine catch up to Dr. Agha's more innovative *Vogue* and then surpass it.* Thirty-six years old when he joined the *Bazaar*, Brodovitch would remain in Hearst's employ for two dozen years, though he continued to freelance and travel widely, keeping abreast of the latest developments in art and graphic design. He also worked briefly as a photographer, shooting the Ballets Russes de Monte Carlo and other dance companies from 1935 to 1939 for his only book, *Ballet* (published in a small edition in 1945). The photographer Irving Penn would later say that *Ballet* "spat in the face of technique and pointed out a new way in which photographers could work." Blurred and distorted, and likely manipulated in the darkroom, yet strictly

*Curiously, Brodovitch didn't put a photograph on the cover of the *Bazaar* until 1940, eight years after Agha crossed that Rubicon at *Vogue*. It was a rare lapse. Even the hidebound William Randolph Hearst had been agitating for photographed covers.

ordered and unified, the book captured motion in a way never before seen—except perhaps in Brodovitch layouts for the *Bazaar*.

Brodovitch continued to teach a series of weekly seminars called the Design Laboratory, which he'd launched in Philadelphia before joining the *Bazaar* and then moved to New York's New School for Social Research. Many of the greatest photographers and graphic designers of the midcentury passed through those classes, including the fashion photographers Lillian Bassman (with her husband, Paul Himmel), Fernand Fonssagrives, William Helburn, Hiro, Tom Palumbo, Karen Radkai, Jerry Schatzberg, Bert Stern, Louis Faurer, Art Kane, Saul Leiter, and the student who would later be most closely associated with Brodovitch, Richard Avedon. Taking Brodovitch's course was a way to be noticed and invited to contribute to the *Bazaar*.

Those who encountered him described Brodovitch as everything from charming to tyrannical, glum and shy to elegant and noble. "It was a pleasure to watch him at work," Frances McFadden, then the managing editor of the *Bazaar*, would recall. "He was so swift and sure. In emergencies, like the time the clipper bearing the report of the Paris Collections was held up in Bermuda, his speed was dazzling. A quick splash or two on the cutting board, a minute's juggling of the photostats, a slather of art gum, and the sixteen pages were complete. . . . Just before we went to press, all the layouts were laid out in sequence on Carmel Snow's floor and there, under his eye, rearranged until the rhythm of the magazine suited him."

His photographers adored him, and he reciprocated. "He loved his photographers, and with them he blossomed," recalled Diana Vreeland, a society woman with enormous style who joined the *Bazaar* as a fashion editor in 1936. Richard Avedon, who would appear at the Design Laboratory eleven years after it began, called him "my only teacher," but saw a different side of him than McFadden did: "I learned from his impatience, his arrogance, his dissatisfaction."

The classes (which were later held in various photography studios, including Avedon's, and continued into the midsixties) usually followed the same pattern. Brodovitch's students would gather around a big table and look at magazine clippings, pictures, layouts, and exhibition catalogs, or movies or performances, and discuss and critique them. Brodovitch dis-

dained the very idea of teaching. "You got no rules or laws," Avedon said. "He was a genius and he was difficult. Like an inherited quality, there was something of him in you for the rest of your life."

Brodovitch nudged his students to find their own way, rarely giving praise, instead making oracular comments in Russian-accented English such as "You have remarkable ability to click the shutter at the right time." But he also gave assignments, though sometimes only as vague themes: jazz, or Dixie cups, or juvenile delinquency. The results of those assignments would be passed around.

Brodovitch loved images that got "under your skin," that irritated and intrigued. "I value shock appeal . . . not things which are obviously posed, obviously artificial." He'd taken as his own Diaghilev's oft-quoted admonition to Jean Cocteau, *étonnez-moi*, "astonish me," and could be bluntly dismissive of work that failed to meet that standard. Avedon said Brodovitch "liked so few of my pictures that when he was enthusiastic over one, I was so elated I could go on that energy for another three months."

The photographers who attended the Design Laboratory likely couldn't say no when Brodovitch asked them to shoot fashion for his magazine. "The best writers, the best photographers . . . were all published in *Harper's Bazaar*," Avedon said. "And that was my dream, that was the pantheon."

"It is largely due to Brodovitch that the responsibilities of an editorial art director were expanded to include almost total control of a publication's visual contents," the critic Andy Grundberg wrote. The first great photographer Brodovitch lured to the *Bazaar*, Man Ray, came not from the Design Laboratory but from *Vogue*. After studying art in New York, Man Ray (born Emanuel Radnitsky in Philadelphia in 1890) had followed his friend Marcel Duchamp to Paris in 1921, where Man Ray would prove himself a master of painting, sculpture, and collage, but was initially most famous as a practitioner of the still-new art of photography. A friend introduced him to the designer Poiret, who hired him to photograph his couture collection in fall 1921. "I could have told him it was perhaps because I was more interested in the girl than in the clothes, but I kept my mouth shut," the photographer later noted.

Inevitably, in 1924, Man Ray got his first assignment from Dr. Agha at *Vogue* and worked with Carmel Snow. Then, after Brodovitch joined Snow at

the *Bazaar*, Man Ray followed. He shared Brodovitch's artistic inclinations and his desire to provoke. But the last season before Paris fell to the Nazis was also the last time Man Ray worked as a fashion photographer. Though he'd been notably successful in the field and enabled fashion's embrace of surrealism, Man Ray worried that fashion had diminished his reputation. Richard Avedon would later credit him with breaking "the stranglehold of reality on fashion photography," but Man Ray barely mentions his fashion work in his autobiography.

More significant to fashion, if not to art, was Louise Dahl-Wolfe, a Californian of Norwegian descent, who joined the *Bazaar* in 1936. The stocky, "cantankerous, wondrously plain photographer" had studied art and design for many years, and her portraiture caught the eye of the omnivorous Frank Crowinshield, then-editor of *Vanity Fair*, who sent her to an interview with Dr. Agha. It went badly—she had a cold, was bundled up, and looked older than her forty years—and the art director accidentally returned her portfolio with a withering, sexist critique he'd written to Nast tucked inside (he deemed her middle-aged, and too stuck in her ways for fashion work). "Louise, who has a healthy ego to match her ability, was naturally furious," Snow recalled, and went to see Brodovitch. Snow, who wanted more color in her magazine at a time when only black-and-white work was deemed important, was drawn to her then-rare interest in color photography. "She developed color photography to its ultimate," Snow would recall.

Diana Vreeland joined the *Bazaar* just after Dahl-Wolfe, and the complementary opposites formed a perfect partnership. Snow had known of Vreeland since the 1920s when she'd been photographed for *Vogue* as an ugly-duckling debutante. She'd then married a banker, T. Reed Vreeland, and moved to England, where his dashing good looks and her great style made them popular in fashionable society. Back in New York, Snow spotted Vreeland dancing in a hotel and learned that, since her husband was unable to support their tastes and lifestyle mid-Depression, Vreeland was looking for a job. She had no magazine experience, but she'd been in love with fashion since childhood, and Snow felt sure her innate style, taste, and sheer presence would make her valuable.

A column of tongue-in-cheek fashion advice that she launched in 1936, Why Don't You? (one famous entry: "Why don't you rinse your blond child's

hair in a dead champagne to keep it gold as they do in France?"), would have such immediate impact it would be parodied two years later in the *New Yorker* by S. J. Perelman. She was also a nose-to-the-grindstone worker, and by 1939, she'd become a full-time fashion editor.

Temper tantrums set Vreeland's collaborator Dahl-Wolfe apart. A few years later, Toni Frissell, frustrated with fashion after America's entry into World War II, decided to stretch her talents "to prove to myself that I could do a real reporting job" and volunteered to take photographs for the American Red Cross. At the time, she was working for *Life*, *Collier's*, and the *Saturday Evening Post*, as well as *Vogue*, and all but the last agreed to pay her usual fee to the Red Cross when they used photographs Frissell took under its auspices. One day in Scotland, photographing rehearsals for the invasion of Normandy, Frissell spied a former *Vogue* editor among the Red Cross volunteers and took her picture with an army sergeant who was flirting with her.

When *Vogue* editors saw that picture, they created a ten-page spread "about the *Vogue* girls having gone off to war," Frissell recalled, "photographed by THEIR photographer [capitalization hers]." On her return to the States, Frissell learned that *Vogue* had refused to pay the Red Cross for the pictures "in spite of [my] being on a leave of absence meaning no pay," she wrote in her unpublished memoirs. "I was so offended that my magazine should behave in such a shabby, stingy bastard way, I resigned." When Frissell subsequently approached Snow at the *Bazaar*, though, Dahl-Wolfe objected—even after getting assurances that Frissell would not be assigned fashion shoots—and threatened to quit if a single Frissell image ran in the magazine.

The German Jewish Erwin Blumenfeld was one of the greatest photographers to slip from Snow and Brodovitch's grasp. Born to an upper-middle-class family in Berlin in 1897, Blumenfeld was forced to go to work at sixteen as an apprentice at a women's clothing firm after his father died from syphilis. "He developed a feeling for textiles and texture," says a son, Yorick. A chance encounter at a urinal with the painter George Grosz the next year thrust him into Berlin's avant-garde. But after fighting in World War I, and

failing to find a foothold in the art world afterward, Blumenfeld opened a shop in Amsterdam selling women's handbags.

The discovery of a darkroom, complete with a bellows camera, hidden behind a locked door in his store changed his life. He'd always taken photographs and thought that if he started again and put pictures of beautiful women in his shop window, he could attract more customers. "I developed and printed all night long so that every morning a new and angelic face in 'high key' could shine forth in the shop," he wrote in his autobiography. Blumenfeld was obsessed with beautiful women. "I started life as a sexless sexual maniac. I took refuge in the Eternal Feminine." Some paid for their portraits; many more were convinced to pose at his invitation, some of them even agreeing to be photographed in the nude, allowing Blumenfeld to indulge his voyeuristic streak.

Blumenfeld's most important photographic angel, the daughter of painter Georges Rouault, spotted the pictures in his store window while in Amsterdam on her honeymoon and asked to pose for him. A dentist, she showed his pictures in her waiting room, where prominent patients such as the Vicomtesse de Noailles saw them. Following his new patron to Paris, Blumenfeld quickly met its prominent artists and personalities and photographed many of them. Though he'd come to Paris with the dream of working for *Vogue*, "he seemed to make no headway," wrote his biographer.

Michel de Brunhoff, the editor in chief of French *Vogue*, would receive unknown artists on Fridays between three and five in the afternoon. "Every Friday I would wait, with a large group of fellow sufferers," Blumenfeld recalled. "Around six, he would come back, slightly overheated, from lunch, pass through the guard-of-honor of artists, as they rose politely at his entrance, without giving a single one the benefit of a glance. He would never receive more than one (either a man with particularly important connections or a woman with particularly attractive legs)." But by 1937, Blumenfeld had been published in graphic design journals and art and photography magazines.

The next year, Cecil Beaton, who'd seen Blumenfeld's portraits, invited him to tea. "The doors to the drawing-room of the world—hitherto barred—seemed to be bursting open," Blumenfeld would later exult. "Under Cecil's wing I soon got into the *Vogue* establishment, and quickly learned to despise

that philistine *Vanity Fair*, in which small-ad profiteers pretend to be arbiters of elegance. Illusions are there to be shattered. In that ants' nest of unrequited ambition, where *nouveautés* [novelties] have to be pursued *á tout prix* [at all costs], I remained—in spite of a thousand pages of published photos—an outsider, a foreign body." De Brunhoff told him, "If only you'd been born a baron and become homosexual, you'd be the greatest photographer in the world."

Despite the heterosexuality that seemed queer in the eyes of fashion, Blumenfeld made his multipage debut in *Vogue* in October 1938 and appeared in the magazine several more times in succeeding months, culminating with a twenty-page portfolio in May 1939, celebrating the fiftieth birthday of the Eiffel Tower, which included photos of the model Lisa Fonssagrives (the wife of a Brodovitch student) hanging gracefully if precariously off the Parisian landmark.

American *Vogue*'s Dr. Agha was underwhelmed by Blumenfeld's gifts. Agha told him, he wrote to Beaton, "I haven't a clue about photography." As an aside, Blumenfeld added, "I could vomit." Agha apparently felt something similar. In spring 1939, Blumenfeld was informed that *Vogue* had no further use for him. That June, he sailed to New York, where he had a meeting at the *Bazaar* with Carmel Snow and came away with an offer to document the Paris collections for her magazine. Rejoicing, he returned to France on August 10, 1939. Nazi Germany had invaded Czechoslovakia that March, and "I still could have fled to America and avoided many abominations, but I had to follow my destiny," he later wrote.

World War II broke out a few weeks later, when Germany invaded Poland. As a German, Blumenfeld was subject to arrest after France declared war against Germany, but he arranged a gentle form of house arrest in a hotel. That makeshift arrangement lasted until May 1940, when Germany attacked France, and he was arrested by the French (which was fortunate for him, as Gestapo agents would come to *Vogue* looking for him on the day the Germans entered Paris) and interned in a succession of French concentration camps. Eventually, "he managed to get out," says granddaughter Nadia Charbit, reunited with his family, "got visas in Marseilles, and came back to New York in August 1941. Straightaway, he was shooting with Snow, Brodovitch, and Vreeland. He had no studio, so he shared Munkácsi's for at least two years; they were very good friends."

By 1943, he'd made enough money to buy a double-height apartment in the Gainsborough Studios, a live-work apartment house built for well-to-do artists overlooking Central Park. But like Man Ray, Blumenfeld seems not to have taken his fashion work seriously. In his memoirs, he hints at the source of his disillusion when describing his return to the *Bazaar*. After borrowing money to buy a suit, he presented himself at Carmel Snow's office, to find her, "shoes off, feet up on her photo-strewn desk, surrounded by arse-licking editors and her arsehole of an art director Brodovitch. . . . Without getting up, without looking up, she delightedly gave me her orders as if we had never been separated by two years of world war. 'Blumenfeld! Talk of the devil! Two of Huené's pages are impossible and he's gone off on holiday again. . . . Run up to the studio right away and do some fabulous retakes . . . a few genuine Blumenfeld pages, sensational masterpieces!'" As an aside, she promised they'd have lunch soon so he could tell her his war stories.

Appalled, he dutifully went to the studio under the building's roof and shot eight pages, working until midnight before falling asleep in a chair. He woke up to a letter from Snow, "thrust into my hand," finally expressing delight at his safe return to America before telling him that since he'd worked in the *Bazaar* studio, using the magazine's equipment, he would be paid only $150 per picture, not his usual $250. Within a few years, *Vogue* came calling again and, in 1944, made an offer he couldn't refuse, and he returned to the fold. But his temperament would eventually bring the curtain down on him there.

Chapter 3

GAME CHANGERS

The man who would end Blumenfeld's career in editorial fashion arrived on American shores almost simultaneously with Blumenfeld in 1941. His name was Alexander Liberman, and though he'd spend the next two decades laboring in Alexey Brodovitch's shadow, he would eventually emerge and reign for decades as a Medici of fashion photography.

Like Brodovitch, he was a Russian who'd passed through Paris en route to New York. Like Brodovitch (and Dr. Agha, too), he was immersed in the worlds of avant-garde art and design and a sometime photographer. But Liberman didn't have the reverence for photography that was the basis of his rival's power; he thought photos were "a useful method of documentation and nothing more," according to his authorized biographers. Unlike Brodovitch, Liberman saw himself as an artist—he painted and sculpted in his off-hours—and magazine work as a grubby if lucrative diversion.

By 1941, Brodovitch had matched and surpassed the innovations Agha had brought to *Vogue* and challenged its primacy in photography. The *Bazaar* was full of envelope-pushing location photography—one fashion editor came up with a camel for a 1935 shoot in a tropical greenhouse at the botanical garden in the Bronx, another "scored points [with Carmel Snow] by conjuring up an elephant for a Munkácsi shoot," Snow's biographer Penny Rowlands notes. The *Bazaar* featured equally daring writing and quickly became preeminent, its circulation almost doubling during the worst of the Great Depression. *Vogue* still sold better, but the cognoscenti preferred the *Bazaar*, where creativity took precedence over popularity.

In 1937, William Randolph Hearst, deep in debt, had lost financial—though not editorial—control of his empire, but by divesting his holdings managed to pay off his creditors and regain control by 1943. Condé Nast

wasn't so fortunate. A British press mogul replaced Goldman Sachs in 1934, taking control of the company, though he left the publisher in charge. *Vogue* and *House & Garden* struggled and endured, but *Vanity Fair* failed. Nast's image of success survived the Depression but was just an illusion. He was dying of a heart condition and, in 1942, was succeeded by a Russian émigré, Iva "Pat" Patcévitch, who'd come to publishing from Wall Street. That turned out to be good news for Alexander Liberman.

Liberman had been born in St. Petersburg in 1912. His mother came from a family of timber merchants, and his father, though born poor, ran large timber firms, first privately and, after the Russian Revolution, for the Soviet government. The Liberman family's lifestyle was louche, his mother a flamboyant pleasure-seeker, his father, an insecure, anxious Soviet bureaucrat, say his biographers. Little Alex had behavioral issues that led his father to put him in a London boarding school. His mother later moved to Paris, taking Alex with her and soon taking a lover. Her husband joined her in Paris in 1926 after suffering a nervous breakdown, and both had extramarital liaisons. Alex developed bleeding ulcers at age seventeen.

Alex showed his first artistic inclinations by taking, developing, and printing photographs. He briefly studied painting, made a feint at architecture at the École des Beaux-Arts, and got a job as a graphic designer in 1932. At twenty-one years old, he made his way into the employ of Lucien Vogel, who'd gone on from a brief partnership with Condé Nast to launch the weekly photojournalism magazine *Vu*. Vogel, not coincidentally, was Alex's mother's latest lover.

Vu specialized in the documentary photography that had flourished after the introduction of 35 mm cameras and fast film. Liberman worked as its art director with photographic masters such as Cartier-Bresson, Brassaï, and André Kertész and created constructivist-style montages of photos for *Vu's* cover. He also freelanced, just as Brodovitch had a decade earlier, designing windows and catalogs. Liberman married a German girl, a model, in 1936, the same year Vogel sold his left-leaning magazine to a right-wing businessman; Liberman was promptly promoted to managing editor. But his marriage was troubled and with war approaching, Liberman's ulcers returned and then he had a nervous breakdown of his own. After a divorce, Alex found himself alone in a house his father had bought on the Côte d'Azur, where, in 1938, he

was reintroduced to his mother's lover's niece Tatiana, who'd married and become the Comtesse du Plessix. Born well-to-do in St. Petersburg, Tatiana had grown up into an ambitious, artistically inclined young woman-about-Paris, where she counted Man Ray's mistress, a model turned photographer, Lee Miller among her friends. Her first marriage was crumbling when she embarked on an affair with the younger Liberman. He felt he'd found his soul mate, though a friend from that era described him as "a flirtatious eunuch" and repeated the response of a *Vogue* editor, Nicolas de Gunzburg, when he was asked if Liberman was homosexual: "He wouldn't dare."

Tatiana's husband, an aviator, went missing while flying to Gibraltar in 1940, and after that, she and Alex were rarely separated. They fled France through Lisbon, arrived in America in January 1941 with Tatiana's daughter, who would grow up to be the writer Francine du Plessix Gray, and fell in immediately with a set of wealthy Americans, easing their transition to their new home.

Within two days, Tatiana found work as a milliner at Henri Bendel. Alex's notion of becoming a full-time artist had blossomed afresh during his recovery in the south of France, and his father gave him an allowance in his first days in New York, hoping he'd pursue painting. But he realized that to have the sort of luxe life he and Tatiana craved, he'd have to get a job, too, so he reconnected with Lucien Vogel, who was working as a Condé Nast consultant and who introduced him to Patcévitch, then Nast's assistant, who sent him to Dr. Agha.

Agha was known in the office as the Terrible Turk, and Liberman was fired after a week at *Vogue* for failing to meet Agha's standards. Liberman left, "crushed and desperate," only to get a phone call summoning him to see Agha's boss, Nast. Patcévitch had told Nast about Liberman, and when he met the publisher, Liberman recalled, "It became clear very quickly that Nast did not know Agha had already hired and fired me." Agha was summoned and Liberman was hired—again—at $150 a month. His biographers say he developed a special relationship with the dying Nast. Liberman would often be asked to join Agha and Edna Chase in Nast's office to choose covers. After Liberman designed one featuring a Horst photograph of a girl in a bathing suit balancing a ball on her bare feet—and put the ball in place of the letter *o* in *Vogue*, Crowinshield declared the newcomer to the art de-

partment a genius. Cultivating his superiors would be Liberman's modus operandi throughout his professional life. He was expert, his stepdaughter would later write, at "playing all the right cards, charming all the right people." In summer 1942, he and Tatiana would share a country house with Nast's heir apparent, Patcévitch, and his wife.

Liberman's rise presaged Dr. Agha's fall. Shortly after Nast died, the Terrible Turk informed Patcévitch that he wouldn't work with Liberman. In February 1943, Agha's resignation was announced, and a month later Liberman's name appeared on *Vogue*'s masthead as its art director. "I was cheaper, probably," Liberman said.

Liberman made the most of the absence of French fashion from the wartime market, emphasizing practical clothes worn by sporty, all-American models (who were the only ones available). He also introduced younger photographers. One of his first "discoveries" was Frances McLaughlin, who would replace Toni Frissell as *Vogue*'s resident female photographer in 1943—and was the first woman to win a *Vogue* contract; ironically, she was introduced to Liberman by Frissell. Despite Liberman's considering her "more imaginative and refined" than Frissell, her relative importance is indicated by her absence from *On the Edge*, the book of photographs *Vogue* published on its one hundredth anniversary.

Liberman had met Alexey Brodovitch in his first days in New York, but as he had with Agha, made a bad first impression. Brodovitch asked him for a sample page, which Liberman produced and the elder Russian rejected. They never spoke again. But Liberman was aware of his rival's preeminence and of the need to differentiate himself. "Elegance was Brodovitch's strong point," Liberman later observed, "the page looked very attractive. But in a way, it seemed to me that Brodovitch was serving the same purpose that Agha had served, which was to make the page attractive to women—not interesting to women. . . . I thought there was more merit in being able to put twenty pictures on two pages than in making two elegant pages."

Yet, it was a onetime Brodovitch protégé, Irving Penn, whose hiring would come to be seen as "one of Alex's finest achievements." New Jersey–born Penn enrolled in the School of Industrial Art in Philadelphia in 1934 and, in his first year there, was an indifferent student. But at nineteen, he met Brodovitch and joined his Design Laboratory. Penn took unpaid sum-

mer jobs as Brodovitch's assistant in 1937 and 1938, opening the great man's mail, but also creating a drawing that Snow ran in the *Bazaar*, Penn's first published work. Though he was not yet a photographer and likely hadn't even thought of becoming one, Penn would later remark, "Brodovitch was the first person to show me the mystical quality of photographs."

The art director noted Penn's diligence: "At eleven o'clock at night you sent the material to the engravers and you never saw the proofs until next morning. But Penn would stay quite often and go to the engravers, then the printer, to check. He had a wonderful background and experience for this kind of cooking." With the proceeds of $5 sales of sketches of shoes to the *Bazaar*, Penn bought his first camera, a Rolleiflex, and began wandering the streets of New York "taking camera notes." Brodovitch and Snow published some of them. Penn's photos of storefronts, signs, and street scenes have an innocent charm.

In 1939, Brodovitch started moonlighting as the art director at Saks Fifth Avenue and, in 1940, again hired Penn as his assistant. A year later, Brodovitch left and Penn replaced him. But Penn, a gentle, quiet, fastidious man, hated working with merchants and wanted to see other cultures, and to try to create something more than store logos and shopping bags. Looking for someone who might replace him at Saks so he could travel, he heard about Liberman from Brodovitch, met him, but decided he was "much too evolved for the job." Penn shortly left for Mexico to try again to be a painter and on his return in 1943 was hired by Liberman as his assistant at *Vogue*, beginning a decades-long association. "So close has their working relationship been that it is often impossible to disentangle their individual contributions to shared creative problems," the photography curator John Szarkowski wrote while both were still alive.

One of Penn's jobs was to dream up covers for *Vogue* to be executed by its team of photographers—Horst, Beaton, John Rawlings, and the newly arrived Blumenfeld—but "they just gave me the back of the hand," Penn recalled. He felt he'd failed until Liberman suggested another route to the same destination—that he take the photos himself—and provided an assistant to teach him to use *Vogue*'s eight-by-ten studio cameras. Penn's first cover, also the first photographic still life in the magazine's history, appeared in fall 1943. Liberman's judgment was vindicated by Penn's clear, precise

images, and over Edna Chase's stubborn objections, the pair continued making pictures—some of them likely sketched first by Liberman, who would often guide photographers in that way.

Penn left *Vogue* and America to join the war effort in 1944 and returned in 1946. By then, Avedon, Penn's future rival, stylistic opposite, and the only other photographer to achieve the same eminence and win equal, near-universal regard, had begun to make his mark at *Harper's Bazaar*. Both Irving Penn and Richard Avedon would be game changers, taking fashion photography into the modern era, dominating the field for decades, and setting the highest standard for all who followed.

Chapter 4

LIBERATION

In August 1944, Paris was liberated. That December, Carmel Snow arrived, met up with Henri Cartier-Bresson, a young disciple of Martin Munkácsi's, and they traveled across France together. Cartier-Bresson's photos ran in the *Bazaar* the next spring accompanied by a text by Janet Flanner. Back in Paris, Snow reconnected with its fashion set, then, arriving home, "embarked almost at once on a new love affair," she later wrote, "another magazine." Based on a section of the *Bazaar* inaugurated in 1943, featuring fashions for young women, *Junior Bazaar* magazine was launched just after the competing *Seventeen* first appeared in 1944. Decades before the debut of *Teen Vogue*, Snow reveled in the chance to cover "a confused world of novices in ballet slippers and wide hair ribbons. . . . Junior *Bazaar* also brought me my last great 'discovery.'" That was Richard Avedon.

Avedon had been looking at Snow's *Bazaar* for years. "I was brought up on *Harper's Bazaar*, *Vanity Fair*, and *Vogue*," he said. The magazines reflected the dreams of his parents. His father, Jacob "Jack" Avedon, was a forbidding, remote, demanding, embittered American of Russian Jewish descent. Born on the boat that brought him here, abandoned by his father, taken from his mother, raised in part in an orphanage on the Lower East Side, he owned a Fifth Avenue women's clothing store with a brother. Dick's mother, Anna, hailed from a garment-manufacturing family well enough off to have had a carriage and horses in the days before automobiles. Like Snow, Dick grew up breathing the heady scent of style. The Avedon emporium was high-end. "I was surrounded by women who believed in clothes," Avedon said. "I learned how deep their love of surface went."

He was born in 1923, and photography was a part of his life from the beginning. His father taught him the basics, and he was already taking photographs with his family's Kodak box Brownie when he joined the YMHA

Camera Club at age twelve in 1935. "When I was a boy," he once wrote, "my family took great care with our snapshots. . . . We posed in front of expensive cars, homes that weren't ours. We borrowed dogs. . . . All of the photographs in our family album were built on some kind of lie about who we were, and revealed a truth about who we wanted to be."

The family's fortunes were traced in real estate. Dick spent Saturdays at the family's store in a six-story Italian Renaissance mansion at Fifth Avenue and Fortieth Street. When Dick was three in 1926, and his sister Louise one, the family moved to a stucco house in Cedarhurst, a suburban town on Long Island. Four years later, at the start of the Depression, when Avedon's went out of business after Jack's brother lost his money in bad investments, Jack became an insurance salesman. In 1931, the family moved to East Ninety-Eighth Street near Fifth Avenue, where Dick slept in a windowless dining alcove that he decorated with fashion photos. When Jack became a buyer at a women's clothing store in 1932, they moved to East Eighty-Sixth Street.

"The family emphasis was on survival, being educated, being a provider, and living up to the world," Avedon said. His father, whom he called The Judge, focused on responsibility, strength, and the power of appearances. "Life was a battle and you had to be armed for it." Dick's mother cared about progressive politics, intellect, and creativity. "Somehow, I got the message that I had to be one kind of person to please my mother, another to please my father."

Dick was a young celebrity collector, "a manic autograph hound," he recalled, who once tracked Salvador Dalí to his New York hotel suite to get his name on a scrap of paper. The surrealist painter came to the door wearing a snake; behind him, his wife, Gala, posed in the nude. The experience stayed with Avedon, and in years to come he would ask women to pose with snakes, leading to his famous poster image of the nymphet actress Nastassja Kinski wearing nothing but a python. Initially, Avedon was satisfied with signatures of celebrities, from Einstein to Toscanini. Sergey Rachmaninoff, the composer, who lived in the same apartment house as Avedon's grandparents, became his first photographic portrait subject. "I was a family gag," he said later. "It was my way of saying, I want to get out of this apartment, this family, this world, and this is the world I want to join. I want to be one of those people. It started with getting their autographs. Then I started to photograph . . . people who performed their emotions."

In the most autobiographical of his books of photographs, *Evidence: 1944–1994*, Avedon included one of himself in his first fedora and double-breasted suit, taken the year of his thirteenth birthday. There is no record of whether he had a bar mitzvah, but that photo could easily have recorded the moment. "I'm such a Jew, but at the same time completely agnostic," he said.

Dick attended DeWitt Clinton, then an elite high school in the Bronx, where he was an academic failure but, as a senior, edited *Magpie*, the school's literary and art magazine. A classmate, the future novelist James Baldwin, was its literary editor. That same year, Dick won first prize in an inter–high school poetry competition, beating thirty-one other students with a poem entitled "Spring at Coventry." An oft-repeated claim that he won a title, Poet Laureate of New York's high schools, can't be confirmed.

By then, he was taking fashion photographs, often using his sister, Louise, as his model as he copied the styles of Frissell, Dahl-Wolfe, and Munkácsi, whose photos he'd pasted to his bedroom walls. He said, "The longings of my almost adolescence were focused on them." He was fixated, too, on his sister. "We all photographed Louise," he said of his family. "Her beauty was the event of her life." Though she was painfully shy, their mother told her that she was so pretty, she didn't need to talk. Her shyness seemed to grow as she aged. The cause, it would turn out, was incipient mental illness.

The seventeen-year-old Avedon either failed or dropped out of DeWitt Clinton (both have been reported) in 1941 and briefly took courses in either literature or philosophy (again, reports differ) at Columbia University, where he would return for the 1948–49 school year, but never graduate. He also studied sculpture at the Art Students League and dreamed of being a poet—he'd long read his poems aloud to a cousin and had published a few for twenty-five cents a line in local newspapers, but "grew up with not just a sense, but a knowledge, that I was a failure," he said. His father was appalled by Dick's flailing in the arts. "He wanted me to be *his* kind of person," Avedon said, "and to have a son who was an artist wasn't the best news."

He got a job as a darkroom and errand boy for two photographer brothers from Brooklyn. Steve and Mike Elliot (née Lipset) had a studio near Carnegie Hall. The Elliots were childhood neighbors who'd first encountered Avedon while delivering newspapers. Dick worked in their studio until Mike joined the merchant marine and Steve, the army.

In 1942, Avedon joined America's naval auxiliary fleet, too. Equipped with a going-away present from his father, a new Rolleiflex, Dick became a photographer's mate second class, stationed at the Sheepshead Bay Maritime Service station, an under-construction training center in Brooklyn, New York, that was "a mire of muddy paths and partly constructed buildings." Avedon shot identification photos of the sailors in America's Victory Fleet. "I must have taken pictures of maybe one hundred thousand baffled faces before it ever occurred to me I was becoming a photographer," he wrote, almost certainly exaggerating for effect. He and Mike Elliot also ran and took pictures for *The Helm* and *The Mast*, the base magazines. Elliot was editor and Avedon his assistant.

Early on, Avedon began shaping his own narrative. Stephen Elliot, Steve's son, repeats a family legend that his father told Avedon he needed a nose job, and the eager young man took his advice. "His wiry body appear[ed] even more slender because he often dressed in black suits," the writer Patricia Bosworth observed. "Terrified of gaining weight, he existed sometimes on a spoonful of peanut butter a day." Avedon would often tell his origin stories in different ways, fudging some details, leaving out others, revealing a knack for self-mythologizing. When his service ended, Avedon felt paralyzed. "I couldn't speak, I couldn't cope," he said, until a psychoanalyst helped ease his passage into adulthood. He would seek professional psychological help throughout his life.

Dick brought his photos for *The Helm* and *The Mast* when he sought out Alexey Brodovitch. Accounts of their meeting differ. In the most coherent if not most logical story, Carmel Snow's biographer Rowlands says he'd decided Brodovitch was the key to his future and made fourteen appointments with him, dressed up in his best suit each time, only to hear from the *Bazaar*'s receptionist that the great man had changed his mind. Avedon even dropped samples of his work at Brodovitch's apartment, impressing the art director with his persistence and gaining an audience—but only because Brodovitch was fed up with Hoyningen-Huené and Dahl-Wolfe's diva antics. Rowlands says Dick enrolled in the Design Laboratory, and six months later Brodovitch announced that Dick had earned a royal audience. "He brought me to Snow," Avedon said in 1992. "Huené and Dahl-Wolfe ruled the roost, [but] they'd tired of the hierarchy of the stars."

Avedon is said to have paid his Design Laboratory tuition with money

made selling photographs to Bonwit Teller, a Fifth Avenue department store; he'd walked in wearing his uniform and asked if he might borrow some clothes and take pictures for the store for free. He then reportedly hired the most expensive model in New York, Bijou Barrington, to ensure their quality. "The management decided to hang them in the elevators," he recalled. "I rode up and down on the elevators, listening hopefully for customers' comments on my pictures. I didn't hear one." A week later, Bonwit Teller gave Avedon his first assignment, a picture of a girl in a bathing suit. He hitchhiked to the beach with a model to shoot it, "for lack of bus fare," he said, and was paid $7.50. A year later, in another version of the story, Brodovitch came around. "Finally, he agreed to see me," Avedon said.

At the Design Laboratory, he and Brodovitch tangled over an assignment to "make" a neon sign in Times Square. Avedon "tried to weasel out of it," he recalled, "by saying, 'Mr. Brodovitch, I'm a photographer and I don't know how to make a neon sign. Could you give me another assignment?' He didn't look up. He just answered, 'Why not to use spaghetti?' I found some pipe cleaners and made them into a sign. From that moment, I never looked back."

Carmel Snow gives the story a different spin: "A slim, dark, eager young man wearing the uniform of the Merchant Marine came into the art department. Brodovitch opened his portfolio with the slightly jaded hope with which my fiction editor opened a manuscript by a new writer," she wrote years later. "What he saw—pictures of seamen in action—made Brodovitch ask the boy to try doing fashions for the young in the same manner. And when I saw the results, I knew that in Richard Avedon we had a new, contemporary Munkácsi."

An aging Brodovitch later remembered young Avedon as "neurotic completely. He was completely out of kilter. He went to different psychiatrists and they straightened him out very well. He just dropped in my office and he showed me very amateurish photographs, just snapshots." But after a couple of lunches, "I felt he had enthusiasm." He joined the Design Laboratory and "after three or four lessons" got a first assignment.

Some of Avedon's Sheepshead Bay photos—including one of a pair of brothers, one of them in focus, the other not—captured motion in the same way Brodovitch had when he photographed the ballet. Brodovitch focused on that shot. "He liked the blur," the *New Yorker* would later report. "If you can bring that tension to fashion," Brodovitch told Dick, "I might be interested."

Regardless of how he got there, Dick's first professional magazine work was for *Junior Bazaar*, which had debuted in March 1943 as a magazine within an issue of *Harper's Bazaar* with the teenaged Vreeland discovery Lauren Bacall on the cover photographed by Dahl-Wolfe. Avedon remembered his first shoot as a failure. "I tried to do what I thought *Harper's Bazaar* wanted," he said, and shot a model "in the manner of Louise Dahl-Wolfe." Planned as a fourteen-page spread, it ended up three small photos on two pages after Brodovitch told him, "This has nothing to do with what I expect of you." So Avedon asked if he could try again without fashion editors "because they frightened me . . . and I *had* to do it my way."

Over the years, he would conflate several early shoots into one as he recounted the story of what followed, also dropping his age at the time to nineteen, when he was actually twenty-three. "So I took my own models out to the beach," he told the writer Nora Ephron, and "photographed them barefoot, without gloves, running along the beach on stilts, playing leapfrog. When the pictures came in, Brodovitch laid them out on the table and the fashion editor said, 'These can't be printed. These girls are barefoot.'" Brodovitch overruled the unnamed editor (likely Vreeland), and a six-page spread resulted. "After that," Avedon said, "I was launched very quickly. Those candid snapshots were in direct contrast to what was being done. I came in at a time when there weren't any young photographers working in a free way." Brodovitch alternately recalled Avedon's first photos as excellent and "technically very bad. But [the pictures] had freshness and individuality and they showed enthusiasm and a willingness to take chances."

To Avedon, Brodovitch, a better father figure than his real one, was "withdrawn and disciplined" with "very strong values. He gave no compliments. . . . I responded to the toughness and the aristocracy of mind and the standards." A maternal figure added warmth to the equation. "The humanity came from Carmel Snow," Dick said. So, too, did introductions to her Parisian circle, dinner invitations, recommendations of books to read and artists to see, and a contract with the *Bazaar* for a term of ten years, though it paid only $75 to $100 a page. The *Bazaar* "paid less than anybody," said Lillian Bassman, who then worked as an art director under Brodovitch.

Chapter 5

"DO YOU KNOW RICHARD AVEDON?"

Before his *Bazaar* debut in spring 1945, Avedon married Dorcas Nowell, a wide-eyed, bookish bank clerk whom he renamed Doe for her startled expression and turned into his model. She'd had a cinematic childhood. Her father had been valet to the king of Siam before going to work as head butler to F. Ambrose Clark, grandson of the founder of Singer Sewing Machines and the builder of New York's famous Dakota apartment house. Her mother, Clark's head maid, died when Doe was two, and after her father died ten years later, Clark raised her as his own on his several estates.

Doe resembled Dick's wide-eyed sister, Louise, but was outgoing and curious, her opposite in temperament. Louise's emotional problems had grown severe, and shortly after Dick married Doe, Louise was institutionalized; she would die in 1968 at Rockland State Hospital. "She was damaged by her beauty," Avedon later allowed. "I believe beauty can be as isolating as genius, but without its rewards." Avedon dramatized the tragedy of Louise as his inspiration. "The conspiracy between her beauty, her illness and her death, was like a shadow that went right through her and into my photographs," he wrote to the critic Jane Livingston in 1993.

He often told the story of how, as a child in Cedarhurst, he taped a photographic negative of Louise's image on his upper arm for several days one summer, burning it into his skin. "When I began to photograph in my adult years, all the models I was drawn to and the faces I was drawn to were memories of my sister," white-skinned brunettes with oval faces, fine noses, and elongated necks, he'd explain. "And something that I knew about Louise and the women in the house would enter the photographs. Compli-

cated. The feeling as a child that women were simply another country. I will never understand them. That's in some of the pictures. Endlessly fascinating to me."

Lillian Bassman begged to differ. She and her husband, Paul Himmel, shared a summer house on the Fire Island barrier beach with Dick and Doe from 1946 to 1948. She called foul on Avedon's romanticizing his sister. "She was no tremendous beauty," Bassman scoffed in a 1994 interview. "She was a rather pretty girl with no real presence, and he certainly didn't create these girls in her image." Avedon's real fascinations, Bassman said carefully, were androgyny and theatricality. The summer community they chose had plenty of both. Cherry Grove attracted entertainers, artists, and homosexuals; in more "out" times, it would become well known as a gay mecca.

Whether or not she was a Louise replacement, Doe was a *Junior Bazaar* sort of girl—and from the very start, Avedon had approached the task of finding models with focused enthusiasm. "We used to scout the streets," Bassman recalled. "He'd watch girls for days. Every photographer had girls they were in love with and used over and over."

Years later, Doe would tell a daughter, Anney Siegal-Wamsat, the story of her discovery. Dorcas worked in a bank but aspired to be a model, heard about Avedon, and learned where he lived. En route to his door, she literally bumped into the scrawny (125 pounds), myopic, five-foot-seven-inch photographer bounding down the stairs. "Do you know Richard Avedon?" she asked, mispronouncing his name. "Sparks flew, and that was the beginning of everything," says Siegal-Wamsat. "He was very young," D. D. Ryan, the *Bazaar* fashion editor, similarly observed. "She was very young. They probably should never have married to begin with."

Richard Avedon never limited himself to shooting fashion. He was already reaching for more in 1946, when he shot images on the streets of New York and Rome that remained unpublished for decades, but placed him squarely in what the critic Jane Livingston called the New York School, a disparate group of influential midcentury photographers. Curiously, Avedon distrusted that side of his talent. In 1949, he would accept an assignment from *Life* magazine to shoot an entire issue on New York and spend six months on the project. "And then I simply felt I couldn't publish the photographs," he explained. "I realized these pictures followed a tradition

that already existed, and that seemed dangerous. I wanted to find my own metaphors, and I turned to something else." He returned *Life*'s money and never showed the photographs. That something else, the flow of metaphors he used to reinvent the visual presentation of fashion, was already pouring out of him.

Now that he was working for the *Bazaar*, Avedon rented a studio nearby and would eagerly race the seven blocks to Hearst's offices, wet contact sheets and prints in hand, to see his new family, "with joy, with pleasure," he said. Snow taught him what made a superior picture. Bassman became a co-conspirator. But Avedon was destined for bigger things than *Junior Bazaar*. On a trip to Paris in 1946, he shot Doe in the Gare du Nord, and that photo soon appeared in "big" *Bazaar*. The following January, he shot his first cover. Then, in summer 1947, Snow gave him his first taste of the big time and took him to Paris for the French collections. Her biographer says she only did so after he threatened to bolt for *Vogue*. Though their work was complementary rather than competitive, the prickly Louise Dahl-Wolfe, by then in her fifties and twice Avedon's age, was not amused. But fashion's guard was changing. Just in time for the Paris collections the summer before, Edna Chase had finally handed the reins of *Vogue* to an underling, Jessica Daves, forty-eight, another dowdy paragon of the absence of chic. Though Chase would haunt the corridors of *Vogue* for a few more years, the start of her slow exit was another sign of the end of an era.

Subterfuge was required to get Avedon to Paris, as Dahl-Wolfe assumed that plum would be hers alone, as always. Snow decided to take Dick along secretly, arriving a week after Dahl-Wolfe did. Snow and Dick stayed together at the Hôtel San Régis, just up the street from the *Bazaar*'s photo studio and the Christian Dior couture atelier, where on one occasion, Avedon and Snow hid together in a dressing room to avoid Dahl-Wolfe.

Avedon would return to Paris the next year and would never again hide his presence. "After that first 'secret' trip, I always sat beside Carmel at the collections," he said. "Her lips barely moved as she talked to me, telling me about everyone in the room. 'You see that woman on your left? . . . *ménage à trois* . . . That mannequin's been kept for years by . . .' She took me into a world I couldn't have understood without her."

Those first times in Paris, Avedon's charge from Snow was "to help the

French economy by bringing back the glamour of pre-war Paris." Since he "had no idea what people who dressed like that looked like," he said, "I made it all up out of my own imagination." The pictures are joyous, but also the product of hard work. "There was no sleeping," Avedon said. "You worked around the clock and then you went out dancing. After the dancing was over, I'd walk all night, worrying about the next pictures."

Avedon returned to Paris in 1948 to shoot the couture with his latest favorite model, Elise Daniels, who portrayed, he claimed years later, "the first anxious woman in any fashion photo ever." He went on to call that shoot, with his models acting instead of posing, "the source of my style."

Irving Penn had returned to *Vogue* after the war and begun shooting fashion, still lifes, and portraits in 1946. Fashion was the least interesting job for him. "Penn stubbornly resisted" it, wrote Alexander Liberman's biographers. "He insisted that he knew little about fashion and couldn't possibly do it." Nonetheless, in 1948, he accepted an assignment to go to Lima, Peru, with model Jean Patchett, where he caught a few unguarded moments—it was rumored that the pair were lovers on that trip—and produced fashion photos that matched Avedon's in their power and modernity.

Penn had met Dorian Leigh before that, when he was just back at *Vogue* and she was already an experienced model, having begun her career with a cover shoot with Louise Dahl-Wolfe and Diana Vreeland. That led to work with *Vogue*'s John Rawlings and the young Richard Avedon, still in uniform and shooting on spec for Bonwit Teller, at the same time he shot Bijou Barrington, who was Leigh's roommate. Leigh then had a lunch with Cecil Beaton and Edna Chase that led her to Irving Penn. "He seemed to me [a] rosy-cheeked, young photographer, and he took pictures, hat pictures, in a car, in front of the synagogue on Park Avenue, and I kept telling him, thinking he's a young know-nothing, the best angles and the light and everything, and he thought that was so sweet, because he had just started."

They became lovers, and Penn photographed Leigh often, including her in his famous 1947 group portrait of the dozen most photographed models of the moment. Leigh's younger sister, Suzy Parker, had followed her to New York and begun modeling, too (Penn shot some of her first test photos—and would publish them years later as covers of *Vogue*). Parker considered Dorian and Penn "sort of semi-engaged." She recalled him coming

to a Sunday family dinner "and my mother just couldn't stand him," Parker said. "He spoke very badly about his mother and his family." Suzy remembers an "up-and-down relationship" marked by "terrible battles." In *Vogue*'s studio, Penn's staff "would lock the two of them in and go away because of the fights," she says.

Their affair didn't end well. Though Leigh treasured the many photographs he gave her, her memories of Penn were mostly etched in acid. She described him as neurotic in bed and alternately insecure and sadistic in the studio. "He used to cry on my shoulder and tell me about his [ex-]wife and how unsuccessful his marriage was and how she threw his paintings out of the windows in Mexico when he was trying to be a serious painter." In 1949, Penn photographed Leigh for a portfolio of styles of the past. But at one point he froze. "Penn just stood there and said to the assistants, 'Perhaps it's the light,'" she remembered. "For some of those photographs, he took nine hundred exposures. Every single one of them the same. He acted as though we should be posing for him for the pure joy of being tortured."

Patchett's experience was quite the opposite. Avedon "felt that we were just chunks of protoplasm and had no brains, we had to do what he wanted," she recalled. He made her nervous. "Having been groomed by [Penn], I didn't understand how Dick worked. I couldn't switch that fast, I suppose."

Penn's pictures of Patchett notwithstanding, Leigh felt he had no interest in other people. "That famous series he did of celebrities [beginning in 1948], where he would put them in a corner and turn them into an object?" she asked rhetorically. "He was a still-life photographer, and that's how he wanted people to be." Ultimately, she judged him "terribly self-involved. He was terribly, terribly important to himself, so pretentious." But this sentiment may have come from Penn's dropping her, both as a lover and as a model, after she agreed to go to Paris with Avedon in 1949. Penn hadn't minded when she shot with Dahl-Wolfe. "He didn't feel she was any competition." Avedon was a different story. Dorian was subsequently soiled in Penn's eyes and he would soon marry model Lisa Fonssagrives, another of the famous dozen of 1947, right after she, too, divorced.

Penn would also cause another divorce—the rupture between Erwin Blumenfeld and *Vogue*. Initially, Blumenfeld had respect for Alex Liberman, even as he ignored the suggestions of Penn and *Vogue*'s fashion editors.

"Liberman recognized his genius and wanted to utilize it," says son Yorick Blumenfeld.

Vogue was important to Blumenfeld: thanks to his exposure in its pages, by 1950 he'd become one of the most successful and highly paid advertising photographers in the world. But in 1955, he and Liberman had a disagreement. He'd grown tired of being told how to take pictures by the people he sometimes called "arsedirectors." Then "Penn did a retake of a Blumenfeld sitting" for *Vogue*, says Blumenfeld's granddaughter Nadia Charbit. "He didn't like Penn."

Yorick Blumenfeld thinks the end of his father's relationship with *Vogue* was more complicated, a slow but inexorable unraveling. "Liberman competed with his photographers. I think he felt competitive with Blumenfeld. . . . He felt ill at ease with Liberman always. Penn was much more amenable." In his later years Blumenfeld would express regret. "I spent so much of my life as a prostitute," he told his son. Yorick says, "The point of view of an artist was very strong in him. He felt the world of fashion was not one of art." In that, at least he agreed with Liberman.

In years to come, Penn's photographs would appear more and more often on the cover of *Vogue* (he would eventually shoot 164 covers), and while he clearly had a style of his own, more than a few elements of it appear inspired by Blumenfeld's innovative work before him. Meantime, Blumenfeld continued to shoot for advertisers, began experimenting with film, wrote his autobiography, broke up with a mistress after a seven-year affair (she went on to marry one of his sons), and then took up with a much-younger assistant, though he remained married to his wife. Worried by prostate problems and fearful of a prolonged decline, he killed himself at seventy-three in Rome in 1969 by deliberately skipping his heart medication and repeatedly running up and down the city's famous Spanish Steps.

Chapter 6

FUNNY FACE

Twenty-two years earlier, Richard Avedon hadn't killed off Louise Dahl-Wolfe, but he had put an end to her reign as the top photographer at *Harper's Bazaar*. She continued to work there for another nine years and shot the all-important Paris collections alongside Avedon, but, she would feel—and be—overshadowed and seethe with resentment.

Seething seemed to follow Avedon in those early years. In 1949, he'd booked another model, Mary Jane Russell, who was married to Edward Russell, a war hero turned advertising executive, to shoot with him in Paris. Then, just before their planned departure, Avedon canceled her in favor of Dorian Leigh, sending Russell a letter instead of telling her to her face. Forty-five years later, the wound was still raw for both the Russells.

Avedon still booked her and she still posed for him. "Dick [was] the supreme master of manipulation," she said, "making the person in front of him responsive. He had no peer. Dick [could] do it with anybody. Dick [could] make a stone respond. It's enthusiasm. Penn, a great, great photographer also, was much more difficult to work with. He was intense, serious on overload, not enthusiastic. It was debilitating working for him. Penn would say to me, 'If I ask Jean to be a princess, she can be a princess. Why can't you?' But Penn was totally honest and Dick was totally dishonest."

Years later, when a magazine published an Avedon photo of Russell, but identified her as another model, Dovima, all the old resentment poured out. Russell's husband, who was also a photographer, wrote a letter to the magazine asking to see the contact sheet for the pictures, which inspired an angry call to Mary Jane from Avedon. "I want these letters to stop!" he yelled. "Tell your nitwit husband, the photo is not you, it's Dovima!" And he slammed down the phone.

"Dick is wrong," Mary Jane Russell said, "but you see, Dick cannot be wrong." Years later, at a photo show opening, Avedon came over to her and announced, "I've figured it out. I looked at the contacts. I redid the sitting with Dovima."

"I just let it go," Russell said. But her husband couldn't. "I had a heart-broken, devastated wife on my hands. It's something you never forget." He mentioned a famous photo Avedon took of Leigh on that 1949 trip to Paris. "Dorian in a tiara, laughing, showing her little, tiny teeth. It is the most unpleasant photograph," Ed Russell said—and indeed, the *Bazaar* refused to run it.* "Why would he do that? There's a cruelty there. There's a revenge against everything that made him."

Then Ed Russell went for the jugular. "Dorian had a marvelous sexual encounter with Dick. Have Dorian describe their activity. She has with me because I don't like him."

But when asked about that, Dorian Leigh just laughed: "He wouldn't have touched me with a ten-foot pole. He was scared of me. One day he said, 'It takes a lot of courage to photograph beautiful women.' "

And something else that happened in 1949 shows how unlikely Ed Russell's story was. Lillian Bassman's careful remark about Avedon's fascination with androgyny hinted at the events that summer. Doe Avedon had decided to change careers and become an actress and, in October 1948, made her Broadway debut in a play directed by Harold Clurman. Dick's career was taking off, he was traveling constantly, and after that, Doe started moving from one play to another. She met and fell head over heels for an actor named Dan Matthews. She would later tell several of the children she adopted with a third husband, the director Don Siegel, that her and Matthews's love was an emotion vastly different from what she felt for Dick Avedon. They hadn't landed in gay Cherry Grove for no reason.

"Richard Avedon was gay," says Nowell Siegel, Doe's oldest child. "It was not a secret between them. I don't think she had any doubt about his sexual preferences from the get-go. At the time, it wasn't okay to be with the same sex. You wanted to be married. He started taking pictures of my mom and he

*It was later shown in the Metropolitan Museum and is one of Avedon's best-known images.

used her to launch his career, and she saw in him a great connection. They did have quite a love affair. I can't tell you if they made love, but I'm sure they did. They had a wonderful relationship through the screen, through the pictures. She was his first love, whether it was sexual or not. She left Dick and it broke his heart. His preferences aside, until the end of his days, he thought of Mom as the love of his life." Dan Matthews was that for Doe, however, says Nowell. "Her true love. He was the only one."

Avedon's sexual preferences would remain a matter of speculation for the rest of his life. He never addressed the subject directly, but seemed to do so obliquely in a PBS documentary: "I do photograph what I was afraid of, things I couldn't deal with without the camera . . . madness, and when I was young, women. I didn't understand. It gave me a sort of control over the situation. It got out of my system and onto the page."

Most public reports of their split say Doe and Dick were divorced in 1949. But Doe's children—and one brief report in a New York tabloid a few years later—say the marriage was actually annulled. "Dan [Matthews] was Catholic, and that was the only way they could marry," says daughter Anney. They were wed in spring 1951 while appearing together in Mae West's review *Diamond Lil*. That same year, Dick's father, Jack, had a heart attack, left his wife, and moved to Florida.

That summer of 1949, Avedon preceded Leigh to Paris to scout locations with Joe Eula, an illustrator, stylist, and gregarious court jester, who often worked for the *Bazaar*. From the sophistication of the photos that resulted, it's easy to forget that Avedon was only twenty-six years old. Leigh recalled sitting on a bench one day during a shoot with him, and he was "telling me his dreams. He said, 'What am I telling you this for? You've lived a whole life.' I was twenty-nine!"*

Not long after returning to New York, Avedon met his next wife. Lillian Bassman and Dorian Leigh both took credit for introducing him to Evelyn Franklin, who was then married to another fashion photographer, Milton Greene, but Greene's second wife, Amy, says it was really her husband's doing. Greene (born Milton Greengold a year before Avedon) had assisted Louise Dahl-Wolfe and *Life* photographer Eliot Elisofon before setting out on his own.

*Leigh often understated her age, too; by some accounts, she was then thirty-two.

Amy Franco had met Avedon long before she met Greene, and as with Doe, he made her a model. She was fifteen and a half, dressed in jeans, penny loafers, and a sweater with a braid down her back, walking with her father in Manhattan, when a shy young man with a "wonderful face" under glasses approached her, said, "I'd like to photograph you," and handed her a business card.

"The man was Richard Avedon," she continues. "Somehow, a bell went off. *Junior Bazaar* had just started and it was in my head or I would have said, 'Give me a break.'" He asked to see her the next day at ten. She said noon, to have time to get her hair done. "Big mistake," she says. "He liked the braid. He pulled his hair out." He took her photo anyway and, the next day, sent Amy to a modeling agent with his contact sheets. "By five p.m., I had a contract."

Three times she went to meet Milton Greene. Three times she was sent away "because he was busy with other guys having a good time," she says. She did a couple of jobs with Avedon, "but he didn't want to do *Junior Bazaar*. He wanted big *Bazaar*. I'm a midget."

Amy would subsequently marry Greene, but only after he foisted his wife off on Avedon. "Evelyn was off her rocker," says someone close to the Greenes. "She wanted to stay in bed all day, without working, cooking, anything. She was a pain in the ass. Milton was a working artist and he had no time for bullshit." Milton wanted out of the marriage, but didn't know what to do. Because Dick was devastated after Doe left him, says Amy Greene, who thought Avedon was heterosexual, "Milton introduced Evelyn to Dick and she got him on the rebound. What Dick saw in her, I had no idea. But all the emotions he had for Doe were transferred to Evelyn." Doe Avedon approved. "Mom said Evelyn was good for Dick," says one of Doe's children, because though Evelyn had mental issues, they weren't as bad as his sister's, and "he could connect with her more than with Louise."

Dick and Evelyn got married on January 29, 1951, at his apartment on East Seventy-Third Street, and left immediately for a honeymoon in Egypt and Paris, where he also shot Dovima for the *Bazaar*. Evelyn seemed to thrive in what was also her second marriage. "She became one of the most elegant women in New York," says Amy Greene. She wore clothes by "Mainbocher [once the editor of French *Vogue*, who'd become a couturier], Norell,

you name it. She went to Paris with him and got clothes wholesale. She spent money like it was going out of style."

The Avedons would have their only child in 1952. "He wanted a child, a son," says Greene, "so she had John and then her position was strong and she could do what she wanted because she'd given him what he wanted." Their interests would soon diverge. "Dick was very political," says Greene, "and Evelyn didn't know who the president was. They drifted apart and she went back to being a recluse."

Shortly before Dick and Evelyn Avedon were wed, a woman who was just as important to him, Dorian's little sister Suzy Parker, had joined Avedon's troupe. Dick had first met Suzy at sixteen in 1948, two years after Dorian induced her to start modeling on school vacations. "In came this girl," he said, "who looked utterly unlike the usual model type, wearing one of the most rebellious expressions I've ever seen on anybody. She positively glowered." To Dorian, Avedon confessed his real fear: "I don't know if I can work with someone so beautiful. There may not be enough I can do to create something of my own." His anxiety seemed justified after their first few photographs together, "in hats," Suzy recalled. "I think I looked awful in them." But then, he took her to Paris in 1950 to shoot the fall collections. "Everything that happened to Suzy, happened after that," Avedon recalled. He would later say that his secret of model selection was to make them "look like real women," and that even if they appeared undernourished, his target audience, women, "seldom resent a truly wholesome face." Parker epitomized that balancing act.

Avedon deserves much of the credit for making Suzy Parker a supermodel. She's said he was the only photographer she enjoyed working with, and the only one who adequately captured her personality. But it was her sister Dorian (who'd opened a modeling agency that represented Suzy when she first came to New York, then took Suzy with her when she joined Ford Models) who "really and truly crammed me down their throats, particularly the first trip to Paris with Carmel Snow," Suzy said. "Dorian said she wouldn't go unless Avedon brought her, too."

That trip to Paris was one of the inspirations for Stanley Donen's 1957 film, *Funny Face*, which incorporated songs from an old Broadway musical by Ira and George Gershwin. In the film, Fred Astaire, one of Avedon's childhood idols, plays Dick Avery, a fashion photographer based on Avedon, who served as special visual consultant on the movie and designed the title sequence. Audrey Hepburn plays Jo Stockton, a bohemian bookstore clerk whom Avery "discovers" in the background of a Parisian photo session and transforms into a model. Though some of her subsequent experiences were inspired by Suzy Parker ("A lot of things I did or said to Dick, he incorporated into *Funny Face*," she said), the character was based on Doe Avedon by screenwriter Leonard Gershe, whom Dick had met in the merchant marines, was part of Dick and Doe's Cherry Grove set, and had a decade earlier first thought of turning them into characters in a Broadway show.

Not long after Doe and Dan Matthews were married, they drove to Hollywood seeking film work but, en route, were in a car crash in Colorado. Dan was decapitated and Doe was stuck in the wreck for three hours. Afterward, Gershe "sent [Doe] overseas to recover," says her daughter Anney Siegel-Wamsat, and then "wrote *Funny Face* as a catharsis," to help her move on with her life. Dovima, another of Avedon's favored models (who was called Doe in childhood); Sunny Harnett, centerpiece of a famous photo he'd shot in 1954 in the casino at Le Touquet, France; and Parker all had cameos in the movie. An art director character is named Dovitch. Kay Thompson, creator of the Plaza Hotel's mascot, Eloise, portrays a fashion editor based on Diana Vreeland, who reportedly hated the way she was lampooned. Gershe's screenplay was nominated for an Academy Award.* Parker would continue shooting with Avedon into the early 1960s.

They "kind of grew up together," she said. "Richard was a director. I would sometimes look and feel awful and I would say, 'Oh, God, we can't work today.' And he would say, 'I'll tell you how you look. I can make you look any way I want you.' He kind of invented me. He gave me my style. It was always, like, let's pretend, let's get dressed up and be that person who

*Doe Avedon had meantime worked as a screen and television actress and married Don Siegel, a film director, but retired the year *Funny Face* was released to raise their four adopted children. She died in 2011 at eighty-six.

would wear those clothes." He also used her to get others to do his bidding, as happened late in 1960, when he brought Parker with him when he photographed America's first three astronauts, Alan Shepard, Gus Grissom, and John Glenn. Parker charmed them into putting on their space suits for the photo. She was "the center of attention," observed Earl Steinbicker, Avedon's assistant on that shoot. At least until a thunderstorm blew in and knocked out the electricity just as Avedon's strobe lights were turned on. Shepard gallantly came to the rescue, tapping into an emergency circuit, allowing the session to proceed.

The mid-to-late 1950s in Paris represented Avedon's apotheosis as a fashion photographer. Though Irving Penn's 1950 daylight studio photographs of Lisa Fonssagrives in Paris couture were among his greatest fashion pictures—and Avedon would later follow him, ripping the coverings off the skylights in the *Bazaar*'s Paris studio and letting the magical light of Paris pour in—Avedon had taken the lead.

Avedon's style was a hybrid of street photography that sought to capture reality and the elegant remove of past fashion images. His flirtation with documentary photography for *Life* had shown him his limitations: he didn't like photographing people on the sly. "Also, I have to control what I shoot, and I found I couldn't control Times Square," he said, so he sought "to create an out-of-focus world—a heightened reality, better than real, that suggests, rather than tells you."

To achieve that, in those early Paris photos, he did intensive research, reading up on possible locations, making sketches, and taking test photos. "Maybe the Marquis had raised a guillotine in a courtyard where I assembled a troupe of acrobats, scattered a bale of hay, and posed a model in a New Look suit," he said. One photo curator found that comment a head-scratcher. "He may be assigning to the Marais courtyard [where he took that picture] the history of the Place de la Concorde, the location of the guillotine that killed Louis XVI, where Avedon photographed more than once," wrote Katherine A. Bussard. But factual accuracy wasn't the point; implied narrative and emotional resonance was.

Research and planning concluded, Avedon would work just as hard with his models, demonstrating how he wanted them to pose, leaping about if that was called for, chattering at them, joking with them, telling them the

stories of the photo narratives he was creating, encouraging them to express themselves and present something other than the affectless faces traditionally worn by fashion mannequins. Even if the ultimate audience, the magazine readers, couldn't afford the clothes the model was wearing, they might be able to relate to her. Thus, aspirational fashion imagery was born. And in creating his movies-on-the-page, Avedon emerged as Brodovitch's ideal photographer.

In 1955, working with an eight-by-ten-format camera, which he'd only begun to master after years of shooting with his easier-to-handle Rolleiflex, Avedon took his most famous single image of Dovima, with several elephants, at the Cirque d'Hiver, an idea of Joe Eula's. In 1956, he shot Dorian and Suzy again in the *Bazaar*'s Paris studio, and Suzy and another model, Barbara Mullen, cavorting in Paris bistros and nightclubs with Gardner McKay, a college dropout who was working as a sculptor (and would later become an actor) and Robin Tattersall, a male model who would later become the official government surgeon on the British Virgin Islands. "Dick picked them both because they were tall enough to be with me," Parker said.

Avedon later told Art Buchwald, the columnist, that he'd spent a year developing the shoot, with the theme An American Woman in Love in Paris, only to get there and find that Parker wouldn't play along. She didn't like McKay and "she only wanted to be kissed by someone she loved," he said. "It was quite a blow to his pride when Suzy wouldn't let him kiss her."

In 1957, he shot Tattersall and Parker and another model protégé of Dorian Leigh's, Carmen Dell'Orefice. And in 1959, the cast of characters at Avedon's epic August shoot in Paris expanded to include Buster Keaton, Zsa Zsa Gabor, Audrey Hepburn and her husband, Mel Ferrer, Buchwald, a Portuguese Chinese model named China Machado (whose photos Avedon would have to force *Harper's Bazaar* to publish by threatening to leave the magazine), the social figure Frederick Eberstadt, and Reginald Kernan, a sportswriter who'd become a doctor working at the American Hospital in Paris, until he had a fight with its board of directors and made an unexpected career change, becoming a male model at Dorian Leigh's latest agency; she'd been one of his patients.

The writer Judith Thurman once compared Avedon and his models— Dorian, Suzy, China, Carmen, Dovima, and the others—to a small repertory

company. "Our rapport was built from sitting to sitting and from season to season," Avedon told her. And it was unique to their group and their moment. "When you were working with Dick, more was not enough," Machado recalled. "I'd do the most incredible things with my body for him in front of the camera. But when I tried to do them at home in front of the mirror, I couldn't."

Avedon's best-known work with Parker was shot in summer 1962 in Paris, before she retired from modeling. In a story called "Mike and Suzy Rock Europe," she and Mike Nichols, then half of the stand-up comedy team Nichols and May, portrayed characters based on Elizabeth Taylor and Richard Burton, who were then having a scandalous affair on the Italian set of their film *Cleopatra*, and being pursued by a new breed of photographers called paparazzi, who stalked and photographed celebrities. Avedon rarely used a 35 mm camera—he found it too small and hard to focus because of his glasses—but he did for some of the photos in that sequence, adding a telephoto lens to lend the portfolio authenticity. It worked: many were fooled into thinking the story was about a real affair. Nichols not only modeled for the portfolio, he also wrote captions for what was conceived as a satire. "In this project Avedon synthesizes every genre within which he has worked: fashion photography, portraiture, serial narrative, satire, and 're-portage,'" Jane Livingston observed. Some onlookers took the whole thing so seriously, they started rocking a car Suzy and Mike were in, while Dick snapped away, yelling, "Push harder!"

Strangely, then, Avedon would later compare himself, in those years, to a deaf-mute he'd seen stranded in an empty Montmartre strip club he'd gone to with Doe in the late 1940s, "looking lost, even trapped, [who] wandered over to the deserted orchestra pit, picked up a horn, and blew a sound on it—a strange, raucous, terrible sound that resembled his expression." But during the same interview he would call his Paris pictures "the last time the sensibility of my fashion work wasn't commercially driven." He explained that just when he felt he'd come to master his art, the context in which it was made changed forever. "The feeling wasn't in it, there was too much narcissism and disenchantment. I kept at it, but it became a craft—a means of support for my studio, my family, and my art, which turned to portraiture."

Chapter 7

"Living the good life"

In the spring of 1952, a seventeen-year-old high school student from Allentown, Pennsylvania, who'd been taking and developing his own photos for five years, wrote to ten New York–based photographers, seeking a job as an assistant, "offering to work hard and cheaply and emphasizing my experience with large cameras and darkroom work." Only three responded, one of whom was Richard Avedon, who suggested Earl Steinbicker come to Manhattan a few weekends later for a meeting in Avedon's skylit studio in a two-story, block-long building at 640 Madison Avenue. Avedon immediately offered him a job. "I believe it was because I enclosed a picture of myself," Steinbicker says. "I was a really good-looking kid back then. I think from the beginning, he was attracted to me. I'm sure you know he was bisexual. I have no hard evidence, but he obviously had something with James Baldwin back in high school."

Clearly, Avedon's relationship with Baldwin was complex. In the archives of Bea Feitler, an art director he worked with briefly at the *Bazaar* in the 1960s, an evocative series of photo-booth picture strips shows Avedon holding a torn image of half of James Baldwin's face up next to his own. Steinbicker says that during the preparation of Avedon's second book, which had a text by Baldwin, the photographer flew into "a screaming rage" when Baldwin disappeared to Helsinki with a boyfriend instead of meeting his deadline for the text for the book. "He said, 'That fucking nigger,'" Steinbicker recalls. "Those were his exact words, and I'd never heard him use that word before. 'Get me a flight to Helsinki tonight.' And he came back with a manuscript. It wasn't very good."

Steinbicker did more than assist in the studio. At the time, Dick and wife Evie leased the bottom three floors of a town house on a tree-shaded, se-

cluded street called Beekman Place, just off the East River. Avedon asked if Steinbicker could repair their "very expensive hi-fi" system, which didn't work, and he told them they'd bought junk and replaced it instead. "He was not a poor man," so he could afford it, says Steinbicker, who recalls the home's ground-floor kitchen, formal dining room, and garden decorated with an Etruscan-inspired statue of a dancing nude. Up a spiral stair, the parlor-floor living room held works by Picasso and Braque. The bedrooms were on the third floor. The Avedons had a cook and a maid but no car. Dick was a bad driver. "He couldn't pay attention," says Steinbicker. "He'd turn and talk to people in the backseat. It was scary to drive with him," so Steinbicker became a chauffeur as well, ferrying the family to Connecticut, where, in summer 1953, the Avedons spent weekends.

Though he returned to Fire Island in summer 1954, Avedon had cooled on the barrier beach and would henceforth spend summers on the east end of Long Island, in the Hamptons. By that time, his friendship with Lillian Bassman and Paul Himmel had also cooled. "The bohemian years of carefree summers in Cherry Grove were over," says their son Eric Himmel. "Dick was growing and his world was expanding at a mile a minute. He was developing associations in the worlds of writing and art and Hollywood"— through his celebrity portraits for *Bazaar* in many cases—"that were way beyond the Himmels' experience. I doubt he even had time to invest in the friendship after 1951."

By the time Steinbicker arrived, Avedon was running a large operation. On his first day at work, Steinbicker met the crew: a studio manager, a first assistant, and an office manager who was the departed Doe Avedon's aunt. Steinbicker then worked on an ad for Maidenform brassieres. Propped against the wall was the background for one of Avedon's most famous ads, for Revlon's Fire & Ice nail polish, which starred Dorian Leigh. Steinbicker learned that his compensation included use of the studio and darkroom in off-hours, and leftover film, because most photographers would only use film from the same batch to ensure consistency. Avedon would later give his assistant a Rolleiflex, too.

Steinbicker's initial jobs ranged from cleaning and darkroom work to putting masking tape on models' shoes so they wouldn't mark the white paper on the floor. His pay was minuscule until he mastered loading and

unloading the massive wood Deardorff eight-by-ten camera used on most fashion and advertising work. But he recalls making extra money posing as a male prop in ads, such as one where he dressed as a bullfighter, and another in which he wore a gorilla suit and carried a model. Unlike Irving Penn, who always insisted on being addressed as Mr. Penn, Steinbicker was encouraged to call his boss Dick.

In Steinbicker's first year with him, Avedon shot more than 150 ads (for Revlon, Helena Rubinstein, Du Pont, Tareyton cigarettes, Cartier, Warner-Lambert, Pontiac and Cadillac cars, Alcoa aluminum, Schweppes, Owens-Illinois glass, Douglas Aircraft, and Hertz—sometimes shooting for as many as four clients a day), 100 editorial fashion jobs, and several dozen celebrity portraits. Steinbicker learned some of his boss's tricks, such as smearing Vaseline on his lens to achieve soft focus, and using tissue paper in the darkroom to make some areas of a photo print soft while others stayed sharp. "He had no compunctions against darkroom cropping and image manipulation, nor against heavy airbrush retouching," Steinbicker later wrote. Avedon also edited his film brutally and only showed a few of the hundreds of images he took on a job to his editors or clients. Steinbicker recalls Diana Vreeland invading the darkroom and rummaging through the trash to find a photo Avedon had rejected that she preferred. Avedon, Steinbicker reports, acceded to her desire to print a rejected image. "Everyone was terrified of her," he says.

About two years after Steinbicker joined the team, Dick learned his studio would have to close and move when the building owner decided to demolish it. Avedon found a new studio on the corner of Forty-Ninth Street and Third Avenue, then still in the shadows of an elevated railway. It was on the second floor of a building that then, as now, was mostly occupied by a steak house. Larger than the Madison Avenue studio, the new place also had a skylight for daylight photography, as well as space for the growing staff, and a second studio where various associates—the most famous was Hiro Wakabayashi, known simply as Hiro—worked under Avedon's aegis.

The photographer and his assistant became good friends. When Steinbicker was in the army from late 1956 to 1959 (and was replaced by Hiro), Avedon would write him with encouragement and news. The assistant would

later joke that he knew his boss was in good hands when he got a letter informing him, "Suzy is still running the studio," referring to Suzy Parker.

While Steinbicker was in the service, the Avedon studio moved again, to even larger and more elaborate quarters on East Fifty-Eighth Street (containing, among other things, the first Color Automat processing machine in America, and an Eames chair on loan from Mike Nichols). The Avedons, along with their poodle, Piffles, moved to 625 Park Avenue, a luxurious limestone-clad apartment house at East Sixty-Fifth Street. He could afford it. Advertising clients such as Revlon and CBS Records were paying him as much as $100,000 a year.

Alen MacWeeney, a twenty-year-old Irish photographer, joined Avedon's studio as an assistant just after the moves and would edit contacts with him in the apartment in the morning. It was decorated "in very expected, successful New York taste," MacWeeney said. "A decorator had obviously done it. It could have been a banker's apartment. It was more flashy than profound. I don't think he had any taste in design at all."

A few years later, the Avedons would move again, to a luxurious town house decorated by the interior designer Billy Baldwin at No. 5 Riverview Terrace, a gated private street just off posh Sutton Place, facing the East River with direct views of the famous Fifty-Ninth Street Bridge from all of its front windows. "It had a studio look but very, very expensive stuff," says art director Ruth Ansel, who worked with Avedon at the time. "It was the artist living the good life." Steinbicker thinks that Evelyn Avedon cherished that lifestyle. "She was interested in shopping and dinner with the right people," he says. But all of that would shortly cease to satisfy her husband.

A GROWING FASCINATION
WITH MORTALITY

In Carmel Snow's last days at the *Bazaar*, the magazine grew stale. After the death of William Randolph Hearst in 1951, the business side of Hearst had begun to flex its muscles, insisting that certain advertisers' garments be shown in the magazine. Snow, in her sixties, was growing frail. Her habitual lunchtime tippling was becoming more apparent. Avedon often played courtier for her. His devotion and gratitude to his professional "mother" were profound. But the professional managers that the company installed to run things after Hearst's death were growing concerned and first urged and then insisted that Snow designate a successor.

Early in 1957, Nancy White, the fashion editor of *Good Housekeeping*, a distinctly unfashionable publication, was named assistant editor of the *Bazaar*, positioned to replace Snow, who was both her aunt and godmother. White's father had been general manager of several Hearst magazines. During the difficult year that followed, Snow rejected some Avedon images. Mary Louise Aswell, who cowrote Snow's memoirs, says that Snow became "more and more peremptory," once leaving contact sheets at the San Régis for Avedon with "NO NO" scrawled on them in grease pencil, "exactly like a child scribbling in a book—the paper was actually torn." Avedon, she reports, "wouldn't speak to Carmel for months afterward." But he worked with her again on her first trip to Paris after she handed the reins to Nancy White, when he shot clothes contrasted with rough wooden boards. *"Not in my magazine,"* Snow barked at him. "I will not *have* it. I *will not* have a distinguished dress photographed on a plank."

Avedon compared her demeanor that night to that of the dowager em-

press of Russia. "I was established by then, remember," he said. "For no one else in the world would I have taken that picture over—not for her, six months before." But he complied. "She knew she'd been fired. I wouldn't have dreamed of not obeying her to the letter at that moment." It was a bad one; she had become quite erratic, culminating in a dreadful incident on her last trip to Paris as editor of the *Bazaar*. At a party at a Rothschild family mansion, she got so drunk, she urinated all over herself.

Snow's last issue appeared at the end of 1957, and White became editor, though like Edna Chase before her, Snow would linger on the fringes for quite some time. Her name appeared above White's on the masthead, but the world knew her title, chairman of the editorial board, was meaningless.

Brodovitch, too, was showing his age, and betraying his loss of interest in the *Bazaar*. Like Snow, he was an alcoholic. Sometimes, he didn't bother going to the office. His country home in Connecticut burned down. His marriage was loveless and his son troubled, both emotionally and physically. In 1949, Brodovitch had been hospitalized after he was hit by a truck. Another country-house fire in 1957, in Pennsylvania, destroyed his archives, including the negatives of his single—and singular—book *Ballet*. The next year was his last at the *Bazaar*; his final issue was in August 1958.

He continued to collaborate with Avedon, serving as midwife for his emergence as an artist (as opposed to commercial photographer) in fall 1959 with *Observations*, a book of photographs designed by Brodovitch with text by Truman Capote, which summed up Avedon's dazzling nonfashion work to that point: it contained celebrity-collector portraits, street photographs, and work that pointed to his more mature future: a growing fascination with mortality, a characteristic that both defied and defined passing fashion. It "established a new standard for opulence and page-by-page discipline in the making of the photographic book," Jane Livingston wrote, "from its (ruthless) choice of images to their sizing and sequencing . . . to printing and binding." It had been immediately preceded by a book by another Brodovitch student, William Klein's *New York*, in 1956. Neither got good reviews. Indeed, both were greeted with hostility by fine-arts critics—setting up a conflict that would rage for decades. Could fashion photos be art?

Comparing himself to Klein, Avedon observed that both of them were impelled to "make a moral statement. . . .We needed another way." Avedon

felt they both found direction in the films of Vittorio De Sica and Roberto Rossellini. "They expressed something about what it means to be a liberal, humanist-minded person. . . . As photographers, we probably liked the same films more than we liked each other's work. . . . But as confused as we all were, as competitive as we were, maybe we felt a sense of community."

Shortly after the release of *Observations*, in November 1960, Brodovitch's wife, Nina, died—and a depression exacerbated by his alcoholism followed and plagued him for the rest of his life, leading to intermittent, sometimes lengthy stays in hospitals. A commitment to the state-run Manhattan State Hospital for the Insane on Wards Island resulted in Brodovitch's only other cycle of photographs. Avedon told Jane Livingston that he and Brodovitch concocted a spy camera for the project by hiding a tiny Minox inside a cigarette pack with a small hole cut out for the lens.*

Brodovitch, ill and impoverished (he received no pension from Hearst), retired to France with his son, Nikita, who was gravely injured in an accident shortly before his father died, near Avignon, in 1971. But Brodovitch's influence endured. "The waves that went out from *Harper's Bazaar* since his first issue are still rippling," Irving Penn would later observe. Noting that he felt precious little affection for him, Penn acknowledged Brodovitch as "our father. . . . There isn't a man of our time who hasn't felt the influence of Brodovitch."

Of Richard Avedon's *Bazaar* family, only his crazy aunt Diana remained in harness, but she was bitter over White's ascension, feeling she should have been considered for the job. Presumably she knew that Snow was among those who'd lobbied against her, telling the Hearst powers that Vreeland was "a brilliant fashion editor but should never, ever be the editor in chief of a magazine." Condé Nast, the company, disagreed. In March 1962, Vreeland would join *Vogue*—and several tense months after that, Jessica Daves would retire and Vreeland would ascend to editor in chief.

As the survivor at the *Bazaar*, Avedon was in a position to influence the

*Brodovitch's biographer says another Design Laboratory student, Ben Rose, gave him the Minox. Avedon would make a similar group of photographs at East Louisiana State Hospital in February 1963, while traveling through the South taking photographs for his second book.

choice of a replacement for Brodovitch, which was Henry Wolf, an Austrian graphic designer who'd studied under Brodovitch before joining *Esquire*, where he'd been made the top visual editor at the age of twenty-six in 1952. He didn't make a good impression on the old guard. Brodovitch had declared him to be "a very good typographer but a very poor picture editor."

Louise Dahl-Wolfe's preeminence at the *Bazaar* had long since waned. Several times, she tried to get Lillian Bassman fired. "Hated me like crazy," Bassman said. "I was the one who threatened her the most by bringing in the young photographers, by changing the look of the magazine; that was absolutely diametrically opposed to what she was doing at the time, which was very stylized, very orderly, all very directed. . . . And we were flying. And she hated us." Barbara Slifka, a *Bazaar* fashion editor, remembers, "Everyone was always angry."

Henry Wolf's arrival—and his recruitment of new photographers with more modern vision such as Saul Leiter and Louis Faurer—proved to be the last straw for the eminent pioneer. "The new art director put in a surprise visit to my studio and had the presumption to look through my ground glass at what I was photographing," Dahl-Wolfe wrote later. "This had never happened in all my years. Suddenly, my enthusiasm vanished . . . and so I retired."

Chapter 9

"AN ASPECT OF TRUTH"

In an extraordinary encounter in 1964, Irving Penn and Richard Avedon—both of whom, though still taking fashion pictures, were doing so with fading enthusiasm—led workshop sessions of Alexey Brodovitch's Design Laboratory when he was absent or hospitalized. A transcript of those sessions, in the collection of the Museum of Modern Art, opens with a solo seminar with Penn, who begins by discussing Avedon's second book, titled *Nothing Personal*, conceived as his statement about America, which had just been published. "I was much more sour than Jimmy was," Avedon once said of James Baldwin's text. Avedon's intention, he continued, "was to expose the corruption in American life." His mother's progressive politics had stayed with him. "The march on the war, against the death penalty, Lenny Bruce, he was behind them all," China Machado once said.

Like Penn, Avedon had leveraged his position as the top photographer at one of America's preeminent newsstand magazines to gain access to celebrities and prominent and powerful people. And like Penn, who squeezed his portrait subjects into corners, Avedon imposed his own vision on them. Penn's portraits tended to glamorize, Avedon's to do the opposite. Avedon was influenced by Carl Dreyer's 1928 film *Joan of Arc*, he would say, by "its white background, enormous, radically cropped close-ups."

Penn and Avedon were both reaching for truth and art in their portraiture, albeit from opposite directions. Though Penn, in his solo session, called Avedon "one of the giants of our time" and "a very remarkable young man," he also criticized some of Avedon's portraits as "cruel" and "offbeat" and took his rival to task for editorializing, although he added that Avedon was gutsy and had every right to do so, even as he predicted *Nothing Personal* would be a "financial disaster." Much to Avedon's chagrin, book critics

would also be harsh about it, perhaps because it contained only portraits and nonfashion work, but also due to its obvious sympathy for what were then considered radical politics.

Penn's passive-aggressive comments revealed his contradictory feelings: "Dick is a very complicated man. Dick is also very much of a little boy." The ascetic Penn sniffed about Avedon's lifestyle, "He has a strong taste for high living. . . . Someone told me he and Baldwin mapped this book on a yacht in the Mediterranean."* Penn seemed to dismiss Avedon as "a journalist . . . always pushing something, much more than I am. He's a very, very contemporary photographer. He doesn't seem to know where his great future lies." Echoing the angry Ed Russell, Penn added, "The question of compassion never seems to come up."

Though claiming that the Avedon woman came "out of his cookie cutters," Penn praised her as "his greatest achievement," before pulling out his shiv again. "She's an American woman with long, thin legs and no breasts and a long, thin neck, who's really not a woman and one whom most of these guys here wouldn't want in a woman. With brilliant energy, he pulled her together by shrewd manipulation, anger, and insistence. . . . She's a very real woman and not to be mixed up with any other age. The very way she stands—the curious stance of her feet, planted wide apart, was something unique—a revolution of the nice woman, and the world has changed because of this. He is much more powerful in setting the pace of our times."

Avedon joined Penn at a later session and they tangled immediately over the former's portraits. Penn accused Avedon of sucker punching his subjects, trying to catch them at their worst. "It's not an accident, it's something I worked very, very hard to achieve," Avedon replied. "I feel that the cosmetic approach of portraiture, the 'nobility of man,' no matter how beautifully done, is the end of an old idea. . . . A photographer is nothing but a machine unless he editorializes. If he's an artist at all, he speaks for the way he feels, and it's a funny little line to draw between the way one man feels and another . . . and call one acceptable or legitimate or okay and the other, not."

*Earl Steinbicker noted that Avedon once had Louis Vuitton make a custom case of black leather (not "those silly LV emblems") lined with red velvet that held two Rolleiflex cameras, lenses, a light meter, sunshades, and rolls of film.

"People have got to be protected against certain aspects of themselves," Penn replied, "and allowed themselves, too. . . . But I try to find something that is not momentary, but if possible, something timeless in that person. . . . I try to find a person at a very serene, true, and fairly restful moment. I feel that Dick tries to find them at a moment that has an aspect of truth which is completely momentary." Penn took particular offense at Avedon's portrait of a bleary-eyed ex-president Dwight D. Eisenhower.

"It doesn't interest me that he was the president of the United States," Avedon shot back. "It interests me that they all have to face their death, and that terror is in all of us, and in my portraits." Madness, too. Three years after Brodovitch shot photos inside a mental hospital, Avedon had done the same—the searing pictures were the diametric opposite of chic fashion. He included those pictures in his book, he said, "to help make clear that the line is very thin."

On and on they went at it. Penn said his vision was "fatter" than Avedon's, which was "white-hot . . . momentary, and consequently narrower." Avedon said he preferred to describe his quest for "the *unguarded moment*, or in the moment that I helped to *create*, I feel that I've cut through a great deal of façade and have gotten what I feel is truer." To which Penn replied, "We agree on one thing, that the important thing is to get past the public façade. The job of a photographer [is] to get past this façade."

Their way of reaching that point was quite different. "We use the same camera, we use the same way of lighting—to a degree," Avedon allowed. "I come to a sitting so charged with what I want out of the sitting, before it begins, that I'm almost sick before I start it. And I know that what I have to accomplish has to be done—on *my* shoulders. . . . I have to make it happen. Penn . . . sits it out. He's a great poker player, I would assume. . . . You slow it down to your pace and you make it happen *your* way. It's just as manipulative as I am. What I try to express of myself in my portraits is very often *violent*, very often a *frightening* or a riotous element in myself. . . . Penn creates his atmosphere in search of nobility, I think."

Avedon and Penn both nodded toward the changing atmosphere at post-Brodovitch fashion magazines. "The printed page seems to have come to something of a dead end for all of us," Penn said. "I've learned the discipline of not looking at magazines when they come out, because they hurt too much."

Avedon said art direction had superseded photography, driving the photographer "away from publication and into his most private feelings." Both had explored that terrain through portraiture, and a decade earlier Penn had branched out into ethnographic portraiture and nudes of imperfect women; both seemed to be reaction against his work in fashion, similar to Avedon's gimlet-eyed portraits. By the midsixties, Avedon was "trying to get at the heart of the matter and not depend on steam trains and elephants as props," Earl Steinbicker observes. "He wanted to regard himself as a portrait, not a fashion, photographer." A remark about Avedon made by the gallerist Lee Witkin applied equally to him and Penn. Both were "very insecure" about being seen as "merely a fashion photographer."

Avedon nonetheless noted similarities between portraits and fashion pictures, saying, "I believe that the fashion photographer's job is to *record the quality of the woman*, of that moment he is working." Edward Steichen's epochal picture of Marion Morehouse did that job, Avedon said. "She was the essence of the twenties. She stood like the twenties. . . . She was boiled-down essence of the million flappers, plus the elegance of Steichen's vision of her. . . . Our job is always to report on the woman of the moment. The way she lives, the way she dresses. Our conception of beauty changes and is always changing. . . . We're both professional enough to know that we're in the dress business . . . but *that* we do automatically with . . . the left hand. With the right, we're trying to draw out a quality in a woman that we feel is beautiful. . . . The *new* fashion photographer will simply find a *new quality* in a woman and show it to us."

Penn did not object to that. But he strove to accommodate "the point of view of the magazine that I work for," rather than attempt to make "a much more profound statement of fashion—fashion in living, fashion in feeling, and in thinking, than I would ever dream of attempting or even be interested in attempting. . . . The pictures that I take are individual images that sit inside their rectangle. . . . I don't attempt to make them profound. . . . I don't think the girl's personality should ever intrude. . . . Dick's view is a much broader one; in that he's telling you something about our time. *Mine* is a *very narrow one*—you can see a great deal more of the buttons and seams." Then, Penn admitted the work was wearing thin for him: "I'm pretty tired of girls,

and attitude, and dresses." But he added, "Unconsciously, we cannot avoid saying what we feel at the moment, because we are alive today."

When he said that in 1964, the moment was far different from the time in which Penn and Avedon had begun their careers. Penn had already withdrawn from the front lines of fashion. Avedon would linger longer in the field he called "such a delight . . . a reflection of the fun of life" and "a way to recharge myself" for "more demanding work." But a change was coming, and a new generation of fashion photographers had already appeared, eager to reveal a new woman and make its mark on magazines, on fashion, and on the world.

EXPERIENCE

I thought, "Shit, there's more to this photography than I thought."

—DAVID BAILEY

"ONE STOLEN FRAME"

Bert Stern started at the very height of fashion—a dangerous place to be.

In 1959, less than a decade after he took his first professional photograph, Alex Liberman drafted Stern, then a hotshot advertising photographer known for a vodka campaign, to shoot for *Vogue*. A year later, he bagged his first cover, a head shot of the model Deborah Dixon giving a hot, come-hither look, lips parted in sultry invitation. With photographs like that, Stern instantly joined the fashion pantheon; over the next decade, he would shoot forty-one covers of *Vogue*. With Irving Penn increasingly reluctant to sell frocks, Stern became Liberman's primary weapon against Richard Avedon and the suddenly destabilized *Harper's Bazaar*. "Penn stood at the top," says Sarah Slavin, then a *Vogue* sittings editor. "Stern, in a way, came next."

Two years later, *Vogue* gave Stern what would turn out to be the most important, memorable, and insanely lucrative assignment of his life. It would overshadow everything else he did in a long and distinguished career and, ironically—as he owed it to a fashion magazine—render his decade atop fashion's heap a footnote.

In 1962, Stern flew to Los Angeles and rented a suite at the secluded Hotel Bel-Air to use as the set for a photo session for *Vogue* with the troubled but still mesmerizing sex symbol and movie star Marilyn Monroe. The shoot lasted several days, fueled by a case of 1953 Dom Pérignon champagne, Monroe's favorite, Château Lafite Rothschild, and vodka. Most of it was conducted with Monroe in the nude—for the first time since the *Playboy* centerfold that first propelled her to stardom.

"Of all the girls I had known or seen in movies or on stage, that one girl who truly intrigued me whom I had never met or photographed was M.M.," Stern wrote afterward. He hoped to take a portrait of her as iconic as Ed-

ward Steichen's great photograph of another, chillier movie blonde, Greta Garbo. "I thought it was a photo opportunity, and also I liked her, and I wanted to get close to her," Stern recalled thinking. "If I couldn't get close to her personally, at least I could get a photo." Like the young autograph hound Avedon, Stern craved a totem of her fame.

The first day's shooting lasted through the night and yielded hundreds of images of a slowly disrobing Monroe. "I didn't say, 'Pose nude,'" he later recalled. "It was more one thing leading to another. You take clothes off and off and off and off and off," ending up with a topless Monroe, flirting with Stern through veils of diaphanous scarves, costume jewelry, and chiffon flowers. "Her beautiful body shone through the harlequin scarf in a tantalizing, abstract hide-and-seek," Stern wrote. "Until she dropped it. And I shot it. Just for myself. One glimpse. One stolen frame."

Stern was exultant; he'd got everything he wanted—and the photographs were evocative enough that forever after others wondered just how far he'd gone with the sexy star. But back in New York, Liberman, *Vogue*'s editor, Jessica Daves, and Diana Vreeland (who'd arrived at *Vogue* just before the Monroe shoot) weren't so sure. Daves thought the photos were too risqué and asked for a reshoot, which was conducted in a second session with fashion editor Babs Simpson, and several dresses, coats, including a lush chinchilla, and all the other clothes and accessories that were *Vogue*'s raison d'être. The eight-page spread that resulted appeared in *Vogue*'s edition of September 1, 1962, and included only fully clothed photographs of the icon.

The issue was on press when Monroe died, a suicide, that August 5.

Later, Stern, who styled himself a ladies' man, would claim he was convinced Monroe was trying to seduce him. "How's this for thirty-six?" he said she'd asked him while revealing her famous milky-skinned breasts. They'd ended up in the suite's bedroom, her naked in bed, "vulnerable and drunk and tender and inviting and exciting." Then she passed out and he took one last photograph of her sleeping. "I saw what I wanted, I pressed the button, and she was mine," he later wrote. His words were certainly quite consciously chosen. In his mind, he'd scored the ultimate sexual conquest with his camera, in that context a farcically obvious phallic symbol. "Making love and making photographs were closely connected in my mind," he'd later say.

Ten years later, Bert Stern was ruined, a drug addict who'd been in jail

and mental hospitals, lost his wife and three children and, many thought, his mind. But for the rest of his life, as most of his accomplishments were forgotten, those images of Monroe at the end of her rope would prove to be Bert Stern's lifeline. Starting in 1968, when Stern first sold pillows and scarves decorated with his Monroe images, he would print and reprint, recycle and republish them to sustain himself, pay his bills, and, at least sporadically, remind the world of his name and reputation.

Those images of Monroe live on, timeless, immortal, often accompanied by Bert Stern's version of those nights at the Hotel Bel-Air, when, a photography curator would have it, he asserted his control over the legendary Monroe, dominating her "for the sake of an image." So it's more than a little curious, as that curator Robert A. Sobieszek wrote in his introduction to *Adventures*, the only major book of Stern's photography, that his name would be "lost to history" before the twentieth century ended. "The artist who had helped establish the commercial photographer as a celebrity, a figure of great wealth and unbridled lust, had simply disappeared."

Bert Stern felt he came out of nowhere: "My life was nothing. I had no story, no beginning, no middle, no end." He was born in Brooklyn in 1929, the son of a baby photographer, "an angry wreck" who "slit his wrists in a bathtub and survived" during the Depression. Raised in a basement apartment, Stern dropped out of high school, worked in a clothing store and at a soda fountain, unsuccessfully peddled jokes to comedians and newspaper columnists, and dreamed of being a cartoonist. "Superman was my only reality of the time," he said. At another menial job, sorting mail in a Manhattan bank, his boss told him he was overqualified, yet he ended up in another mail room, albeit at *Look*, a photocentric national magazine that competed with Henry Luce's *Life*. "And my life began."

Stern's mentor was Henry Bramson, the magazine's promotional art director, who took the young clerk under his wing, encouraged him to study art, taught him the fundamentals of design, and brought him into *Look*'s art department as an assistant. From Bramson, Stern learned that most good design is based on geometry, and that the most compelling pages contained triangles; they became his signature visual motif. He befriended Stanley Kubrick, who would become a renowned film director but was then a young *Look* photographer. (Years later, Kubrick would hire Stern to photograph

promotional materials for his film *Lolita*. The resulting photos of starlet Sue Lyon wearing heart-shaped glasses and sucking a lollipop would be among Stern's most famous images.) Through Kubrick, Stern met his future first wife, a model who at first spurned him. A more important encounter was his first with an Irving Penn photograph, a still life that "got me interested in photography," he said. "It was divine, spiritual." On first impression, he immediately understood, he continued, that "the photographer had so much power, he ran the show."

Pushed out of the *Look* nest by Bramson, Stern took a job as art director at a small fashion magazine, where a commercial photographer nudged him to buy his first camera, a 35 mm Contax. He returned to work with Bramson when the older man moved to *Flair*, an innovative but brief-lived arts and culture magazine created by publisher Mike Cowles's wife, Fleur; Stern became its "pseudo art director," as he put it, after Bramson had a heart attack. He felt he'd found his direction in life, but *Flair* went belly-up, and then Stern was drafted into the army and sent to Japan, where he would head to the PX twice a month to leaf through new issues of *Vogue*, "the only magazine I liked, because of Penn."

Out of the service in 1953, Stern still thought he'd be an art director. "Photographer was the last thing I wanted to be." So he got a job for another little fashion magazine and reconnected with Bramson, by then working for an ad agency, who asked him to execute freelance layouts for one of his accounts, Smirnoff, then a minor vodka brand seeking to dislodge gin as the favored alcohol of martini drinkers. The company had a slogan, "Driest of the dry," and Stern came up with a campaign idea: still lifes photographed in the desert. "Who should shoot it?" Stern recalled asking. "I said Penn, of course." Though Penn had taken groundbreaking images of Jell-O pudding and pie filling for ads that very year, Stern continued, he "said [the Smirnoff idea] couldn't be done with photography." When Erwin Blumenfeld also said no, Stern said, "I guess I could do it."

Bramson advanced him the funds to buy a car and drive to White Sands, New Mexico. He hired Teddy Ayer, the model he'd met through Kubrick and hadn't forgotten, as his assistant, and they came back with an image that set the ad business buzzing, a man wearing a hat and a tuxedo perched on a

chair in the desert distance in the blinding light of dawn with a lemon be-
tween him and a Smirnoff bottle and a martini in the foreground.

Instantaneously, Stern's Smirnoff campaign (which later included an
even more famous image of the pyramid at Giza, outside Cairo, rendered
upside down in a martini glass) became the talk of Madison Avenue, and
Stern, the boy wonder of commercial photography. "I think Penn was right,"
he would later admit, "the shot was impossible. But I got lucky."

He and Teddy Ayer got married. "I didn't want to get married," he later
said. "I just wanted to make out." But she had virtues beyond her sexual at-
traction, among them finding him a studio overlooking Bryant Park and the
New York Public Library in the same building where Steichen had once
worked and Irving Penn still did. It had a skylight and Stern would shoot
using only daylight for the next four years because "I didn't know how to use
a light meter."

His first marriage lasted less than those four years but quite a bit lon-
ger than a brief flirtation with Brodovitch's Design Laboratory. Stern left
after a single session; he felt he didn't need it. His work in advertising was
already as influential as that of Brodovitch and Avedon's was in magazines.
That mattered most to him. "I didn't think of money," he said. "I was very
frugal. Making wonderful pictures was the goal. I could take impossible pic-
tures for Smirnoff and they'd appear in *Life* magazine and I'd be on a plane
and everyone would have a copy and they'd stop people. That was the goal."

His life became as chaotic as his career trajectory was meteoric. Before
he even started shooting fashion, he left Teddy Ayer for another model,
Dorothy Tristan, who was "very dangerous . . . too beautiful and she drank,"
he said. They met when she was eighteen and just back from Europe, where
she'd modeled in Paris and was living with a photographer in Rome. She
promptly broke up with her boyfriend "because Bert was so much fun," she
says. She isn't sure of when they met. "I must have had a job with him,"
and she's sure it was on location, "which is always dangerous. I was young
and selfish and absolutely ruthless and I didn't think about anybody else's
feelings."

Tristan knew Stern was still married to "a cute thing, adorable, I for-
get her name." Tristan came to sympathize with Teddy because after Stern

cheated on his wife with her, "he was extensively unfaithful, which made me angry and caused a lot of trouble." She adds, "He was not a great lover at all. He was after everyone and in everyone's pants, but he didn't know what to do when he got there." Sometimes, it was over in an instant. Sometimes he had trouble ejaculating. "I don't know what his sexual problem was. Maybe he was unused to intimacy. But he was great fun," she hastens to add. "He was naughty." Even while working. "You'd lie down and he'd get right on top of you, right in your face, straddling you, and music was playing, mostly classical, because I liked it." Working for De Beers diamonds, "we went to the desert and shot in the moonlight. He was a wonderful artist, very exciting, very sexual."

They never lived together. "I don't think he could live with anybody," Tristan says. "He was very generous but very selfish. Screwing around is the height of selfishness. We were off and on for years." Somehow, they even survived the night she threatened him with a knife. "He was carrying on as usual." Another time, at a party in his studio, "I looked over the balcony and he was with a model, so I put my fist through a loudspeaker. He was shocked. And we kept on going."

He cheated a lot, not always with models. "Models were just things that happened," Stern said. "God created women. Let's face it. Best thing he's done. I was crazy about girls. Women were everything to me. You did anything to get over them or under them. All guys are interested in women and photography was a way to meet women. I wasn't booking models to sleep with them. But I did find women the best thing there was. What else was there? Movies, women, photography, success, women."

"You could see her tongue"

The next woman Bert Stern fell for, New York City ballet dancer Allegra Kent, was the love of his life. The then nineteen-year-old virgin was upside down when he first saw her, hanging from a fire escape onstage in a Broadway musical in spring 1957. Over the next two years he grew obsessed with her, watching her in performances choreographed by George Balanchine, inviting her to his studio (she came three times before he felt he could photograph her), and then courting her assiduously. "She'd been kept as a vestal virgin by Balanchine," says Peter Israelson, a longtime assistant of Stern's. "Bert was enamored; she was a particularly beautiful hothouse tomato."

Stern was the first man Kent ever dated. He reminded her of her father, who'd deserted her family and was also "a womanizer," says Israelson. In summer 1958, Stern took Dorothy Tristan with him to Newport, Rhode Island, where he and a neophyte filmmaker named Aram Avakian made the first music-festival documentary, *Jazz on a Summer's Day*, at the Newport Jazz Festival.* Back in New York, Kent confronted Stern and he admitted he'd been seeing Tristan. Only when Kent declared their relationship over did he seem interested in her again. "I couldn't depend on him," she later wrote in an autobiography, *Once a Dancer . . .*

But that was hindsight. Stern and Kent married a few months later in February 1959. Their first night of marriage "was not particularly wonderful," she wrote years later. "Bert was annoyed that I was completely inexpe-

*Avakian would later have relationships with both Tristan, whom he married, and Allegra Kent, who was his companion when he died in 1987.

rienced." And he was likely not a patient tutor. But "Bert saw marriage to me as the joining of two celebrities," she wrote. Others were fascinated. At the same time that they were married, an art director named "Miki Denhof called and offered me work at *Glamour*," Stern remembered. Denhof, an Italian raised in Austria, a protégée of Alex Liberman's, had come into her own as a mentor to many émigré photographers.

Glamour had been Condé Nast's last magazine launch, introduced in 1939 as a competitor to *Mademoiselle*, which had been published for twenty-four years by a rival outfit, Street & Smith. Street & Smith and Condé Nast, which had been losing money, were both acquired by a new owner in 1959. That March, Samuel Irving Newhouse and his wife, Mitzi, proprietors of a coast-to-coast chain of fourteen American newspapers, bought Condé Nast Publications. Newhouse, then sixty-four and a child of Russian immigrant parents, added Street & Smith in August. He promised hands-off management by his executive team, mostly family, including his brother and two sons, S.I. Jr., known as Si, thirty-one, and Donald, twenty-nine.

Over their many years together, Mitzi Newhouse had convinced her workaholic husband to indulge her taste for life's pleasures. They lived in an apartment at 730 Park Avenue, the Jewish analogue to its chic, exclusive neighbors 720 and 740 Park, and had a country house in New Jersey. The petite, attractive Mitzi wore couture clothing, and Sam famously joked that one day she'd asked him to run downstairs and buy her a fashion magazine. So he gave her *Vogue* as a thirty-fifth anniversary present.

Alex Liberman had long been frustrated by the "stodgy and pedestrian" *Vogue*'s lack of "snap and dazzle." Its latest editor, Jessica Daves, had balked at his attempts to modernize the magazine's look with the more suggestive and intimate pictures that he was coaxing from female photographers such as Frances McLaughlin and Karen Radkai. *Vogue*'s editors also disdained Irving Penn's fashion pictures, complaining to Liberman that they "burned on the page." That criticism was one of the reasons Penn refocused on portraits and still-life work. Liberman tried encouraging the American-in-Paris William Klein, a snapshot-style photographer in the Avedon mold, but with his own quirky, winking style. But Liberman's biographers note, "Alex was careful to surround [Klein] with pages and pages of less jarring work." If such compromises bothered Liberman, he didn't let it show; he got his cre-

ative jollies painting on weekends, generally abstract variations on a geometric theme—just like those Stern learned from Bramson, only Liberman favored circles.*

Now, Liberman had new patrons to cultivate, the Newhouse family. He joined Pat Patcévitch, Condé Nast's president, at his first dinner with the new bosses, and Liberman and his wife, Tatiana, rapidly cemented a relationship. "I became in a way Newhouse's confidant," Alex said. "I think Newhouse felt more comfortable with me than he ever did with Pat. He really listened to me, and he learned a lot about how the magazines operated as a result." If Liberman's friendship with Patcévitch suffered as a consequence, he felt it was a necessary but acceptable loss. "I had to exist."

Actually, Liberman thrived. "Alex instantly jumped into the lap of anyone who enabled him to increase his power," said Rosamond Bernier, a longtime *Vogue* editor. In October 1962, Alex was promoted to editorial director of Condé Nast, his name just below Patcévitch's on the mastheads of all the magazines. The promotion followed the third and last bleeding-ulcer crisis of Liberman's life; finally, his problem had a surgical cure. A diseased portion of his stomach was removed; he made a full recovery and continued to invest in his future with the Newhouse family.

Condé Nast magazines were young Si's favorite outpost of the empire, and he dedicated himself to learning the business, starting at *Glamour*, where art director Miki Denhof walked him through issues of *Vogue* and the *Bazaar*, explaining why the latter was more stylish, and convinced him to steal the competition's two best assets, Vreeland and Avedon. At the same time he poached the former, Newhouse moved to overseeing *Vogue* (he would be named its publisher two years later).

Vreeland's promotion to editor in chief was announced about two months after Liberman's ascension, but she knew who the real boss was— Si—and played nice with the "wonderful boy," as Vreeland addressed him in a note of congratulations. For his part, Liberman "took [Si] under his wing,"

*"Over the years, Alex had developed a kind of self-protective contempt for his work at Condé Nast," wrote Francine du Plessix Gray. "He felt that the financial security brought by his job also liberated his art (or so he rationalized it) from marketplace constraints, from the whims of critics and art collectors."

said Peter Diamandis, a Condé Nast editor, and became Si's "surrogate fa-ther," mentor, and cultural guide. "Si was rough, a snob, a poker player," Richard Avedon said after his departure from Condé Nast. "Alex cleaned him up."

Alex had not yet received his new title when he first received Bert Stern, who wanted to work for *Vogue*: "I had a meeting with Alex and I said the same thing [he'd told Miki Denhof]; I said I didn't have a real feeling for *Glamour*," but would agree to take pictures for the magazine if he could also shoot for *Vogue*. He began at *Glamour* ("I didn't shoot pros," he said, "I used regular girls") and "finally Alex Liberman called with a jewelry job for *Vogue*. I got very excited, and of course, I booked Suzy Parker, and also Debby Dixon." Liberman turned a photo of the latter—taken for the jewelry port-folio contained within the issue—into Stern's first cover.

"You could see her tongue," Stern recalled, and readers were shocked. "They got letters about it. Alex called me in and said, 'Don't work for *Glam-our* anymore; work for *Vogue*.'" He gave Stern a contract for one hundred editorial pages a year that also allotted him an annual portfolio to fill how-ever he chose; the Marilyn Monroe portfolio would be his idea. While *Vogue* retained ownership of the copyright and negatives for most of his work, he got to keep the film and rights to those portfolios.

Why Stern? Liberman prided himself on his knowledge of high culture; he was impressed with Stern's wife. "She'd modeled for Dick—six pages in *Bazaar*—before I met her," Stern said. Liberman told him those connections made him "particularly suited for *Vogue*." But he also seemed suited to the sixties. "He kind of personified it," says fashion editor Sarah Slavin. "Bert understood the modern vulgarity, the people of the moment. Penn never pretended to be of the moment." And Stern's experience in advertising—where high-handed diva behavior is anathema and the ability to produce on order paramount—made him easy to deal with.

"He was enthusiastic about work, period," says Nancy Perl, who'd worked for Avedon and Penn before joining Stern's studio and attended his meetings with Vreeland. "He was very centered, very involved." But also very self-involved. "He was a creative artist so he was mostly involved with his own work. He lived in the moment he happened to be in and he was very much interested in Bert."

Another longtime assistant, Vicky Stackliff, met Stern through Perl's husband, Arnold, a television writer who'd helped with *Jazz on a Summer's Day*. In 1962, Stackliff went to Stern's studio—or more precisely, studios, as he'd bought two more nearby buildings after branching out into making television commercials in the late fifties. He'd partnered with a friend he'd made in Korea, Eddie Vorkapich, who'd grown up in Hollywood as the son of a Croatian film director. The McCann Erickson agency hired them to make their first commercials for Coca-Cola and reportedly paid them $1 million.

Stern "worked very hard, it had to be perfect," Stackliff says. "Bert was the idea man, and the editors got it together."

Stackliff remembers the studio as an image factory, albeit one with huge hanging speakers blasting whatever pop music the models asked for. "First, the clothes would come, racks of clothes, boxes of accessories, and it all went downstairs to the dressing rooms. Then the ladies. They were always somebodies with some connection to society. They weren't very friendly. They were very chic. Then the girls [i.e., the models] would come and [hairdressers] Kenneth [Battelle, aka Mr. Kenneth] or Marc Sinclaire, and makeup. It took a long time. Hairdos were very complicated then, there were hairpieces that were all braided and twined around. Bert would watch and make suggestions. Then he'd shoot on no-seam paper with music in the background."

Monique Knowlton, then Monique Chevalier, a German Swiss beauty, had started modeling in Paris at eighteen in 1958 and "just sort of caught on," she says. Four years later, Monique was booked for a shoot with Stern that showed her seated, in a feather-sleeved dress, improbably reading a stock market ticker while having her elaborate hairdo teased out by Kenneth.

Penn was Knowlton's favorite. "One always looked like a lady with Penn," she recalls. "He had the most serene studio. He wasn't like Avedon. You didn't have to jump over a camel or wear a snake around your neck." But she kept shooting with Stern for *Glamour*. "Stern doesn't come close to Penn," she insists, but adds, "Bert was very, very talented. Bert was also the only one who made passes at everyone. I threw him out. I only made love with someone I was in love with." But that aside, "it was easy to work for Bert. It was more difficult with Penn; you had to concentrate and breathe out. Bert always had the Everly Brothers on, that helped, it made you relax.

And once he was sure he wouldn't get anyplace, it made it easier to work with him."

Perl says Stern would often change his mind and rethink a shoot entirely. "He was always looking for better things." Knowlton concurs: "He was the opposite of Babs Simpson. She was an extremely organized lady. Avedon and Penn seemed very organized. Bert would make changes in the middle and try to do things differently and tied himself in knots. I never had the feeling that he knew what he was doing. It was what he wanted, when and how. If he could have had slaves, he would have had nothing but slaves. He was always all over the place, disorganized, inconsiderate." Yet adaptable. Shooting Sophia Loren in furs for *Vogue* in 1962, he decided to pose her with cats and stocked his studio with a tiger cub, a panther, a bobcat, a lion cub, a leopard, and several ocelots. Loren refused, fearing they'd scratch her face. Stern convinced her to pose with the leopard by giving it a tranquilizer.

By 1965, when Bert was thirty-five years old, he employed twenty-one people, and a conservative estimate put his billings at $500,000 a year, most of it from advertising at $2,500 a page. That helped pay for his over-the-top ideas. "Nothing was too elaborate," says Knowlton. "Nothing was too expensive." And a model's comfort had nothing to do with it. "If he decided a beautiful snowy day was perfect for a white organdy dress with white embroidery, never mind if the girl was dying of the cold. Bert felt the more you suffered, the more interesting it would look. I think he liked the excitement of creativity, of music and a camera and you can get people to move. Clothes were never his main interest. Everyone else has clothes in mind and he didn't. I don't think he had any interest in fashion."

No matter how much a picture might change, his focus never did. It was about images and women, women and images. "I'm trying to get at the way women are," he said. "I am interested in the woman as a woman. When I click the camera, she has to be alive at that moment. Technique isn't really important. What I want is a believable moment." Sometimes, those moments became quite real, indeed. "He didn't run off with every model in town," says Perl. "He *was* involved with a couple."

From Allegra Kent's perspective, he was *always* involved with someone else. In spring 1960, she learned she was pregnant shortly after she had reunited with Stern after an eight-month separation. She'd left him—after just

a few weeks of marriage—for being unkind to her, because she felt they had nothing in common, and because she believed that her marriage had caused not only unhappiness but a career slump. She returned because her mother convinced her she'd never find sexual happiness otherwise, and "unfortunately, I listened to Mother," she wrote.

That June, Stern rented a new apartment on East Sixty-Fifth Street, and they started fresh, though "I knew my marriage to Bert was just a temporary measure." He admitted he didn't want a child; she fled again and gave birth to their first daughter, Trista, in Los Angeles. Meantime, Stern had spotted a brunette model on a bus and decided he had to shoot her, but she disembarked before he could get her name. All he knew was she'd been carrying an envelope addressed to Pamela. He combed through model composites for girls with that name until he found her. Pamela Tiffin was already modeling for *Vogue*.

Stern asked her to pose for a lingerie ad, and initially she refused, even though underwear paid double the normal hourly rate. But she finally gave in, on condition that only one photograph would run, not the several originally planned. Her eyes half-closed, wearing only a shimmering white slip, Tiffin appeared in the nylon-yarn ad that Thanksgiving weekend in the *New York Times* Sunday magazine. And she got involved with Bert Stern. "She liked older men," her biographer, Tom Lisanti, notes. The director Billy Wilder was so taken with the photo, he said, "Get me that girl," and cast her in his 1961 film, *One, Two, Three*. She became a starlet.

Tiffin gone, Bert visited Allegra in California after Trista was born and "became a serious man, a handsome photographer with a great eye, and the father of our baby," Allegra thought. He agreed that if she returned to him in New York, he would enter marriage counseling, but by early 1962, she'd decided "our life together was not better." He thought that yet another apartment would help her "leave past unpleasantries and disappointments behind," and they moved again. But by summer '63, he was back to playing the field. "There were certain unmistakable signs," Allegra wrote. "His hours at work increased and he wasn't always where he said he would be." Throwing common sense to the winds, and with no expectation it would fix her marriage ("I had grown up without a father"), Allegra got pregnant again that Halloween, "without consulting Bert."

Bert meantime had taken up with Holly Forsman, a wholesome, petite, and pert-nosed blond junior model who worked for *Seventeen* and posed for ads for tampons, poodle socks, Coca-Cola, and Clearasil. "I was like his second wife," Forsman says.

Just back from a year modeling in Paris, Forsman was married to an older man she wanted to dump. But because he wanted to save their marriage, every weekend they went to Fire Island, where his family owned a beach property and the Sterns rented a summer house. "My husband had a nose for celebrities, and he met Bert," Forsman says. "Bert invited us all on a boat he'd rented," and they went to the Pines, another gay community adjacent to Cherry Grove, to go dancing. "I went to discos every night. Bert loved the way I danced the frug, the wild, swinging hair. Allegra, seeing that, did a dance for him." After his wife's assertion of territoriality, Forsman didn't see him again, until he booked her for a job.

"By then, I had my own apartment," Forsman remembers. Other girls and a client were on the set, "but after everyone left, he showed me the Marilyn Monroe pictures. Then he called and asked me out, and we really clicked and began to see a lot of each other. He said his marriage was very loose. He loved and admired Allegra to death and was a really good father." In years to come, she adds, she would sometimes come along when Bert took his daughters to lunch. "Allegra was very dedicated to her career. She was always in class or rehearsal. He had a lot of time and he was surrounded by young, pretty women. He had little things with quite a few people but not while we were together. He'd talk about how beautiful girls were. I didn't care; I'm not the jealous type. We liked to have a good time. We'd go to clubs and drink champagne."

Fashion didn't care how Bert Stern conducted himself. The more girls he had around him, the better. His overt heterosexuality was still a novelty. It made his pictures fresh at a moment—world war in the rearview, prosperity spreading from America to a recovering Europe—when the hunger for something palpably different was gathering. Fashion was becoming a mass-market product. The stylish elite were being elbowed aside by people such as Stern: nobodies from nowhere going somewhere.

Chapter 12

"STROPPY BLOKES"

Visionary—and straight—men invaded fashion in what-are-they-putting-in-the-water numbers as the sixties gathered steam. Jerry Schatzberg, Melvin Sokolsky, and David Bailey all got started in the late fifties, saw their reputations soar by the middle sixties, and retained their influence long afterward, even though they, too, labored in the shadow of Richard Avedon.

Schatzberg, like Avedon, came from a fashion family; his father and three uncles ran a wholesale fur business and sold their wares at Russeks, a retail store begun by the family of another photographer, Diane Arbus, who briefly worked in fashion photography, but became known for photos of eccentrics and people, then called freaks, who were far from fashionable.

Schatzberg was two years older than Stern but got off to a later start. He failed early on as a fashion salesman—"I couldn't sell anything," he says—spent the years 1945 to 1947 in the army, lost another year to college, got married, had a child, and went back to work for his family and "hated it," he says. "I hated business." His interest in photography was vague, at best. "I looked at magazines in the showroom," he says, but he wasn't particularly interested in fashion pictures. The only photo credit he recalls noticing was Milton Greene's. Schatzberg would take two-hour lunches just to spite his father, whom he'd never got along with, and regularly wandered through a camera store a few blocks from the showroom. "I don't know why," he says. "I was just attracted. It was different and I was curious." He finally bought himself a Speed Graphic camera. What motivated the purchase? "I just wanted out."

He saw a want ad for a photographer's assistant. "I had no idea what that was," but he went to see Lillian Bassman, who'd become a photographer after *Junior Bazaar* folded in 1948. She mentioned Alexey Brodovitch. "I didn't

know who they were," Schatzberg says, and though he loved the glamorous feeling of Bassman and Paul Himmel's studio, he couldn't afford to accept her offer of a mere $25 a week to assist Himmel. Schatzberg had a second child on the way, so he kept trying but failing to get assistant positions. Finally, an uncle who was a baby-photo salesman like Bert Stern's father got him work shooting children at $2 a sitting, six days a week. "But I could do ten sittings a day, and in those days, 120 dollars a week was a lot of money."

Finally, after six or seven interviews, he was offered a job at advertising and fashion photographer William Helburn's penthouse studio on Twenty-Fifth Street and Park Avenue South. "I was the assistant on the camera: I loaded it, set the lens, pulled the slides, put up the backgrounds, cleaned the toilet, whatever he wanted." Schatzberg learned to dodge the cameras and light meters Helburn would sometimes throw at him and started falling in love with his new profession. By 1954, he was on his way.

Helburn's darkroom assistant taught Schatzberg to develop and print; Helburn "let me watch and learn as much as I wanted and gave us the use of the darkroom and studio, which is a very big thing when you're young," Schatzberg says. He started testing inexperienced models from minor agencies. "I didn't realize, if you got good pictures out of those people, you were doing really good," he says. Eileen Ford of Ford Models saw some of his tests "and wanted her girls to test with me."

Still living with his wife in the suburbs, Schatzberg started coming home at midnight, getting only three hours of sleep. "We did location trips, and if we went with three or four girls and Bill had one, I'd be with the others, talking, learning, sometimes flirting. At that point, my marriage was basically finished."

Schatzberg befriended Bob Cato, a onetime student of, and assistant to, Alexey Brodovitch. Having worked at *Junior Bazaar* and *Glamour*, "he knew everyone," Schatzberg says, "taught me a lot, socially and artistically," introducing him to artists such as Jasper Johns and Robert Rauschenberg, Merce Cunningham, and John Cage. When Cato gave Schatzberg an assignment, he decided to rent a studio of his own in an empty building near Helburn's studio that had once housed Tiffany & Co.'s silversmiths. "I took three spaces, cut out the walls between them, and made a studio. My wife didn't like my total dedication, but I just had to do it." Later, after his marriage

ended, he moved into a tiny room in the studio, using a toilet in the hall ("I don't remember how I showered"), and then later took another space above and built himself a bedroom, kitchen, and bathroom.

Cato got fired before Schatzberg gained traction at *Glamour*, and he had to do "anything I could" to survive and pay his rent, "small ad jobs, store windows, anything." At first, he copied the lighting system Helburn had used, huge banks of incandescent lights with spun glass in front of them. They were too hot so he redesigned them with cooler fluorescents, but couldn't afford to build them. When he got his first job for *Vogue*, the magazine "built the lights for me."

He says, "I sent my portfolio to Liberman. He saw something I didn't see. My first assignment was a simple little fashion thing on gray paper with a secondary editor. Clothes for average people. He liked them and gave me more assignments, and of course, as a young photographer, I tried to copy the best I could, Penn. I spent thousands trying to duplicate his lighting, his cameras, his film, his lenses, his chemicals, his light, his attitude." At a lunch with Liberman, Schatzberg confessed that copying worried him, and Liberman replied, "If you copy good people and do it well, eventually you find your own personality." By 1958, Schatzberg's photos were appearing in *Vogue* regularly, and he was publishing pictures of the models Anne St. Marie in the Fulton Fish Market and Betsy Pickering running through the canyons of Wall Street that would become classics of the genre. He was thirty-one years old and "I started to travel, my work got better, and I got known."

Liberman asked him to shoot trapeze dresses by Dior and emphasize that they had a particularly original shape. "I'd spend two or three nights a week at the Palladium Ballroom on Broadway watching people dance," Schatzberg says. At the so-called Temple of Mambo, a dancer named Killer Joe Piro played MC. Celebrities flocked to learn the latest dance steps. Inspired by how the dancers moved doing the cha-cha-cha, a Cuban dance step that was then the rage, Schatzberg hired two dancers from the Broadway production of *West Side Story* and had them dance in his studio. "When I saw something I liked, I stopped them" and had models dressed in Dior copy their moves.

Schatzberg began traveling to London after meeting a contemporary, the young British photographer Terence Donovan, when Donovan called

him while visiting New York for the first time. "He booked me a room in the YMCA on West Thirty-Fourth Street!" Donovan recalled. "He's thinking I'm a penniless Englishman, and I booked into the Y with ten thousand dollars in my pocket."

"We were equivalents," Schatzberg says. "I would show him New York and we became instant friends." Through Donovan, Schatzberg would later meet Brian Duffy and David Bailey; the three Brits would soon be dubbed the Terrible Trio, or just the Terribles.

Born in 1936, the son of a truck driver, Terence Donovan started taking pictures as a child, "photographing the girls in the street where I lived," he said. "I thought, 'Oh, this is good. I like this.'" After studying lithography, apprenticing in the printing business as a teen, and a stint as a British military photographer, he began his career as an assistant, ending up in the studio of John French, a London fashion photographer who was "a marvelous sort of queen," Donovan said. David Bailey, a bit younger, followed Donovan as a French assistant.

Brian Duffy, three years older than Donovan, was a self-described "thuggish child of war," who grew up on the streets of North London during World War II. He studied fashion at art school because "the most attractive lot were those girls doing dress design," he said, and became a designer, but turned down a job at Balenciaga in Paris when his new wife got pregnant and he took work as an illustrator instead. Duffy started taking pictures around the same time as Donovan, after seeing his first contact sheets while dropping off some fashion drawings at the English edition of *Harper's Bazaar*. "Gawd, this looks dead easy compared to the drawing lark," Duffy thought to himself. "I'll give this a whiz. Take up photography as an easy way to make money. Just my sort of thing—women, gadgets, clothes—I must have a go at it."

He got a job assisting celebrity-portrait photographer Adrian Flowers, who had a studio in London's Chelsea district, just off the fashionable King's Road. "Shit, this is the game," Duffy said to himself. "This is it. This is for me." His first pictures appeared in the *Sunday Times* in the late 1950s. He took his first photo for British *Vogue* for its Shop Hound what's-in-stores section in 1957.

"I was at the very bottom of the snappers," he later wrote. "First of all,

you start doing the dregs because there are hundreds of little photos that had to be taken all the time . . . horrible little pictures that no one else wanted to do." But he was spotted by Claire, Lady Rendlesham—wife of the Eighth Baron Rendlesham, a landholding member of Ireland's peerage—who'd joined *Vogue* in 1952. Lady Rendlesham was unlike the typical British *Vogue*ttes, who "nearly always had double-barreled names, it was very elitist," Duffy thought, "girls with fruitcake voices and thick legs, quite sweet, but not very bright." Rendlesham promoted young designers and photographers, and clothing designed for the young. She launched a *Junior Bazaar*–like section in British *Vogue* called Young Idea. Duffy thought she "had great taste and style" and "was an instigator for the new wave of change." And she loved Duffy and Bailey, bringing both to prominence.

The three stood in stark contrast to the prevailing image makers, who "had a slightly effeminate approach," Duffy recalled. "The way to be a photographer was to be tall, thin, and camp—you were seen to be inside the tent, and we were not. I'm not saying they were all homosexuals, but a lot of them were. . . . We would just talk to the girls and make them laugh. . . . 'All right, love, hold your bristols up more, that looks good.' Before that it would all have been obsequious toadyism, but our way seemed to work, and we were backed up by people who liked it. . . . I didn't have any affectations so I believe I was slightly brutal, maybe just straightforward, with the girls. . . . You want to get a response, a look, to make her feel she has some potency, other than just being a model stand, so that's why one imbued in them a sort of sexual tension, to make them think they were desirable."

To Bailey, all that required was making them look human. "I made girls look like people," he says. "I photographed portraits of girls wearing clothes rather than fashion being the most important thing. The edge was getting something out of people."

To the Terribles, change meant more than clothing. "People like myself, Terry, a whole clique," Duffy wrote, "were not deferential and said, 'No!' 'Why?' 'What?' 'Who told you so!' 'Go on make me!' The sort of chippy oiks like me and Bailey . . . were not prepared to roll over. There was a breakdown of society, not a lot of aggression, just people questioning everything, and wanting to change things. . . . It was the beginning of what I call 'Attitude.'"

By 1959, Duffy had his own studio and had begun shooting for a land-mark men's magazine called *Man About Town*, renamed *Town* after it was bought in 1960 by the future British politician Michael Heseltine. Bailey and Donovan would later work for it, too, in "pre-swinging London," Duffy wrote, "before anybody knew it was actually swinging."

None of the three could recall how they met. "We've all got different versions," Duffy said. Bailey, the only one still alive, recalls meeting Duffy at *Vogue*. "Within a year, we all got very known very quickly," Donovan said. His breakthrough came with shoots for *Town* characterized by a street-smart, reportage style. "It's dressing women so someone can come along and undress them," Donovan said. He was the last of the trio to go to work for *Vogue*, publishing his first photo there in 1963, two years after Duffy had a slow falling-out with the magazine and began doing what he later con-sidered his best work for a Swiss art director, Peter Knapp, at the French weekly fashion magazine *Elle*, another force driving fashion photography out of the ghetto of haute couture and into the streets.

All three of the Terribles were known for their abrasiveness—no sur-prise since they defined themselves in opposition to the prevailing fashion culture—but Duffy took that to extremes, earning a reputation as angry and epochally difficult. One fashion editor later described him as "a bit of a bastard, really." The film producer David Puttnam, briefly Duffy's and Bai-ley's agent, said, "You risked death being his assistant." Bailey found Duffy's quirks endearing. "He was always winding people up, Duffy," Bailey says. "Just a troublemaker. If you said it was Thursday, he'd say it was Friday. That's why I liked the Irish git. He was one of the cleverest men I ever met."

Duffy pushed everyone's limits, including his own. He was twice fired from *Vogue*. Though he continued to shoot fashion for *Elle*, and two influ-ential magazines in London—*Queen*, a magazine for young society and its aspirants, and *Nova*, an avant-garde publication—he increasingly turned his attention to portrait work, technically impressive advertising photography, and, for a brief spell at the end of the sixties, film (he coproduced *Oh! What a Lovely War*, the first film directed by Sir Richard Attenborough and starring Laurence Olivier, John Gielgud, and Vanessa Redgrave). Among Duffy's other credits were the covers of three David Bowie albums, beginning with *Aladdin Sane* in 1973, and two Pirelli calendars. In 1977, he embarked on an

ad campaign for Benson & Hedges cigarettes that was as famous in its time as Bert Stern's Smirnoff ads in the fifties, depicting cigarette packages in surreal scenarios. One showed a pack inside a newly hatched egg. By 1979, though, he was fed up. When an assistant asked him for some toilet paper, he suddenly decided he had too much on his shoulders and took loads (though not all) of his negatives into the rear yard of the house he used as a studio and burned them.

"In a flash, I decided to end it," Duffy said. "My career went down the bog with a piece of paper. Bailey watched. That's the sort of turd he is. . . . Keeping a civil tongue up the rectum of a society that keeps you paid is an art that I was devoid of."

"I never had any education at all," remembers the youngest of the Terribles, David Bailey. His father was a tailor's cutter, but also "a bit of a wheeler and dealer. He had a little club, a little drinking bar, and he was always duckin' and divin'. With the girls, too. He got slashed by the Krays [East London criminals Bailey would later photograph]. I didn't know him much." But because of his father's job, "we always looked better than other people because we got free clothes."

Dyslexic and dyspraxic, Bailey did badly at school and dropped out at fifteen. "They thought I was a fuckin' idiot. They put me in the silly class, but I was at the top of it." His childhood influences were Walt Disney and Pablo Picasso. He remembers his mother, a machinist, as "tough, like a tough Diana Vreeland." She had a Brownie box camera, and he learned to develop photos in their coal cellar. "I liked the technical side of it" more than taking pictures. "I wanted to be an ornithologist. I tried to do pictures of birds in the backyard. I didn't know about telephoto lenses. I always wondered why they looked like little black dots, why I couldn't get closer to them."

Briefly, he played trumpet and thought of being a jazzman. "I like the blues," he says, and in his first self-portraits shot at age seventeen, he poses like the jazz musician Chet Baker. Another hero was Hoagy Carmichael, "the first cool white man," whom Bailey spotted in the Howard Hawks film *To Have and Have Not*. The desire to *take* photos hit Bailey when he saw an image of four women in the Himalayas by Henri Cartier-Bresson. "I couldn't believe it was a photograph," he says, "and I thought, 'Shit, there's more to this photography than I thought.'" A year later, he was serving in

the British air force in the Far East when his trumpet was stolen "by an offi-cer and a gentleman," but he'd already come to prefer his camera and books and magazines about photography. He shot "the usual," he says, "Edward Weston tree stumps. And I had the best-looking WAAF in the Far East and I shot her, yeah, and I fucked her all the time." He'd pawn his camera to pay for film and processing, "then I'd get my twenty-four shillings a week, get the camera back," and start all over. "I've still got a Chinese pawn ticket."

Back in London, he tried to enroll in a printing and graphics arts school and, when told he was underqualified, became an assistant. He started with an advertising photographer, running errands, then wrote to the top twenty photographers in London. Only Anthony Armstrong-Jones (the future Lord Snowden) and John French bothered to reply. Armstrong-Jones gave him tea out of a silver pot and asked if he was good at carpentry. "I want to take pictures," Bailey replied, thinking, "I don't want to build sets for you, you fucking cunt." Fortunately, he didn't say that until over a half century later.

He joined French and stayed for eleven months. "He looked like Fred Astaire. There were always three assistants. I was the middle one. I had to press the button on the camera." French was renowned for never, ever, touching cameras himself. Eventually, French offered Bailey the first assis-tant's job. "He offered me the moon; I didn't want the responsibility." Also, Bailey says, "I think he was sort of in love with me. I was pretty dynamic and a bit rough. They liked a bit rough, all those middle-class people."

Like Duffy and Donovan, Bailey had married young—a "marriage of convenience," he says. By 1960, he'd begun taking weekly portraits for a newspaper, the *Daily Express*. Assigned a fashion job, he shot a model named Paulene Stone "on the ground, talking to a fuckin' squirrel," he remembers. "Real intellectual pictures. Donovan phoned me up and said, 'Was that an accident or did you do it on purpose?' 'No, I did it on purpose, you cunt.' Those pictures changed everything for me." Three months after he left French's studio, "*Vogue* gave me a contract."

Actually, first, *Vogue*'s art director offered him a staff job. "I was working for cheap magazines then. I didn't care," he says. "I just wanted my pictures published. But Condé Nast is so fuckin' cheap, he offered me twenty-five pounds a week, what I was getting for a picture, and I said no." Three months later, *Vogue* offered him a contract. "I didn't know what a contract

was. I didn't realize it involved copyright and all that shit, so I said, yeah, and once you sign a contract with them, they've got you by the short and curlies." Like Duffy, he started taking Shop Hound pictures. "He was angry because he was a staff photographer and I got a contract. Duffy was older and had been to art school."

Within a year, Bailey was shooting covers. Six months after that, he wandered into a *Vogue* studio where Duffy was shooting a neophyte model for a Kellogg's cereal ad.

"Who's that girl, Duff?" he asked.

"Ah, she's too posh for you," Duffy answered.

"I asked if she wanted to do some tests, and that's how it started." Her name was Jean Shrimpton, and once they came together, they were poised for stardom. In January 1962, Lady Rendlesham brought Bailey and, at his insistence, his new girlfriend, to New York to shoot a Young Idea spread. Declared the new Prince of the Glossies after that, he was shooting two thousand frames a week and was reportedly making £10,000 a year. "At least that, yes," Bailey affirms, "but I was paying eighty-six percent tax when I was making that kind of money. The Beatles wrote a song [called "Taxman"] about it." A new British society was emerging, and membership in it was consecrated by a portrait by Bailey, Donovan, or Duffy. "I just photographed a group of stroppy blokes and I think they're going to get very famous," Bailey told Donovan one day. They were called the Beatles. Few had ever heard of them. "It seems incomprehensible, but it's true," Donovan said. "And then, off we went." The Beatles and the Rolling Stones became subjects as well as friends of the Terribles.

In years to come, the Terribles would become most legendary for their sexual exploits—a reputation that began when Bailey hooked up with Shrimpton. "David Bailey makes love daily," Mark Boxer, a British editor, quipped. "Bailey and I shagged ourselves absolutely senseless," Donovan would later recall. That reputation was warranted but exaggerated. Duffy stayed married to his first wife all his life, even if he strayed at times (hairdresser Harry King remembers a Duffy shoot during collection season when "every time a dress arrived," he and the model would emerge from a back room, with him "pulling up his pants with an erection and she'd need her hair done again"). Donovan had relationships with two models,

Jacqueline Bisset and Celia Hammond, before marrying a second time in 1970; and Bailey also had lengthy relationships: "Every five years, he had a recast, hoping one or two would come quietly," Donovan joked.

But regardless of their sexual box scores, all three insisted that beneath their roguish exteriors, they were deadly serious about their work. Their hypersexed images may have made them celebrities, but they wouldn't have become the first fashion people truly famous beyond their little realm if the work hadn't been worthy of attention. "Everyone gets the wrong idea, like I was only doin' it to get a fuck," says Bailey. "It wasn't that. I had no problems getting fucked. It was, I thought, the only way to be creative and get paid for it, to do fashion pictures. I never really liked taking advertising pictures because they always wanted to tell you what to do, and I thought that was pointless."

Donovan agreed: "It wasn't calculated. It was just magazines and we took photographs and our names appeared on them. I used to do four assignments a day, work, work, work, work, we were out every day, year after year, London, America, Paris, Rome, photographing."

Said Duffy, "We were just workers. We just wanted to be good at it. We spoke [about photography] for hours and hours, ad nauseam."

On his first trip to New York, Bailey met Alex Liberman, and the art director asked him to shoot for the flagship *Vogue*. "I did pictures that were a bit pop-arty for the times, lots of signs on garages and things, and then he offered me a contract," Bailey recalls. "And then, I got caught up with *Vogue*, and suddenly I had French, Italian, American, all the fuckin' *Vogue*s." He was already entrenched in *Vogue*'s stable the next year when Vreeland arrived. "I thought she'd drop all of us and bring all the *Harper's* photographers, but she didn't," Bailey remembers. In fact, she and Bailey became such "good mates," as he put it, that he felt free to call her a "fucking old bag" when she rejected some of his photographs, and on another occasion, after a night of drinking, he and Jack Nicholson stole the knocker off what had been the front door of her house in London, pre-*Bazaar*, while Vreeland waited in a limousine nearby.

Chapter 13

A FASCINATION WITH MOVEMENT

One of the photographers Vreeland worked with before leaving the *Bazaar* was among the last of the greats to appear in its pages while Alexey Brodovitch's aura of excellence still clung to the enterprise. "Diana saved me on almost every shoot," Melvin Sokolsky told Vreeland's biographer. She saved him, he went on, from Carmel Snow's successor, Nancy White, whose appointment marked the beginning of the magazine's decline. "Some great photography still took place because she didn't know how to say no yet," recalls Ila Stanger, then a *Bazaar* editor. "It became gradually more ordinary."

Sokolsky may have been the unlikeliest character ever to rise to the top in fashion photography. He was born in 1938 on New York's Lower East Side and grew up in a four-room apartment that he shared with his grandparents, parents, and a brother. His father was an assistant at a lithography press; he brought home lush picture books and had a camera he let Melvin use to take family snaps when they visited their summer bungalow in Spring Valley, an inexpensive getaway for lower-class Jewish New Yorkers just north of the city.

Melvin couldn't fully indulge his immediate passion for photography because no money could be spared for film and processing. So he contented himself with intent study of his father's old snapshots. Wondering why they changed in look, quality, and level of detail from year to year, he started to learn about film and its chemistry. Photographers bought whatever film was available, and "the palettes changed based on what Kodak offered. I call it the emulsion of the day," he says, laughing. Technical details from film to light would captivate him ever after.

One day when Melvin was just past fifteen, his father was thrown off a bus, allegedly for being drunk; it turned out he had multiple sclerosis. "Somebody had to get a job," Sokolsky says, and he found one sweeping floors at a local barbell club, a gym for weight lifters, but it didn't pay enough money to support the family, so he forged proof of age, making himself appear five years older to get temporary work at the post office.

But the gym was where the short, red-haired, and blue-eyed Sokolsky learned about life. A former circus employee "taught us bravery tasks," he says, such as standing on a high bar and diving into someone's arms. "It gave me confidence." So did weight lifting. "When you can clean and jerk two hundred pounds? It's not about I look great. I can take care of myself."

He also developed entrepreneurial muscles. Bodybuilders wanted to be tan for their competitions. Sokolsky built a tanning machine. "I was suddenly making thirty dollars a day—in quarters!" Then a Mr. New York State contestant started griping that he couldn't find attractive trunks to wear while lifting for the judges. Sokolsky bought panty girdles from a pushcart on nearby Orchard Street, had his mother sew in a crotch and seams "so it would look good," and dyed them royal blue. He gave them to the contestant, who promptly stepped up to a posing mirror. "Everyone was, 'Where'd you get those?'" Sokolsky recalls. "'How much?' 'Four dollars and ninety-five cents.' I bought batches and farmed out the sewing." The bodybuilder and muscle-magazine publisher Joe Weider demanded a dozen—and offered Sokolsky a free ad in his magazine if he could "get 'em fast." Next, he started a mail-order line of T-shirts called V-Man, accepting only cash or money orders. "In a year, I made thirty-four thousand dollars." He kept the profits in a cigar box.

A lightbulb went off over the head of the budding businessman. His interest in photography hadn't disappeared, it had just gone dormant. He recalls the day he met the Mexican photographer Edgar de Evia's partner Robert Denning (later half of the interior-design firm Denning & Fourcade) at the gym and argued over a de Evia photograph of Jell-O pudding. Sokolsky didn't like it, felt it was too sharply focused. "I don't feel the movement of the chocolate," he said.

"You don't understand what it takes to do this," Denning told him. "And do you know he got four thousand dollars for it?" Denning challenged

Sokolsky to try it, "and I did and I realized I had a lot to learn," says Sokolsky. He began to visit de Evia's studio on the top floor of the Rhinelander Mansion (today, the flagship of the Ralph Lauren empire) and "understand the mechanics."

He spent some of his T-shirt profits on wheelchairs for his parents and used what was left to buy Deardorff and Hasselblad cameras—top-of-the-line equipment. He took over a little photo studio off the gym, and when a bodybuilder named Mickey Hargitay walked in one day, Melvin shot him and his girlfriend—a budding starlet named Jayne Mansfield. Sokolsky then started shooting bodybuilders regularly—and selling the pictures, a dozen for $4.95. He named his business Toggaf Studios after his audience. "Spell it backwards," he says. By the time he was twenty, he was ready to show his photos to advertising agencies. He rented a studio on East Thirty-Ninth Street, right near Bert Stern's, "from a gay muscle guy," he says.

Sokolsky was straight; he was already with Button, a beginning English model he'd met at William Helburn's studio who would become and remain his wife until her death in 2016. But neither did he care what other people thought of him—as a visit he made to Alexey Brodovitch at *Harper's Bazaar* that year demonstrated. It was the end of Brodovitch's tenure at Hearst, when his drinking problem had become acute. When Sokolsky appeared, he hardly glanced at the photos the young man showed him.

"He grumbles," Sokolsky remembers, "and walks me to the elevator. He treated me like a piece of shit. Why did I waste his time? He was the most arrogant trying-to-be-upper-class fool you could meet." Eight years later, Sokolsky had a similar experience with Alexander Liberman, who at least bought him lunch and seemed "much brighter and friendlier than Brodovitch." But their conversation never went much beyond the one question he recalls Liberman asking: "I love herring, do you?" Says Sokolsky, "These were pretentious men who showed no affinity for me. I was a peasant in jeans and a work shirt." Like the oiks from England, he was a new breed.

Sokolsky did better in the rougher advertising world, where his first job, shooting watchbands, won him a two-page spread and an award from the Art Directors Club. "Once that comes out, you start getting calls," he says. "I go up to Doyle Dane Bernbach," then emerging as the hottest ad shop on Madison Avenue, and got a job to photograph a coat. He booked a top

model, Anne St. Marie ("I was scared of her"), and cadged film from a William Helburn assistant. "He had five sheets of eight-by-ten film," Sokolsky says. "If you're a shooter, you use a thousand sheets a month. When you're down to the last few, you don't want to use them on an important job [because every batch of film was different]. It was junk to him, but to somebody else, it was valuable." St. Marie seemed intrigued by the funky studio and "this kid," says Sokolsky. "She knew how to pose. I knew how to light. Whatever she did made me look good. She was magic inside and knew how to project it. Every gesture was something." The resulting ad ran in *Harper's Bazaar*—and earned him $250.

People noticed. "All of a sudden, Penn's wife shows up," Sokolsky says. "If you want me, I'll pose for you," she said. Says Sokolsky, "I was so young. I had no idea. I was afraid." Nonetheless, he asked Lisa Fonssagrives Penn to pose nude for him—and she did. "I was a kid they could show their wares to who wasn't going to be pushy. It was trusting somebody for no reason," he says, still boggled by the compliment her appearance implied.

Six months later, the phone rang. "Helllllooooo?" said a high, wavery voice with a vaguely Middle European accent. "Is this Melvin Sokolsky? My name is Henry Wolf and I'm the art director at *Harper's Bazaar*." Wolf liked Sokolsky's ad and offered four pages in the magazine and possibly a cover, too. Melvin booked China Machado and Mary Jane Russell. A month later, Wolf called again: "The pictures are stronger than I thought. How would you like to become a permanent fixture here?" Sokolsky met with Diana Vreeland and a young fashion editor, Polly Allen, "and I was off and started," he says. Everyone at the magazine called him "the kid," except Vreeland, who referred to him as "my White Russian," for reasons only she knew.

Jordan Kalfus, then Sokolsky's agent and later his business partner, remembers that fateful meeting differently. He'd represented artists such as Jasper Johns and Robert Rauschenberg and the art director Bob Cato and took Sokolsky on as a client while he was still hanging around the barbell club. "I took him to see Henry Wolf, and in the room was Martin Munkácsi," Kalfus says. "Munkácsi looked at the work and said he thought Melvin was talented, so Wolf gave us an assignment."

They'd unknowingly invaded Richard Avedon's turf. "Avedon was the pinnacle," says Kalfus. "He got the best assignments, the best editors, the

best models. If Melvin wanted a model and Avedon had reserved her, you had to find somebody else. That was needling. We called him Dick Avery," after Fred Astaire's *Funny Face* character.

"You're a kid," Sokolsky says. "You don't understand the politics. You have respect. Melvin from Ridge Street is gonna compare himself to Avedon? You do a bunch of pictures, they're reviewed by the industry and other photographers. Very quickly, I got a rep for being special. Avedon was getting the most beautiful clothes. I got New York collection suits. But people would write in. 'I love them. Who is this Sokolsky?' I got advertising immediately and it kept me alive." It lost him the friendship of Edgar de Evia, however. "I got a Jell-O ad," Sokolsky says. "Two pages in *Life*. But it was Edgar's account. Suddenly Edgar doesn't want to see me anymore."

Sokolsky still had Diana Vreeland. "She was magical," he says, "a very smart lady who pontificated in a manner that was not understandable." She was always "transmitting a thread the editorial staff was expected to weave into a napkin," says Sarah Slavin. "You had to listen, go home, and think a day or so and then figure it out because so much was hyperbole."

To Sokolsky, Vreeland communicated "between the lines." Except when she communicated with a bluntness that shocked Sokolsky. Vreeland assigned Polly Allen to be his editor. A society girl from Hartford, Connecticut, Allen had been poached by Vreeland from *Mademoiselle*. In 1951, Allen had her first job with Avedon. "She was so noisy and I needed to concentrate," he said, so he asked to never work with her again. Vreeland insisted on a second chance—on a shoot with the then-neophyte actress Audrey Hepburn—and warned Allen, who "never said a word" that time, inspiring Avedon to ask, "Are you all right?" and add, "From now on, speak up." From that day forward, they became coconspirators.

Avedon "was just a dynamo," she says, "with definite feelings and opinions, and he surrounded himself with the most interesting people, and things would rub off on him constantly. He went towards the off-ish." She feels that was the key to his art. When he clicked his shutter at a model, "it wouldn't be when she looked most beautiful, but when she was a little off." Later, when editing, she saw what he'd learned from Brodovitch and Snow, "understanding that *this* picture was the outstanding one but didn't work in the series, and you have to work within the story." Allen considered

her position by his side to be "a privilege," but nonetheless left to get married and wouldn't return to fashion for a decade. In 1961, Vreeland "wanted me back," she says. "I wanted to do something else but she said, 'You can't. You were meant to be in fashion.' So I went back to *Harper's Bazaar*." She worked with several photographers, including Sokolsky, but they didn't get along the way she did with Avedon.

One day, Sokolsky was waiting outside Vreeland's office for a meeting when Avedon showed up. Within moments, Vreeland's voice drifted out the door. "Twelve pages of color for Sokolsky," she ordered. "Sokolsky is so much better with color. Give the black-and-white to Avedon." Avedon shot the younger photographer a look he describes as bitter. "I realized, schmuck, this is the big time," Sokolsky says. "There ain't no nice person." He came to understand Avedon "saw me as a force against him."

Sokolsky's situation vis-à-vis Avedon worsened in May 1961 when his sponsor and mentor Henry Wolf abruptly left the *Bazaar* and was replaced by Marvin Israel, a painter, photographer, and art director who'd studied with Brodovitch. Israel was intense, moody, opinionated, alternately encouraging and abusive to the students he taught at the Parsons School of Design, and the photographers he worked with as art director of *Seventeen* in the 1950s. Like Avedon, he was raised in Manhattan, the child of women's-fashion retailers. Like Brodovitch, he became something of a cult leader, gathering talent and attempting to mold it to his vision. To Avedon, he was a godsend. "It was as though we were two brothers who were opposites but of the same cloth," Avedon told Jane Livingston. "Completely linked and always at war . . . We triggered the outlaw in each other. After Brodovitch, I felt that overnight my editorial work slipped. It wasn't until Marvin that I got back on my feet. We were completely united in our goals."

Israel was an avid promoter of many photographers, not just Avedon; Diane Arbus's biographer Patricia Bosworth credits Israel with launching the photographer in magazines. When Israel took over the *Bazaar*, Arbus followed him there, but quickly ran into stiff headwinds from Israel's boss, editor Nancy White. She wasn't the only one who found White narrow, puritanical, and intransigent. "There was no aristocracy of thought there," Avedon said. But generally, he was not only protected but pampered; he'd already been given ever-greater numbers of pages to fill in the magazine,

the entire eighty-six-page editorial well in the September 1960 issue, for ex-ample. "He was a major influence and had more to do with the look of the magazine than anyone including me," Henry Wolf declared. Avedon "did captions and layouts. They would sometimes change it but I learned how to be an editor," Avedon would later say, even claiming that after Snow left "I was running the magazine."

Whether or not that was true, "Dick really wanted to envision and pro-duce his own features, not just photograph them," says *Bazaar* editor Ila Stanger. Israel encouraged him to do more in his fashion pictures and to demand extra pages from Nancy White for his nonfashion work, portraits that were becoming ever more incisive (influenced, no doubt, by a grow-ing friendship with Arbus, who often visited his studio and would sit on the phone with him for hours at night when he was kept awake by insomnia), and reportage that contrasted "upper-class apathy and corrupted sensuality" with the idealism of the political movements Avedon was increasingly drawn to document, beginning with the civil rights movement.

At that moment, with Bert Stern ensconced at *Vogue* and Avedon throwing his weight around at the *Bazaar*, the balance of power shifted within maga-zines. In the fifties, "the power was the editor," said the hairdresser Kenneth Battelle, one of the first stylists to work regularly on fashion photography sets. "I saw the editor weaken and the photographers strengthen. They became the stars, really." That process accelerated in the sixties as street fashion began to dominate magazines that had once focused on haute couture. "You had to have somebody who could take nothing and make it something," Battelle observed.

Avedon's coverage of the fall 1961 Paris collections, an in-depth portrayal of the controlled chaos behind the scenes at the shows, starring the models China Machado and Margot McKendry, presaged his move into a new kind of photography—which appeared in both his fashion work and his portraits—photos taken against a pure white seamless paper backdrop or a cyclorama wall that seemed to go on into infinity and removed his subjects from any context whatsoever other than the photographer's gaze. That experiment would overtake Avedon's oeuvre, especially after he began encouraging his subjects to leap about his set, a fascination with movement inspired, the writer Carol Squiers suggests, by portraits he shot that year of the ballet dancer Ru-dolf Nureyev, who'd just defected from the Soviet Union to the West.

At age thirty-eight, Avedon was at the peak of his power as a fashion photographer when a new assistant, Alen MacWeeney, arrived in Paris to assist him at those collections. The work seemed endless. After shooting all day, MacWeeney often processed film until 3:00 a.m., so he could review contact sheets with Avedon the next morning at nine. "Everything was as soon as possible. Sooner in most cases. Three assignments a day, seven days a week. I didn't know this wasn't normal."

MacWeeney found his new boss endlessly fascinating and, despite his prominence, socially insecure: "He was jealous of Cecil Beaton and John Rawlings for their social connections. Dick would mention Rawlings's alligator shoes and handmade suits. It buoyed him up to be friends with people like Leonard Bernstein," a frequent subject. "It was a social ambition." But sometimes, Avedon also seemed to suffer from "delusions of grandeur." He'd fly home from Europe with half his film and send an assistant on a separate plane with the rest. "To think your work is that important when that magazine will wrap fries in a month?" MacWeeney asks. "To go to the trouble of having two planes bring your bloody film across the ocean" struck him as "the height of egocentricity." Years later, MacWeeney would conclude that whereas Irving Penn was "deeply involved with photography," Avedon was "deeply involved with his fame. I think he lived through his photographs."

Yet Avedon also impressed him—and clients—with his commanding presence, dancing around the studio to the show tunes he played, "always snapping his fingers like showbiz, and it *was* show business," says MacWeeney. "Nobody else did enthusiasm and movement in fashion with such enjoyment. It was pure theater and it was all his. No one else could do it."

Chapter 14

"THE GESTURES OF THE TIME"

In spring 1961, Richard Avedon photographed a beautiful Italian-American heiress, Countess Christina Paolozzi, topless, but the photograph was pulled from the fall issue of the *Bazaar* in which it was initially scheduled to appear. Broadway columnist Earl Wilson reported that the countess's mother had objected—but the photo did run a few months later, in January 1962, creating the expected scandal. The easily shocked Nancy White "evidently felt the need to justify the publication of this photograph by situating it within the history of art," Carol Squiers wrote years later, noting a caption that compared it to nudes by Praxiteles and Matisse, and the poem that ran on the facing page. Both presumably inoculated the magazine with a dose of high culture.

Nancy White also objected to the paparazzi story Avedon shot the next year, but was again overruled. "Dick Avedon often felt like tearing out his hair after an editorial meeting with Nancy," *Bazaar* editor Ila Stanger told Patricia Bosworth. He grew discouraged. Melvin Sokolsky felt much the same, but White was only one of his problems.

Though he worked in relative isolation compared to Schatzberg and the Terribles, Sokolsky felt himself part of the same image revolution and was acutely aware that the roost at the *Bazaar* was ruled by Avedon, who was then still comparatively old-school, taking pictures of women in couture poses, while Sokolsky favored girls with legs akimbo. "I was doing the gestures of the time," he says. He considered his photos commentaries on class.

When he pushed those ideas, Nancy White balked, and felt free to object even more loudly after Vreeland departed for *Vogue* in March 1962. Sokolsky vividly recalls White's reaction to a shoot with a six-months-pregnant China

Machado, whom he photographed seemingly floating off the floor; she was perched on a bicycle seat cleverly inserted through the no-seam paper behind her to create the weightless illusion.

"They told me how it was done," White announced. "I keep seeing the seat," even though no one else could. Her objection? "A pregnant woman shouldn't be touched by a bicycle seat in that way," Sokolsky recalls. The photos were rejected. "Henry Wolf allowed me to be personal; he and Israel were overjoyed when I came up with something. Then people tried to impose themselves. I saw the freedom being taken away by retards, by monkeys."

Ironically, Polly Allen, the stylist he didn't get along with, agreed with Sokolsky. Working with White and her then fashion editor, Gwen Randolph, "was a joke," Allen says. "You were dealing with another level of taste, another level of quality, and a very strong business sense was coming into the picture. Before, we were protected from advertising and salesmen." But that was no longer true. She recalls being required to shoot "a disgusting dress and I turned it inside out," which Vreeland would have applauded, "and I was told, 'We don't do things like that.' Another thing that was thwarting was Nancy White's vision of women and her strict Catholicism and you didn't do certain things." White once killed a photograph of Suzy Parker simply because she'd slipped her hand into the pocket of the raincoat she was modeling. White worried that Parker was touching herself. White was that oppressively, if imaginatively, puritanical.

White would shortly replace Gwen Randolph as fashion editor with Machado—and she would become Richard Avedon's primary collaborator—but they couldn't stem the tide. A changing of the guard was in motion—and the balance of power between *Harper's Bazaar* and *Vogue* shifted even further toward the more commercially oriented Condé Nast title. Marvin Israel wouldn't last much longer at the *Bazaar*.

The January 1963 cover featured an Avedon photograph of a strong-jawed model named Danielle Weil wearing a snoodlike red, white, and blue scarf. She had a cigarette holder protruding at a jaunty angle from her mouth and held her arm in an affected manner that Avedon later described as "a typical Vreeland pose." Weil, like Vreeland, was *jolie laide,* a woman of untraditional appearance who was nonetheless striking. But it's commonly

thought among *Bazaar*is of the era that Nancy White decided the model resembled (or perhaps, as one gossip column reportedly alleged, *was*) a transvestite. It was likely bad enough that a clear tribute had been paid to the departed Vreeland. Israel was fired. "Dick should've gotten the heat—not Marvin," says Melvin Sokolsky. "Marvin didn't have ideas. Dick was always full of ideas." Avedon remained under contract.

A pair of twentysomething assistants in Israel's art department, Ruth Ansel and Bea Feitler, were promoted to replace him. Israel and Avedon "hated Nancy [White]," Ansel says. "They were naughty boys and she wasn't Vreeland or Carmel Snow, so they played tricks on her." As far as Ansel knew, they'd plotted the January 1963 cover to look like Vreeland "to stick it to Nancy." But Israel also defended White, who would "say novenas when she had to decide whether to run a nude picture," says Ansel, "and then ran the pictures. She was completely schizoid. But Marvin said we should be grateful we had an editor who allowed us to do things even though she was totally conflicted."

Melvin Sokolsky wasn't sorry to see Israel go. "An unattractive man who didn't like himself and saw himself as an artist, but didn't make it," the photographer says. "He aligned himself with Avedon. I was secondary. He was extremely political and he knew the Sokolsky camp ain't taking him where Avedon would." Yet one of Israel's last acts as art director was handing Sokolsky the plum job of shooting the Paris collections for the first time in 1963.

It was a huge break, and while considering how to make the most of it, Sokolsky harkened back to a fever dream he'd had when he was nine years old. On his sickbed, he'd imagined soaring above the earth in a transparent bubble like the one in Hieronymus Bosch's triptych masterpiece, *The Garden of Earthly Delights*. Almost two decades later, he decided to photograph a French model, Simone d'Aillencourt, in a clear plastic sphere floating over the streets and sights of Paris, "hanging out over the friggin' Seine in the dead of winter," as Jordan Kalfus puts it.

A skeptical Richard Avedon pronounced, "It will never fly." It did. Shooting over the Pont Alexandre III, the most elaborate bridge across the river, on their frigid last night of shooting, d'Aillencourt recalled, "It was so cold the camera stopped working" and was heated up with a hair dryer. "I was

in another world," she continued, "and I'm not talking about the bubble it-self—I was transported by something else, in another dimension where cold couldn't touch me."

The crane that lofted the contraption at each location was carefully re-touched out of the final images. The arrest of Sokolsky and crew by French police that night on the Pont Alexandre III (the one time their well-con-nected French fixer failed to show up) was never mentioned; when one of Sokolsky's assistants saw the police closing in, the former Avedon assistant Frank Finocchio grabbed the two rolls Sokolsky had already shot, pulled a third out of the back of the camera, and whispered to the photographer, "Put these in your pocket, get in that taxi, and go to the hotel." Every-one else spent the night in a police station. The photos ran in the March *Bazaar*. Ansel and Feitler first appeared as co–art directors of the *Bazaar* two months later on the May 1963 issue's masthead.

Sokolsky's star was burning bright. "We started to get press," Kalfus re-calls. "We were the young Turks. Our studio had a burnt-out upper story, and Melvin used it as a set. It was startling, with peeling walls and beautiful feathery dresses on gorgeous ladies. It was the antithesis of glamour." So was Sokolsky, the weight lifter in work shirts and jeans. "Melvin brought to it the way a man feels about a woman, flesh and blood, sexual and sensual. He was not a model chaser, but he was a man. It worked. It was a breakthrough. We were quite the talk of the town."

Avedon, unhappy working for Nancy White, likely upset that Israel was gone, and seeing a new generation rising in his wake and adding sex to what had been a sexless equation, appears to have taken some time off at that very moment to work on his first one-man museum exhibit, at the Smithsonian Institution (it ran for six weeks at the end of 1962), and then to take a series of trips (including his visit to the East Louisiana State Hospital, a mental in-stitution, in February 1963) to shoot pictures for his second book of photo-graphs, the highly political *Nothing Personal*.

Though they'd crossed paths before, Sokolsky and Avedon's first conver-sation took place on the latter's return. Avedon appeared in the *Bazaar*'s art department, where Sokolsky was working with Feitler and Ansel. "He came flitting in and said, 'Bea, Ruth, you've got to see my new book.' He didn't realize there was another character in the room—me. I'd done a couple cov-

ers, I was getting a shot, but this was the master." Avedon showed the trio his layouts. "I was stuffed with nice things to say," says Sokolsky. But Avedon hardly gave him a chance.

"Did you think, all these months, I was sitting back doing nothing and letting you do all the covers?" Avedon snapped at him. Sokolsky was taken aback. "I didn't know you owned this magazine," Sokolsky claims he said, as he realized that "Dick thought he micromanaged my career at *Harper's Bazaar* without my knowing." Sokolsky was appalled. "He was one of the great contributors to fashion, but he had no space for anybody but himself. If anyone else took a picture, he couldn't give it credit."

Despite Avedon's apparent animus, Sokolsky continued to make his mark on the *Bazaar*. Though he'd started out working with established models, one of his greatest skills turned out to be discovering new ones. "I picked models people thought were odd," Sokolsky says. "They were way more than props. I drew from who they were. Everyone came from a house where they gestured and ate a certain way. It was as if I lived with them, ate with them, slept with them. I understood who they were. They were willing to give because you understood. I never said, 'Do this' or 'Do that.' I would maybe move my shoulder. I had no comprehension of what I was doing. It wasn't planned. It was pure instinct."

Around the same time he first met Avedon, Sokolsky booked Donna Mitchell among a half dozen models in a group posing for a fiber ad. "I put a 150 mm lens on and started to pan, watching this incredible Madonna face with inner intelligence, clocking everything around her, and I said to myself, 'If I'm really smart, I'll take her to the collections.'"

Mitchell was sixteen at the time, and though she was wearing a tatty raccoon coat closed with a safety pin, he sent her to an editor at the *Bazaar*. "She said, 'Get out of here, you're putting me on. She's so poor.' 'We'll put rich clothes on her. She has a great face.'" Sokolsky tested her. "Behind my back, they sent her to Dick, who didn't think much of her. But Donna could turn the gestures of the street into the highest form of elegance. She had knowledge of the world in that little face." In 1965, she went with Sokolsky and another favorite, Dorothea McGowan, to Paris to shoot the collections. McGowan, a *Vogue* model, was given dispensation to shoot for the *Bazaar* only because of Vreeland's affection for her White Russian. That time,

Sokolsky dispensed with the bubble and simply showed his models flying through rooms such as the elegant Café de Paris restaurant.

Donna Mitchell thought of herself as a break from the mannered models of the Avedon/Penn era. Though most models still carried suitcases full of makeup, hairpieces, and accessories with them whenever they went on shoots, she refused. "Hairpieces were grotesque," she remembers. "Underwear, I didn't wear. Carting this all around? I'd rather stay in bed. Bailey, Duffy, and Donovan allowed someone like me to exist at that moment. I was incredibly lazy, but I loved to work. I really was the transition. The first model with straight hair and funny makeup. I remember my first sitting with Melvin. Nancy White came and said, 'Our own Eliza Doolittle.' It rankled me a bit."

Mitchell and Sokolsky were both enamored of shoots that had big ideas behind them. "I liked to develop ideas as opposed to being someone who jobbed in," Mitchell says. "I looked at old magazines. I knew who Horst and Munkácsi were. I met Antonio Lopez [a fashion illustrator] and [his partner] Juan Ramos when I was sixteen and they educated me. We'd spend days talking about photographs and what made them good. I learned as I went along. I had to project something. Take what they wanted, filter it through my sensibility, and give it back."

She was eighteen by the time Sokolsky took her to Paris. But despite his pride in discovering her, it's McGowan in all his flying pictures. "I wouldn't do it," Mitchell reveals, "I'm afraid of heights. I can feel it now, my stomach went to my feet, I started to sweat, I lost my breath. I *was* in some of those pictures—but in the backgrounds."

McGowan, on the other hand, was totally game to fly in a custom-made harness. "I would start dancing in the air and creating shapes that were beautiful shapes that would stand in the six-by-six format Melvin was using, just doing my thing," she recalled. "There is no such thing as impossible for Melvin when he has an idea."

Back in New York, Mitchell would shortly start working with Richard Avedon and China Machado. Avedon couldn't have helped but notice that the fashion in fashion photography had taken a startling turn. "He realized fashion as we knew it was over; all of a sudden, Dick didn't want to do the

usual fashion pictures," says Sokolsky, whom Bruce Jay Friedman, writing in *Esquire*, would shortly declare "the new Avedon."

Having already pioneered by forcing the multiracial China Machado into magazines, Avedon began actively looking for more models of color. And he began shooting different sorts of pictures. Suddenly Avedons began to resemble what the Terribles were doing in England and what Sokolsky and other younger photographers such as Bob Richardson had begun to do in the United States—attempting to portray real women with real emotions. "Dick spoke of Richardson with great envy," says Ruth Ansel. "He was obsessed with what Bob was doing, opening a door to women's psyches that was part of the sixties. He wasn't doing that until he saw Bob's pictures. They scared him." He even asked to work with Deborah Turbeville, Richardson's *Bazaar* editor, telling her, "You and Bob are doing the most interesting stuff out there."

In 1964, Avedon shot two identical Spanish twins, Naty and Ana-Maria Abascal, with a handsome Brazilian diplomat, in a series of improvised yet sexually charged situations on the Spanish island of Ibiza. The story was designed "to celebrate the cynicism, narcissism and boredom of the people who are adored by fashion magazines," he said. The implied ménage à trois ("Everyone read something different into the pictures," Avedon said soon afterward. "Most of what they read, I intended to be there") made it explicit that twenty years after he'd started taking pictures, the old Avedon was renewing himself and was still on the cutting edge of culture, perfectly aware that manners and mores were changing as fast as fashion always had. He had no intention of being left behind.

Chapter 15

"A TABLEAU OF . . . US"

Jerry Schatzberg didn't last at *Vogue*. Otto Storch, another Brodovitch-trained art director, had revamped a women's magazine called *McCall's* and asked Schatzberg to work there. "I talked to Alex Liberman," Schatzberg says. "I'm not your psychiatrist," he remembers Liberman saying. "If you want space, it's there, but you have to be exclusive." Schatzberg considered Liberman "the old sophisticate" and Brodovitch "a bohemian" and "a drunk." Like his British friends, he was less than enamored with authority. "So I had to quit *Vogue*," he says, admitting that later he regretted it. He still worked for *Glamour*, though, and in 1962 it sent him to Paris to shoot the collections and allowed him to shoot a separate behind-the-scenes feature for *Esquire* on Yves Saint Laurent's debut as a couturier.

"Bailey and Duffy and Donovan were all there," says Schatzberg, and they all went to a party at Régine's, a nightclub, together. Though Schatzberg thought Bailey a bit territorial about Shrimpton—"He wanted to possess this thing and not let anyone else photograph her or have her"—the four photographers ended up close friends. They didn't play by the old rules and they all loved to play.

"I'd go to England and stay with Donovan, and Donovan and Bailey would stay with me in New York," Schatzberg says. "I went to London to photograph the Beatles and I was absolutely astounded; all these men with long hair in the airport. As a fashion photographer, I knew that was a change and I was riveted. I went to London eleven times that year, let my hair grow, people called me a faggot."

Later, Bailey would tell Schatzberg about a new band, the Rolling Stones. "I was having breakfast in a friend's yard and Mick Jagger came," Schatzberg remembers. Jagger was dating Jean Shrimpton's sister Chrissie. "He didn't

look particularly clean; he had long nails and drowsy eyes and I very na-
ively asked him silly questions." The Stones were playing that night an
hour's drive out of London, and despite Schatzberg's interrogation, Jagger
arranged tickets for him and the Terribles, and they all piled into cars and
went together. When their caravan hit the venue, "hundreds of screaming
kids" rushed the car. Jagger dashed for a door and was grabbed, his sweater
torn. "I couldn't believe what I was seeing," says Schatzberg. The other acts
were all in stage clothes and he expected the Stones to follow suit. "But he
came out in his ripped sweater and they were sensational."

One day in the snow on Schatzberg's New York roof, Bailey posed in the
nude while Donovan, "dressed to the nines," waved a little British flag. They
were young and having fun, just like Bert Stern. And the Terribles' fame
rubbed off on Schatzberg. In October 1964, the Stones came to America for
their second tour, and Schatzberg and a former *Vogue* editor named Nicky
Haslam, then working at *Show* with Henry Wolf, hosted a party for the band
in Schatzberg's studio or, rather, merged it with one for Andy Warhol aco-
lyte Baby Jane Holzer's twenty-fourth birthday. The theme was Mods and
Rockers, named for two competing British style cults, the décor S&M, com-
plete with leather boys, and an all-girl band dressed in gold lamé played
until 5:00 a.m.

Tom Wolfe covered the affair for the *New York Herald Tribune*'s Sunday
supplement, *New York*, edited by Pamela Tiffin's then-husband, Clay Felker.
"Schatzberg says the photographers are the modern-day equivalents of the
Impressionists in Paris around 1910," Wolfe wrote, "the men with a sense of
New Art, the excitement of the salon, the excitement of the artistic style of
life." He found them isolated from the rest of the party in the inner sanctum
of "Schatzberg's . . . pad . . . his lavish apartment" above the studio, where the
cook brought a cake and Baby Jane blew out candles. "This is like the Upper
Room or something," Wolfe continued. "Downstairs, they're all coming in
for the party, all those people one sees at parties, everybody who goes to
parties in New York, but up here it is like a tableau, like a tableau of . . . Us."
Meaning Jean or "Shrimp," as Wolfe called her, "with her glorious pout and
her textured white stockings" and Schatzberg "with his hair flowing back in
curls." Bailey was "off in Egypt or something," but was a presence anyway;
Holzer was talking about him and the summer of 1963. "Bailey created four

girls that summer," she told Wolfe. "He created Jean Shrimpton, he created me, he created Angela Howard and Susan Murray. There's no photographer like that in America. Avedon hasn't done that for a girl, Penn hasn't."

Wolfe got it. "It's not so much what people *do*, that's such an old idea, what people *do*," he wrote. "It's what they *are*, it's a revolution."

Except when it's a soap opera. Bailey's wife filed for divorce in 1963, blaming Shrimpton. Shrimpton, at twenty-one, started wondering if her association with Bailey wasn't limiting her. Perhaps aware she was growing restless, or restless himself, Bailey encouraged her to work with other photographers and says he talked *Vogue* into letting Cecil Beaton shoot her. When Shrimpton and Bailey did still shoot together, their on-set fights could be epic. "She would be in hysterics," said hairdresser Kenneth Battelle. But they'd get the job done. "They would pull their acts together finally."

Early in 1964, Shrimpton met the actor Terence Stamp, whom she'd recently posed with for Bailey, at a wedding she attended with Bailey, and felt an instant attraction. That spring, she came to New York alone, seeking work with other photographers. Her ambition was to pose for Avedon, whom she considered "the greatest fashion photographer in the world." Sensing something was awry, Bailey called her daily, then followed, as planned, two weeks later to join her. When he landed, Shrimpton was too busy to see him, shooting with Mel Sokolsky.

She found herself attracted to both Sokolsky and his business partner, Jordan Kalfus, who was then involved with Sokolsky's stylist and girl Friday, Ali MacGraw, who would go on to become a model herself and then a movie star. Then Terence Stamp arrived in New York. Once he left, Shrimpton broke up with Bailey, and before long she started sleeping with Stamp—or at least in the version of the story she told in her autobiography.

Making matters even more complicated, William Helburn claims that he, too, was sleeping with Shrimpton. He'd just been dumped by his mistress, actress Elsa Martinelli, met and proposed to the model who would become his second wife, the same Angela Howard who'd just been "made" by Bailey, and was finalizing his divorce from his first wife, another model, when Shrimpton appeared in his studio, he says, and he promptly fell in love.

"I'm crying over Elsa, getting divorced, getting married, and cheating with Jean Shrimpton," says Helburn. "It's a potpourri. I picked up Angela at Mel's studio one time, and Jean was there. What a crazy life!" A magazine writer was there and watched him pull Shrimpton onto his lap and kiss her neck over and over.

"He embarrasses me," Shrimpton protested. "Get him to stop."

Helburn says he knew Jean had the hots for Jordan Kalfus. "She calls Bailey and says, 'David, I want to break up.'" Helburn also claims he set in motion the affair with Stamp that followed. Appropriately, this game of romantic musical chairs began when an Italian film producer decided to make a movie about a randy, model-chasing fashion photographer.

The 1966 film *Blow-Up*, starring David Hemmings as Thomas, a Terrible-type photographer, gestated for quite some time. "It was [producer] Carlo Ponti's idea before [its director, Michelangelo] Antonioni got involved to make a London photographer film," Bailey says. "These two Italians came to see me in their suits at *Vogue* and started talking to me, saying we're interested in you making a film. I thought they wanted me to direct. Then one of them said to me, 'What about the way you dress?' 'What's that got to do with anything?' 'Well, if you're going to play the part.' I said, 'Hang on.' I'd started doing commercials then. 'I'm dyslexic. I can't remember your names let alone a fuckin' phone number.'"

Bailey was thinking of directing a movie of his own called *The Assassination of Mick Jagger*, to be financed in part by his friend the Polish filmmaker Roman Polanski, so he passed. *Blow-Up*'s subsequent success—and the general perception that he inspired it—may explain why Bailey calls the movie *Blow-Job*. Helburn says Ponti then approached Terence Stamp about playing Thomas. While Shrimpton was in New York, Stamp went to Helburn's studio; the producers had told Stamp he ought to see what a hot photographer's life was like. Really, the movie wasn't based only on Bailey or the Terribles, as has been said, but on the whole generation on both sides of the Atlantic who'd given the profession a new image.

The day Stamp went to visit Helburn, he was shooting Shrimpton in a "crazy sweater for *McCall's*," Helburn says, "and Terry wants to be in a picture, so he gets into a sweater and poses, and that was the end of Jean and me." Helburn adds, "Bailey hired Angela and fucked Angela at the collec-

tions—I'm not married to her yet—and he says, 'Tell that to Bill.' I'm going with his girl. He lays my girl. Shrimpton meets Terry." Shrimpton wouldn't last long with Stamp, but another relationship she forged in New York, with Avedon, would last longer and be more fruitful.

When Stamp returned to New York in the fall of 1964 to appear on Broadway, Shrimpton went with him and finally got her chance to work with Avedon. A month after his story with the Abascal twins in Ibiza, Avedon shot Shrimpton with actor Steve McQueen for the February 1965 issue of *Harper's Bazaar*. Avedon and Shrimpton's collaboration would last through her retirement at the end of the sixties and thrive even after Avedon began shooting a later girlfriend of David Bailey's, a saucer-eyed society girl named Penelope Tree. Tree would be followed by Anjelica Huston, from the movie clan. She'd already modeled for Bailey (in a professional collaboration that would continue for years) and would shortly be the girlfriend of Bob Richardson, another of the new generation of shooters. Avedon was more than willing to follow the lead of younger photographers, at least when it came to the models of the moment. Thanks to their sex drive, they served as pointer dogs for the older photographer, who once declared, "You can't fuck and photograph at the same time."

That didn't stop models from falling in love with him. "He was always moving, dancing," says Iris Bianchi, who would go on to style for him after the end of her posing career. "He was the most vivacious, energetic soul," says Susan Forristal, who arrived in New York at the end of the decade. "You knew it was a big deal—and for him, too. He created an atmosphere that said what you were working on was special, unique. And once you worked for Dick, you were a top girl. The other models looked at you differently. I had a crush on him. I was in awe of him. I had dreams about him."

Even straight male models fell for Avedon's charms. "My all-time favorite," says Tony Spinelli. "The type of guy who's interested in you and your personality. That was his way of knowing what you were capable of and getting more out of you."

Shrimpton already knew that Avedon was ruthless. "All photographers have their quirks," she would recall years later. "All the models who worked for him knew perfectly well he would give them a different body if their own was not up to his exacting standards. I have seen my head on someone else's

body—he had doctored a photograph of me he took for Revlon. . . . He had photographed me with a teddy bear, but when I saw the advertisement, the hands holding the teddy were not mine. They were much better hands, with longer nails. It did not worry me. It was still a privilege working for him."

———— ∞∞∞ ————

But *Funny Face* was a distant memory. This was the *Blow-Up* era. Claimants to the title of its inspiration were many, although Avedon wasn't among them. Bert Stern, too, was convinced it was partly about him, and he had a photograph to prove it. He'd met Bailey and Shrimpton at Alex Liberman's house on one of their first trips to America. Two years before the film was made, he shot Bailey lying on his back pointing a camera up at the great six-foot-one-inch-tall German-born model Veruschka, standing between his legs in a sleeveless pillar gown, looking for all the world as if she might kick him in the balls. "It was me," Stern said of that photo. "It was the image of photographers in the sixties." Bailey confirms it; Stern was in the driver's seat that day: "It was Bert's idea. He said, 'Get on the floor.' That's how we became friends."

In *Blow-Up*, a scene based on that picture features the actor David Hemmings kneeling over Veruschka, straddling her as he snaps away, just as Bert Stern loved to do. In 1960, Stern claimed, he'd chased director Antonioni out of his studio while he photographed the star of his earlier film *L'Avventura*. "I wanted to be alone with Monica Vitti," Stern said. He was willing to share the status of inspiration for the lead character in *Blow-Up*: "Somehow, I felt Antonioni blended David and me into one character. The sexual encounters were familiar."

Chapter 16

"MAGAZINED"

After the scathing critical reaction to Richard Avedon's *Nothing Personal*, the book ended up in bargain bins and "he had a nervous breakdown," says Alex Chatelain, then his assistant. "He locked himself in a room for six months." Simultaneously, Avedon's second ten-year contract with Hearst was ending, and as much to reassert himself as to celebrate that milestone, he accepted an appointment as guest editor of the *Bazaar*'s April 1965 issue, photographing the entire thing, making it a celebration of the new pop society. "It was a distillation of everything going on in the sixties," says *Bazaar* editor Ila Stanger. The cover featured Shrimpton with a blinking lenticular eye—a patch was pasted to each issue. The imagery within ranged over the space race, comic books, socialites, artists, Bob Dylan, and the requisite high fashion, some of it shot on China Machado, some on Avedon's latest model discovery, Donyale Luna, an angular, elegant African-American from Detroit whom the photographer had reportedly signed to an exclusive one-year contract after a sketch of her appeared on *Bazaar*'s cover that January. (In March 1966, she would become the first black model to appear on the cover of an issue of *Vogue*, shot by David Bailey for the British edition.) Today, Avedon's issue is a collector's item, but at the time, like *Nothing Personal*, it sold badly and was condemned. Avedon couldn't catch a break.

"Advertisers objected," Earl Steinbicker remembers. "They said there was too much photography and not enough clothes. This was not to the taste of Nancy White." Hearst management made its displeasure known. Hearst "was so conservative, they couldn't bear anything out of the ordinary," says Ila Stanger. "They wouldn't let him get away with anything outrageous after April." Avedon's mood went from bad to worse in August, when he went to Paris to photograph the collections in a brand-new *Harper's Bazaar* studio.

"The pictures were rather conservative," says Steinbicker. "They just didn't have the magic." Steinbicker collapsed, was confined to bed, and "decided the time had come" to stop assisting and set out on his own. Avedon referred penurious potential clients to him—"jobs where they couldn't afford Avedon," Steinbicker says.

That fall, Avedon's contract had run out. "I was negotiating after twenty years to have some sort of health insurance, benefits, and a better financial relationship," he recalled. "I was just fed up." A Hearst executive who never went to studios "came to the studio with a contract" and offered a deal that was "a little better than before but not much," said Avedon, and in exchange for a raise from $75 to $125 per page wanted the right to use photographs in British *Bazaar* for free. "I thought I'd blow up," Avedon remembered. "I didn't want to [sign] but I stuck my hand out and said okay. If he'd said one more word I would have lost my temper."

Vreeland knew Avedon's deal was expiring ("Talk about your grapevine," he said, laughing) and called that very night, begging him to talk to Condé Nast before re-signing. A few days later, on a Saturday, he met with Alex Liberman, who'd left seven phone messages for him at his home in the interim. Pat Patcévitch and Newhouse had already approved a record-setting $1 million deal. "It was terribly rough for me," Avedon said. "I was going to a strange place with Diana, the most eccentric of the three" *Bazaar* editors he'd considered his adopted family.

Even with Avedon aboard, Vreeland didn't have it easy at *Vogue*. "Nancy White rose to the occasion," says a former Hearst editor. Hiro, Bill King, and Bill Silano were still taking interesting photographs at the *Bazaar*. But under Vreeland, *Vogue* rose inexorably and "took first place," Liberman later said. "To my regret, Hearst mysteriously let the *Bazaar* deteriorate."

Liberman was experienced at controlling photographers—and would only get better at it. He would soon ban both Norman Parkinson and Francesco Scavullo from *Vogue*'s pages, the latter after he impudently tore up a *Vogue* layout of his pictures and returned them to Liberman in a garbage bag. But the news of Avedon's hiring caused a permanent rift between Liberman and Irving Penn. On the surface, nothing changed. "The big star of *Vogue* was always Penn," says Sarah Slavin. "Penn was the abiding genius of *Vogue*. Dick was second or third. Dick was more a hired gun."

Years later, it would emerge that Penn considered Avedon was a gun aimed straight at him. "Penn felt as though he'd been kicked in the gut," wrote Liberman's biographers. Though Penn's guarantee was raised to two hundred pages a year (double Bert Stern's), he later called Avedon's arrival a turning point, the moment he began putting his personal work above his job at Condé Nast. Penn likely also worried, and quite correctly so, that Vreeland would prefer Avedon's theatrical approach to fashion photography. So Penn turned his attention to printing; by 1968, he'd hired a new assistant, Keith Trumbo, who was expert at making subtly beautiful platinum prints, the printing technique favored by photography's earliest masters. Known for their tonal qualities and permanence, platinum prints were a key to Penn's move from fashion to art photography.

Penn's experiments in printing were far more satisfying than sessions shooting girls in clothes, which continued, but had become routine. "How many dresses can you shoot?" asks Slavin. "He was possibly out of sync with the crazy stuff called fashion in the sixties. I can't imagine he liked a lot of that crap."

Models would be readied by Babs Simpson or Polly Allen, who were rarely allowed on the set. "They would present them to Mr. Penn," says Trumbo, "and he'd look and chew," and once he was satisfied, "we'd march downstairs," where Penn sat on a tripod stool while an assistant manned a spotlight, because, like the myopic Avedon, Penn "never trusted his eyesight."

Trumbo continues, "Everyone was always respectful. The models were never jumping around. He'd never get that excited. He'd seen so many dresses, but once he was there, he'd get into it." Except when he didn't. "He could fidget," says Slavin. "He could walk in and look at a girl you thought was ready and say, 'No,' and you had to start over." Penn would even walk out of a sitting if he didn't like the girl, several editors say. "You needed to know your job to work with Penn," Slavin continues. "Dick had more tricks. Penn didn't use them. He could be intimidating. Dick made an effort to be friendly. Penn made an effort to be polite. Dick would look at passing air and pull something out of it he thought enticing and photograph it. Penn left a lot out because it didn't have the timeless validity he was always looking for. Dick was trying to catch a moment and time that was passing faster and faster. I don't think Penn cared."

Vreeland's chief assistant, Grace Mirabella, had a harsher opinion of the differences between *Vogue*'s two stars. She found dealing with Avedon's ego distasteful, "a constant hassle," and hated that Avedon wouldn't show *Vogue* his entire sittings, "only the two or three pictures that *he* thought should run. . . . Avedon was just a royal pain. . . . For Dick, a sheerly beautiful picture of a girl was too banal. His pictures had to be arch, fresh, blatantly sexual," even if that meant they were "ugly and distasteful." And she resented that it was her job to tell him so. "Irving Penn, on the other hand, was a dream . . . a seeker of truths," uninterested in razzle-dazzle, though he, too, could be a pain when his perfectionism kicked in and he refused to click his shutter. Yet she found that more palatable than Avedon's divalike protests "that his pictures couldn't face Penn's" or "that Penn was trampling on his turf." One diva was enough for Vreeland's number two.

Trumbo says Penn worked seven days a week and estimates that half his time was spent shooting for *Vogue*, a fifth on advertising, and the rest on making art prints. "His heart was absolutely in the platinum printing," Trumbo says. "Nothing could compete."

Driven though he was, Penn also had a sense of humor—and at least once Vreeland was the butt of the joke. Penn loosened up when he was shooting collections on location. Lisa Fonssagrives, his wife, would often accompany him, and out of his element, "he'd get a little more excited, he'd feel a bit looser," Trumbo says. "You're working late at night, it's a bit exhausting, but it shifted his centeredness so he was more willing to play." Though shoots themselves were still deadly serious and succinct, off the set he'd laugh and joke and talk about art, music, and life.

One year, in Paris, Penn had a gallstone attack, was sent to the American Hospital, and decided to have surgery in Lisa's native Sweden. David Bailey was recruited to step in at the last minute and complete the shoot, using Penn's team. "Diana Vreeland had stopped visiting studios," says Trumbo, "but she came to thank Bailey." Trumbo was taking light readings and, just as she walked in, accidentally plugged American lights into a 220-volt outlet. "Everything explodes," Trumbo recalls, "and Vreeland immediately thought it was her greeting. I told Penn what happened and he just about split his sides laughing."

Like Liberman, Vreeland felt photographers were neither artists nor wor-

thy of the same esteem she reserved for fashion designers, yet she, too, was capable of flattering, cajoling, and manipulating. After Avedon shot Nureyev the next year, she dashed off a note to Dick: "These are the best pictures you have ever taken in your life and that's saying a hell of a lot." Just six weeks later, she criticized a cover photo he'd taken of Jean Shrimpton, clearly softening him up to reshoot it, telling him the model's hairpiece was "terrible . . . poverty-stricken and horrible. Lets watch this like mad [*sic*]."

So photographers were more likely to hate Liberman, whose power at Condé Nast was unprecedented and, mostly, unquestioned. Peter Beard, an heir to American tobacco and railroad fortunes, shot for *Vogue* for a few years in the early sixties, until he realized he hated the milieu. "Magazines have ruined people," he says. Richard Avedon was "wrecked, magazined. *Vogue* destroyed him. I was there and I saw it happen. *Vogue* had all the money and all the boredom and one of the most manipulative and mediocre parasites of all time in Liberman. They had a very, very confused social-climbing collection of people and no art director and café society and the horrible elements of New York who were ruining the creative process. The commercial things took precedence. *Vogue* bought Avedon for money and they fucked him and ruined him and he became a total phony."

Avedon had, in fact, seen the writing on the wall at his very first lunch with Liberman. He asked the art director "what particular qualities in his editorial work they wanted to emphasize at *Vogue*," wrote Liberman's stepdaughter, Francine du Plessix Gray, who became a close friend of the photographer's. "Alex said, 'Dear friend, your Du Pont ads. You and Jean Shrimpton. There is no one who can make a woman look as beautiful as you can,'" Avedon told Gray. He was "appalled" by that, she continues. "It was immediately evident to him that *Vogue* would have no interest in" pictures that explored "the underside and artifice of fashion," the very thing that drove him. "His disillusionment deepened when *Vogue* gave him his first major assignment," to photograph in Japan with the newly married Polly [Allen] Mellen and Veruschka, instead of his choice of model, Donyale Luna. Liberman and Vreeland agreed to a compromise; he could take both models. But when he landed in Paris en route to Japan, he was told *Vogue* had canceled Luna after all because the magazine was afraid of losing advertisers. "It was too late for me to cancel the trip," he said. "That's pretty rough pool."

Avedon would ultimately deem Liberman "pretentious." But Vree-land's photographer-management techniques balanced out Liberman's and brought Avedon around; not only was she his last remaining link to his *Bazaar* past, she also liked the sort of thing he'd done in its April 1965 issue and urged him to dive deeper into pop culture. Eventually, he realized that he had to think of *Vogue* as another client, like Revlon or Clairol. "I'm loyal to the company that hires me," he said. "This is business. I'm a company man. You serve their purposes." And thanks to Vreeland, *Vogue* would serve his as well for two more decades.

In November 1966, Vreeland, Avedon, and Cecil Beaton all spotted a young society girl named Penelope Tree at Truman Capote's epochal Black and White Ball at New York's Plaza Hotel. That was the moment she was formally discovered, though she'd been shot by Diane Arbus four years be-fore. Vreeland called the next day, announcing, "We'd loooooove to pho-tograph you," Tree remembered. Avedon shot her immediately. "She's perfect," he said. "Don't touch her." She epitomized the look that fashion insiders would call "*Vogue*-ugly," not pretty, but striking and angular and of the moment all combined and therefore absolutely riveting. *Vogue*-ugly girls such as Tree, Veruschka, Loulou de la Falaise, and Marisa Berenson would be a regular presence in the *jolie laide* Vreeland's *Vogue*. "I could still do my kind of photographs," Avedon realized, thanks to "eccentric women" such as Vreeland and the models she favored.

David Bailey got along with Vreeland, too, and has no bad words to say about Liberman. Bailey's relationships with them lasted far longer than those he had with his many girlfriends through the sixties. The longest may have been with Penelope Tree. In a reversal of the Shrimpton story, he met, shot, and lived with Tree only after Avedon made her a model.

Breaking up with Shrimpton was "the worst," Bailey says. "It was like losin' my cameras. She'd been my muse for about three years. And then I had to work with other girls and I found it really difficult. I liked to stick to the same girl." Shrimpton was followed in his affections by another British model, Sue Murray. "Sue was like an angel," he says. "I forget how I met her. I was just looking for girls. Sue was around for ages. I got married to some-body else, but I still saw Sue."

That somebody else was the actress Catherine Deneuve, whom he met

through his friend Roman Polanski, who'd cast her as the lead in his film *Repulsion*, then convinced her to pose nude for *Playboy* and Bailey. Polanski "kept saying you're going to fall in love with this girl," Bailey recalls. "I said no, she's too short. He said, no, you're made for each other. Roman is very forceful. He kept on and on about this girl, and in the end, we got together." It's been reported that their 1965 marriage only happened because Brian Duffy bet Bailey she'd say no if he asked. "Not really true," Bailey reports. "He said she won't marry you, no fucking way, and I said I bet she would, but that's not why I asked her to marry me. I never thought marriage was anything other than a bit of paper. It was a hangover, a thing people did."

They separated in 1968 and divorced four years later. "She's making films in Normandy and I'm fuckin' shooting in Fiji, and once we were in New York staying in different hotels. One day, she phoned me in Paris, I was shooting French *Vogue*, and she said, 'Bailey.' 'Oy, Catherine, I haven't see you in ages.' 'We got divorced today. It's great, because now we can be lovers.'"

Long before that, early in 1967, Deneuve had seen Avedon's photos of Tree and told Bailey, "'You're going to be with this girl,'" he says. "I hadn't met her then." Then British *Vogue*'s editor, Beatrix Miller, who'd previously run *Queen*, called Bailey. "She said, 'You're photographing this girl; she's high society and I don't want any of your hanky-panky,'" Bailey recalls. "So she set it up in a way 'cause once she said don't go near this girl, it made me interested more."

The following year, Bailey was in New York doing a shoot for American *Vogue* and saw Tree, then eighteen, in a nightclub. "And then she came to London and then I met her in Paris—it must've been '68 because the bombs were going off in Paris the night I seduced her." Just another night in the life of a sixties lensman.

Chapter 17

"I'D BECOME A THING"

Michelangelo Antonioni wasn't alone in finding Bert Stern inspiring. A fashion editor newly arrived at *Vogue* from the *Bazaar* had begged to work with him. Polly Allen had got married again early in 1965 and become Polly Mellen. "When Dick told me he was going to *Vogue*, I said, 'Don't leave me here. Don't forget me,'" Mellen recalls. "The camaraderie of Diana Vreeland and Dick Avedon was very strong. Where else would he go?"

A year later, Mellen followed after Vreeland called and asked, "Is your passport ready?" Mellen was not only being summoned to *Vogue*, but her first trip was planned. Vreeland wanted her to go to Japan with Avedon, Veruschka, and fifteen trunks of clothes for five weeks for "the most expensive shoot *Vogue* ever did," Mellen says. She was three months pregnant—and when she got off the phone, her still-new husband, Henry, asked if she'd told that to Mrs. Vreeland. "No, I didn't," she replied briskly.

"People at *Vogue*, their noses were out of joint and I don't blame them," Polly says. "Ice is all I can tell you. It was really hard for me." She told Vreeland she was worried. "'Who needs friends, Polly?' Vreeland said. 'Just do the right shoots for you. And it's what Dick wants as well.' I remember Mrs. Vreeland saying Dick had asked that I just work with him. I said I was flattered but I also want to work with Bert Stern. Most of all, Bert Stern. I wanted to learn more, see more, extend myself."

She knew Avedon's reputation; he was so possessive that if a model he liked worked with someone else, he would "never work with them again," Polly says. "There were moments I thought he was beyond cruel." But she must also have suspected that Avedon wouldn't be able to throw his weight around *Vogue* the way he had at the *Bazaar*.

"Bert had a very interesting eye," Mellen says. "He was very flip. It fasci-

nated me. His pictures were different." She remembered a *Vogue* shoot he'd done in 1961 with Monique Chevalier, standing on a no-seam in a black, floor-length dress with six naked infants at her feet. "I wasn't at *Vogue* yet," Mellen says. "I wished I'd done that shoot. Fantastic!"

Never mind that it took all day and that actually a dozen babies were grabbing at Chevalier and the clothes, "because you had to have spares," the model says, and they were swapped in and out of the set because "there was always a child crying and there was always a child peeing, so every fifteen minutes the no-seam paper had to be changed."

Stern's was still a cottage business when that photo was taken. What Mellen found when she finally worked with the photographer was quite a bit different. By 1966, he'd undergone a transformation, moved his studio uptown, and was running a multimedia empire.

Toward the end of 1963, Allegra Kent had got pregnant again, and Stern, whose business was doing quite well—he was grossing perhaps $600,000 a year, a tenfold increase in volume in just four years—decided to buy a town house. "Somehow," Kent wrote later, "Bert thought of himself as cementing the strength of the family through property." If he created the appearance of stability, perhaps the reality would follow. Stern bought a brownstone at 243 East Sixty-First Street with a $20,000 down payment and put it in the name of his business, even though Kent had contributed $1,000 more than he had.

Susannah, their second daughter, was born in June 1964. That fall, they moved into the top two floors of the four-story building; below was empty space, and the whole place was curiously underfurnished. Allegra complained that Bert's better stuff—antiques and the paintings he'd begun to collect (he'd own a Picasso, a Cy Twombly, a Tom Wesselmann, a Duchamp)— were in his office. One of the few things the couple still shared was a therapist, even though he'd started out as Bert's and Allegra didn't like him. But she exercised almost no control over her own life. At work, she belonged to George Balanchine. When she got home, she handed her paychecks to Bert, who did whatever he pleased—with the money and in general.

Meantime, Stern was getting grand and was still getting around. One night in Paris, model Linda Morand was taken to dinner at Castel, a restaurant nightclub, by her agents, Eileen and Jerry Ford, to introduce her to Stern, who'd booked her for a *Vogue* shoot the next day. "I'm this naïve little

thing," Morand says. "Eileen said, 'Dance with Bert.' This ancient old man? He looked like a truck driver. I was into handsome young men. There was no chemistry. Something in me was afraid of him." But they danced, and meantime the Fords "left without saying good-bye. I was stuck alone with Bert so I said I wanted to go home." When they reached her hotel, he asked to come upstairs. "I have to be with you," he said. They had "a scuffle in the doorway," Morand says. "He was very put off." In the morning, her phone rang and she picked it up to hear Eileen Ford screaming. The *Vogue* booking had been canceled. Her consolation prize was a shoot with David Bailey. "I would have gone out with Bailey, he was cute," says Morand. But Catherine Deneuve was in the studio, "watching him like a hawk," because Jean Shrimpton was there, too. Stern got his revenge. "He told *Vogue* I wasn't *Vogue* material," Morand says. "It put a big damper on my career."

That same summer, Allegra Kent's mother called to say she'd read Stern's name in a newspaper; he was being seen around town with a model, likely Holly Forsman. When Kent confronted Bert, he said he was thinking of leaving the marriage. She resolved to hang on.

With his television-commercial business growing, Stern needed still more space, and in September 1965, he bought two buildings on First Avenue and Sixty-Fourth Street, borrowing $44,000 from the seller. Previously a school named for the poet Walt Whitman, Stern's new studio was a short walk from his brownstone. He eventually installed a darkroom, film-editing equipment, a silk-screen press, expensive offset-printing equipment and a carpenter's shop to build sets, a studio for *Vogue* shoots in what had been the auditorium, offices on the floor above that, and a television soundstage on the top floor in what had been the gymnasium. At the same time, he bought a three-bedroom apartment in Manhattan's first condominium, the St. Tropez, a block north of the studio. It would be his private clubhouse.

Peter Israelson started working for Stern that fall. He had a master's degree in literature from Oxford University and was working at Random House when they met through Holly Forsman. "She dated me to make him jealous," Israelson says. "We all ended up in homes on Fire Island. Bert and I would be pleading our cases outside her window. 'Both of you, go away.' 'Let's grab a cup of coffee.' I needed a job and wanted to get into photography, so he hired me."

Israelson was in awe of Stern: "Bert was a lot smarter than everyone, street-smart, inherently creative. He made something out of nothing. He was the icon with all the original ideas, instructive, intuitive, personable, charming, a great gift of gab. The camera sort of disappeared and then suddenly it came out. He wouldn't fret like Bailey. He was always on. I sat there gaga."

On advertising shoots for clients such as Arpège perfume and Vanity Fair lingerie, Stern charged as much as $20,000 a day, "for doing nothing!" Israelson crows. "We did shoots all over the world: India, Japan, Vegas, South America." On a location shoot in Rio de Janeiro in 1966, he says, "the procession of hookers through our rooms was unbelievable. Six months before, I'd been studying Chaucer, and here was someone with a banana you know where! I'd died and gone to heaven." Stern approached work with an insouciance that was as impressive as his excesses. "He'd take a billion pictures and eventually something would work," says Israelson. "He'd turn something that went wrong into a virtue."

Stern paid no attention to a job until it was his, then he'd drive his Jaguar to whatever agency had hired him and put on a show. "There was no agony," says Len Lipson, who first hired Stern to direct a Lipton tea ad in 1964 and became his agent for television commercials. Stern would meet the writer, art director, and agency producer, ask to see the storyboard of the proposed commercial (usually for the first time, though the client wouldn't know that), and then say, "I've given this a lot of thought," Lipson says. "Then he'd do forty-five minutes off the top of his head. He was a quick thinker."

He was even more nonchalant about photography jobs, showing up on location—even for major shoots—with just a small Nikon and a Hasselblad with a Polaroid back to check contrast and f-stop. Through-the-lens light meters were becoming common, but Stern didn't use them. "He understood light instinctually," says Israelson. "Everyone was in awe of him." Certainly Holly Forsman was. She believed Stern really cared "about beauty and making a beautiful picture and making it different. He'd look at a model's face and the way light played on it and he'd talk and let them talk and find out about them and click without making a big deal about it."

In December 1966, Georgina Howell, writing in England's *Guardian*, declared Stern one of the legends of fashion photography, right alongside Avedon, Penn, Beaton, and Horst.

As time went by, though, it became harder for Stern to juggle the women and his wife and children and Vreeland and *Vogue* and all the advertising clients. So he got some help. "When I started, there were no drugs," Stern said. "Nothing. I'd never heard of marijuana or cocaine. In the midsixties, things began to happen. I was very programmed by the American dream. I was married to dreams. But I woke up one morning and Allegra said, 'You didn't tell me you had no money.' I called my agent and asked, 'Isn't there simpler work I can do to make money?' So I started to make more money, and I guess that led to trouble. With money came the desire for town houses and penthouses and big studios, which led to the need for an empire, which led to a need for more energy—and of course, I was invincible." He'd actually started taking drugs years before, but hadn't given it much thought when a doctor wrote his first speed prescription around 1957; he would just pop the pep pills when he needed a little boost.

By the midsixties, a little boost wasn't enough. Late in 1965, Stern's secretary, who "had so much energy," he remembered, told him about a doctor, Robert Freymann, who injected his patients with a special mix of vitamins that gave them unlimited vigor and optimism. "There were a lot of vitamins in those shots," Stern said. "A lot of good stuff. But I began to figure out that there was something that made you feel good—and it wasn't vitamins." It was amphetamine. "I never looked at it as drugs. I looked at it as the doctor." The Leipzig-born Freymann had already been found guilty of unprofessional conduct for giving drugs to addicts and would lose his license for six months in 1968 as punishment for performing abortions. But he was the go-to guy for sixties celebrities. "I have a clientele that is remarkable from every sphere of life," he boasted. Though he declined to name names, he added, "I could tell you in ten minutes probably one hundred famous names who come here."

The more energy Stern had, the more work he took on. The more he took on, the more speed he needed. The upgrade to injectables turned the action up a notch. He bought a jukebox and two huge speakers for the studio. "I'd put twenty-five cents in and play a record for each dress, three minutes per dress," he said. "The rhythm of the music and the girls and the clothes came together for me." And that, too, fed the "desire for a bigger lifestyle," way beyond what his wife wanted. "*Blow-Up* was a simple photographer," he later lamented. "I'd become a thing."

He thought he was invincible. "He started believing his own press," says Peter Israelson. "He saw himself as an icon, and that's fatal." Israelson's diagnosis boiled down to pharmacological delusion "coupled with megalomania." Stern felt he could get away with anything. "We make a wonderful fantasy world," says editor Sarah Slavin, "but woe betide those who actually believe in it."

He'd leave Allegra at 7:00 a.m., return at midnight, and then stay up for hours. "Sleep and rest were elusive, and euphoric fantasies replaced logic," she remembered. "He became my tormentor . . . and our family life, always precarious, started to suffer even more." Once, when he came home at 3:00 a.m., having been "with a woman, I was certain . . . I took a hammer and smashed his Tom Wesselmann watercolor," then scrawled "You are a destroyer" on it with a Magic Marker and left it at the foot of the stairs. "Bert, of course, was furious."

He'd been in the condo in the St. Tropez; it was "his lair," says Holly Forsman. They mostly hooked up at her nearby apartment, though: "A woman likes to be near her bathroom." They dined at Maxwell's Plum, a famous singles bar, also nearby. When he went to an interesting location, Forsman went with him, working as a grip. "I loved watching him work," she says. "Often, he'd look at the light and at me and take a picture and sell it."

She knew the relationship was going nowhere, so she also had a boyfriend, and they were "engaged to be engaged," she says. "Bert didn't like this." Then "something bad happened." Stern booked her for a commercial and she didn't show up after staying out late and partying too hard. "TV wants you at the crack of dawn and then doesn't use you for three hours," she gripes. Stern had someone wake her and take her to the doctor. "And within half an hour, I was gorgeous and lively and I slid halfway down a fireman's pole, said a line, and then continued sliding, but I thought, 'What the hell was that shot?' Bert said vitamin B12. That's when Allegra called me."

It was spring 1966, and Kent was pregnant again when her mother called to say she'd spotted Bert on the street with Forsman. Allegra confronted her. "I know you're seeing Bert," she said. "Stop. I can make trouble. You're young. You can find someone else. And I'm pregnant."

"I just listened," Forsman says. "And then I said I was sorry and not another word. And that was it. I told Bert I wasn't seeing him anymore. I also

said, 'Stop using drugs.' I saw a difference. He had wonderment and curiosity and joy and that started to vanish and I didn't want to be with this other person." Forsman got married. Bert and Allegra's son, Bret, their third and last child, was born at the end of that year.

Forsman was right about Bert. But not everyone noticed or wanted to see what was happening. Or else they thought it was just great. "We marveled at his energy," says Len Lipson.

Even while shooting, Stern was always alert for new possibilities. "He was a mogul," says Peter Israelson. "He was always on, making deals." In 1966, Stern spotted a photo in the *Daily News* of Twiggy—the hottest new model to emerge since Shrimpton—around the same time Diana Vreeland saw her in French *Elle*. They shot Twiggy, a scrawny cockney whose elfin hairstyle was being copied by teens all over England, at the next Paris collections, where "people kept knocking on the door from the newspapers," Stern said. "I could see it right away, this was going to be a riot. She was Cinderella." Aware she would shortly be coming to America for several months, Stern secured an exclusive from her Svengali boyfriend—a Vidal Sassoon hairdresser who'd assumed the name Justin de Villeneuve—and then called Barry Diller, an ABC-TV executive, and proposed a documentary.

"Barry said, 'Let's do three films,'" Peter Israelson recalls, "and suddenly Bert had a deal" worth $250,000 to make one hour-long and two half-hour shows, *Twiggy in New York*, *Twiggy in Hollywood*, and *Twiggy, why?* "Bert was the center of the pop storm at that point," says Israelson. Avedon shot Twiggy, too, but only after Stern. Avedon's loss of primacy first bewildered and then embittered him. He would see that moment as the end of haute fashion, when "the world switched and fashion magazines switched" from exalting "a beauty representative of higher values" to chasing "a stewardess's dream." High on his shots and himself, Bert Stern knew how to pilot that plane.

Back in New York, Stern reveled in his new celebrity, which had now surpassed his wife's. "He hobnobbed with everyone," says Israelson, with "lavish dinners with Balanchine" and "a salon with artists and writers." The hottest pop stars came to his parties. "All his competitors showed up at the court of the king." Irving Penn shot Stern's portrait. Avedon visited the studio and called the music Stern played junk. "Avedon was playing Sinatra," Stern responded with disdain.

With Forsman out of the picture, Bert found a new blonde—and this time, she insists, it wasn't about sex; it was pure obsession. Today, Dian Parkinson is probably best known as the former hostess of television's *The Price Is Right*. In 1966, she was finishing a year's run as Miss World USA when she came to New York to model and soon found herself locked in Bert Stern's embrace as "his protégée—his muse," she says.

Parkinson (née Dianna Lynn Batts) was a Mormon, "naïve," she says, but pretty and curvy, when Vreeland sent her to Stern's studio on a go-see. She sat around for an hour and a half with three other, more typical models. Finally, the receptionist announced, "Mr. Stern isn't seeing anybody today." They all got up to leave, but the woman behind the window stopped Parkinson: "Except you. He'll see you." She was sent around the corner to his condo.

Stern declared her the "next Marilyn Monroe" and invited her back that evening, when he tried to get her to pose topless with a scarf around her. After shooting a few rolls of film, Stern urged her to take all her clothes off. Parkinson refused—she was married—and said no again when he murmured, "Do you want to play?" He sent her away. But the next day, Stern summoned her back to his studio and they became inseparable. He'd found something he'd been looking for, "the American Dream Girl." Parkinson shot exclusively with Stern for years afterward. "Dian Parkinson didn't exist until I found out what she looks like," Stern said.

"You could be pulled in," she says. "I couldn't be pulled in as far as he wanted, but he had a huge hold on me. I loved Bert in my own way. I spent years trying to figure it out. Did I really know him? I was mesmerized. I wasn't in love. But whatever it was we had was probably stronger than what I had with my husband. I had a husband who was very busy. Bert respected the fact that I was true to my husband. But he would sit and talk with me. He gave me something I was missing. It could have been more powerful than sex. It was easy to fall into this." He kept trying to seduce her, "but he knew there were boundaries and he didn't want to push me too far because he might lose me." They worked together for Blackglama furs and *Cosmopolitan* magazine, both clients with an appreciation for full-figured models.

Bert had learned an important lesson: he didn't flaunt Parkinson on the

streets or in restaurants and nightclubs. "We were only in his world," she says. He offered her a contract as a salaried model. "I think he was afraid I'd go someplace else," Parkinson says. "I don't remember it being a huge amount. It was just Bert's way of holding on to me and making it look more professional. It made me feel secure. He was always building me up."

Later, as he grew older and had similar relationships with other much younger women, some around him would speculate that Stern had become like the fictional Lolita's lover Humbert Humbert, obsessed with innocent nymphets. Parkinson's memories fit that theory: "*Obsession* wasn't a word I knew. I was younger than my years, and something about that intrigued him. Or maybe he just wanted me all to himself. In a lot of ways, Bert's a mystery. But sometimes an emotional bond can be worse than sleeping with someone. Good Lord, I wasn't interested in that at all!"

"YOU WON'T TAKE ME ALIVE"

In 1968, Bert Stern Inc. was still in expansion mode. With more than three dozen employees and an operating overhead of $10,000 a week, Stern was stretched thin, though he was reportedly grossing twice that amount. On a visit to the studio in 1970, Irving Penn reportedly said, "My God, man, what are you doing? What happens if you get a bellyache? Who supports this cast?" "There's never enough money," Stern told a reporter. That July 1968, one of his companies, K N Equities, borrowed more money—$64,950 this time—from Fred Hill, the real estate man who'd sold him the Walt Whitman School. Stern named Ed Feldman president of K N Equities. A financial consultant who was married to an ex-model and often served as a factor, buying receivables from modeling agencies to fund their ongoing operations, Feldman once sent an agency owner who was late with repayments to the hospital—by beating him with a mallet. He described himself as "a bullshit businessman," says his son. He was "a wheeler-dealer," says his widow, Kathleen. "I really didn't know what the hell he was up to."

Then, Stern rented a First Avenue storefront near his studio, where, in September, he opened On First, a gallery and boutique selling artist-designed products, some mass market, such as paper plates and wrapping paper designed by Roy Lichtenstein, some in limited editions, such as Day-Glo colorized and solarized serigraphic prints of his nude images of Marilyn Monroe. Unlike the pictures published in *Vogue* six years earlier, some of these had been marked with *X*'s by the actress when Stern offered her the chance to edit the sitting. Though she'd hoped to keep those images from ever being seen, Stern realized their value and would henceforth market them at every turn, as if Monroe had collaborated with him to turn them into art. He made Monroe silk scarves and wallpaper, too—the latter

sold for $35 a roll. On First also sold some of Stern's odd inventions, such as stools mounted with bicycle seats. He compared them to Marcel Duchamp's found objects.

The store cost $200,000, lost money from the start, and closed in less than a year. It didn't help that the so-called Go-Go economy of the midsixties had stalled. Stocks fell, interest rates and unemployment rose, and the dollar swooned. The simultaneous demise of the economy and On First coincided with a spike in Stern's drug use. Dian Parkinson knew something was amiss: "I could tell this wasn't normal, but I was too dang naïve to realize he was going over the edge."

Stern became "cantankerous, volatile, imperious," says Peter Israelson, who left the studio in 1969. "It was a classic unraveling." Stern began vanishing. "He'd disappear and not be available when we needed him," says Lin Bolen, later a television executive, but then a producer and salesperson at Stern's fledgling TV commercial company. Sometimes, Dr. Freymann would make house calls to the St. Tropez to inject him. Israelson saw the doctor "all the time," he says. "Then Bert would be revved up for another ten hours." Sometimes he wouldn't bother going around the corner. "He did drugs in the studio," says Bolen. "He'd go in his office and do it. We all knew he took amphetamines." And that wasn't all. Bolen says he was also "snorting coke or taking a pill or downing some booze—he drank pretty good, too."

He was insulated by an inner circle of acolytes. Maggie Condon, daughter of Eddie Condon, the jazz musician and nightclub namesake, joined the Bert Stern Studio as a production assistant in 1968. Condon and a tall, slim, blond California-hippie type named Larry Brown, ostensibly a writer, became Stern's closest confidants. They were assumed to be drug buddies. "They never left his side," says Judith van Ameringe, who printed silk screens in the basement of the studio. "They were really fucked-up most of the time. They'd come in the middle of the night and destroy things. I loved Bert, but my mouth was open all the time."

In September 1969, Allegra Kent called Robert Freymann and told him Stern was getting drugs from other doctors—John Bishop and Max Jacobson, also well known to Manhattan celebrities and underground scenesters. Savvy customers, Stern among them, would visit them all and max out on their "vitamin" shots. Kent thought Stern was somehow getting speed from

his dentist, too. "Bert was headed toward a point of no return," she recalled, "and I was helpless to prevent it."

That summer, he became delusional. Then, he unexpectedly invited Allegra along on a location shoot in Saint-Tropez for Coca-Cola. "The clients were going with him on the shoot, and perhaps he wanted a certain look of respectability," she speculated. "Maybe he was just between girlfriends." She decided to be optimistic. But then, she found a cache of filled syringes tucked behind a fruit platter in their hotel minibar. "Bert said they were just in case, but their number decreased."

One month later, K N Equities borrowed another $50,000, consolidating five previous mortgages on the studio, and left Stern $300,000 in debt (about $1.9 million today). In the same deal, K N granted the debt holder, a real estate man, the right of first refusal in the event K N sold the property. Ed Feldman was listed as president of K N Equities on some of the documents; Bert's name was on others. Either Feldman had bolted or Stern simply couldn't keep track. Word began to spread that Stern was in trouble.

Dwight Carter joined Stern's studio early in 1970. He'd begun his career as the lowest assistant at Avedon's Fifty-Eighth Street studio in 1967, "cleaning the floors and the bathrooms," he says, but eventually helped create Avedon's psychedelic posters of the Beatles. But as a black man in a white world, and somewhat diffident, he was always "nervous as hell." Carter didn't gel with coworkers and was let go a year later, replaced by Claude Picasso, the painter's son. Facing the draft, Carter volunteered to join the army and served in Vietnam. On his return, he got a job managing Stern's studio and darkroom, where a walk-in safe held Stern's archives. They were totally disorganized.

"It was the beginning of the end, but of course, I didn't know that," Carter says. On one of his first location trips early in 1970, he joined Stern, Dian Parkinson, Maggie Condon, and Larry Brown in an RV equipped with a color television set and stereo system. Stern took it across the country when he was commissioned to photograph a promotional book for Levi Strauss, the jeans company. But Carter kept to himself, so he wasn't privy to all that happened when the RV reached San Francisco.

A hotel room was wrecked, Parkinson recalls. "They started getting weird. Obviously, stuff was going on." Brown was "always getting in trou-

ble," she continues, and Bert was "scattered, never pulled together." The shoot team abruptly returned to New York, where Stern "was in trouble with the people with *Vogue*. I could sense they put up with a lot." How much? "I remember very late sittings," says sittings editor Sarah Slavin. "You never knew how long he'd be able to stand up."

Vreeland would recall having to fight her way past receptionists and assistants to get to Stern. "Bloody well tell Mr. Stern I am here and I'm waiting," she'd say. "No, he will not call me back. I am busy but I am waiting." When he took her call, she snapped, "You're in a dream, Bert. Now listen to what I'm saying." He'd lost interest in fashion, says Maggie Condon. "He was shooting for *Vogue* constantly, but he was more interested in other stuff." Such as shooting speed, which he now had "delivered in blue Tiffany boxes," Condon says, so he could inject himself. "All he did was get stoned all the time."

Carter worked on a couple of *Vogue* shoots, but Stern's relationship with Condé Nast was tailing off by the time he arrived. Stern's last cover ran in October 1970. Around that time, Vreeland made one of her rare visits to his studio, where she was reduced to shouting his name in a dimly lit hallway. "Stern!" she cried. *"Bert Stern! Where are you, Stern?"* He finally appeared, "dressed for the third straight day in a pink flowered cowboy shirt and rumpled khakis," Jim Cornfield wrote a few years later. "Greeting Vreeland with an arm around her waist, he parried her rebukes for the wait and guided her into his domain." Stern continued shooting interior pages for *Vogue* through 1972; a bathing suit spread that November would be his last work for Condé Nast for a decade.

Though his first cross-country trip for Levi Strauss bore no fruit, he succeeded on his second try and, in 1970, produced a folio of nine images (including studio photos of model Marisa Berenson doing a partial striptease) extolling blue jeans. He'd manipulated and collaged the images and printed the results on his photo-offset equipment. First shown in February 1971 at a menswear convention, the folios were sold by Levi's retailers the next summer; individual prints cost a few dollars, boxed editions went for $150, and a signed art portfolio carried a $350 price tag. But the Levi's campaign was Stern's last gasp. From the chaos caused by Stern's drug addiction and the collapse of his business, it's difficult to reconstruct a precise timetable of

what happened, but the accounts of those around him paint a clear picture of utter disintegration. Dian Parkinson left without saying good-bye. She discovered her husband was cheating on her and "ran away from it all," she says, moving to Los Angeles. "I probably hurt Bert. Leaving as abruptly as I did might've been painful, but it was time to leave Dodge." She never heard from him again. "Kind of sad, isn't it?"

Sometime in 1971, Dr. Freymann gave Stern a bad shot on purpose; Allegra Kent speculates he was punishing Stern for seeing other doctors and perhaps trying to scare him straight. On another occasion, Stern abandoned daughter Trista, then ten, in the lobby of a Broadway theater when he saw portents of doom in a poster advertising the musical *Follies*.

He was "bullfighting with shadows," Kent wrote. "Like a toreador, he'd edge away from them and let them slip past him." Then he started "seeing dangerous penumbras, shadows from his future—from another hemisphere—that threatened his family, not just him." He was sometimes violent. Maggie Condon saw the same symptoms: "He believed he had another reality. He thought consciousness was layered and he was on the fourth layer." Condon and Peter Israelson did their best to cover for him. "Assistants were snapping the pictures" when Stern "vanished," says Jeff Sado, a distant relative he later befriended and in whom he confided.

In her autobiography, Kent says Stern had lost everything by the time she took the children and left him in September 1971, but it appears that the business limped on for some time afterward, bleeding money, the staff shrinking along with Stern's funds. "People started leaving," Dwight Carter says. "The carpenter, the accountant. We pretty much knew it was over." Some of the departed helped themselves to pictures, including unsigned Marilyn Monroe prints that ended up in galleries across the country.

Dwight Carter stayed until the bitter end, when the payroll was due but there was no money. Stern ordered someone to his town house to take a Picasso from a closet and sell it. A few days later at the studio, "in walk two guys in suits we didn't know." They approached one of the remaining employees and said, "'We're marshals and we're locking the doors. You have ten minutes to get your shit and get out,'" Carter recalls. "We all ran and grabbed our possessions and they put a chain on the door." Two days later

the chain was removed—Carter doesn't know how—and everyone was summoned back to work.

The chain was likely removed thanks to Joseph Rubenfeld, a real estate man from Queens who had a taste for culture. He'd ventured to Manhattan in 1968, opening an art gallery on West Fifty-Seventh Street. About a year later, Stern's sidekick Larry Brown appeared in Rubenfeld's office. "A rich hippie type in love beads," says Howard Edelstein, Rubenfeld's nephew. After Brown left, Rubenfeld announced he was going to see a property that belonged to Bert Stern, "and next thing, Joe says he's going to get involved with him. We're moving there. He takes the top floor." He put Edelstein in charge of leasing spaces in the building and brought in filmmakers and magazines who could use Stern's photo studio and soundstage. Edelstein thought he'd died and gone to heaven. "Photographers and makeup men are all gay and I'm eighteen and these gorgeous models are walking around stark naked," he says. "This is a dream job."

It's documented that in 1971, Rubenfeld loaned K N Equities $200,000. Edelstein says that over the years, Rubenfeld loaned closer to $400,000. "In cash!" he marvels. "I said, 'Joe, are you sure you know what you're doing?' Larry Brown had a problem." Edelstein thought he was on heroin. Finally, Rubenfeld brought in a garment-center accountant "to try and run it as a business," Edelstein says. That lasted until the money really ran out. "'Where's my paycheck?' 'Where's Bert?'" Edelstein remembers. "He could have been on Mars."

"Bert was not there a lot," Dwight Carter allows, "but we had to be. Eventually, it reached the point of, this place is going to close." Stern summoned Carter to his town house. "Do I owe you any money?" he asked. He didn't. Stern asked the same question about other employees and suppliers, and Carter assured him all were square. Carter handed Stern the keys to the studio and left.

Though Stern was, by any reasonable measure, insolvent, he never declared bankruptcy, Edelstein says. "He just handed [Rubenfeld] the keys" to the studio. "The Bert Stern Studio collapsed." Rubenfeld auctioned off Stern's equipment and put the building up for sale, finally unloading it in 1975 to a religious cult called Foundation Church of the Millennium.

"He did not get his four hundred thousand dollars back," Edelstein concludes.*

While losing his real estate, his studio, his clients, and his reputation, Stern still sought to win back his wife and kids. "I wasn't going to stay on the high-wire without her," he said. "It was all done for her in a sense." Allegra still seemed to care. "She told me, 'You're going to kill yourself,'" he remembered. But he didn't—or couldn't—stop taking drugs, and his attempts to reconcile only scared her further.

Allegra and the children moved out that fall, despite a plate-smashing attempt by Stern to stop them. A few months later, Stern talked his way backstage at the New York State Theater, where Kent danced, and raced around looking for her. He was out of control. When one of his speed doctors cut him off, he broke into the doctor's office and stole drugs, then "had the nerve to go back a few days later," says Jeff Sado. But Stern still had his lucid moments. By the time Lawrence Schiller, a photographer, author, and deal maker, met with him about an exhibit Schiller was planning to commemorate the tenth anniversary of Marilyn Monroe's death, Stern had even moved all his negatives from the basement safe in the schoolhouse to the town house, which wasn't his anymore. He'd returned the deed to the real estate man who sold it to him.

"The idea was to bring together all the Marilyn Monroe photographers," Schiller recalls. "He said he didn't know where the Marilyn pictures were, maybe in the bathroom in a box by the toilet." But Stern knew what he wanted. "How much money will you guarantee me?" he asked. Schiller said all the photographers would be paid the same. "Stern asked, 'Who are they?' I said, 'Avedon, Beaton.' He said, 'Okay,' and gave me a box of transparencies. 'Take what you want and return it.'"

Larry Schiller expected a couple of hundred people to turn out when the show of 176 Marilyn photographs by sixteen photographers opened in August 1972 in Los Angeles, but lines went around the block. He convinced Norman Mailer to write a text about Monroe and went back to each photographer to negotiate for a book. Stern asked for an advance and Schiller offered $2,000.

*Stern also lost his St. Tropez condo. "The building had a right of first refusal and bought it and resold it at a profit," says a former head of the condominium's board of directors.

"When?" Stern replied.

"He was desperate," Schiller says. But the money kept coming after Mailer's *Marilyn* was published in May 1973, and Schiller put together more Marilyn products such as date books and calendars. "I didn't know I put him back on his feet," Schiller says now.

How far had Stern fallen? In March 1972 Bert's brother, Shelly, and their brother-in-law Monroe Schlanger went searching for him after Allegra called Shelly and begged for help. "Shelly and I drove in from Long Island to look for him," Schlanger says. The police accompanied them to the town house, but Stern wasn't there, so Schlanger and Shelly walked around the neighborhood. Just as Schlanger called his wife, Bert's sister, to say they couldn't find him, Bert turned a corner and dashed into the house. "We got the police back and he was committed" to Gracie Square Hospital, a posh psychiatric facility.

Kent says Robert Freymann helped Stern escape, and he returned to the town house and started stalking his daughter, Trista, following her to Allegra's apartment. Allegra opened the door on a chain to confront her thin, unshaven, hollow-eyed husband. She let him in and fed him a peanut-butter-and-jelly sandwich. After a week, she talked him back into treatment and had him locked up in a mental health ward at Metropolitan Hospital. While he was there, she visited the brownstone and saw the evidence of his dissolution. His "voices" had told him to paint the place black and red. He'd built seeming shrines with cockeyed candles and broken mirrors and scrawled white crosses on the doors. Feeling safe with Bert behind locked doors, Kent joined the New York City Ballet for an engagement in Munich, Germany. While she was away, Bert escaped again.

There are several versions of how he did that. Kent wrote that he fled while being taken to the dentist. Jeff Sado heard he'd gone for a psychiatric evaluation, where he told a doctor, "I've been yes'ed to death for twenty years. If I wanted to go to the Taj Mahal, they'd give me a million dollars. I have to get grounded. I need to eat in diners and take walks." He was allowed out, accompanied by a male nurse, and leaped to freedom through a bathroom window. His sister and brother-in-law think he slipped away between doctor appointments and walked out the hospital's back door.

Regardless, Bert was free and again knocking on Allegra's apartment

door, scaring the children. She returned to New York and summoned police to the brownstone. In Kent's version of what happened next, Bert suddenly appeared, saw the plainclothes police, and ran up a flight of stairs to the roof of the brownstone. Chasing him through the house, they passed destruction everywhere, burned photographs of dancers, torn clothes of Allegra's. She knew a gun was in the house, and when she heard a shot, she feared the worst, but suddenly a handcuffed Stern came down the stairs with a plainclothes cop behind, pushing. Kent wrote that Bert had fired a starter pistol—not a real gun. But Jeff Sado's mother told him Stern was chased across rooftops while waving a water pistol and shouting, "You won't take me alive."

Stern was taken to the Nineteenth Precinct station house on East Sixty-Seventh Street and remanded to the Tombs, the city's municipal jail. In Kent's telling, a friend bailed him out, but he somehow ended up back at Metropolitan Hospital, where an admitting psychiatrist immediately released him.

"It was really sad," says Holly Forsman, who saw Bert again fresh out of the hospital. "He was hearing voices from Mars." Later, Allegra Kent called her—again. "I don't know how she found me," Forsman says. "She said, 'Bert is a lot of work and I think you should help me with him.' Maybe she thought I could connect. She meant well. It wasn't ugly, but I'd moved on." So, inevitably, would Bert. According to Kent's account, he got tossed out of his house about a month after his arrest.*

Broke and homeless, he hit bottom.

*Years later, the house would pass to Camille Cosby, wife of the comedian Bill Cosby, and was alleged to be the site of some of his alleged sexual assaults on women.

Chapter 19

"Another fuckin' ceilin'"

Bert Stern was not abandoned. He had a girlfriend who got him clothes and money, says Jeff Sado. "He stayed with me afterwards," says Maggie Condon. Then, his old friend Eddie Vorkapich threw him a line. In the late sixties, Vorkapich had built a television-commercial studio in Mijas, a town on Spain's Costa del Sol. Afraid of bankruptcy and Allegra's wrath, Stern called him, "frantic," says Vorkapich's widow, Hanne, and Vorkapich loaned him $10,000 to ship all the negatives, contact sheets, color slides, and pictures he'd salvaged from the schoolhouse to Spain to protect his legacy from both divorce court and creditors. Jeff Sado says Bert's brother, Shelly, "packed everything up" and sent it all on a boat. At Vorkapich's invitation, Stern came to Mijas, too.

Vorkapich had set up his studio while married to his second wife, a former secretary of Stern's. Vorkapich had realized that in economically troubled times, ad agencies and international advertisers would appreciate a low-cost alternative to making expensive TV ads in America. Third wife Lynn and Eddie got married in 1972. When Stern arrived, the compound was "like a country club," says Lynn, who lived in luxury, attended by servants. Stern's first stay, in fall 1973, was brief. He returned and stayed longer in mid-decade. It was his self-prescribed rehabilitation.

Peter Müller, a Swiss photographer, arrived in Mijas as an assistant just before Stern did. "One day, Eddie said a dear friend is coming with containers, containers, containers." Soon, a seventy-square-meter room in the studio was filled with Stern's stuff. Müller thinks the boxes contained "old clothes, old shoes, everything! Even a car. Was this man carrying around elephants? He didn't have a penny. Eddie paid for everything. Eddie gave him the chance to put it back together."

"He was a basket case," says Lynn Vorkapich. "He slept half the day. He'd go to the pool in his pajamas. He had no personality. It was hard to believe he'd been so successful. He was devastated by his ongoing divorce. It was pathetic. I felt sorry for him." Eventually, Vorkapich helped him find an apartment nearby, and slowly he went back to work. Müller became his assistant. "Bert was a mess," Müller says. "He would smoke his joints, take an upper, a downer. Obviously, he would drink. He'd forget everything. If you gave him a car, he'd put in gas instead of diesel. He wasn't drugged. He was a mess. He'd walk out of a restaurant without his jacket. It's the form of life he'd had, like a rock artist. He wasn't a normal person.

"At the beginning, he couldn't adapt," Müller continues. Just as in the old days, he'd get up at dawn, look at the light, and, if it struck him wrong, just go back to bed. "We told him, 'Here, this doesn't work. We're using expensive models, flying them in from New York.' People weren't used to that."

Over time, Stern got some of his mojo back. "He didn't need any paraphernalia," says Müller. "He'd work with basic materials, a reflector and an old Hasselblad. He was very, very meticulous about styling and makeup. He did fantastic work." He even started shooting for magazines again, albeit for *Playboy*, not *Vogue*.

Bert Stern and Milton Greene had met through Larry Schiller, and when Stern felt well enough to return to New York late in 1973, Greene offered to let him use his studio (previously used by *Vogue*'s John Rawlings) near Sutton Place. Stern was newly methodical. "Everything was pre-tested," says Milton's son Joshua Greene. "He'd come in, say what he wanted, we'd do color tests, lighting tests. Then the next day, he'd shoot. He'd shoot his way into the shoot. He'd shoot constantly. He'd shoot twenty rolls of film, where Milton would use five, with two or three cameras. He was a strange bird. He didn't speak much. But he had the chops."

He still had issues. "We used to go to Elaine's," a New York bar and restaurant popular with media types, says Schiller, "and he would nod out at the table. Eventually, we'd sit in the back so no one would see." Still, in 1974, Stern got a studio of his own and hired an assistant, Ken Gilberg, who found him flaky at best. "He was trying to be like Warhol," Gilberg says. "He printed [bed] sheets with the [Marilyn Monroe] pictures so people could say they were sleeping with her." But he also started disappearing

again—and seeing a Dr. Feelgood. "He'd get shot up with speed. Supposedly, it was just vitamins. It was wearying to watch a guy be so irresponsible. I remember calling that doctor and saying, 'Why are you giving him speed?'"

He was living with a girlfriend on the West Side, but Gilberg recalls Stern pining for Allegra and his children, whom he only saw in court. Kent remembered a spring 1975 court date when Bert, representing himself, appeared before a judge ten minutes late, in jeans and barefoot, saying he'd walked that way eighty blocks downtown because he didn't have enough money for a subway token.

"'She ruined my life,'" Allegra quoted Bert saying. "'She didn't care about me. Only her career. And now, I have no money.'" He was "smirking with happiness," she wrote, "delivering his punch lines, and waiting for their reception." She was granted a divorce. It would take another year to work out child support. "Bert congratulated me on the divorce and went to Spain," wrote Kent, who dropped his last name.

Bert Stern would attempt comebacks for the rest of his life. The first came in December 1976 when Monique Knowlton, formerly the model Monique Chevalier, was running an art gallery, needed a fall show, and "it occurred to me to call Bert," she says. She asked $1,000 for eight-by-ten Marilyn images, but nobody bought the pictures, she thinks, because Stern refused to number them. "He was always extremely difficult," she says with a tight smile.

Shortly after that, Stern formed a production company with a new friend named Larry Chilnick, a onetime journalist who worked for an organ-transplant clearinghouse. Chilnick's wife, Janet, suspects Stern and Chilnick bonded over a shared taste for drugs. Chilnick, who liked cocaine and marijuana, introduced Stern to Barry Secunda, who worked in the music business. He thinks it possible Stern and Chilnick shared a cocaine dealer. "In that period, cocaine was rife," Secunda says, "but for a guy with Bert's personality, it didn't help. He was already high-strung and paranoid." Yet drugs proved to be a salvation of sorts. At the time, many drug users owned a fat reference book called the *Physicians' Desk Reference* or *PDR*, a guide to prescription drugs. But it was "unintelligible," says Janet Chilnick. Chilnick's family was full of doctors—and Secunda suspects that's how he came up

with the idea of creating a *PDR* for laymen, called *The Pill Book*, and revising it every eighteen months so it would always be accurate.

"How do we sell it?" Chilnick asked Secunda, who came up with the notion of having every pill on the market lovingly photographed by the great Bert Stern and volunteered to serve as agent for the project, which he sold to Bantam Books for a $50,000 advance against royalties. "I did the indexing," says Janet Chilnick, "Larry did the writing with two pharmacists, and Bert did all the photography. He lived at my house. He had no money." They also went to Mijas together to "archive all his art," she says. "He'd shipped it there so Allegra couldn't get it, but he was always thinking of ways to get her back."

Unfortunately, Stern was also often high. "He did a lot of drugs," Janet Chilnick says. "He did drugs until the day he died." Which may explain assistant Ken Gilberg's claim to have shot all the pill pictures. "And I never got paid," Gilberg says. The first edition of *The Pill Book* was published in spring 1979 and was an instantaneous sensation. Stern would claim he did the book because he wouldn't have abused drugs had he known more about them. But he was also titillated by the irony. "How many of these do you think I took in my life?" he asked Lawrence Schiller while showing him the layouts. "How many have you taken?"

Stern made enough money from *The Pill Book* that he was able to move to an apartment of his own, albeit one on Roosevelt Island, reachable by tram from the East Side of Manhattan. The book would sell four hundred thousand copies a year for the next fifteen years and, in 1983, inspired a spin-off Stern likely appreciated, *The Little Black Pill Book*, a guide to the most abused prescription drugs, for which he and Chilnick each received an advance of $150,000. By then, he'd moved again, into a high-rise in the Murray Hill neighborhood back in Manhattan, where he'd remain the rest of his life.

The success of the pill books caused constant arguments between Chilnick and Stern. At one point, they stopped paying the pharmacist who consulted with them, and in 1986, Bantam bought them each out for a mid-six-figure sum. "I advised against it," says Secunda. "I said it would never slow down. But neither one of them had a buck." *The Pill Book* remained in print for years, ending only with its current, fifteenth edition. Stern "un-

derstood how to make money," says Schiller. "A lot of great photographers never understood that. But he was always a short-term thinker."

Certainly, his behavior toward Allegra Kent was not a product of long-term thinking. On his return from Spain, Stern befriended a cartoonist, Barbara Slate, who recalls Stern trying to reconnect with his ex-wife and Kent eventually seeking an order of protection against him. "I was just trying to talk to her," Stern told Slate. But Slate says Stern "had something behind his back" when he did that, and "she thought it was a gun."

His cavalier treatment of his most precious remaining asset—the original negatives from the 1962 Marilyn shoot—was another indication that Stern wasn't fully functional. He gave many away to a loan shark as collateral and left others behind in Milton Greene's studio. In 1980, when his seven-year contract with Lawrence Schiller was expiring, he made a deal to put together a book of Marilyn pictures. "I didn't know him, didn't know who he was," says Ned Leavitt, then a junior agent at William Morris. Stern simply appeared there one day, looking for a book deal, carrying some old Marilyn pictures. "I wouldn't have paid any attention if it wasn't for the photos," says Leavitt. "I was blown away."

Leavitt noted "a sense of desperation—yet he had an amazing story and he said he hadn't told anybody. The key question everyone asked was, had he slept with her? He dodged and weaved," but ultimately admitted he hadn't. Leavitt found a writer, and though Stern was "not easy to work with," a book was produced and earned him enough money to finance his move back to Manhattan. During the move, an envelope full of Marilyn pictures—21 color prints and 172 transparencies—was stolen, or so he said when he contacted several newspapers, offering a reward for their return and winning some press about his latest comeback.

The Last Sitting came out in 1982 in both a slender American edition and a fat German one that contained every image he still had in his possession from the Marilyn sessions. Briefly, the book's publication seemed to mark a new beginning for him. *Vogue* ran an excerpt in its all-important September issue, finally using the nudes it had refused to publish twenty years earlier. Monique Knowlton did another show at her gallery. And Allegra Kent showed up, describing herself to a reporter as "Mr. Stern's divorced wife." The Monroe revival rebooted Stern's relationship with Condé Nast; he

would shoot covers for *Mademoiselle*, *Brides*, *Vanity Fair*, and *Condé Nast Traveler* into the nineties, but his career gained no traction and his work never again appeared on the cover of *Vogue*.

"When I met Bert, he was struggling to get it back together," says Kay Saatchi, then a Condé Nast publishing executive. She accompanied him on a trip to Paris to photograph the couture collections for French *Vogue*. "His dream had gone wrong and he longed for a chance to right it. He edged into telling me some of the crazy things he had done. I was a bit of an innocent and I think he liked Lolita types, women who were uncorrupted and weren't on the make. I can't say he wasn't sometimes a little loopy, but I adored him and he me. I would spend hours looking through his piles of negatives and proof sheets. I found his reliance on the Marilyn pictures a little sad. Yes, there was money attached to them, but it was not his best work."

Bert Stern had the eight to ten good years Alexey Brodovitch's dictum allowed him before his crack-up. David Bailey's active career in fashion lasted longer than that. But finally, in the eighties, he, too, burned out. "One year I did like eight hundred pages for Condé Nast, which was fucking unbelievable," he says. "I thought, shit, I can't look at another dress, and all those hysterical fashion editors, lots of 'em are great, but lots of 'em have no taste at all. You'd think, 'Why am I listening to this woman?' All they ever want to see are the shoes. I said I've done enough. I can't bear to see another frock. I just decided to do more reportage and more portraits."

Bailey consciously resists looking back: "I hate nostalgia, it's boring. I got fed up with the sixties. Everything was fuckin' sixties. You couldn't get out of it. It's like fuckin' Michelangelo must've said, 'Don't ask me to do another fuckin' ceilin'.' Can you do it? Yes, but I'm not going to."

After quitting *Vogue*, Jerry Schatzberg continued shooting fashion but was better known for his celebrity portraits. He shot the Rolling Stones in drag and Bob Dylan for the cover of his *Blonde on Blonde* album in 1966. Around that time, *Esquire* sent Schatzberg to shoot a starlet named Faye Dunaway, who'd just appeared in her first film. A year later, after she became a star in the gangster film *Bonnie and Clyde*, Dunaway called Schatzberg to

ask for more pictures, and they became involved. Schatzberg hoped to make a film based on the life of his friend the model Anne St. Marie, who'd had a nervous breakdown. "I quit photography two years into the development of the script," he says. *Puzzle of a Downfall Child*, starring Dunaway, was finally released in 1970.

"In the back of my mind, I thought I could always get a space and start taking pictures again," he says. But then he directed *The Panic in Needle Park*, starring Al Pacino, and had a new career. "All people do their best work at the beginning," he says. "Then, they're copying themselves. I was fortunate enough to go into film. I left photography, and when I picked it up again, I went to the streets, my farm, and other things. That doesn't mean I can't take a good fashion photograph again, but maybe I'm not hungry enough to have nothing to lose."

Melvin Sokolsky stayed in fashion into the early seventies. At first, "you were able to move at your own rate" at the *Bazaar*, he recalled. "They respected your vision. But as time went on, the editors felt, these guys just push the button and editors were the creators, like directors who hired cameramen. It watered down the singular vision." By 1967, he was being used less and less and moved briefly to *Vogue*. That led to his last tussle with Richard Avedon—and brought down the curtain on his fashion career.

Sokolsky met a model named Uschi Obermaier at a party, felt "an immediate chemistry," he says, and called Grace Mirabella, who'd succeeded Diana Vreeland as *Vogue*'s editor, to say he wanted to shoot her. Then he got a letter from Mirabella that said, a year earlier, Avedon had reserved the right to use Obermaier exclusively, and *Vogue* had to honor that commitment. Sokolsky quit. "Two days later, Uschi went to see Dick, and he never took a picture of her," Sokolsky says.*

Sokolsky and his partner Kalfus followed Bert Stern's lead and went into producing television commercials, thinking they might one day make movies. That never happened, but the commercial business turned into a multimillion-dollar operation. They broke up after their bookkeeper embezzled about $2 million from their business between 1987 and 1992. She "got con-

*Asked about his exclusive on Obermaier, Avedon said, "That was how it worked." He also said that he did photograph her for *Vogue*. "There was resentment. I was powerful."

victed and put away," Kalfus says, "but we were left in a very bad situation and decided we had to go our own ways."

Like Schatzberg, Sokolsky now tends to his archives and waxes philosophical about his fashion career. "I worked eight a.m. to four a.m. for years," he says, "and you can't say no. But there's a point of exhaustion when you really need space for yourself." Nonetheless, years later, he would shoot for the *Bazaar* again, even reviving his famous bubble for a cover photograph of the actress Jennifer Aniston. But he insists he isn't taking fashion photos: "There is no such thing as fashion. They're just photographs of people. That's what fashion is. We depict a given time."

"Movement and freedom and letting go"

Sometimes, it seemed the only person who would never stop shooting fashion was Richard Avedon. Two decades after his first photographs, he was still going strong in the late sixties. Gideon Lewin was hired to work in the studio at $65 a week just before Avedon's move to *Vogue*. Shortly after, Earl Steinbicker quit, and "Dick turned to me and said, 'You're taking over,'" Lewin recalls. He would run Avedon's operation for the next fifteen years.

Lewin assisted Avedon on his last trip to Paris for the *Bazaar* and invented there the lighting style that the photographer would use for fashion shoots forever after. Lewin put a strobe on a long pole with an umbrella behind it, "and I started to move with Jean Shrimpton, this way and that way and redefined the light as I saw fit to make it more dramatic, give it more dimension. It was about lighting the face; faces are uneven and light can even them out." Lewin's innovation helped nudge Avedon toward "taking away background and simplifying his canvas so [his photographs would be] about personality without distraction. That was his idea."

Lewin compares the studio to a film set with Avedon as director, and everyone else contributing. "We worked with teams. It was always a joint project. We edited together. But Dick got the last word." Lewin admired his boss. "He was up-to-date about everything. He had a curious mind. Politics, poetry, art, theater, and he loved youth."

Like Alen MacWeeney, Lewin did scut work, but perhaps more happily. They would process film right after a shoot, look at the contacts, "decide we can do better, let's reshoot and stay until it's done, at maybe two a.m. Nobody got paid overtime. That was the culture, the way of life."

Avedon's life clearly "was in transition," Lewin says. "Dick and Diana Vreeland were a great team, and she really wanted him at *Vogue*." Lewin joined Avedon, Polly Mellen, Veruschka, and hairdresser Ara Gallant on that long trip to shoot furs in Japan, where they picked up a sumo wrestler to play Veruschka's lover in pictures based on one of Vreeland's favorite books, *The Tale of Genji*. "On location there was always a story that gave him a road map to what he would do." But Lewin mostly remembers chasing snow. "Wherever we went, the snow had just melted so we had a great tour and ended up in Hokkaido, where we reshot most of what we'd done."

Lewin saw Avedon take his greatest delight in finding models. Sometimes his interest was sparked immediately. With Lauren Hutton, it took some time. He'd rejected Hutton three times before Vreeland insisted Avedon use her in 1966. "She wanted [something] more all-American" than the *Vogue*-ugly girls, says Lewin. "I was at Dick's the next morning," Hutton says. He asked about her story, and she told him about her childhood in Florida. Next thing she knew, she was "leaping in the air, running, jumping" and ended up with an eight-page *Vogue* spread.

"What Dick did was really find out about the girls to see their strong points and how far he could push them," says Lewin. "They didn't just go to the dressing room. He wanted to know about their lives, and it gave him inside information. It was never openly sexual with Dick. It was sensual. He built chemistry, but in an intellectual way, and he got sexuality by directing them. He realized what he could do and then he stretched it. How can we make it bizarre looking? How can we make a big statement?

"He worked on it. It didn't come by itself. Dick had a way of extending them beyond their limits; that's what made the photographs extraordinary. He loved movement and freedom and letting go. He tried to have as little restriction as possible. He was up-to-date on everything. He'd have an idea and get obsessed and research it. He followed through diligently."

Avedon would later cite Hutton's rise as another sign of the "fall" of fashion imagery "from aristocratic beauty to the girl next door who moved away. It was the beginning of a sort of democratizing pandering to mass appeal that ends with Madonna on the cover of *Vogue*." But in the late sixties, he didn't voice that bitterness. If he felt it, he kept it private, as he did his life with Evelyn, which was never a topic of conversation in the studio. Asked

about Avedon's private life, Lewin shrugs. "He didn't really have one. Life was about work. He never felt he had enough time to finish what he wanted to do."

But Avedon couldn't hide his frustration from the man who worked with him every day. "It was wonderful doing extravagant, wonderful projects with Vreeland," Lewin says. "But she and Alex Liberman were total opposites," and "a power war" between the art director and the photographer never let up. "Liberman was very controlling," says Lewin, and when Avedon moved to *Vogue* he lost a lot of the power he'd accumulated and the creative freedom he'd enjoyed at the *Bazaar*. "It wasn't exactly what he anticipated. All of a sudden he was not the star. He was one of several very prominent photographers, and Liberman pitted one against the other."

Avedon may have felt his world was shrinking, but Peter Waldman felt the world was opening up to him when he joined the Avedon studio in the summer of 1967. Waldman was a photographer's assistant in London looking for a new job when he heard Avedon was coming for a few days and needed some help. Waldman went to see David Puttnam, Avedon's British agent, "thinking there would be a queue, but it was just me," and after a two-minute chat, Puttnam said, "'Turn up tomorrow,' and it began."

Waldman worked with Avedon and Lewin on two advertising shoots, loading cameras and numbering rolls of film, then assisted Avedon again when he came back to town that August to shoot the Beatles for *Look* magazine and was "gobsmacked" by the experience, he says, so when Avedon asked if he'd ever thought of going to America, Waldman leaped at the opportunity, arriving in New York at the end of the year. He started out in the darkroom, running Avedon's color-processing machine, and learning some of the photographer's tricks. He'd done shots of each Beatle separately and pieced group shots together in the darkroom. And "if a dress didn't quite say the right thing, the shape could be changed," Waldman says. "All the pictures were heavily retouched."

Once he got to work on Avedon's set six months later, carrying Lewin's light-on-a-stick, he learned how dedicated the photographer was to realizing his visual ideas. Shooting Penelope Tree in a silver mask, Avedon moved his camera at the second his flash fired to create a reflected blur on the metal surface. "It was creating, not accepting," Waldman says, "using his

vast knowledge to do something quite different. He treated each assignment quite seriously, making something different of each one rather than sitting on his ass turning out something acceptable. You were very focused on what he wanted. He'd say, 'Yes, that's it,' and you'd know the kind of light he'd like on that person. A second camera was always ready to go. There were six to eight cameras, always loaded. It was a very slick routine."

Over time, Waldman, too, became aware of growing friction with *Vogue*. "I got the sense he wasn't happy. The magic was going. Fashion was becoming more of a commercial item." Waldman also saw Avedon's growing interest in portrait work subsume his fashion pictures. "The eight-by-ten camera gives a completely different image," Waldman says. "You can see every square inch of somebody; the detail is phenomenal. It's a very different challenge. The camera has no depth of field, so you constantly have to check focus. I'd be loading the back of the camera" with reversible plates that held one image on each side, "and Dick would be in front cocking and releasing the shutter." Focusing required the film to be removed, and the photographer to duck beneath a cloth so he could see what the camera saw, only upside down, and frame and focus the image he wanted. "You're lucky to do one photo a minute" with an eight-by-ten camera, Waldman continues. "They haven't got the speed. They don't disappear into the woodwork or take pictures just to warm a situation up," the way a Rollei or a 35 mm camera could. "You have to choose your moment much more selectively." The equipment, combined with his interior sensibility and the external pressures on him, encouraged Avedon to change his work's focus.

When Waldman arrived, fashion was still "the bulk of the work," but over the next four years, "it went to seventy to ninety percent portraits." In fall 1969, Waldman assisted on Avedon's first two group portrait shoots, respectively featuring the cast of characters of Andy Warhol's Factory and the defendants in the political show trial of the anti–Vietnam War activists known as the Chicago Seven. Those shoots, which led to many more group portraits over the years, were "very much planned," says Gideon Lewin. They were also products of darkroom magic, pieced together like the *Look* magazine Beatles pictures from separate images. "He was experimenting with composition and continuity," Lewin says. The murals were each made from several separate photographs, with the placement of the figures within

each frame carefully planned. In some cases, Avedon even sketched them in advance.

Those shoots were part of the run-up to his second museum show, a retrospective of his portraits at the Minneapolis Institute of Art that ran through the summer of 1970 and marked a momentous shift in how he thought of himself and presented himself to the world. "There's a whole transformation," says Gideon Lewin. "He runs around the country photographing revolutionaries," continuing even after the Minneapolis show closed.

"Fashion was a different track," says Lewin. "It paid the bills and he loved doing all that. It got his imagination going. But deep inside, it was about real life, interesting people, changing the world, and the powers that brought about change, and he needed to document and be part of it. There was a split personality there. Fashion was glamour and fantasy, and then we'd have these revolutionaries smuggled into the studio, so to speak. I was not into American politics. Some of it was distasteful to me. It didn't sit well. I didn't get the point. I think he went too far—at least to my taste. He was not really a revolutionary. He capitalized on them to get photographs."

Waldman describes Avedon's shoots that summer as theater. Lewin uses the same word. "Was it true documentation or was it theater?" he asks. "There's a blur of the borders between the two. He wanted to get the most memorable photographs. Life was a stage, and to be noticed, you had to make a bigger statement." Those were no longer fashion statements, though Avedon would keep an oar in fashion's waters for three more decades.

Chapter 21

"THROWING A BOMB"

In the early eighties, Bert Stern found a new agent, albeit one who also liked drugs; she would die of an overdose about fifteen years later. Before that, she helped Stern start shooting again, and he had talks with John Avildsen, the director of the film *Rocky*, about making a movie of his story, but nothing came of it. He was often "stoned out of his mind," says Hanne Vorkapich, Eddie's fourth wife and widow, who loaned Stern cameras when he could find work. "He was living hand to mouth. He seemed to be homeless. We gave him sweaters, money. He owed so much money to so many people. Very few people had anything good to say about him. Then he started to pick himself up a bit and made some money."

"He'd go to the precipice, but he never fell off again," says Larry Schiller.

Stern and Nancy Perl had grown close. In 1983, near her apartment, she spotted a beautiful girl about thirteen years old, roller-skating in Central Park, and told her she had a friend who had to photograph her. "She went home and looked him up and came to my apartment and said yes." She also said, "He discovered Marilyn Monroe!" Her name was Shannah Laumeister, and Stern did photograph her and told her to call him when she got older. She reappeared about four years later, and they dated for a few years before she went to Los Angeles, "to become a star," she says.

By the time she returned, Stern was "starting to come back," Laumeister says, shooting for *Rolling Stone*, *Playboy*, the Italian fashion magazine *Amica*, several foreign editions of *Vogue*, and doing a Pirelli calendar. "He was back on his feet," Laumeister says, "but he was getting hired for what he'd done. How do you beat what he did in the fifties and the sixties?" He wouldn't take just any job, she adds. He didn't need the money. He could always sell more prints of Marilyn.

At the start of the nineties, Stern asked his relative Jeff Sado to help him bring his archives back from Spain. Sado asked the Schomburg Center for Research in Black Culture, a division of the New York Public Library, to pay the outstanding $50,000 storage bill and get the archives released in exchange for all the footage, including outtakes, from *Jazz on a Summer's Day*, and Stern's belongings were shipped home. Stern took an adjacent apartment and filled it with his archives. "He was totally paranoid," says Laumeister. "He barely let anyone in." Eventually, he acquired a second home in Sag Harbor on the east end of Long Island and some of the archives moved there. "He saved everything," Laumeister says, though "he didn't keep it organized." His memory was closely guarded, too. "He remembered his schoolteachers' names, but there were entire parts you could not get him to discuss." Among those was his relationship with two twins, Lisa and Lynette Lavender, models who were by his side whenever he wasn't with Laumeister.

At the end, even after he gave up marijuana and cut back on his wine habit, old friends came away from encounters with Stern with the same reaction as Dorothy Tristan, who met him for a drink. She thought he was "very strange" and wondered if he had Alzheimer's. Stern called Holly Forsman in about 2004 and they had lunch. "He didn't look well," she says. "He said he was living with twin sisters." But he had the "depressed look he never lost after the drug episode. I bought him lunch. He'd bought me so many."

One of Stern's last acts was to agree to appear in a documentary directed by Laumeister, telling some of his story. They started filming in 2006. In fall 2009, they were secretly married in Las Vegas. Barbara Slate hosted a second wedding at her home in Hudson, New York. In 2010, Stern replaced a will he'd written in 1997 in which his children were the primary beneficiaries with a new one, naming Laumeister his executor and giving her control of a trust he established at the same time that would inherit all his belongings, most notably his photographs.

In 2011, Laumeister took her documentary, *Bert Stern: Original Mad Man*, out on the film festival circuit. Two years later, in May 2013, Stern called her in LA. He was sick and wouldn't go to the doctor without her. She flew to New York and took him to the hospital, telling administrators she was his next of kin. "I didn't want the crazy twins or his family telling me what to do or how to do it," she says.

But finally Laumeister told the twins that he was hospitalized and thinks they told Bert's children, and a day later, they and Allegra all showed up and learned for the first time that Bert had married Laumeister. "You don't realize you're throwing a bomb," she laments. "Threats followed. They hate me. What else would they do?" Bert's children and the Lavender twins contested the 2010 will. Citing the court fight, which was ongoing as this book was completed, neither Stern's children nor Allegra Kent will discuss him.

Stern's doctors said his problem was neurological, but as for a specific diagnosis, "they never figured it out," Laumeister says. "He couldn't walk. I knew we were days away." She moved all of Stern's negatives into storage before he was released from the hospital and sent home to die. "I thought he'd kill me," she adds, "but you couldn't move him back here with nurses twenty-four/seven. They steal." He died two weeks later.

"I felt sorry for him at the end," says Barbara Slate. "He always had chaos, and maybe it sparked him. I don't know. That's the way he lived. It's who he was. He always had a lot of pressure on him. He created it, but at the same time, it was very sad."

Speaking at his father's funeral, Stern's son, Bret, said some of his earliest memories of his father were in family court, where he was asked to make three wishes and he said he wanted toys. In retrospect, he said, he wished he'd asked for Bert Stern as his father for a day.

Part 3

INDULGENCE

The idea is to skewer as many of them as you can.

—GUY LE BAUBE

Chapter 22

"THE BIGGEST DICK
IN THE BUSINESS"

In September 2000, *Elle*, the American edition of France's great weekly women's magazine, celebrated its fifteenth anniversary with a party during New York Fashion Week. It had plenty to celebrate. Looking backward, it could have feted art director Regis Pagniez, who'd retired two years earlier after turning French *Elle*, with its five-decade legacy as a unique news-and-fashion magazine, into the world's bestselling fashion magazine brand, which was then earning over a billion dollars a year. Looking forward, *Elle* could have used the occasion to introduce its brand-new editor in chief, Robbie Myers.

Instead, the party became a celebration of the work of the magazine's chief shutterbug, Gilles Bensimon. Though he'd shot pictures for *Elle* for thirty-three years, the choice was still surprising. Then fifty-six, Bensimon is an elfin, mumbling, not-quite-handsome Frenchman better known for having married a supermodel than for having sat atop *Elle*'s masthead—above even Myers—as its publication director. A force to be reckoned with, he was quite possibly the most published fashion photographer in the world, and the man responsible for *Elle*'s extraordinary rise to America's number two fashion wish book. Within *Elle* and the Lagardère empire, which owned it (along with everything from television stations to an auto manufacturer to aerospace and defense contractors), he was worshipped. "In France, they think Gilles is God," said an executive of Hachette Filipacchi, *Elle*'s publisher.

It was all due to *Elle*'s legacy, which was defined by an insistence that style and beauty aren't limited to wan six-foot-tall white women in their late teens and early twenties, a point pounded home by the floor-to-ceiling,

room-circling grid of Bensimon photos that hung around the party at the Deitch Projects gallery. Looking down on the throng were the eclectic sorts who'd graced the magazine's cover, running the gamut from the expected—supermodels Gisele Bündchen and Cindy Crawford—to sixtysomething singer Tina Turner, coal-black model Alek Wek, smoldering Latina Salma Hayek, and suburban pop princess Britney Spears. *Elle* had championed diversity long before *Vogue* or *Harper's Bazaar*.

Bensimon's gospel said there was no bad style, no ugliness, only a failure of the eye to see beauty. "Most women in America are not skinny, blond, and six-two," he said in an interview that year. "We show the clothes," he boasted, "but also a woman who exists."

Given the magazine's power, and its potent postfeminism, it seemed a bit strange how few notables turned up to kiss Bensimon's ring. The only designers there were Nicole Miller and Tracy Feith, the only star, Sweetie, *Elle*'s "celebrity" canine columnist. But fashion was still a tight clique, and *Elle* and Bensimon were relative outsiders.

That difference made a real difference. So at the turn of the millennium, when magazines still mattered, Gilles and *Elle* were admired but also feared. And they were talked about. Indeed, two durable rumors about Bensimon illustrated why friends, associates, and exes both loved and hated him, and why the gossip-loving fashion world was both intrigued by and terrified of him. Bensimon was said to have a prodigious penis. And he was said to be quite a big dick in business, too. Indeed, several people who've known him for years describe him as a killer.

He steadfastly refused to comment on the first story.

He was boggled by the second. "I am not a killer," he insisted. "But I think sometimes I regret I am not."

Where Richard Avedon said he ran a magazine, Gilles Bensimon actually did. He'd taken over *Elle* two years earlier, and it was already miles ahead of its sisters in foreseeing and aligning itself with fashion's new global attitude. Its crisp style, clear focus, and international reach (Bensimon's photos were appearing in *Elle*s in thirty-three countries) made it wildly popular with readers and all-important celebrities—Madonna chose *Elle* for her first cover appearance following the announcement of her marriage to director Guy Ritchie.

"People criticize *Elle* saying it's only Gilles, but *Elle* is Gilles," Elaina

Richardson, the magazine's penultimate editor, said at the time. The identification was total. The curly-haired, blue-eyed Bensimon wasn't known for a style of his own, but as the living embodiment, albeit a male one, of *Elle* style, neither haute nor humble, casual but intentional.

Elle's joie de vivre, its insouciant sexuality, its Paris-bred street cred, and its obsessively clean style scared the bejesus out of the competition. Anna Wintour would be hired to remake Condé Nast's *Vogue* in 1988 and the late Elizabeth Tilberis installed as editor at Hearst's *Harper's Bazaar* in 1992 in response to the threat posed by the French invader.

Tales of those two fashion divas were well known to the public. But Bensimon was as much a mystery as he was an anomalous fashion star—a heterosexual man running a women's magazine, a Parisian who never wanted to come to America, a not highly regarded photographer who nonetheless ruled his roost. Only the keenest observers knew much about him.

"I've heard the rumors, but I cannot testify," said Myers, just after being named the twelfth editor of *Elle*. She'd certainly heard Bensimon was an editor killer; *Elle* was renowned for what its publisher, Jack Kliger, CEO of Hachette's American subsidiary, called its "editor-of-the-month club." As a longtime employee of Hachette, Myers likely also knew some thought Bensimon had gotten rid of Pagniez, until then his closest friend, whose fifty-year career in art direction ended ignominiously in 1998 when he was forced from his job.

Bensimon cultivated his image problems by being a provocateur. A lifelong boxer, he whacked his studio assistants often enough that they joked about it. He was once knocked out in the ring by another French photographer of his generation, Alex Chatelain, in payback for some of the "playful" slugs Bensimon had given him over the years. Bensimon was even said to have gotten a bit too physical with an *Elle* employee—strangling her "jokingly," as the *New York Observer* reported in 1999, inspiring her and the magazine's art director to resign. When a writer for *Talk* magazine was working on a never-published story on him in 2000 that addressed the stories about his genitalia, Bensimon called him and barked, "How you know how big my dick is unless I shove it up your ass?" He telephoned again later to blame the first call on his then wife.

Bensimon was also accused of riding to success on the backs of his wives

(a writer at *Elle* and a supermodel) and girlfriends (a fashion editor and more models). One of his ex-agents compared him to the scorpion who hitches a ride across the river on the back of a turtle, only to drown midpassage because it's unable to control its sting. "Only Gilles lets you take him to the other side," the agent said. "Then he kills you."

"It's always love-hate with him," said Chatelain. "He has a lot of charm, he's very artistic, very cultured, can be quite generous, but he can be Machiavellian. He was always into politics. He was an operator. He loves to control and manipulate. But there's an expression in French, *c'est de bonne guerre*. It's just business." And that was before he took over *Elle*.

Bensimon's new power stirred up even more envy and dislike. Many conversations about him eventually turned to what a dick he could be. The rest usually got around to his endowment. By all accounts he was penis proud. "He likes to go around naked and show his dick," said fellow photographer Oliviero Toscani. "The biggest dick in the business. I saw him naked." Others said they'd seen him take it out and twirl it to imitate a helicopter—or turn it into an elephant with an assist from turned-out pants pockets. It's supposedly tattooed with a shark, which supposedly grows into a great white when . . . well, you get the idea.

Gilles Bensimon is no shrinking violet like Irving Penn.

"I grew up in the world of image," says Bensimon, but he was born in the world of war, in occupied France in 1944. The son of an advertising art director and a painter and fashion-plate mother, he had an early learning disability, which his mother addressed by giving him art lessons so he could express himself. As an adult, he carries a sketchbook in an old brown Fendi bag, and a bottle of *encre de Chine* is always within reach.

Gilles was an insecure child. His parents separated after a move to Paris in 1945. His father didn't get along with Gilles's wealthy grandfather, Gaston, who co-owned Bensimon, the family's tony *antiquaire* across the street from Maxim's on the rue Royale. Though Gilles was descended from Algerian Jews, he attended a Catholic school, where he got into so many fights, his mother told him to keep rocks in his pockets. He escaped into the pages of American magazines and bought his first camera when he was twelve to take a picture of his brother. He's said to have never used it again, but it's also said he knew he wanted to be a photographer. His father was against it; the photo-

graphic stars of the era, the photojournalists of *Paris Match*, "were playboys in red sports cars," thought Bensimon père. "He preferred I be a painter."

"To be a photographer of *Paris Match* at that time, you were a star," affirms Just Jaeckin, who worked at *Match* as an art director in the early 1960s. "They lived, they traveled, they were close to war. To travel? It wasn't even possible to dream."

Like Jaeckin, Bensimon served in the French military at the tail end of the Algerian War. He was incarcerated in military prison. "I didn't kill anyone," he said. "I did a lot of stuff. I go away all the time. I want to see the women." In his early twenties, Bensimon worked at Club Med, teaching sailing in Agadir, Morocco. "They kicked me out for smoking pot," he said. "At this time, I did a lot of drugs." Back in Paris in 1965, he took a job as a photographer's assistant. Not long afterward, he fell in love with a staffer in the beauty department of *Elle* magazine.

A symbol of postwar France, *Elle* was founded as a newsweekly in 1945 by Hélène Gordon-Lazareff, the Russian-born wife of the owner and editor of the Parisian newspaper *France-Soir*. In couture nation, *Elle* was the bible of street chic and came to hold a special place in the lives of French women. "It was the first magazine about women," says Bensimon. It covered the Pill, abortion, and women's rights and portrayed the woman who had it all: family, career, and style.

Elle was an instant sensation in no small part because Lazareff had arranged for her first fifteen covers to be shot by Americans using color film, which wasn't readily available in postwar Europe. Its look was "unexpected and charming," wrote the art director Véronique Vienne, "not a look but an attitude. More dash than cash." Where American fashion magazines and their European offshoots, rooted in high society and haute fashion, were aspirational, *Elle* was accessible.

In its first decade, its fashion photography wasn't particularly notable. Jaeckin would eventually move into film, but he started out a still-life and fashion photographer and saw the industry change within a few years. He began taking pictures in 1964 in Paris. "At that time there were only five photographers in each country," he says, speaking of the few who mattered.

"Jeanloup Sieff was between me and the old ones," says Jaeckin. By the sixties, when Sieff lived in New York (and posed with Jean Shrimpton for

Avedon), he'd be working for several *Vogue*s and would in 1971 take his most famous advertising image, of a naked Yves Saint Laurent reclining against leather pillows.

Also known for nudes was Helmut Newton (né Neustädter), born in 1920 to a wealthy German family. Newton had a more dramatic story than most of his fellow fashion photographers—and would eventually shoot pictures that mined his subconscious memories of a spoiled Jewish childhood in Nazi Germany.

Newton bought his first box camera at age twelve. His interest in photography was encouraged by a film-cameraman cousin, and he would sometimes stalk Martin Munkácsi, then still working in Berlin. The passage of Nazi racial laws restricting the activities of Jews in Germany didn't slow Newton's visual education. He was sixteen when his mother arranged an apprenticeship with a photographer named Yva, who shot fashion and lingerie pictures and head shots of performers. One night a week, Newton was allowed to use her studio.

Newton's childhood ended with Kristallnacht, a two-night orgy of anti-Jewish violence, in 1938. His father was sent to a Nazi concentration camp. At the end of that year, his mother got Helmut a passport and booked him passage on a boat to China, one of the few countries Jews escaping Germany could enter. Newton disembarked in the British colony Singapore, where he got a job photographing society parties for a local newspaper. But as suddenly as his childhood had ended, so did his Singapore idyll when the British abruptly loaded the *Queen Mary* with Newton and others like him and shipped them all to an Australian internment camp.

In 1942, Newton was given the choice of further internment or enlistment in the Australian army. He chose the latter. Discharged in 1946, he changed his name to Newton, "driven by the ambition to become a famous photographer," and immediately opened a wedding-photo studio and married June Browne, an actress. Newton started taking fashion pictures in the fifties and was working for *Vogue*'s Australian supplement when he was offered a yearlong contract by its British parent. But its editors didn't like his work, which "was terrible and got steadily worse," so he quit and moved to Paris.

There, in 1954, Hélène Lazareff hired Peter Knapp, a Swiss artist and graphic designer, to design a magazine she'd just taken over, called *Le Nouveau Femina*, and in 1959 moved him to *Elle* as its artistic director. Influenced by Brodovitch, he revamped the magazine. "She could tell that I was a fan of the opposite sex—that I looked at women more than at their clothes," Knapp has said. "She wanted me to give her magazine the imprint of a straight man's sensibility. In the rarefied fashion context of the time, this was a revolution."

Knapp, who dated Nicole de Lamargé, the top French model of the era,* attracted a team of straight male photographers who collaborated on the magazine's "upbeat, friendly, youthful and seductive" look, wrote Véronique Vienne. "This strategy brought the weekly circulation of *Elle* from six hundred thousand in 1954 to 1 million in 1960. One French woman out of six was a regular *Elle* reader." But *Elle* was a double-edged sword. "Knapp's smart, cutting-edge design, while fostering a perception of avant-gardism, masked the subtle sexist subtext of the editorial message. How to attract and please a man was the driving force behind most of the articles."

Unfortunately, Helmut Newton did not attract or please Knapp when he came to show him and Fouli Elia, an *Elle* photographer, his portfolio. On his way out, he reported, "I was followed by their hollow laughter." Knapp later damned him with faint praise, saying, "I was a pretty good technician," Newton remembered.

Newton learned fashion from the French, but in his autobiography spent as much or more time writing about Parisian prostitutes as fashion editors. "There is something about buying a woman that excites me," he said. His wife, June, apparently understood his desires, including his lust for fame in fashion, and supported him when he chose to reject studio work and advertising.

The Newtons returned to Australia. His contract with Australian *Vogue* made him a nice living and he shot for American *Vogue*, which had sent a young editor to Australia as an envoy to meet the staff of its local edition.

*De Lamargé would later marry a *Paris Match* journalist and die in 1969, in a car crash in Morocco.

"Usual *Vogue*, they said while you're there, take some clothes, and Alex Liberman assigned the photographs to Helmut," says Grace Mirabella, who found him to be a "nice man" who "had it all planned out." But Helmut wasn't happy and, in 1961, returned to Paris, where he went to work for British and Paris *Vogue*, as well as *Queen* in London, and advertising clients such as the trendy London shop Biba. Aside from a two-year hiatus when French *Vogue* broke ties and he briefly shot for *Elle*, he remained at Condé Nast's French flagship for more than two decades. But not until the early seventies did Newton find his métier and become a superstar.

Chapter 23

THE MOB

Hélène Lazareff met Gilles Bensimon, then twenty-three, through his new wife, Pascha. He'd met Pascha in Just Jaeckin's studio. Jaeckin had encountered Bensimon when he was a GO, or *gentil organisateur*, one of the employees whose job is to embody Club Med's spirit at the holiday company's resorts, and Bensimon followed the photographer home.

Pascha bought Gilles his first Hasselblad, showed him his first *Harper's Bazaar*, and helped him become a fashion photographer, booking untried models for test photos, doing their makeup, and styling his pictures. "At first we worked on weekends," says Pascha, later the owner of a Paris ad agency. "I thought he was so talented. A special sense of style and elegance. After a few months, he started to work for *Elle*." When Pascha moved to an ad agency, Bensimon began shooting ads, too. He spent time in New York and Germany, but always returned to Paris.

"I was bad," he's said. "I had girlfriends. Sometimes I work for *Elle*, sometimes they kick me out. I don't think Peter Knapp liked me very much. He probably didn't care about me. But I was doing well." Knapp had actually left *Elle* in 1966 but went back as art director in 1974, which may explain why, in *Les Années Elle*, a coffee-table book on the magazine's history, no photographs by Bensimon taken before 1982 appear. Knapp's own photos fill the pages on the sixties; he not only hired photographers such as Brian Duffy and Sieff, he was one himself.

Bensimon fell in with a loose agglomeration of aggressively heterosexual fashion photographers who, though they hailed from all over, would become known as the French Mob, the French Connection, the French Mafia, or just the Frenchies. At its core were his countrymen Patrick Demarchelier, Alex Chatelain, and Pierre Houlès; Mike Reinhardt, the

California-born grandson of the German film director Max; British-born John Stember; and a German, Uli Rose, whose father and grandfather had both been photographers. Rose had followed a girlfriend to Paris from Düsseldorf when she got a job as a model agent. On the Mob's periphery were another American, Arthur Elgort, and Jacques Malignon.

They were "the new wave," Jaeckin says. "Malignon, Patrick, Bensimon, were my assistants." Working out of doors with available light, 35 mm cameras, and telephoto lenses, they made fashion photos on the cheap. "They arrived and said, 'I'll do shots for two hundred dollars,'" says Jaeckin, who charged five times that amount. They were the generation attracted to fashion by *Blow-Up*. "I was terrified of them," said model Marie Helvin, David Bailey's third wife, whom he married in 1975 after splitting with Penelope Tree. "They were so outrageous. Whether it was true or not, the story was that they all had mattresses in the studio."

Demarchelier grew up in Normandy, near Le Havre, got his first camera when he was a teenager, and learned to print and retouch by working in a provincial camera shop. He moved to Paris and another photo lab in about 1963 and, within a year, became an assistant. "I didn't want to be stuck in a shop all my life," he says, so he started visiting modeling schools, and he got a job taking test photos for neophyte models in a little studio on the premises of a modeling agency, "thirty girls a month," he says. "I had to do a book for each girl. Some could never be models. So that's how I got involved with fashion."

That's also how he met Jacques de Nointel, the son of an Arab-affairs educator who would become a notorious Parisian model scout and model chaser. De Nointel was putting together a stable of photographers and trying to be an agent. He vaguely represented a few French Mob shooters. They were disdained by members of the generation that preceded them, who disparaged the newcomers' lack of studio skills. Meantime, the Mobsters picked off their pages.

In 1970, de Nointel hooked up with John Casablancas, a child of wealthy Spaniards who'd become refugee jet-setters at the start of Spain's Civil War.

Casablancas, who had a model girlfriend, had just opened a small Paris modeling agency and thought he might represent photographers, too. De Nointel had played fast and loose with his photographers' money. "It was a mess and the photographers caught up with it and decided to leave him, so that's where I came in," Casablancas said many years later. "I took over, adding a few people."

Mike Reinhardt first met Nointel at a competing modeling agency run by the former model Dorian Leigh. While attending law school in the south of France, he'd met and married a beautiful girl, who was discovered on the street by the agent Eileen Ford and started modeling in Munich, where Reinhardt was writing a doctoral thesis on international law. The money she made "was immediately astounding," Reinhardt recalls. So they not only moved to Paris, he went to work for Leigh. "I saw all these incredible girls around me. I was a young guy. I was blown away. It destroyed the marriage" when he had an affair with a Helmut Newton model. "Then one day in walks one of the most beautiful girls ever, Gudrun, and behind her, a noisy guy in a leather jacket and aviator glasses, and it was Jacques. I was reluctant to become Jacques's friend. He had an obnoxious edge that scared me. But he had a good side."

De Nointel "made Mike a photographer," said Casablancas, but Reinhardt says, "I don't think it would be correct to say that Jacques 'made me.' There might have been some occasions when he used his influence to help my career. My road to photography was mainly shaped and influenced by two things. The first was, of course, my fascination with beautiful women." Working for Leigh, Reinhardt saw the *Blow-Up* effect in full blossom. "These guys were all off in Nassau with pretty girls. I thought, 'I really want to take photos.'" Fortunately, he "had enough money to take time off and learn." He was mentored by Louis Faurer, who'd been shooting fashion for years, but had recently given it up and moved to Paris.* "If anyone really 'made me,' it was Lou," says Reinhardt. "He helped me develop a personal style and then encouraged me to take up photography as a professional."

Reinhardt simultaneously worked as a photo agent, representing John

*Faurer left his negatives and prints with a friend in New York when he moved to Paris and despite constant importuning never picked them up. They were presumably destroyed.

Stember, and started a design business, through which he met photographer Jean-Louis Guégan. Guégan's then-assistant would become Reinhardt's best friend and one of the most influential, if least known, figures in fashion photography in the seventies.

Pierre Houlès grew up in Béziers, in the south of France, moved to Paris at thirteen, and at seventeen became a Studio Guégan assistant. In 1964, he joined the military for mandatory service, working in a cinematographic unit. There, he befriended Claude Guillaumin, an aspiring architect. In 1966, Guillaumin and Houlès returned to Paris. "He showed me the studio where he was an assistant." There was a lingerie shoot going on. "I have to do this!" Guillaumin said. Briefly, both worked as assistants. Houlès, more advanced than Guillaumin, next worked for Guy Bourdin.

Bourdin, already a shooting star, had been abandoned by his mother as an infant and was raised by his paternal grandfather, who owned land in Normandy and a Paris brasserie. Guy was a solitary child who liked drawing and became an aerial photographer in the air force. After serving, he took a job selling camera lenses at the Bon Marché store in Paris and started showing drawings and photographs. He was encouraged by Man Ray, who said he was "more than just a good photographer," after the neophyte knocked on his door seven times before finally being allowed in.

Bourdin caught the eye of an editor's assistant at French *Vogue* with black-and-white photographs of the buttocks of nude men and women. He started shooting for the magazine in 1955; one of his first photos was of a model in gloves and a conical hat and veil beneath the decapitated heads of five slaughtered calves hanging from chains in a butcher shop window.

Despite a negative reaction from readers and advertisers, Bourdin would become and remain a mainstay of French *Vogue* for the next three decades. When Houlès went to work for him, he was mostly shooting beauty photos, but was also experimenting with surrealism. His perverse humor was balanced by a refined sense of composition and his "hyperreal look created by using flash in a very harsh way," says an assistant, J. P. Masclet, who admired his ability to create "incredibly clean images, despite content that was disturbing but not dirty."

In years to come, Bourdin and Helmut Newton would compete in pushing the outer limits of acceptable content in fashion photographs. Both

insisted on artistic control of their pictures. Bourdin would often present French *Vogue* with a single image and destroy his outtakes by cutting them in half so they couldn't be used. He was also a sexual bad boy, worse than the apparently faithful Newton. On a trip to New York, Bourdin began an affair with his twenty-year-old assistant and, when back in France, left his wife and young son for her. Two years later, he would leave that mistress for a model, and some time thereafter, his wife would die. Accounts differ on whether it was suicide or a heart attack. It would later be reported that he reconstructed her death scene in a photograph for a Charles Jourdan shoe ad.

Bourdin was a loner. Houlès and the rest of the next generation of young Parisian photographers all bonded, often assisting each other. "They wanted each other to succeed in the beginning," says model Bonnie Pfeifer, who became Elgort's girlfriend. "They shared information. They were competitive, but they took that out on Ping-Pong tables." Patrick helped Mike. Uli assisted Patrick and bonded with Elgort, who "had a tremendous influence on me," Uli says. Patrick shot young models for Casablancas. Claude Guillaumin and Pierre Houlès went to New York City together. A similar spirit abided there, says Joan Juliet Buck, a young editor at *Glamour*. Buck fell in with a group of young Frenchmen she met through her first boyfriend in New York, Jean-Paul Goude, an illustrator who'd just been named the art editor of *Esquire* magazine. "My gang," as Buck calls them, included Bourdin, Houlès, and Guillaumin.

Houlès had announced to Guillaumin that "all the best photographers were in New York, his sister was married to an American, and we should go to New York, so we went," Guillaumin says. That sister, Valerie Unger, found them an apartment, and they both went looking for work as assistants. Like David Bailey, Guillaumin would hock his camera when he needed money to live. Houlès went to work for Bill Silano, a Brodovitch protégé who had a studio nearby and worked mostly for *Town & Country* and *Harper's Bazaar*. An art director at a Paris advertising agency where Guillaumin had worked arranged an introduction to Miki Denhof, the Austrian in charge of visuals at *Glamour*. For his first job, she hired Cheryl Tiegs, "one of her best models at that time," Guillaumin marvels, "so for me it was really easy. Really fast."

He worked with *Glamour* for two years, and later, for *Seventeen*. "*Bazaar*

wanted to use me, but I was so afraid, I didn't call back. If I make a mistake for *Harper's Bazaar*, it's over!" Guillaumin also assisted Bourdin on his trips to New York. Soon, Guillaumin and Houlès moved into a studio in Carnegie Hall. Guillaumin stayed until the end of 1970. "When I started making money, I went back to Paris and worked for *Elle*." Houlès was different. "He wasn't interested in photography, he was more interested in girls," thinks Guillaumin. "He had a lot of romances, I don't know, hundreds."

"Pierre worked if he wanted to," his sister Valerie says. "If he didn't like you, if he didn't like the project, if he didn't like the girl, he didn't do it. He was very independent. My husband offered him a studio. He said he had no wife, no kids, he wanted no responsibility. I never understood how he did it, but he was always in cashmere, the best shoes from John Lobb, using Hermès appointment books." And then there were his women. "He was very chic and good-looking," says his sister, "with blue eyes, dark hair. He always had a girlfriend and unfortunately, sometimes, two at a time."

Back in Paris, John Casablancas took eight or nine of his photographers' portfolios—big, heavy wooden cases—to Germany in his Porsche Carrera in July 1970. "I went to see all the advertising agencies for four days and on the fourteenth of July," Bastille Day, got back to Paris at 2:00 a.m. and decided to leave the heavy portfolios in his car overnight. "It was the stupidest thing," he admitted. The next morning, the top of his car was slit open, and the portfolios were gone. He immediately sold the business to Gerald Dearing, an uncle of Patrick Demarchelier's who'd been raised as his half brother, who'd been working for Casablancas. "John wasn't that interested," Dearing says. "He didn't have the time or the eye for it." Instead, Casablancas opened a new modeling agency called Elite.

Dearing, Demarchelier, Uli Rose, Chatelain, and Bensimon pooled their funds, bought a large apartment on the rue du Mont Thabor, a block from the Tuileries Gardens, and created a photographic studio cooperative, Atelier de Tuileries. Arthur Elgort wasn't a partner and preferred to work outside, but he would use the Atelier, too, when he came from New York and had a studio job. But mostly, the traffic was in the other direction; almost immediately, the French Mob discovered America. Their pied piper was a seventeen-year-old American, Bryan Bantry, who showed up in Paris in 1973, seeking to represent Chatelain.

Bantry was the ambitious son of a fashion model, Soames Bantry, who was the girlfriend and muse of Saul Leiter. "I grew up in his studio, I went on location, I was on the cover of *Queen* when I was eight," Bantry says. At thirteen, he started a dog-walking business. Three years later, bored with it, and with Leiter's constant grumbling about his agent, "I said I'd do it and he let me." At sixteen, he was naïve enough to think he could help the irascible Leiter, who'd been "so awful to so many," Bantry says. "It doesn't matter how talented you are if you're unpleasant and argumentative. Clients don't want to be around you. There's always someone else, not as talented, perhaps, but good enough." The French photo Mafia fit that description.

The model agent Wilhelmina took a liking to Bantry and suggested he seek out Chatelain, who introduced him to Demarchelier. Chatelain was impressed that Bantry knew his photographs. "They all had an eye on coming to the States," Bantry says. "At sixteen, I left home and never talked to [Soames or Leiter] again." He took a studio on Madison Avenue for $195 a month and became a photographer's agent, or rep, in the parlance of the day.

The photographers streamed across the Atlantic. "They were all starting," says Bantry. "They all worked for *Glamour*, *Mademoiselle*, and *Seventeen*." And they all mixed work and play. Houlès was their role model. "He was so good-looking and the rest were not," says a model. "He got the chicks and they followed him because they wanted to get laid."

Demarchelier played the field, dating lots of models. "You meet the people you see every day," he says. "Doctors meet patients and nurses." But unlike his fellows, he insists models weren't his priority. "First, I liked to make money," he says. "Girls weren't the most important thing. I loved the work, the magic of the picture. After, you realize there are models. You like women. It's a lucky thing. I'm a lucky guy."

"I wouldn't call Patrick nice," says Louise Despointes, a top French model who stayed in fashion as a modeling agency owner. "He plays very well the game, he's a very smart guy, he liked money, and he likes to be famous." He also liked models. "He saw every new girl. He was all over the place. He was always with the new Swede in town. Not the top girls, though. He tried, but it didn't work for him. This macho thing is pretty French. To exist, you have to chase every girl, and if they told him to get lost, they didn't get the job unless he was obliged to use them. But he always tried."

Demarchelier would play the field openly until 1981, when he married a Swedish model, Mia Skoog. Then, he played more quietly. "He managed to wiggle his little affairs no matter how much Mia was on him, and she came to a lot of shoots," says fashion editor Lizzette Kattan. "Don't get me in trouble with Mia," he once warned a writer at the start of an interview. He got into trouble often enough himself that industry gossip has it that Mia owns an extensive jewelry collection. Demarchelier could afford it. Other photographers admired how he handled himself. "I'm the exact opposite of Patrick," said Alex Chatelain. "I never think things through. He's in control of everything."

Success "started rather quickly," says Mike Reinhardt. At first he was "barely scraping by." But then, like Demarchelier, he started getting jobs with Italian magazines. "One day in Milan, after three or four years, I walked into the Hotel Diana and there are two girls in the lobby and one of them said, 'That's Mike Reinhardt,' and I had almost a heart attack of joy."

In 1970, after his wife left him, he hooked up with another model, named Beska, whom he stayed with for the next five years. Though he kept an apartment in Paris and traveled constantly, they moved to New York that fall. "They heard about us, the Frenchies doing something in the States," says Claude Guillaumin. "It was freedom, freedom, freedom. Homosexuals, blacks, music, girls, marijuana. It was love."

Freedom meant temptation. Reinhardt says he was "being a good boy, relatively," but "I was unfortunately neurotic enough to fall in love and I couldn't be completely faithful. I didn't realize monogamy was necessary for a relationship until much later. It's hard to be monogamous in your twenties. Models are prepared, in many cases, to fuck for work. It's easy to do with a young, sympathetic, attractive photographer. It's convenient."

Meantime, Demarchelier had followed Reinhardt to New York, sometimes sleeping on the couch in the Carnegie Hall studio Pierre Houlès shared with his then girlfriend, model Viviane Fauny. "I didn't speak English," Demarchelier says. "Doors were closed. I had to redo everything. It was difficult." But Reinhardt helped him, they both started working for *Glamour*, and in 1972, Houlès told Reinhardt that an advertising photographer named Art Kane was abandoning his Carnegie Hall studio, and Reinhardt took it over.

Reinhardt and Demarchelier were hard workers; Houlès, not so much. "The rest were more interested in money," says his sister, Valerie Unger. "Pierre wasn't." He loved to travel. "He was all over the place." He also loved women, particularly models, and they him. "I prefer women to photography, and I'm always available to seduce them," he told the journalist Jean-Jacques Naudet.

Houlès seemed to know it all. "Stay away from this one and that one," he instructed a model he slept with. "Don't be like those models." And he was manipulative, playing models and model agents against each other in what is usually described as mind games. John Casablancas came to despise him, considering him "a shit because he was a guy who didn't like money, didn't like anybody, didn't like his own shadow." Houlès's sister, Valerie, in turn, calls Casablancas "a nasty piece of work," but admits that her brother "was really opinionated." Did he know a lot about the model business? Valerie Unger ponders that a moment, then says, "He probably thought he did. Those girls were very young. They were in love with the guy. They followed."

Model Christie Brinkley was an art student when she was discovered in Paris in 1973 and began working almost immediately, with Reinhardt among others. He told Eileen Ford about her, and Brinkley moved to New York, where she shot multiple covers of *Glamour*, won a spot in the influential *Sports Illustrated* bathing suit issue—a star-making vehicle for models— and a contract with CoverGirl cosmetics.

After five years with Beska, Reinhardt lived with model Barbara Minty for four years. When they broke up, she took up with another French photographer in New York, Jacques Malignon.* He shared a studio with Patrice Casanova, who first took test photos of Reinhardt's next model girlfriend, Janice Dickinson, who had dark hair, big lips, small eyes, and major attitude. Dickinson and Brinkley became pals, and Dickinson sometimes photographed her when they did shoots together. She showed Brinkley's pictures to Houlès, "and of course, they ended up in bed," Dickinson recalled.

By 1979, Brinkley was living with Houlès in Paris, unaware that Viviane Fauny was still sharing his Carnegie Hall studio. When she found out,

*In 1977, the actor Steve McQueen saw Minty's photo in an ad and arranged to meet her. She later married McQueen, who died in 1980.

she had a brief rebound affair with Reinhardt that she came to regret but, perhaps, shouldn't have. That year, Pierre's sister had a birthday dinner in a private club and Houlès drove her crazy, dithering over which of his two girlfriends he should bring. "Christie showed up, thank God," says Valerie Unger. "She was well known and beautiful. My husband asked Pierre, 'How can you cheat on a girl like Christie?' Pierre said, 'She has short legs.'" In the aftermath of the romantic roundelay, Dickinson and Reinhardt broke up, and he and Houlès didn't speak for years.

Reinhardt and Houlès wreaked havoc on their girlfriends' relationships with their agents; they advised the girls to be tough with them. Former model Louise Despointes was shocked when Houlès and Gilles Bensimon let her know that they expected to be paid the equivalent of a finder's fee for delivering Brinkley to her new modeling agency. "Gilles was not yet powerful," Despointes continues. "Their only power was, sorry, fucking top girls. They threatened, 'We won't use your girls.' I said, 'Fuck you all, I don't care.' Christie did come with me," thanks to Reinhardt, who she thinks won a psychic arm-wrestling match with the others over her. "Mike was much cooler than Gilles Bensimon," says Despointes. "Mike made it through the girls, too, but he had a jolly hippieish way; the others were much more vicious. And Pierre liked to flex his muscles with me because he wanted to go out with me and I always refused. I loved him as a friend and was sad he mixed the two," work and personal relationships.

Chapter 24

"YOU'RE GOING TO BE HUGE"

Five foot ten, with auburn hair and blue-gray eyes, Patty Owen was a sexually precocious athlete—a high jumper in training for the Olympics—when she came to New York in 1979 to model. Two weeks later on a go-see, she was raped by a fashion photographer she won't name. Then, he tried to befriend her, and "I succumbed," she says, "thinking that would make it okay." Then he raped her again, only the second time he drugged her first. So going to Paris meant escaping a fire, even if she landed in a frying pan. "I was very happy to leave my rapist and heroin-ridden models hanging out with William Burroughs," she says.

She spent the next two years in Paris, where she met Pierre Houlès and a more important Parisian shooter, François Lamy, on a go-see. "Let's 'go and see' if the photographer wants to screw you on a trip," Owen jokes about that term. "Of course, I wasn't aware of that yet." She did a trip with Lamy, and he booked her again the next week when she was also offered a trip to Mexico with Houlès. "He wanted me to cancel and work with him, so I go to Mexico, I'm having fun with the editors and other models. We had to sit in the sun for three days to get tan, and Pierre's very nice, interested in my life, sympathetic and understanding, and then the shoot starts and he turns into an utter monster, screaming at us. 'You look like fucking cows!' Just berating and degrading."

At the end of the first day of shooting, a dinner was planned, but when the group gathered in the hotel lobby, Owen appeared with a packed suitcase and demanded to be taken to the airport. "Ah, c'mon, Patty, this is just the way I shoot," Houlès said. "You're new; you don't know what you're doing." When she again demanded to go home, he sat on the lobby floor and apologized and said he would "try to be somebody I'm not because you're going

to be huge. You have an amazing body." She agreed to stay another day on condition he behave. "He was such a good boy," she says, "after a couple of days, I started sleeping with him."

His seduction began with innuendo. "Stop the bullshit," she told him. "He said, 'I have such a small dick, it won't hurt you. You won't notice it. You had a black boyfriend.' He said it several times over a couple days." She wondered if he said that to all the girls. Then they had sex, and "I realized he wasn't kidding," she says, "and therein lies his Napoléon complex. It was so small that to this day, I've never again encountered anything like it. My pinkie, when erect. I felt sorry for him. Was this God's way to keep him humble?"

Houlès was fourteen years older, "which seemed really old to me," she says. But he was so handsome. "Very handsome, very charming, and he had the time to seduce because he wasn't working. His girlfriends made the money." Back in Paris they had dinner, and Houlès and Lamy both urged her to join L'Agence, an offshoot of Elite owned by Casablancas.

Owen did, but kept frustrating Houlès. She met a wealthy Frenchman named Thierry with a Harley, and they were a couple by the time Houlès called again. He demanded she join him for dinner because he'd met her first. "Trust me, you're going to make it," he told her. "Don't waste your life with a rich kid when you'll have travel, covers, famous friends, artists and writers." And "he seduced me," she says, "and I end up sleeping with him again."

A month later, Houlès was back. Again, she refused to see him. But her boyfriend became Houlès's unwitting accomplice. "He wants to be a photographer," says Owen, so the next time Houlès called and complained his assistant had just quit, Owen told Thierry even though "I knew in my bones it was a bad idea," and he got the job.

"I knew I was in trouble," Owen says. "I felt sick. It was Pierre's way to stay close. We'd go out to dinner, the three of us, and he'd have his hand up my dress under the table. 'Follow me to the bathroom. You don't call me anymore.' I'm still feeling sorry for this guy with his little dick, and I'm afraid of being blackballed because to me, he was pretty big." They hooked up sporadically for the next three years. Then she moved to New York and her boyfriend joined her and "I became his sugar mommy," paying all

the bills, she says. "Pierre encouraged it. He said, 'You girls make so much money! C'mon, share!'" At twenty-two, she developed ulcers.

Owen understood that her secret ménage was a problem and again tried to break with Houlès. In response, he turned aggressive whenever he saw her, "grabbing my tits, kissing me, 'Why won't you see me?' And Thierry saw my face. He smelled the truth."

"Is it true?" he demanded. She told him to ask Houlès. "Eh, yes, sometimes, I'm a man, but, you know, I met her before you," Houlès said. Then he asked Patty, "Happy now?" She stayed with Thierry until *he* got nasty, demanding money. That was Pierre Houlès's mantra. Thierry was history.

Owen knew the whole Mob and shot with most of them, but not Reinhardt. "Never such a cold go-see," she says, "and Mike is notoriously *chaleureux*, very warm with the girls." The others wouldn't go near her off set. "I think I got a pass because they all knew I was sleeping with Pierre. He didn't respect their girls, but they respected his."

One night Houlès said, "You know, Christie, she hates you. She knows I'm fucking you."

"Isn't she fucking Mike?"

"Well, she loves to see me, too."

"He loved to stir up shit," Owen says. "His biggest turn-on wasn't sex; it was a power trip." And his power base was the Mob. "He couldn't be bought and all the others were, so they listened. 'Fuck these people and this bullshit business.' *He* held on to his artist's roots. *They* made a fortune."

Pierre spread stories about Bensimon, Owen thinks, out of penis envy. "Gilles had a big dick," she says. "I saw it in pictures."

Louise Despointes liked Pierre Houlès so much she set him up with the only woman he married, Josie Borain, whom Despointes had brought from her native South Africa to Paris in 1982: "She was staying with me, and Pierre was after me again, so I put Josie in his arms so he'd leave me in peace."

"I was very young, I didn't speak French, I was a handbag," says Borain. "She was invited to dinner by Pierre and brought me along. She didn't want to be alone." After dinner, they visited a peep show near the rue Saint-Denis in Paris. There, the two women's stories diverge. "I put them in the same booth and she flipped, it was love at first sight," says Despointes. "I left and they were together for quite a long time."

"We were never alone" and never in a peep show booth, Borain says. Houlès called her sometime later, took her to La Coupole for lunch, and they clicked and were together for the next few years. She knew Houlès was a player. "I knew some of the women he fucked," she says. She lived with him, but "I never worked with him and he didn't work that much. The industry is a bit of an ass-lick and he didn't like it. He was doing more documentary stuff," photographing artists and boxers. But Houlès became her adviser: "Pierre was eighteen years older, he was my guru."

Borain moved into Carnegie Hall with Houlès in March 1983. She started out with Ford Models, but only stayed for two months. During that brief tenure, the Ford family realized, in the words of the agency's president, Jerry Ford, that "she was getting other advice." It led her to another agency, called Click, which had offices in Carnegie Hall. Agents there introduced her to the photographer Bruce Weber, who shot for the wildly competitive Bronx-born fashion designers Calvin Klein and Ralph Lauren.

Borain shot many photos for Lauren that year, while also modeling in-house for Klein, as a sort of muse, since Click wanted her to belong to Lauren exclusively for advertising. According to court documents, Click tried to win her a contract with Lauren while she was privately discussing a similar arrangement with Klein. In the meantime, she and Houlès talked about taking a year off and driving from the northern edge of Europe to the southern tip of Africa. They went so far as to get married so Borain could get a French passport that would allow them to cross borders freely. Houlès encouraged her to tell all concerned she'd decided to quit modeling.

When Borain told Klein, he asked, "What if I made you an offer you can't refuse?" She and Houlès continued planning their trip. But just before they were set to leave, Klein reappeared, offering her a $1 million, three-year contract. Houlès urged her to sign. "He said Africa's always going to be there," Borain recalls. The deal with Klein was made without Click, and when its principals learned of Borain's end run, Click claimed it had negotiated a much better deal for her with Lauren and sued. Borain claimed, then and now, she knew nothing about any Lauren deal.

Months later, just before the case went to trial, Klein settled and paid commissions to Click. Borain says she wrote a check, too. Joey Grill, one of the agency's founders, is unsure what role Houlès played in the drama. "She or he

didn't want her to pay commissions," he thinks. "That, I felt, was the crux of the matter." Louise Despointes thinks there was more to it than that. "I know [Houlès] got money" from Klein, she says. "He told me after he left Josie."

Josie says she left him due to the disparity in their ages and experience. "I was at the beginning of my career and he'd done it all already," she says. Soon, Houlès installed another model, Julie Nelson, in his Carnegie Hall studio, though she says their relationship was platonic. Meantime, Borain realized she still loved him, and they discussed getting back together. "He was definitely ready to settle down," Borain thinks. "We were talking about having a baby." She finds it hard to believe Despointes's story that Houlès made money off her Calvin Klein deal. "Very unlikely. Pierre never met Calvin." Borain felt his manipulative days were over. "I never knew that Pierre. I found an older, wiser Pierre."

Nelson, on the other hand, found Houlès in full. "The things he'd say about people!" she marvels. "He treated women like garbage." He called the latest girlfriend of Gilles Bensimon a "pinhead," and fashion editor Grace Coddington a "two-faced bitch"—a particularly nasty swipe as Coddington had had facial-reconstruction surgery after a car crash. Even his photographer friends got the Houlès treatment. "Everyone thought they were his best friend," Nelson says. "'Ugh, Patrick's coming over. . . .' He was their leader because he didn't care."

By 1986, Houlès had bigger problems than his conflicts about the world he inhabited. "Something's not right," he told Nelson one day. "I don't feel well. I can feel my body rotting." That August, he was in Paris and went out for a run; he was training for the New York City Marathon. "He was supposed to go to the airport to pick up our father," says his sister. "He didn't show up." His body was found in the Bois de Boulogne, where he'd fallen, dead at thirty-nine.

<center>❦</center>

Gerald Dearing bailed out of the Atelier de Tuileries and went to Los Angeles to try to make movies after Uli Rose sold his share of the studio to another photographer, André Carrara, using Bensimon's lawyer. Rose made a bad deal and felt cheated. "There was a big disagreement," but it's "water under the bridge," says Rose, who later worked for Bensimon at *Elle*. "I have

no animosity. But you know what? You get four fashion photographers in a room, you have problems." Dearing had had enough, though, and still hasn't forgiven Bensimon. "Gilles had fights everywhere," he notes. "If there's a fire, he lit the match."

Later, one of Gilles's brothers lived in the former Atelier—"a divine apartment about a block from the Tuileries," Bensimon says with faraway eyes. "I do so many bad things in this studio." Then he laughs sharply. "I don't remember!"

Despite his boasting, Louise Despointes thinks Bensimon cared more about power than women or photography: "Gilles saw where his niche would be—to use women. He went out with editors and plugged into *Elle*. He is part of the degeneration of this business. He brought mediocrity because he couldn't compete with genius, but luck turned his way."

Dearing wasn't impressed with Bensimon's photographic skills, either: "He was not better or worse than the others, but he was driven." That set up a wall between Bensimon and his fellow Frenchies. He also lived a different life. "I was very bourgeois," he claims. When the others were off with models ("The idea is to skewer as many of them as you can," a peripheral mobster, Guy Le Baube, once said), Bensimon would head home to Pascha, their baby daughter, and their apartment on the Place de Bourbon, across the street from French *Vogue*, or a fifteenth-century castle they'd bought in the country, where he would cook dinners for friends. "Everything had to be perfect," says Dearing, "underdone, but in a European way, so the wire to the lamp had to be twisted just so."

Appearances deceive. Just before Alex Chatelain left Paris for New York in 1976, he and Bensimon took a trip with a stylist for *Depeche Mode*, Douce de Andia. "She was quite beautiful," Chatelain remembers, "with beautiful, huge breasts." He and Bensimon dared her to bare them in a stuffy provincial restaurant as they were heading back to Paris. "She did it," says Chatelain. "The waiters didn't know what to do. I think that's where she and Gilles started."

Bensimon says he and Pascha had drifted apart. Pascha remembers it differently: "We separated because of Douce. He told her he was free and he was not. I asked him to go away." But any hard feelings have long since departed. "I brought him a lot, but he brought me a lot," says Pascha. "I had a fantastic time with him."

Chapter 25

"EVERYTHING IS A FASHION PHOTO"

Paris had two schools of photographers in the midseventies. The Mobsters couldn't have been more different from the flash-style photographers such as Guy Bourdin and Helmut Newton, whose images were stolen moments from dangerous artistic, individual fantasy narratives that happened to include fashion. To create his, Bourdin collaborated with his models—or at least those who could pass the tests he set for them, "keeping them working under tricky conditions, of light, position, and body language," says his assistant J. P. Masclet. First among them was Louise Despointes.

Bourdin was her teacher, her mentor. "Every night to his house," she says. "Guy had the most ideas and was the least constrained. He was the most instinctive. The others—Horvat, Sieff, Newton—were intellectual. Guy laughed. It was emotion. His mind would go. Guy was not mediocre. Guy was not crazy. He would send me to museums. He would make me paint. He would make me have opinions. He had ideas that were out of this world."

One night, he stormed BHV, the grandest hardware store in Paris, at 2:00 a.m. so he could build a wall with a window in it in the *Vogue* studio for a single shot the next day. He stationed Uli Rose, who was assisting, behind the window and ordered him to throw out paper airplanes, one after another. Bourdin was testing Rose and he failed. "That was Guy's spirit. He felt Uli didn't have it in his belly to be an assistant," says Despointes.

"He was right!" says Rose, who'd turned down a job assisting Horvat when he first arrived in Paris. "He showed me a coal cellar and said paint it white and learn French in three weeks," Rose recalls. "I declined." That day with

Bourdin, which stretched into the next night, "what broke the camel's back," Rose says, was Bourdin's insistence on playing and replaying the side of Isaac Hayes's 1969 LP, *Hot Buttered Soul*, that included the song "By the Time I Get to Phoenix" "again and again and again," says Rose. "The whole night. It was taking hours. I turned the record over and he flipped out." The memory inspires others. "He was really bad. He never paid. Did you know he didn't pay his taxes and they confiscated his cameras? He told them, 'You can't take Beethoven's piano away!' But he was a genius in his way. And I learned from Guy. He said, 'Everything is a fashion photo.'"

Bourdin and Despointes were well suited. "He liked perfection," she says, and she learned to do his bidding, no matter how difficult or dangerous his ideas seemed. "You could think he was a sadist, but he wasn't. People say it was misogyny, but it wasn't. He was not nasty to people he cared for, but there were very few. He would make me walk through glass, but I understood that was his work, his vision."

Bourdin cut her off, however, after she dared work with Helmut Newton.

Newton's relationship with his wife, June, fascinated Despointes. "Helmut thinks, he constructs," Despointes says, "and his wife is the drive behind him; he doesn't move without her. She used to paint what became his shots. She painted his fantasies. You could be crazy with Guy." But not with Newton. "Only in his pictures, not in his private life at all."

Despointes's longtime boyfriend Steve Hiett, a British rock musician inspired by Bourdin and Newton to become a Parisian photographer, felt the same: Newton "never got involved," Hiett says. "His whole thing was, he didn't want to know the model because it would interfere with his fantasy. The whole thing happened while he was taking the picture. He got his rocks off and it was over. It was voyeurism at its highest level."

Newton and Bourdin stood at one end of the Parisian spectrum. At the other were the daylight photographers Dearing represented, who made grainy pictures with their long lenses of adorable blondes. Despointes drew a line between the deep, dark, well-marinated concepts of Hiett, Newton, and Bourdin and the apparently thoughtless happy snaps of the new crew in town. "Creativity was leaving and a new era was starting," she thinks.

Back in America, Diana Vreeland's fabulous but expensive extravagance had abruptly fallen out of fashion at the same time the French Mob was forming. "It was like trying to catch up with a wild horse," said Alexander Liberman, who'd belatedly seen the wisdom in Carmel Snow's doubts about Vreeland. "Everything was extravagance and luxury and excess. She was given too much power; she took too much power. I was the editorial director," he lamented, but he was impotent in the center of the storm of the free-spending Vreeland and "her court of admirers." Avedon's trip to Japan with Polly Mellen and Veruschka was said to have cost $100,000. Another time, Vreeland sent Bailey to India to shoot white tigers and never ran the resulting photos. As the bills mounted and income shrank, the businessmen at Condé Nast saw red—and not only on the walls of Vreeland's office. "I know how to handle those men," Vreeland assured an underling. "When they get this way, you just give it to them back." But "Liberman didn't trust Vreeland with anything anymore," her assistant Grace Mirabella thought.

In May 1971, Vreeland was summoned to the office of Condé Nast's latest president and abruptly demoted to a consultancy, but really fired as editor of *Vogue*. At a meeting with Si Newhouse, they stared at each other "for what seemed like a very long time," Newhouse recalled. Vreeland held silent. Newhouse apologized that things hadn't worked out. The encounter was chilly but polite. But that night, Newhouse later admitted, "I had a very bad dream about it, a wild nightmare."

Vreeland's replacement, Mirabella, who'd come to the magazine in 1951 from jobs at Macy's and Saks Fifth Avenue, had almost left when Vreeland arrived. But then, "I thought, I don't want to miss this. She wanted me as an anchor and I was. I had to sell the stories to the advertising department and I straightened things out when people were upset." Which was often. Designers—and even her editors—found Vreeland's lack of interest in commerce appalling.

By 1971, Si Newhouse was appalled, too, and decided *Vogue* needed the anchor. The magazine had been buffeted by the declining American economy, but that wasn't its only problem. "A profound change in society" had occurred, Liberman said. Feminism had gone mass market at the intersection of women's liberation and self-actualization. The extravagance and au-

thoritarian single-mindedness Vreeland had executed with such verve fell out of fashion. No longer would editors issue dictates like the character in the film *Funny Face* who cried, "Think pink!"

"Alex would come into her office and say, 'Diana, we can't keep doing all these remarkable clothes. Can't we find less expensive clothes?'" Mirabella recalls. "And she did. But I remember they weren't very good."

Just a year earlier, *Women's Wear Daily*, the fashion industry trade newspaper that had made dictates its calling card, announced the death of the sexiest fashion of the sixties, the miniskirt, declaring that women must cover their knees with what it called the longuette, and the rest of the world soon disparaged as the midi skirt. But fashion designers and retailers followed *Women's Wear*'s lead, and the *Boston Globe* reported "the $8 billion American fashion industry—the country's fourth largest—suffered untold financial disaster. . . . The truth is that women have had their say."

"Women weren't buying fashion magazines, either," says Mirabella. Circulation was "just plummeting. *Vogue* had nothing to do with what was going on in the world, zero. It was all icing and no content." And Vreeland hadn't seen the writing on the wall, so busy was she being Vreeland.

"Change happens," said Si Newhouse. "You don't have three months to prepare. It's always traumatic. It may appear abrupt to people outside, but it was not a sudden decision." It was a surprise to Grace Mirabella, who was summoned home on the red-eye from a shoot in California with photographer Arthur Elgort. Her promotion took her by surprise—sort of. She was already working comfortably with Liberman. "I was the one who was around," she says. "I guess he got the feeling of how I sounded." Confronting Vreeland wasn't easy. "I was embarrassed," says Mirabella. "She had the style to make me feel okay. I was a fan and a pal of hers, but I didn't have the character to keep that going, so I lost the connection. I let it go."

Condé Nast was actually quite generous with Vreeland, keeping her on the payroll—and in another office painted red—for months afterward so she could qualify for full retirement benefits. Those included severance and a $20,000-a-year pension, which, after a later negotiation, was doubled; she also got hefty consulting fees until her death, a clothing allowance, and contributions toward her rent.

Mirabella knew full well who would rule the new regime at *Vogue*: "I sup-

pose Alex looked around and said to himself, 'Who is likely to think the way I do?' And there I was. We rarely disagree on anything." Together, they would reinvent *Vogue*, turning it into an unprecedented force in both the fashion and magazine businesses. "When I came on, Alex played a big role. He realized my beginning was a very new take. The magazine I wanted to have was one for women who were working and capable and more interesting. We worked together to make this happen. My *Vogue* was a bit more accessible. Women aren't inanimate objects you hang clothes on."

Liberman would never be as influential and admired as Alexey Brodovitch, but now, backed by his boss-protégé Newhouse, he'd won power beyond anything Brodovitch had ever known and set out to wield it. "Alex took over and began supervising all the magazines," says Roger Schoening, then *Vogue*'s art director. "If he made a suggestion, you followed it." Some felt his rule was less than benign. "He's the villain," Rachel "Ray" Crespin, then a fashion editor at *Vogue*, told Leo Lerman, a *Mademoiselle* editor. "At last, he's the czar of the fashion magazine world. He's power crazy." Lerman, who'd soon become *Vogue*'s features editor, judged Liberman "monstrous . . . hard, hollow, cold, shrewd, and the enemy."

Mirabella made Jade Hobson, *Vogue*'s accessories editor under Vreeland, a fashion editor. Hobson says Liberman had nothing to do with the clothes—probably fortunately, as he wore identical outfits to work every day: severe gray suits, pale blue shirts, and hand-knit navy-blue silk ties. Hobson thought Liberman "was brilliant, a little sexy. He never raised his voice. He would call you darling. He had a button under his desk that closed his door. I was just fascinated." Mirabella ran the magazine and Alex its look. "You knew he was very, very strong. Alex had staying power. It was calculated, having a plan, a path, a future, and going after it." Hobson also saw his Machiavellian side: "Certainly, with Vreeland. She was *Vogue* and then—*poof!*"

Hearst wasn't sleeping while *Vogue* was adapting, though the company's executives set *Bazaar* on a very different—and quite bizarre—course in July 1971, when they hired James Brady to be editorial director and publisher, and Nancy White's boss. That was a mere week after the *New York Times* reported that both *Bazaar* and *Vogue* were changing to meet the new challenges of the seventies. Unfortunately for White, her response to Mirabella was the introduction of sew-at-home patterns, hardly a modern idea.

On his first day at *Bazaar*, Brady handed out visors like those old-fashioned newspaper desk editors wore and informed the *Bazaar* staff, "You're all reporters now." White declined a new contract to work for Brady and quit in December 1971. Fortunately for her, she'd left the building before the January 1972 issue's release; it featured a look-alike posing as President Richard M. Nixon on the cover, announcing a politically themed package. Brady started calling *Bazaar* "the thinking woman's fashion magazine." Charles Revson, founder of Revlon, the magazine's biggest advertiser, warned him, "Don't ever ascribe thought to your readers—it's dangerous."

Six months in, Brady fired Bea Feitler because she and Ruth Ansel "hated one another," he wrote, and he felt two art directors were "a structural abortion." "A month or so later, I was fired, too," says Ansel. "I really remember hating Brady. He had no sense of design or style. He destroyed every aspect of [*Bazaar*'s] elegance and fashion leadership and made it ordinary." Brady hired Rochelle Udell, an assistant to the art directors Milton Glaser and Walter Bernard at *New York* magazine, to replace Ansel and Feitler in mid-1972. "Three months in," Udell recalls, "thirty-five people were fired." Brady was the first to go.

The next occupant of Carmel Snow's chair was Anthony T. Mazzola, who'd joined *Town & Country* straight out of design school as art director in 1948 and become editor in chief in 1965. William Randolph Hearst had bought the geriatric society magazine in 1925 to make friends for himself and his mistress, the actress Marion Davies. Mazzola had a long history of publishing great photographers; he'd worked with Dahl-Wolfe, Avedon, Schatzberg, Milton Greene, and the magazine's star, Slim Aarons. *Bazaar* "still had a certain look," says a fashion editor hired by Nancy White, who remained into Mazzola's tenure. "It was still Hiro and Bill King and Bill Silano." But fashion wasn't Mazzola's strong suit. He sacked China Machado the day he got the job and replaced her with Carrie Donovan, a Vreeland acolyte disgusted by Grace Mirabella's hiring at *Vogue*. "I came to solve a problem," Mazzola said two decades later. "It was not an orderly transition."

Mazzola "edited with an eye towards Fifty-Seventh Street," where Hearst's managers had their offices. "He'd say he had a reputation," recalls a former Hearst publisher. "'I save money.' He always wanted to come in

under budget." He also had an eye for pretty girls in the office, making a play for a secretary, Michele Morgan, heiress to an Indiana canning and food-processing company fortune. Mazzola didn't have an eye for fashion photography, though, says Betty Ann Grund, a *Bazaar* sittings editor. Grund fought with him "all the time," she says. "He didn't have taste. I'd have meetings with corporate to say, 'We're not in the game. We can't get top models.' I don't know how that went on."

Like Liberman and Mirabella at *Vogue*, Mazzola turned away from the outré, but instead of upholding *Bazaar*'s elegant DNA, he turned away from fashion, too. "Fashion is out of style," his boss, Hearst publishing director William Fine, told the *Boston Globe*. "The clothes featured in *Harper's* will relate to living rather than living-in-fantasy. . . . The world is no longer enraptured by youth." So the August 1973 cover of *Bazaar* featured the forty-nine-year-old actress and socialite Dina Merrill, photographed by Neal Barr, a former Irving Penn assistant and *Bazaar* mainstay since 1966, next to the headlines "How You Can Feel and Look Sensational in Your Forties," "Sex Begins at Forty," "Childbirth after 40," and "Good News about Menopause." "The one thing we did," says fashion editor Ila Stanger, "we were the first fashion magazine to utter the word *forty*. That was really ahead of its time."

Yet Mazzola said, incredibly, "Ours is a very subtle approach. The great fashion magazines of the past had readers who had arrived. Everything was heavily priced, grand, unreachable. . . . We're just trying to talk to the average girl, not trying to be superchic. There ain't no more superchic."

Instead, he had formulas. "Tony loved them," said the former Hearst editor. "Forty and Fabulous worked for him." Over the years, more theme issues were added. "He thought it separated us from other magazines," says a *Bazaar* fashion editor of that era. "The Ten Most Beautiful Americans always got publicity. But we called it The Ten Most Available. Who's around? Who'll actually do it? The people they wanted were never available."

Mazzola's fashion-deaf attitude and the self-help tone of his magazine caused its fashion editors to flee, and his iteration of *Bazaar* had no fashion influence. The fashion staff of the time blamed Michele Morgan, who'd briefly stayed behind at *Town & Country*, but eventually became Mazzola's wife and his partner running *Bazaar*. "Michele was so antifashion," says a

former Hearst editor. "She wore jeans to lunch with Valentino; they couldn't believe it! She's well educated, but she's a very rich hick."

Mazzola may not have cultivated the fashion world, but like Liberman, he cultivated his bosses, starting at *Town & Country*, where he'd made social connections for them. *Bazaar* had its own rewards. "They were all unhappily married," says the former editor. "Tony provided girls." A *Bazaar* business executive from the eighties confirms, "He'd get Cindy Crawford to show up. He'd seat [a top Hearst executive] next to Cheryl Tiegs. They were dazzled."

Mazzola's reign—and *Bazaar*'s decline—continued into the early nineties. Talented photographers such as Hiro, Silano, Sarah Moon, Phillip Dixon, and Jean-Baptiste Mondino still worked there, "but what was demanded of them was very straightforward," says Stanger. *Bazaar*'s devolution into a product more suited to supermarkets than haute couture salons made their work seem less urgent, less important. "Nineteen years later, it still hasn't turned around," James Brady said in 1992, with a certain satisfaction.

Chapter 26

"How can we subvert this?"

Bazaar still had talent. The brightest was Bill King, a young American photographer who'd moved to London in the *Blow-Up* era and started shooting covers for *Queen*. Sold twice in two years, *Queen* had become part of Hearst and renamed *Harpers & Queen*. King shot for it and American *Bazaar*. An issue with a cover photo of Lauren Hutton by King was on the newsstands when Tony Mazzola arrived.

Born in the Netherlands Antilles around 1940 and raised across the Hudson River from upper Manhattan, in Cliffside Park, New Jersey, King studied painting at Pratt Institute, took graduate courses at New York University, and began taking pictures while still a student. He considered his career an accident. His sister Janet worked in a photography studio in London. "He wanted me to show him around," Janet McClelland says, "and he decided to stay."

"He did a photo on his own on some beach in France or Spain," says *Bazaar* editor Betty Ann Grund. Back in London, King showed it to a beauty editor from *Queen*, "and she thought it was great and used it." He got his first assignment in late 1965 and worked with Erica Crome, *Queen*'s new men's fashion editor, who assumed he was a rich boy. With no visible means of support, he had a nice apartment on Flood Street in Chelsea and a studio in the Pheasantry, a nineteenth-century building on the King's Road, home to artists and the musician Eric Clapton's studio. "He could afford Turnbull and Asser shirts and made-to-measure suits," says Crome. "He was not one of those impoverished photographers." She recalls that King's mother had a serious gambling addiction though, so the family's fortunes fluctuated.

King was gay, and his construction executive father didn't approve. Bill had realized taking pictures might free him from financial dependence on his disapproving dad, "until I decided what to do," he said.

King's first sitting with Crome was totally improvised. "We decided not to do the expected, a good-looking, broad-shouldered guy in a tailored jacket," she says. So she had clothes custom-made from velvet and other fabrics associated with women's wear, and when she and King agreed that male models of the time were too butch, they trawled King's Road to find a boy with dark, curly hair. King admitted he'd never shot anyone full length and didn't know how to do it, so they had the model sit on a white box and tucked his legs in beneath him because "I needed legs and feet," Crome says. "We ended up with his crotch at the center of the picture. We treated men like sex objects. It was not the done thing."

Since *Queen* was a fortnightly magazine, the pictures went into layout and to the printer as soon as they were processed with no second-guessing. The photos were well received, and Crome and King became a team. "We had the freedom to run with an idea," Crome says. "We were both, maybe not consciously, mode breakers. Men's editors were all male and mostly gay, and I was a married young woman with a different view of what makes men attractive. Bill was gay. We were a perfect combination. The question was always, 'How can we subvert this?' You could be as brave as you liked at the *Queen*."

Crome remembers King as clean shaven, with a dimple in his chin, wearing a little tweed jacket and tortoiseshell-framed glasses. He was "bashful," she says. "He didn't appear confident, though I wouldn't say he wasn't." King was a pot smoker and considered Crome's taste for Campari and soda anachronistic. "Why can't you smoke like everyone else?" he admonished her. "He tried very hard to teach me," she says.

King was hooked on photography. "On a trip back to New York, I went to the public library and took twenty years of *Vogue* and *Harper's Bazaar* and . . . analyzed the pictures and the formulas," he said. When he returned to London, he had "all kinds of ideas," says Crome. He preferred shooting in the studio to location, but did both. And he was happy to churn out commercial work, making mundane pages for advertisers. He had a knack for adding the odd detail that made a picture special without "annoying the person paying for it," Crome says. His editorial work then was "static, but glam-

orous and sexy. Someone would always be laughing or their eyes would be twinkling."

King himself was oddly static. He was the first photographer Kaffe Fassett posed for when he started modeling. "Since I was a novice, I was desperate to please and present myself like the professional I certainly wasn't," says Fassett. "He would peer at me and nod his head but issue no instructions. I'd try to discern what he wanted and contort my body, making different expressions, all the while feeling I wasn't good enough. It was exhausting for me and I often felt I was letting him down. Yet he asked me back time and again. I always felt it was because I was cheaper than any of the other models." Fassett fondly recalls a party King staged for a sitting with celebrities such as Twiggy and Paloma Picasso. "Bill was quiet and introverted, peering out from under his fleck of dishwater-blond hair and glasses, watching us relate to each other."

By 1966, King was a star in London and had begun to work with Bea Feitler at *Harper's Bazaar*. "He had a strong relationship with Bea," says Ruth Ansel, because both were closeted homosexuals with a taste for psychoactive substances. "They had a lot in common aside from being a great art director and a great photographer."

King was crossing the Atlantic regularly, working mostly as a beauty photographer, when he met the young hairdresser Harry King, no relation, on a midnight shoot in Covent Garden. The model was Marisa Berenson and the client, the *Daily Telegraph* newspaper. "Marisa sat on the floor and did her makeup," says Harry. "Bill said, 'That really looks old-fashioned. Make it clean and simple.' He made her take it off, then walked out for two hours. He worked to build up a neurotic frenzy. She wanted to leave. She had to go to Paris the next day. He gave her half a pill. I don't know what he gave her," but they worked until 4:00 a.m. "All night long. 'Here, baby, c'mon, baby.'"

Two days later Bill King came to the salon where Harry worked and invited the hairstylist to his "fabulous flat, to smoke pot," says Harry. Bill had upgraded to a triplex with a private elevator on Ormonde Gate in swinging Chelsea. "And he jumped me and we ended up in bed." Then came a weekend in Paris when "he gave me acid and didn't tell me what it was," but Harry didn't mind. "He was a star. He had the best taste in the world."

King dosed Erica Crome, too, on a shoot on the Irish coast for the Wool Secretariat. "I'm an upbeat, energetic person," says Crome, and she spent the first day of the sitting racing around, making sure everything was in order. On the second day, after she briefly put down and then retrieved a Coca-Cola she was sipping, she found herself almost paralyzed, unable to move for several hours. "Bill had put a tranquilizer in my Coke to slow me down. I daresay he wanted everyone at the same level he was—whatever that was. He always wanted to draw non-drug-takers into his web of drug taking. He would encourage you as strongly as he could to indulge. It was almost, if you're not with me, you're against me." It made her think of his mother, the gambler. "Addiction is inherited but manifests itself in different ways."

Approaching age thirty, Bill was five years older than Harry King. "He was very elegant," Harry says. "He was a bit neurotic. I didn't know any-one like him. I was enthralled by him. It wasn't love, I had lots of affairs in those days, but it turned my life around. He was very uptight about being gay, but all of us were. He had girlfriends. I had girlfriends." Bill introduced Harry to one of them, Paula Mazure, whom *Vanity Fair*'s Stephen Fried later described as his "lady-in-waiting . . . at his disposal, ready to jet off to the islands for a vacation, assist on a sitting in Mexico, go to the movies, hetero-sexualize a business dinner, or mother him."

Bill was anything but heterosexual with Harry King. "He said, 'You can be my boyfriend or you can work with me.' I thought, 'He's much too neu-rotic to work with.' We went on to have a romance" that only ended when Harry moved to New York in 1973. By then, "He was with *Harper's Bazaar*," says Harry, "and I was a *Vogue*tte."

King took a final star turn in London in September 1970, shooting much of what *Queen* called its "Great Men's Wear Issue," behind a cover shot of Michael J. Pollard, the actor, and Lauren Hutton, who'd costarred in a new film about motorcycle racers. King's signature style was invented for that issue. Erica Crome thinks the ebullient jumping that would henceforth characterize King's work was Bea Feitler's idea.

Crome had flown to New York for the sessions, often standing just off camera, jumping around herself to inspire the female models, who were mostly not professionals. "The idea was [to pair] male models with differ-ent kinds of American women," Crome says, but the execution was looser.

The "women" included the Andy Warhol superstars Jane Forth and Candy Darling, a drag queen; several women recruited off the street to represent the Black Power movement; a Puerto Rican transsexual who danced at the drag bar 82 Club ("I wasn't quite ready to dress somebody with tits and a cock and balls," says Crome); US Navy Waves in dress uniform whose officer later tried, unsuccessfully, to kill the photos; Playboy Bunnies ("One had a nipple showing," says Crome, but it was airbrushed out of the published image); several lesbians ("We went to a dyke bar looking for women who were as butch as possible"); the Spanish model Naty Abascal; Elizabeth of Toro, a Ugandan princess who modeled while in exile from her homeland; some children; and "a rich old lady we found having tea at the Plaza Hotel," Crome says.

Some of those photographs showed the fruits of King's study of old *Vogue*s and *Bazaar*s: the influence of Richard Avedon's running and jumping pictures is evident. The influence of Irving Penn became clear when King rented a studio in the same beaux arts office building on the corner of Fifth Avenue and West Fifteenth Street in Manhattan where Penn then also worked in a studio rented for him by Condé Nast. As the years went by, King would adopt some of Penn's more obsessive work habits, too, insisting on silence in the studio. "Every photographer played music," marvels Betty Ann Grund. "But with Bill, never, ever, ever." He'd bend only when someone such as Diana Ross appeared, and he would play her songs.

King would take it much further than Penn, turning his shoots into quasireligious rites with areas of the studio marked off with tape, reserved for King and the subjects du jour. Zones were differentiated with colored tape marking where editors, stylists, and clients could stand. One assistant handled the cameras, another the lights, a third the wind machine King liked to use. Assistants were not allowed to speak or look his sitters in the eye. Ultimately, white lab coats became a mandatory uniform for King's assistants. King favored uniforms himself: he wore khakis and white oxford-cloth Brooks Brothers shirts all day, every day.

"He had a steely determination to control things," says Adrian Panaro, who assisted him for three years. "He liked things just so. Cords had to be coiled. He was adamant about technique." He overexposed his Kodachrome on purpose to "make beautifully sharp, contrasty slides."

King's regimented days stood in stark contrast to his nights. He had a longtime boyfriend, David Hartman, who would eventually become a photographer himself, shooting often for *Vogue Patterns*. But King was a habitué of the furthest frontiers of New York's sexually liberated scene. That was the black-leather-and-lube gay bar and party circuit where anything imaginable went, sexually and pharmaceutically, from bondage, discipline, sadism, masochism, and fisting to regular trips to "the trucks," an outdoor parking strip in the city's ironically named Meatpacking District, where gay men disappeared into unlocked, empty delivery trucks for anonymous sex. Nearby clubs called Anvil and Mine Shaft offered similar enticements indoors and became regular haunts of the fashion crowd, some participating, some only engaging in outré voyeurism. King was famous for days-long binges of anonymous and dangerous sex fueled by cocaine and brought back to earth with the hypnotic sedative Quaalude.

Jane Hsiang was a model when she met King. They grew friendly, and he convinced Tony Mazzola at *Harper's Bazaar* to try her out as a stylist. Her first picture, of Rene Russo, ended up on *Bazaar*'s cover in October 1976. They continued working together even though "he was always fucked-up," Hsiang says. After a shoot on Fire Island, she continues, "he got so high on whatever, my boyfriend said, 'Leave him there.' I said no, he was so high he'd fall into poison ivy, so we put him in the backseat and took him home."

In the midseventies, King would call Robert Mapplethorpe, the art photographer who chronicled those scenes in his most controversial work, "really late at night," says Paul Sinclaire, a fashion stylist who was close with Mapplethorpe, "and Robert would pack up and go." Mapplethorpe would later show hard-core homoerotic photographs that caused Washington's Corcoran Gallery of Art to cancel a planned retrospective. Sinclaire, who later styled for King, says Mapplethorpe recruited models for those photos "out of Bill King's orgies."

"He was perfectly good fun in England, really happy with his success," says Erica Crome. "He became a different, much less nice person in America. He developed a destructive streak."

King scored a coup in 1972 when he took on one of the most visible advertising jobs in fashion, shooting celebrated women in furs for Blackglama and its "What Becomes a Legend Most?" campaign. King took the job from

Richard Avedon, who'd shot the portraits since 1968. Blackglama was a client of Trahey/Wolf, an advertising agency formed two years earlier, whose partners were Jane Trahey and Henry Wolf, the onetime *Bazaar* art director.

Wolf had originally suggested Avedon shoot the ads because he was as famous as the women—Melina Mercouri, Lauren Bacall, Bette Davis, Barbra Streisand—they hoped would appear in them. "You needed as many famous names involved as possible" to launch the campaign, says Peter Rogers, an executive who would take over the agency. "He'd photographed all of them when he was very young, and they wanted to be photographed by Avedon. They were just washed-up broads to him at that point. He *expected* them to come to him. He knew his name would bring them." Another inducement to the stars was a free mink; Avedon got $1,000 per portrait.

Avedon and Rogers got along—well enough. "I worked out the poses," says Rogers, but the stars were as much in charge as Avedon was. "They all knew every angle, everything about themselves in photography. To Avedon it was just another session. It wasn't fun with Avedon." So Rogers decided on a change and hired Bill King. "I had a real relationship with King. I directed every shot. I'd established myself as an art director, and my concepts were so strong I wanted them executed exactly as I saw them, so I hired photographers who could"—and would—"do it. Bill King could anticipate a move before it took place. He didn't just click away. He knew exactly when to click. It was amazing to watch him."

Avedon called King a copyist; "Avedon hated him," says Jane Hsiang. "Avedon disdained everyone!" Rogers snorts. "King was not a clone, not in any way. He captured a spirit and movement I didn't see in anyone else at that time. He had every famous model wanting to shoot with him. He gave it more energy than Avedon did."

And all he did, says Betty Ann Grund, was "stand with his arms folded and let them move."

Chapter 27

"HE SEES IT ALL
VERY CLEARLY"

The new decade was an awkward turning point for Richard Avedon. Like Penn, he'd tired of the fashion-go-round. "The last time I saw really great clothes was in the 1960s," he'd later say. By 1970, he was more interested in attending antiwar demonstrations, and he went to Vietnam in 1971, taking pictures of America's military leaders in Saigon, Vietnamese civilians disfigured by war, and soldiers in the field with his eight-by-ten Deardorff camera for a new book. He was candid in admitting he was there for selfish reasons. "Every American is in some way using the Vietnamese for themselves," he told Gloria Emerson of the *New York Times*, "to build a reputation, to advance a career, to satisfy a need, for something." Demonstrating his own confusion about a war that had confounded most of his countrymen, he included the American soldiers he met, but said he also disdained them. "I feel only rage toward young men who allow themselves to be put in that position without any idea of what they're doing and why they're doing it. This is the punishment for mindlessness. And the punishment can be their lives."

Avedon returned to America that May and went to Sarasota, Florida, in the middle of the month to see his father, with whom he'd reconciled in the sixties, after Avedon decided, "It was just criminal of me not to make the effort." They'd made a real estate investment together, buying a small low-rise apartment complex in northern Florida. "We finally had something to talk about," he said. He'd recently written his father a letter and asked if Jacob would sit for a portrait. "I've learned your business now," he wrote. "I hope you'll learn mine. After all, I'm a really good photographer and I hate giving the best that's in me to strangers." Over a weekend, Ave-

don conducted the first of about fifty sittings that produced a harrowing series of portraits, chronicling his father's slow decline as he died of liver cancer.

Grace Mirabella preferred Penn's photographs to Avedon's. "Penn was stronger," she says. But woe betide an editor who brought him a girl he didn't like. "He wouldn't take a picture," Jade Hobson says. Not even for Mirabella and a Parisian hairdresser flown to New York for one day. "We were very keen to have him," Mirabella recalls, "and Penn would not take a picture, and [the hair] had to be washed, redone, and rearranged, and it went on like that, and finally, I said to Penn, 'Can't you take one picture?' 'No!' 'Something for the girl?' 'No.' So we went home without a picture."

Mirabella also preferred Penn as a man. Where Penn would write elaborate thank-you notes to everyone involved in a sitting, Avedon "considered me Vreeland's pencil-pusher and treated me with all the disdain due someone in that position," Mirabella wrote. She was skeptical of his "divine insight into the supremely marvelous." And she was intolerant of Avedon's protests "that his pictures couldn't face Penn's" in the magazine, and of his claims "that Penn was trampling on his turf." Avedon's "emergence as a power broker" in their world was a development she found troubling. When he summoned her to his studio "to interview *me* about his prospects at the new *Vogue*," she was annoyed, but also pleased he was "sitting up and taking notice" that *Vogue* "was about to profoundly change." It's telling that after recounting that summons, Mirabella never mentions Avedon again in her memoirs.

The photographer's relationship with *Vogue* deteriorated markedly. "There was resentment," he said. "I was powerful." Avedon had previously considered his Condé Nast contract a necessary compromise based on his financial needs. Post-Mirabella, he decided it diminished him. "Grace was brought in to do this thing," he said, to be "more conscientious toward the reader and her concerns." In *Avedon Fashion*, a product of the Richard Avedon Foundation after the death of its namesake, the curator-critic Vince Aletti wrote, "The narratives were far fewer and less lavishly produced and gradually, very gradually, he lost interest. Liberman, free to air his irritations, began taking more liberties with Avedon's photographs, cropping and running type across them." And worse, "his work had begun to look

conventional. . . . He was an old-school classicist. . . . He had become the Establishment."

Perhaps to prove he wasn't, Avedon attended a march on the Capitol in Washington, DC, on May 21, 1972, to protest the bombing of North Vietnam and the mining of its harbors—and was among 178 people arrested. That same month, he took a well-known photograph of Veruschka twisted like a pretzel in a yoga pose.

Early in 1973, another of Avedon's models, the gap-toothed Lauren Hutton, decided to try to get a modeling contract with a big cosmetics company. She concluded her best chance lay with Revlon and its photographer, Avedon. "He thought it was a great idea and became a great co-conspirator," she says. "It was Dick's idea to make it exclusive and buy out all my business so I'd only work for Revlon in the US and I'd get more money." They shot tests for a new line called Ultima II and showed them to Revlon's owner, Charles Revson.

"I really got that contract with Revlon for Lauren," Avedon said. "Revson didn't like her teeth. I went to Revson and said, 'I'll experiment. If you like it, I want more money.' We did a couple of tests." Revson went for the deal and offered Hutton a three-year $100,000-a-year contract, and Avedon a higher rate than he was normally paid. "Except Dick [insisted on] working with a lot of other people," Hutton says, so "Revson went ape" and vowed revenge. He only gave Avedon a one-year contract, and when it expired, Revson told Hutton she would henceforth be working with other photographers. Her contract specified she could approve photographers. "But I want to work with Dick," Hutton said.

"I'm not going to have it," Revson roared.

Says Hutton, "He was the kind of guy who you cross in a business way and he'll make an unbusinesslike decision and burn everybody to the ground. He didn't renew Dick, and I think it was quite a while before they started using him again. Dick was very, very hurt."

Simultaneously, Avedon was in a tense spot at *Vogue*. "Dick and Alex did not get along," says Polly Mellen. "Alex had a way of being very condescending. It was almost insulting. I think it was jealousy." Hutton, who'd started making movies and was often in Hollywood, disconnected from the fashion grapevine, was unaware of the tensions behind the scenes.

Shortly after her Revlon deal was announced in June 1973, Hutton was summoned to Alex Liberman's office, where an issue of Andy Warhol's *Interview* with her on the cover sat on his otherwise bare desk. She'd been photographed for the magazine by Francesco Scavullo. Liberman wanted to know if she liked working with him. "I said, 'Sure, he's fine,'" Hutton recalls, and Liberman asked if she would work with him again. "I said, 'Fine.'" Only years later did Hutton realize she'd been used.

Scavullo returned to *Vogue* as Liberman's weapon against Avedon. "I had been working only with Dick and Penn for some time," Hutton continues, "and I literally wasn't smart enough to figure it out, [but] Francesco had changed his lighting. It was very similar to Dick's. So you have someone who's been trained by Dick, me, using positions that [I] learned [from Dick], and Scavullo was taking pictures very similar to Dick's. What I didn't know was, it was to show Dick that they didn't need him. I should have figured it out because I had never been called into *Vogue* before."

Not only that, Liberman's office called Avedon's studio, where he and Hutton were shooting for Revlon, to remind her of the job with Scavullo, "and Dick heard me talking to them, and he said, 'Don't do it.' If he had explained everything to me, I wouldn't have done it. Dick had been so instrumental to me in my life, in my career, and Dick was mad at me."

Indeed he was. He also despised Revson, despite having profitably worked for him for years. "Avedon called [the contract] the stupidest mistake of his life," says Nick la Micela, an art director at Revlon's ad agency. "He said, 'Now that Revson owns me, he can shit on me. I sold my soul. Before that I was the connoisseur of beauty. Now, he doesn't respect me." In fact, Revson had set a trap, and "at the end of the year, he kept Lauren and dumped me," Avedon said. "Lauren didn't go to bat for me at all. I was so pissed." He added, "If she worked with Scavullo, I wouldn't use her again. We worked exclusively with models, then moved on, but she simply disappeared."

Scavullo thought Hutton arranged their 1973 shoot for *Vogue*. "She loved me, she pushed me, she went to Liberman and told him," Scavullo said. "That's when I got a contract." At their first *Vogue* sitting, Hutton's eyes were all red. "Apparently, Avedon threatened they'd never work together again if she worked for Scavullo," he continued. "Nothing bothered me. Nobody pushed me except me. Not Brodovitch, not Liberman. I was tough

as nails." But Scavullo would "kiss ass for a beautiful picture. I want everyone happy. Make 'em happy and you get great pictures."

As he and Hutton started to shoot, the phone rang—it was Avedon, calling to wish him luck. "I said, 'Thank you,'" Scavullo remembered. "I wanted to say, 'Fuck you.' He's talented, but he's vicious and as shrewd as they come."

<center>⊸∾⊶</center>

In December 1970, Richard Avedon moved his studio one last time, to a house on East Seventy-Fifth Street between First and York Avenues he bought from Reid Miles, a photographer and graphic designer best known for modernist LP record jackets for Blue Note, the jazz label. Miles had built a ground-floor studio in the house. "It was a photographer's place," says Avedon's studio manager, Gideon Lewin, who loved its curved cyclorama wall that obviated the need for seamless paper backdrops. Avedon could paint it any color he wanted. Lewin added a basement darkroom and upstairs, living quarters.

Says Lewin, "He decided to simplify his life completely and live like a Spartan. He wanted to just be creative and do his work without interference." Lewin had a policy not to pry into his boss's private life and says, "Something was happening, but I didn't know what. I built him a platform bed upstairs. A short time later, he showed up with suitcases."

The troubled marriage of Dick and Evie had come to an end. She would henceforth live alone in an apartment Dick had recently bought at 870 United Nations Plaza, one of twin modernist towers just north of the United Nations, the last great luxury cooperative apartment houses built in Manhattan, and later home to both Si Newhouse and Alexander Liberman.

The Avedons would never divorce, but would never live together again. "They see each other often," the former fashion editor D. D. Ryan would say in the nineties. "He's looked after her. They go to the theater. He's involved with the romance of photography, the romance of friendship. After seventy years of therapy, he sees it all very clearly."

Avedon's professional colleagues felt certain he never had another sexual relationship in his lifetime, though he had close relationships with sev-

eral women and there was a certain curiosity about them. The novelist and essayist Renata Adler, whom Avedon photographed in 1969, was the first. Another was Doon Arbus—one of the two daughters of Diane's—who was Avedon's longtime in-house copywriter and editor. Years later, he was also said to be involved—somehow—with Nicole Wisniak, a Parisian married to a French magazine editor, who became a fixture on the city's artistic-social scene in the early 1970s. She started publishing *Egoïste*, her own magazine, funded by her parents, in 1977, met Avedon when she interviewed him in 1984, and collaborated with him for twenty years.

The back-to-back moves into United Nations Plaza and the new studio were followed by the fifty-year-old Avedon's collapse and hospitalization in spring 1974. He blamed it on pericarditis, a minor heart condition that can feel like a heart attack. "I got a call," says Gideon Lewin, "he'd had an emergency and he was hospitalized." He wasn't a good patient. "He would not stay in the hospital. He left before he was supposed to."* But he was hobbled, he later said, and unable to work for nearly a year.

Avedon had reached a moment of truth. "Something serious happened to me," he said in previously unpublished portions of an interview he gave in 1992. For the first time in his adult life he couldn't work—and thus couldn't speak as far as he was concerned. And it turned his life around. "I wanted to concentrate on another side of my work. It was time to use editorial and advertising to support the studio. There are only so many hours in the week. So I said no more editorial fashion."

What serious thing, exactly, happened? It's unclear what was cause and what effect. He'd left his wife and home. His first ten-year contract with Condé Nast was running out; Liberman was manipulating him; Mirabella disdained him; Lauren Hutton deserted him; Scavullo was the latest mosquito buzzing past his ear; and never, ever mentioned was another burden, this one financial. "Dick paid for everything," says someone close to his son, John.

*Avedon's book *Evidence* has a photo of him in a hospital bed, working on a Bloomingdale's catalog in his studio with model Rosie Vela and Gideon Lewin, taken in 1974 according to the caption. In fact, that photo was taken three years later, when Avedon was suffering from hepatitis, says Adrian Panaro, the studio assistant who shot it. According to *American Photographer* magazine, Avedon turned the photo into a postcard and mailed it to friends.

Avedon not only had an expensive studio to run, he supported both his now-adult son and his wife, whose behavior "was increasingly extreme," says John's intimate. "She was falling apart. She was a shell of a human being."

"I'd been told Evie was crazy," says Renata Adler, "but I thought she was not any crazier than the rest of us." Then, though, Evie decided Dick was having an affair with Lee Radziwill, Jacqueline Kennedy Onassis's younger sister. To prove otherwise, Adler showed Evie a photo of Radziwill with the photographer Peter Beard, whom she was dating. "She thought I'd conspired to put that picture in *Women's Wear Daily*." A few months later, Evie called Adler to say she was having electroshock therapy.

Avedon's sense of responsibility for his family was strong. His father's lessons had stuck with him; advertising supported his family, he said, and taking care of them was "the definition of being a man." So to make ends meet, he cut a new deal with the devils of commerce, Newhouse and Liberman. Afterward, he made it all sound like a model in his studio: impeccable, faultless. "He knew how to present himself in the way he wanted to be seen," observes Jim Varriale, who joined the studio as an assistant in the midseventies.

"My covers were selling terrifically," Avedon said in that same interview. "I'd never worked for *Mademoiselle* or *GQ* and Liberman wanted me to do four covers a month for a very good fee. He said, 'Dear Dick, why are you punishing *Mademoiselle*?' That would keep me connected to Condé Nast. And Newhouse was terrific, completely supportive. At Hearst, there was never any lunch money. If I wanted to photograph Sophia Loren, I paid my carfare to Rome." While Condé Nast didn't nickel-and-dime, neither did it give ten-year contracts anymore. He got four-year deals. "Everything was changing," he said. "They were changing editors everywhere and I think the feeling they had was, I was a stable, known entity. It was something I could do creatively and well. Immediately, the sales of every magazine went up. Everything was okay."

Avedon spent 1975 preparing for another exhibition, the first-ever show of photography at the prestigious Marlborough Gallery and Avedon's first gallery show, accompanied by a book, devoted to his portraits. By the time it opened that fall, he'd found a new venue for his editorial photography at *Rolling Stone*, which agreed to give him an entire issue, edited by Renata

Adler. The magazine's editors asked him to chronicle the 1976 presidential campaign, "the candidates and the conventions," they wrote, "from beginning to end." Avedon expanded his brief to "the political leadership of America." It was released that October as *The Family 1976*.

His protests notwithstanding, Avedon also continued shooting the crème de la crème of fashion. His latest stylist, Julie Britt, who was "entranced by his vision," she says. "I'd tell him what was going on. He wanted to be involved," without actually going places, such as the disco of the moment, Studio 54. Britt found Avedon "Proustian" and "an isolator." She says, "He wasn't adventurous. He wouldn't go out with groups. He liked his studio, where he was in control. He preferred that insanity to sitting next to Anne Bass at dinner." But great as they were, the models of the moment—Kelly LeBrock, Rene Russo, Janice Dickinson, Rosie Vela, and Patti Hansen—couldn't compete with the Metropolitan Museum of Art, which mounted a retrospective of his fashion photography, again accompanied by a book, in September 1978. It represented "a kind of closure to his most important work in fashion," according to one of his official histories.

Fashion just wasn't his focus anymore. Over the next six years, inspired by his part-ownership of a ranch in Montana, he pursued a book and exhibition he called *The Western Project*, a set of portraits of working, down-and-out Americans shot in 189 separate locales in seventeen states. "It was a grand treasure hunt out West for faces that interested him," says Jim Varriale. It was partly funded by the Amon Carter Museum in Fort Worth, Texas, which showed the results in September 1985. After its opening, Avedon described his thirty-year effort to create "a group portrait of America. You can't say you're doing that until you've almost done it; it sounds like such a grand ambition. . . . I knew it could never be complete until I photographed—I hate the word *working class*—ordinary, hardworking people."

Meantime, Avedon signed another contract to shoot covers for Condé Nast and still did the odd fashion spread. "He was a dynamo," says Varriale. "He had more energy than any three people I ever met." His new isolation inspired and invigorated him.

Chapter 28

"OUT OF THE NEST"

Alexander Liberman and Si Newhouse issued a challenge to *Vogue*'s new editors. "We had to find a whole new group of models and photographers," says Jade Hobson. "It was women's lib, remember?" says Vera Wang, another *Vogue* sittings editor. "Suits and sneakers to the office." Even though Middle America sometimes still considered feminists hairy-legged harridans in Birkenstocks, the postliberation *Vogue* woman was bigger, blonder, shinier, healthier, decisive, and sexually adventurous.

The French Mob seemed designed for that moment. "Hypersexual photographers with their pick of the most beautiful women in the world," says Wang. Mirabella wanted models whose "open smiles beckoned and whose all-American looks shouted stylish informality," the editor wrote. "We simply couldn't afford to push women away anymore." Men who loved women were playing her song. Arthur Elgort, the auxiliary Frenchie, emerged as a soloist. His ability to capture "a sense of movement" made him one of Mirabella's favorites, and to her, Elgort marked "the last turning point in the history of American fashion photography." His work struck her as quintessentially modern and American.

After studying at New York's Stuyvesant High School and Hunter College, where he'd majored in painting, Elgort decided to be a photographer because "I wasn't a bad painter, but I wasn't good, either." After college, he had his heart set on shooting fashion pictures. "My mother looked at *Vogue*. There must have been something there." His motivation was simple: "It was girls. That was a good reason."

Right from the start, he saw how to do it. "I had an idea: I was outside. I went to Central Park all the time. I didn't want to be an Avedon. I enjoyed girls." He started with pictures of dancers at ballet schools, a personal ob-

session. Then he began testing girls from the Zoli modeling agency, which opened in 1970. A fan of exotic beauty, Zoli would "give me models who were hard," says Elgort. Making them beautiful was great training.

Elgort's next stop were the darkrooms of Carl Fischer and Gosta Peterson, a Swedish illustrator-turned-photographer who'd specialized in shooting children in the fifties and moved into fashion at *Mademoiselle* in the early sixties. "I started to photograph people, not models," Peterson says. "Liberman wanted me to come to *Vogue*, but I said I wanted to do my thing. I liked people with character, rather than girls who looked so pretty. That's why I couldn't shoot for *Vogue*."

Elgort admired Peterson, Saul Leiter, and Frank Horvat—snapshot photographers all. "I learned from Gus because he just did it, he didn't worry about it," Elgort says. Peterson told him to shoot fashion models the way he did the dancers he loved. He pored over photography books. Soon, he was shooting for *Mademoiselle*.

"Fashion-wise, *Mademoiselle* was always on the cutting edge," says Roger Schoening, its art director in 1960, when 35 mm cameras became common. They made it easier to shoot in "natural settings as opposed to formal studios. Handheld meant you could move around very quickly." Schoening gave Elgort his first assignments. "I said you'll never know how good I am unless I get a lot of pages," Elgort recalls. "Schoening said, 'Give me ten pages and we'll see.'" Elgort shot the spread with an editor, Deborah Turbeville, who was trying to become a photographer herself, taking the successor to the Brodovitch Design Laboratory courses, then taught by Richard Avedon and Marvin Israel. "Everyone thought she was a little bit nutty," Elgort says. Schoening used Elgort a lot but "never thought of him as a superstar." Elgort realized, "I wasn't going to do much here, so I took a chance and went to Paris."

He started out testing new models as he'd done in New York, "then all of a sudden I get a job from *Vingt Ans*, then *L'Officiel* and British *Vogue*. I worked pretty fast." He fell in with the Frenchies. "We all ate together and had girlfriends we tested together. I liked the girls more than the guys."

Like all the Mobsters, Elgort had a model girlfriend, Bonnie Pfeifer, who'd come to Paris by way of New York, where she was a finalist in a Model of the Year competition in 1968. Her first job landed her the cover

of *Seventeen*. Then, she took off for Europe. Her next job was with Gilles Bensimon, ten pages for French *Vogue*. "That's how I met all the boys," she says. "They're hot on the trail, but I'm not interested." She assumes they discussed her. "That's what they did, talked about girls all the time." She and a model boyfriend broke up, "and all of a sudden, I got booked on a job with Arthur." They became a couple "right away. He was hilarious, we worked hard, we laughed. With Arthur, I could be one of the guys and talk about girls, too.

"The boys were practically all play, pretending to be grown-up, successful photographers, but they were girl-crazy boys." And they shared models. "They talked about it, and I wasn't going to go there. I was glad to be with one guy." The Mobsters spent weekends at one another's country farmhouses—and Pfeifer was part of the gang. "I have brothers; I'm not intimidated."

Arthur and Bonnie were a good team. "It was easier with somebody you knew really well," Pfeifer continues. "Basically modeling is looking in a lens but interacting. Photographs combine both your personalities. You couldn't always connect, but Arthur and I connected great, and it started with the camera between us." When a shoot wasn't working, Elgort would say, "Okay, fall," and Pfeifer would "stumble and push somebody, and it would break the mood, get something going," she says.

Starting out in Europe was great, Pfeifer thinks, "because if they believed in you, the magazines let talent take a chance, because not a lot of money was riding on it, compared to in America." The tear-sheet principle also applied. "You couldn't get jobs in America without wonderful, creative stuff from Europe." Once a photographer had published tear sheets, or samples, it was easier to get more work.

Elgort got those tear sheets quickly—"He couldn't go a couple of hours without taking pictures," says Pfeifer—and the couple crossed the Atlantic regularly. By 1972, they had an apartment in New York's Eldorado, a twin-towered luxury building on Central Park West. Their dining room table flipped over for the Ping-Pong games the Mob loved. "Then we started having different clients and taking trips apart," says Pfeifer. "We grew up, and one day he pushed me out of the nest. I was upset, but he was right. We were growing apart."

Elgort first shot for American *Vogue* in 1971, but it took two more years

before he became a mainstay. "I met Liberman, and he said, 'Now, you're going to work for me at *Vogue*. Do *Mademoiselle*, too, but don't try so hard anymore.' He liked me." Liberman endowed Elgort with the ultimate prize, a *Vogue* contract. Elgort's essential humility showed through when they discussed his deal. "You put my kids through school," he told Liberman.

"I love Arthur," says Jade Hobson. "He was so spontaneous. A lot of his pictures are just off moments," such as the time Patti Hansen in a white one-piece swimsuit was caught at the Breakers in Palm Beach, Florida, "his winter studio," just drinking a piña colada.

Elgort's assistants worshipped him. Ross Whitaker, who joined the studio in 1977, calls their first meeting "one of those Robert Frost moments that completely changed the direction of my life. I was a technical, still-life photo kid. I think my naïveté impressed him. He said, 'You have to get a passport; we spend half the year in Europe.' All of a sudden, I'm doing London, Paris, Milan. Arthur taught me how to be a photographer. He never left the house without a camera. He taught me to look at photography as storytelling."

"Arthur Elgort is the most wonderful, generous, extraordinary mentor a young person could ask for," says Peter Michael Kagan, now a music-video and short-film director. In 1979, he went to work for John Stember, another of the peripheral Mobsters. After a year, Kagan moved to Elgort's studio. "The sound track was gorgeous," Kagan says. "He was an usher at Carnegie Hall as a young man and had an encyclopedic knowledge of jazz. Great classical, too. His whole world was unbelievably true elegance." He shot with elegance, too, seamlessly switching cameras and film formats, "so many difficult cameras at one time, all flying around while he's making on-the-fly calculations," says Kagan. "He was one of Liberman's favorite reportage guys. There were others doing it, but no one as fleetingly as Arthur was."

Elgort's effortless style is manifest in his best-known image for *Vogue*, a 1979 photograph of model Lisa Taylor driving across the George Washington Bridge in New York, with her hand to her chin and elbow out the window of a Mercedes 450SL, hair flying in the wind. Getting it was anything but effortless. "We started on one side and drove back and forth and back and forth," Elgort says. "She was a very good driver. I told her to keep an eye on me. I remember her saying, 'Don't stop, just keep going until you get a picture,' and it was very hard because it was very difficult to focus." Elgort

waves off the shot's importance: "It was just a picture. I was doing my job. I didn't think about it."

"Arthur is very funny," says Taylor. "He just keeps you laughing. He loved it for the art, and he had a way with people. He was the real thing. He didn't like posing. If you posed, he started talking and got you to move. I didn't know how to pose, so he and I hit it off."

As the eighties began, Elgort fell in love with a dancer, Grethe Barrett Holby, whom he met when her sister, Kristin, better known as the model Clotilde, married photographer Jacques Malignon. "I went out with her, but not right away," Elgort says. "She had a boyfriend. Then, she called me up and made believe she wanted pictures. I was already fortysomething. I'd had fun, although I didn't like to go out at night. I wanted to sleep. I took drugs but not, like, cocaine."

He didn't like advertising much, either, though he did his share: "You have to do advertising to keep a studio." But though he worked for brands such as Valentino and Yves Saint Laurent, none of his advertising work mattered to him. "I was more a magazine photographer. I enjoyed it more. You didn't have an art director."

Elgort remained a magazine photographer, and a mainstay of *Vogue*, for the next two-plus decades, taking iconic yet casual photos such as his 1995 shot of the British model Stella Tennant diving fully clothed in designer tweeds and a pair of Wellingtons into a swimming pool after a tiring daylong shoot. In 2010, he had a stroke. Fighting back, he returned to shooting, and late in 2014, when he was seventy-four years old, New York's Staley-Wise photography gallery mounted *The Big Picture*, a career retrospective accompanied by a book of the same name. Its opening night was jam-packed with photographers, friends, and admirers: Bruce Willis; editors Grace Coddington, Grace Mirabella, Jade Hobson, and Amy Astley; the photographers Gosta Peterson and Pamela Hanson; and the models Christy Turlington and Stella Tennant. This tribute to the enduring, and still working, happy snapper was a reminder that even in fashion photography, every once in a while, at least, a nice guy wins.

Part 4

DECADENCE

It got all-over crazy, all the time.

—BITTEN KNUDSEN

Chapter 29

"AN INTOLERABLE AND MENDACIOUS FICTION"

Si Newhouse and Alex Liberman had judged the changing mood of fashion consumers well. But *Vogue* could not live on happy snaps alone. "A magazine can't be all sugar and happy," says Polly Mellen. "I love Arthur Elgort and he did wonderful things, but it wasn't exciting enough for me." The Frenchies "loved the girls, they played with the girls and the girls played with them. Their pictures didn't turn me on, but, yes, they were important. It was the way Alex was feeling and what he wanted. He was the boss." And he wasn't a one-trick pony. "We'd want a mix," says Jade Hobson. And Liberman not only knew how to orchestrate it, with Vreeland gone he could. "I'm guessing Alex thought there wasn't anyone in the wings who could take Mrs. Vreeland's place," says Mellen, "unless it was Alex himself."

The May 1975 issue of *Vogue*, then one of the magazine's most criticized issues, now greatly admired, illustrated the tightrope Liberman walked at what seems, in retrospect, the apex of his career. Judging the book by its cover—a pretty shot of model Lisa Taylor by Francesco Scavullo—tells nothing about the improvised explosives tucked inside. The issue contained beauty stories by Penn and Avedon, but in the decades since, they've been forgotten, whereas two stories by fashion photographers then relatively unknown in America are touchstones in the history of the genre.

Helmut Newton's "The Story of Ohhh" and Deborah Turbeville's "There's More to a Bathing Suit Than Meets the Eye" set off a tsunami of complaints and subscription cancellations, but demonstrated how far the fashion photo had evolved since Avedon's nude of Christina Paolozzi. Newton's portfolio of sexually ambivalent images, shot in Saint-Tropez, included

an iconic picture of Lisa Taylor sitting in a dress with her legs spread, twirl-
ing her hair while coolly eyeing a passing bare-chested man. Turbeville's
photos, shot in a bathhouse that to some evoked Nazi death camps, seem
tame today, but at the time even a *Vogue* editor called them "slightly aber-
rational." An offended *New York Times* art critic, Hilton Kramer, confirmed
their importance when he condemned them as "pathological . . . clamorous
and unsavory."*

Certainly, they demonstrated the new status of the fashion photo, which
was enshrined as fine art that same year at Hofstra University in *Fashion
Photography: Six Decades*, reportedly the first-ever comprehensive museum
survey of the subject.† Not everyone was happy about that. "This is a de-
velopment likely to be disturbing, not to say enraging, to many people who
take photography very seriously," wrote *Times* critic Kramer. "The fashion
picture, judged by the standards of the documentary esthetic, is an intolera-
ble and mendacious fiction." Writing on the same subject in the *Wall Street
Journal*, Manuela Hoelterhoff said, "It presents some truly frightening social
commentary."

Liberman had lured Newton back to American *Vogue* shortly after its ed-
itor transplant by asking him to shoot a forty-five-page portfolio in the spirit
of his work for French *Vogue*. Though he'd taken interesting pictures, such
as one of a model being chased down a runway by a low-flying plane, shot
for British *Vogue* in 1967, Newton's visual ideas—often hatched in late-night
alcohol- and nicotine-fueled sessions with his wife, June—had not yet become
particularly clamorous, unsavory, or frightening. But Liberman's phone call
led to the event that would prove a professional turning point for Newton.

In the months before that call, Newton had sometimes worked as long
as a week on twenty hours' sleep, so he "arrived in New York completely
worn out," he wrote in his memoir, "run-down, short of breath, and my

*It was evidence of Richard Avedon's increasing irrelevance that a cinematic sitting he shot
with Polly Mellen at Philip Johnson's Fort Worth Water Gardens that December, portray-
ing models Rene Russo and Tony Spinelli as a couple "going through all the emotions of
a relationship over twelve pages," as Spinelli puts it, including a photo in which Spinelli
appears to slap Russo, also drew protests but has since been mostly forgotten.
†That same year, *Fashion 1900–1939*, a broader exhibit that featured fashion photographs,
followed at London's Victoria and Albert Museum.

heart was banging away, but I didn't take any notice of this, I just started work for Alex." One Friday night a few weeks before Christmas, he ended up in an emergency room, but was told nothing serious was amiss and sent on his way. The following Monday, he collapsed while shooting in the street, stood up, then collapsed again, "except this time I couldn't get up." He'd had a massive heart attack. June, who'd recently picked up a camera for the first time when Newton was ill, finished the *Vogue* job, launching her own career as a photographer under the pseudonym Alice Springs. Newton wasn't completely recovered for several years, but thereafter he felt he had a new lease on life. "Everything seems to cure itself when I'm working," he wrote. "There is something about a camera. I find it can act as a barrier between me and reality." Henceforth, his cameras would provide more than defense; they would give him the means to giddily provoke and offend.

Liberman was a fan of men's magazines such as *Playboy* and *Penthouse* that, about a year earlier, had begun to stretch the boundaries of the permissible in soft-core porn by showing pubic hair in the photos of the nude women that were their calling card. "Apparently, Alexander Liberman, the editorial director of all Condé Nast magazines, felt that the most 'interesting' photography was in men's magazines," says Stan Malinowski, a *Playboy* and *Penthouse* photographer who would shortly be recruited to shoot for *Vogue*. "So he had all the women editors perusing through magazines from *Playboy* to *Hustler*, looking for talent."*

A few months after Newton's hospitalization, Hugh Hefner, the founder and president of *Playboy*, announced the launch of a new publication to be called *Oui*, based on *Lui*, a *Playboy* copycat published by Daniel Filipacchi, a onetime *Paris Match* photographer who'd established a second career as a magazine owner. *Oui*, which shared content with Filipacchi's magazine, was created to serve a younger, better educated male reader. Its photography was just like its older brother's and helped make it an immediate success, with sales topping a million copies when it was just three issues old.

*In *Them*, her memoir of her parents, Liberman's stepdaughter, Francine du Plessix Gray, reported that in the eighties Liberman and his wife would spend weekend nights at their country home watching pornographic movies.

Stylist Tina Bossidy was named *Oui*'s fashion director in 1973. That meant shooting men in clothes alongside women without them. She had already worked for *Town & Country* photographers Slim Aarons, Bill Silano, and Chris von Wangenheim, the last a neophyte shooting for Bea Feitler at *Harper's Bazaar*.

When Bossidy arrived at *Oui*, a number of *Lui* photographers were shooting for the magazine. "I was stuck with them, so I decided to get someone who interested me, and that was Helmut Newton," says Bossidy. He was easing his way back into working, so on their first sitting, which took place in Haiti, June Newton issued strict orders to Bossidy that he couldn't do anything stressful. But Newton didn't hesitate to drag Bossidy along as he checked out local brothels, where one dined looking into the open doors and windows of busy bedrooms. "You saw parts," says Bossidy. Whether they inspired the rape scenes he shot is unclear, but "Helmut always tried to push the envelope," and *Oui* gave him "an incredible platform to do fashion sex pictures." For a while, working for *Oui* embarrassed the photographer, but "he got to play with sex with *Oui*," says Bossidy. "He didn't get to do that with French *Vogue*." The experience liberated his creative id—and allowed the inner Newton to emerge. He'd shot vaguely erotic fare for magazines before, such as a series in which models seemed to flirt with store mannequins, but nothing like the *Oui* pictures. Newton and Bossidy next created a series of "flashing" pictures, which reflected the latest craze for streaking, running naked through public gatherings, in a Florida shoot based on John D. MacDonald novels. The photos showed women in disguises, ostensibly escaping indiscretions, baring body parts along US 1, a north-south highway that runs up the East Coast of America.

One model, Margrit Ramme, a German like Newton, but with blue eyes and blond hair, came to the set with a black eye and broken nose, and Newton and Bossidy had to cover her bruises with makeup and sunglasses. Newton decided there was "some S-and-M stuff going on" with her and her boyfriend, she says. "He thought I spent my nights having wild sex, which was not the case. Actually, I was mugged in Manhattan, but he didn't believe me. That was Newton's fantasy. He had this obsession with Nordic, German faces. You'd think he wouldn't like that look." Ramme saw a big change in Newton's interests from the many shoots she'd done with him in the past for

"the *Vogues* and *Queen*," she says. "They were harmless compared to what he did after [his heart attack]."

In 1976, he'd celebrate (and gave new fashion luster to) Hermès, a stuffy Parisian equestrian and leather-goods emporium, as an unknowing S&M gear purveyor, shooting a model wielding a riding crop and another on all fours in jodhpurs and riding boots with a saddle tied to her back and the expectant look of a steed about to be mounted. In years to come, he'd advance on these S&M themes, shooting nudes in surgical braces and casts.

Clearly, his experiences as a child in the hedonistic Berlin of the late Weimar years, a Jewish teenager in Nazi Germany before World War II, and a sex-obsessed young man in exile during the war lingered in and fed his imagination. "My favorite photos are often those which evoke a strong feeling of 'I have been here before,'" he wrote in a different context. His talent and sense of humor were such that, his detractors notwithstanding, he was able to turn his memories and associated fantasies into commercial images that first sold frocks and other fashion accoutrements, and then stood the test of time as fine art.

Newton wasn't only interested in Aryan blondes. On that Florida shoot, his fondest wish wasn't to visit whorehouses, but the Hotel Fontainebleau in Miami Beach, where he was riveted by the nouveau riche, overdressed, mostly Jewish guests. His taste for tawdry, trashy, extravagant display would never leave him. Neither exhibitionism nor Newton's voyeurism was limited to sexuality.

Newton and Bossidy would return to the flashing theme, taking pictures along the Seine and at the Hotel George V bar in Paris. After a 3:00 a.m. shoot of a model wearing a boa constrictor "and nothing else," in the shuttered bar, a bartender somehow got hold of one of Newton's Polaroids, and when the team woke up the next day, "all hell broke loose," says Bossidy. Newton got a police summons, a batch of fur coats were confiscated, and Bossidy and her hair-and-makeup man had to sneak out of the hotel to try to recover them and then get out of France. Bossidy eventually got the furs back, but somehow the authorities or the hotel ensured that the photos never ran. She never found out what happened to them.

Another *Oui* portfolio would gain renown when images from it were used to portray the work of a fictional photographer whose oeuvre linked

sexuality and violence in the 1978 film *Eyes of Laura Mars*, starring Faye Dunaway as the title character, a photographer. "I wanted to do murder pictures," says Bossidy, and she researched the theme by visiting morgues and collecting murder-scene photographs, "and of course Helmut took them. I could do what I wanted, and if Helmut liked it, we'd go to town. But Helmut, and this is the major point, was very pure. The sexuality was clean and out there, nothing was hidden or weird." There was also always overt humor, as when Bossidy took a shoot crew to a drive-in burger joint in Palm Beach and Newton photographed a nude with a burger in her crotch.

"Helmut would do S and M, but in a different way," Bossidy says, recalling a shoot in Las Vegas with model Jerry Hall, who was photographed licking the cowboy boots of a male model riding a horse. "I'll never forget her licking the boot," Bossidy says. "That was Helmut's idea of heaven. Most photographers love that sort of thing. They're controlling a model. There are sexual connotations of subservience. Penn would do the same thing, but just not as sexual." Bossidy did a wear-when-wet accessories story with Penn that required a model to sit still while pails of water were tossed in her face. "We sat and waited for the film to be processed, then he did it again. There was a lot of that. All of them do it—probably whenever they can. They're naughty, those guys."

Some of the images Newton shot for *Oui* were reproduced in his 1976 book, *White Women*, which propelled him into the pantheon and certified the genre known as porno chic. At the time, though, it was greeted as a curiosity, "one of the more bizarre photography books of the season," according to the *New York Times Book Review*. It described his photographs as "lurid, even sado-masochistic" and reported his book was selling well that holiday season, albeit only to "women and gays." "*Oui* gave him a platform he hadn't had before to start to play," says Bossidy. "Pre-AIDS, it really didn't matter. It was kind of an amazing time."

Models, however, found Newton demanding and difficult to work with. "I'd say, 'What are you thinking?'" recalls hairstylist Hamid Bechiri. "She's naked, it's under twenty degrees, and he says he can't shoot because she has goose bumps. And the girl would stop shivering. They knew who he was. He could make your career."

"Models used to say they needed a week off after a couple days with

Helmut," Jade Hobson agrees. "He saw the pictures in his mind" and put the models into the pose he envisioned. Then he'd take a break and "two minutes later say, 'Get back into that position.' He'd remember where their little finger was, and that's hard on models. It was very controlled."

Yet Newton could improvise when necessary. Once, working on location in Montecatini, Italy, Newton spotted an indentation in a hedge where it was apparent a statue had once stood. "Helmut's mind starts working," says Hobson. "I'd really like to do a nude there as a statue," he said. "Can we get a pedestal?" Both models on the shoot declined to disrobe, but Newton refused to be stymied. "Who would do it?" Hobson continues. "Brigitte Nielsen was nearby, in Germany, and said, 'Of course,' and she came and we did a couple more shots. That's the way he was, so spontaneous and all-seeing."

"As time went on," says Grace Mirabella, Newton "perfected the kind of sitting he wanted to be doing," and they made him a brand-name photographer for the rest of his days, an icon of kinky modernity. "A little perverted," says Hamid Bechiri. "A woman who's not fuckable but would go fuck a truck driver." But to magazines, Newton's work—thereafter shot with books and exhibits, not the demands of fashion commerce, in mind—wasn't quite as sacred as Avedon's and Penn's. "There was a moment when finally he went too far, too too too extreme," says Mirabella, who saw the fruits of another sitting in Paris and declared unusable the photos of a girl in fur and lingerie standing on a curb with a pimplike man lurking behind her. "Alex wanted to disagree," she says, "but he knew. It was a hooker on a street corner in great lingerie. French *Vogue* bought one picture. It was really not worth a whole sitting."

Liberman's "typically European disdain for what he called American Puritanism" didn't impress Mirabella, who thought his newfound emphasis on sex wasn't "particularly inspiring." But she rationalized it by telling herself that at least the photos that resulted put women on top in sexual encounters. In hindsight, she allowed that *Vogue* "moved out of the past in fits and starts."

Certainly, "The Story of Ohhh" was a giant leap forward. "The idea was a story on fragrance," says Polly Mellen, "and Alex and Grace think Helmut should do it. We've spoken to him and he's very interested. A day goes by and he calls and says, 'Only if it's Lisa Taylor,' who he was entranced with, and she loved a little bit of danger in the picture, erotica, sex. You try like

hell to get something special. With some photographers, you can push, and with others you can't. Behind the scenes is where it all happened. Grace might have an idea and Alex would ponder it overnight and take it into the bizarre. Then it's Newton's mind and mine feeding his and his feeding mine, and it went way beyond the original thought."

Curiously, no one thought that Deborah Turbeville's portfolio in that same issue was at all controversial when it was photographed, laid out, or sent to press. Judged by her résumé, Turbeville was an insider, a former fashion editor trained by Diana Vreeland, Alexey Brodovitch, and Richard Avedon. But she was also an outsider by inclination, and not just because she was one of the rare women to crash a field so long dominated by gay men and, then, the heterosexual males who sometimes made it hard to differentiate women's from men's magazine pages.

Chapter 30

"A LITTLE OFF"

Deborah Turbeville was born in 1932 and raised outside Boston by nonconformist parents who taught her to appreciate culture and value individual style. They spent summers in coastal Maine, whose bleak, barren landscapes she loved. Though she would never describe her childhood as lonely or isolated, neither did she recall time spent with friends or the joys of a playful, exterior life.

After dropping out of the University of Georgia during her freshman year, the gangly redhead moved to New York, where she worked at the Stork Club, dated its owner, Sherman Billingsley, and became a fit model for and an assistant to designer Claire McCardell, one of the pioneers of easy American fashion. McCardell introduced her to Diana Vreeland, who lured her to *Harper's Bazaar* in 1963 to become a fashion editor at the tail end of the Snow-Brodovitch era.

Turbeville hated the job. "I'd get a note from some senior fashion editor saying, 'We find your arrival half an hour late for Bill Blass appalling,'" she recalled. "I just stopped going. I'll tell you one reason I hate those things now. It's seeing all those people who you've seen for years, who've spent fifty years of their lives just looking at clothes. I mean, I've got nothing against them. It's not really a feminist point; it's just that I don't want to be there."

What she loved was working with photographers such as Diane Arbus, Richard Avedon, and Bob Richardson. She and the equally tall, lean, and intense Richardson shot *Bazaar*'s biannual children's fashion portfolios and strove to be controversial. Often, their shoots were inspired by films. "He always worked like it was a scenario in a film," Turbeville said. "He would give me the script." But sometimes, things went off script, as when the two went to photograph the Kleberg family, owners of the 825,000-acre King

Ranch in Texas, and friends of their children. The shoot team stayed with the family, but the first night, at an alcohol-fueled dinner, the talk turned to horse racing, and Turbeville upset the Klebergs when she said she thought the sport dishonest, according to a young assistant who saw the angry reaction and kicked an oblivious Turbeville under the table in a vain attempt to shut her up.

In Turbeville's telling, it was Richardson who "insulted the host and hostess and we were asked to leave in the middle of the night." Like Bert Stern, Richardson was an amphetamine addict, and capable of explosive, irrational behavior, but the assistant says they stayed two or three more days in a guesthouse before finally decamping to a hotel in San Antonio.

The next morning, Turbeville and Richardson left early to scout locations, while the assistant stayed in the hotel and was rescheduling the child models when she got a panicked phone call from Richardson. "He was just terrified," she says. He and Turbeville had been arrested for trespassing in a small Texas town and thrown in jail, and they needed the assistant to go to their hotel rooms, fetch identification, and come get them out. While looking for Richardson's passport, the assistant came upon "a ton of stuff in a satchel," including syringes, hypodermic needles, and bottles. "This must be drugs," the assistant decided, before rushing to her photographer and editor and confronting a "sheriff with his feet up on a desk and a rifle over his legs. I said, 'Do you know who they are?' And he said, 'I know who they *say* they are.' He was loving every minute of it."

Finally, the sheriff set the pair free. "It was out of a movie," says the assistant, though not the one that inspired the shoot. Turbeville never gave a full or coherent account of what happened next, except to say that on her return "I was asked to leave the magazine" because Nancy White thought she was "just too much." She bolted to *Ladies' Home Journal*, and Richardson made French *Vogue* his principal outlet. It's hardly a stretch to suspect that somehow Nancy White found out some of what had gone on in Texas.

Turbeville was already on thin ice at *Bazaar*. Late in 1963, she and Richardson had shot the children of a socialite in sexually suggestive situations at the Costa del Sol home of a Spanish duchess, a shoot that ended with the duchess on her terrace screaming imprecations as Richardson and Turbeville departed, says her close friend Paul Sinclaire, a fashion editor and ex-

ecutive. On another occasion, she and Richardson concocted an aristocratic lineage for a penniless woman they shot for *Bazaar*'s Fashion Independent feature, and White was furious when she learned the truth. "There were many situations," Sinclaire says. Taken together, they propelled Turbeville into shooting pictures of her own.

In 1966, Turbeville joined the *Diplomat*, a magazine owned by Igor Cassini, a former society columnist and playboy. Unable to get its photographers to shoot stories as she envisioned them, she herself did a fashion shoot in Yugoslavia. "I went into a store, bought a camera, and the man loaded it for me," she said. "I took a long lens and everything was out of focus—but the magazine liked them. I learned what I had to when I needed it. Too much technical knowledge can hamper you." Richard Avedon reportedly saw those photos, saw his own early efforts reflected in them, and invited her to join the Brodovitch Design Workshop classes he taught with Marvin Israel.

"If it hadn't been for the two of them, I wouldn't have taken my photography seriously," Turbeville said, "because it was so out of focus and terrible. The first evening in class, they held up pictures. They said, 'It isn't important to have technique, but you must have an idea or inspiration, and we feel the only one who has it is this person who's never taken a photograph before.' I became very unpopular in the class." She was so intimidated she said she stopped taking pictures for months. But after the *Diplomat* went out of business, Turbeville went back to taking test photographs.

Her next stop was Condé Nast's *Mademoiselle*, where she became a fashion editor in 1967. "I was able to ask them if ever I could do a sitting of my own and take the pictures," she's said. "That's how I built my portfolio. . . . I didn't have to earn a living being a photographer at first. . . . Had I been out on my own, I might have had to compromise my work." Instead, she developed an individual style. "Her models loll about in powdered morning light, glide through opiate afternoon and collapse, neurasthenic, to the hissing of summer lawns," the critic Brian Dillon wrote of her first exhibit in the UK. "Soft focus functions as a fog of longing, regret and debilitating privilege."

By 1975, Turbeville was shooting for *Vogue*. Soon, Alexander Liberman summoned her to his planning room and assigned her ten pages of bathing suits, "but to do five girls across a double-page spread," she recalled. "Do something remarkable, dear," he said. "I'm expecting it." She'd always been

"drawn to bathhouses," she later wrote, especially old, dilapidated ones. A friend found an abandoned one on East Twenty-Third Street in Manhattan, the Asser Levy Public Baths, built for New York's immigrant population at the turn of the twentieth century.

Its atmosphere, Turbeville wrote, "began to dictate the pictures," which "became increasingly surreal, bizarre, Marquis-de-Sade in feeling. . . . It all seemed a little sinister, like the women were somehow trapped, isolated . . . lost in their own world. . . . For me, it was just a problem of fitting five girls across a double-page spread." In another context, she would say the pictures were "done in complete innocence."

Clearly, though, the bathhouse photos were something more than a solution to a spatial challenge. Turbeville and the fashion editors Polly Mellen and Frances Patiky Stein made a series of choices beginning with the location, but going against the grain of the typical bathing suit photograph, which emphasized breasts and backsides and healthy, glowing tans. They chose to work with models so thin, they appeared to flirt with anorexia, their hip and pubic bones jutting, and their faces painted with stark white makeup. Whatever their intention ("And I've done some controversial stories," Turbeville allowed), it wasn't to meet the programmed expectations of the typical fashion-magazine reader. "She was never showing the clothes, and the girls never smiled," says her longtime agent Marek Milewicz. "She didn't like beautiful models. She liked models who were a little off."

The controversy her pictures generated propelled Turbeville into a position she'd maintain until her death in fall 2013. And almost all her work would bear the hallmarks of those pictures, which remained her best known: a hint of moody narrative; bleak, haunted settings; an atmosphere of chic decay; a certain self-consciousness; a sense of insecurity, embarrassment, isolation, loneliness, or alienation; an illusion of invaded privacy.

Turbeville worked hard to achieve those effects. As with Newton, the picture came first, not the model's comfort or her own. Sara Foley-Anderson, an assistant editor at *Mademoiselle*, did her first shoot with Turbeville at the landfill that is now Battery Park City in lower Manhattan, "not the most appetizing place," she recalls. Makeup artist Sandy Linter compares a Turbeville shoot with "going on a journey." They would pick up a location van in front of Condé Nast's offices, then "wander all day long, looking for locations, old

burnt-out buildings. It was exhausting. She was also very quiet but you knew when she liked something. Then she'd let you go at it full on, no rules. What I did with Debbie Turbeville was what all shoots should be."

Neither fairy tales nor nightmares, but something in between, Turbeville's photos represented an intensely interior, resolutely female world, the polar opposite of the harsh colors and glossy perfection of Helmut Newton's or Guy Bourdin's. "I am totally different," she said. "Their exciting and brilliant photographs put women down. They look pushed around in a hard way: totally vulnerable. For me, there is no sensitivity in that. It is the psychological tone and mood that I work for." But they all shared a feeling of breakthrough, driving the commercial craft of the fashion photo—designed only to catch and stop a viewer's gaze—steadily into the realm of artistic achievement.

"PANDEMONIUM, DAY AND NIGHT"

Through the seventies, the international fashion machine was accelerating, feeding the ever-growing need in image-obsessed Western culture for self-expression through outward display. Inexorably, the we're-all-in-this-together culture of the sixties gave way to the Me Decade's obsession with self-image, and fashion, long an elite preoccupation, went mass market. That meant more fashion marketing, which meant more fashion magazines with more editorial and advertising pages and more photographers and models to fill them.

Giuseppe Della Schiava, known as Peppone, ran a textile company that had been inherited by his wife, which sold fabrics to many French and Italian fashion houses. In 1974, he decided the newish Italian edition of *Vogue* (Condé Nast had bought and transformed a magazine named *Arianna*) was insufficiently appreciative of the huge sums he spent on ads, depriving him and the manufacturers who used his textiles of the editorial coverage they felt they deserved. He also liked the company of models, says Daniela Morera, a fashion editor. So he bought the right to publish an Italian edition of *Harper's Bazaar* (and other magazines) from the Hearst Corporation.

Two years later, he recruited a former model, Lizzette Kattan, as his fashion director. The black-haired, brown-eyed Honduran, though petite, had modeled for four years—and Kattan allows that Peppone had his eye on her, but she wasn't interested. Four months later, Della Schiava's wife, Patrizia, who was running Italian *Cosmopolitan*, asked Kattan to become her assistant. A year later, she started styling beauty shoots in Paris.

"I had a lot of freedom as long as I came home with great shots," she says. She'd modeled for Steve Hiett, Alex Chatelain, "and all those French guys, so I contacted all my friends in Paris." She was soon named fashion director of both Italian *Cosmo* and *Bazaar* and opened an office in New York. After her first spread with Helmut Newton, she ended up running *Bazaar*'s French and Italian editions, the local *Cosmopolitan*, and a *Bazaar* for men, too. "All of a sudden, there I was with everything in my lap. I really had to perform, and I was twenty-four years old. Peppone had the money and the trust. My life was twenty-four/seven." For the next fourteen years, she estimates, she produced and published thousands of pages of fashion per month. She was likely the biggest buyer of fashion photos in the world.

Bryan Bantry introduced her to his client Patrick Demarchelier and to hair and makeup artist clients, and Italian *Bazaar* quickly became known as a hot magazine that treated talent well. "I couldn't care less about fashion," says Kattan. "I wanted amazing pictures, and we were lucky at that time that fashion wasn't dictating the pages so we could do what we wanted. Photographers were so eager, they'd work day and night" despite pay as low as $50 a page plus expenses. "We gave them freedom," says Kattan. Though she chose every dress that appeared in the pictures, "I was more interested in the context than the clothes. I knew who would like what, and if the photographers were uncomfortable, I'd change things to give them the security they needed to give me the right product."

For years to come, Della Schiava would rent rooms in bulk at hotels in Rome, Milan, and Paris during the seasonal fashion shows and fly in as many top photographers and models as he could to fill them and shoot for fifteen straight days.

It was "pandemonium, day and night," says Kattan. "Fifty models, eight photographers, ten stylists," says photographer Patrice Casanova. "It was Club Med. We would shoot all day and party all night, knocking on doors at three a.m., waking up people, looking for girls. It was nasty laundry. If you brought a girl to Peppone, he wanted to have her. The game was you scratch my back and I'll scratch yours. 'Bring me a girl, I'll present you to other girls.' Every night a dinner and the protégé of the day would be moving around." Kattan says Della Schiava was "having a lot of fun," and that "a

lot of the stories" told about him are true, but some are "inflated" and need to be taken "with a grain of salt. I remember because I wasn't taking drugs, I wasn't partying, I was working."

For models, Italy had always been the Wild West, a place to test their mettle, and prosper—if they survived their initial hazing. "I was so shocked," says model Marie Helvin. "The drugs, the sex, everything was so free. And it was almost a given that if you worked with a photographer, you slept with him that night." It could also get ugly around the randy French Mobsters and their friends. "None of them were friends," says someone who was there. "They were all fucking each other, stealing each other's girls, each other's work, playing games. They'll kill you in the back."

Into the early eighties, the fashion-picture demimonde was often fueled by drugs. Mike Reinhardt liked to smoke pot, but was once arrested in Milan for possession of cocaine while shooting for Peppone. Still, Reinhardt remembered those *Bazaar* shoots as "heaven on earth," he says. "The food was great, and I took great pictures, too, because I was completely liberated. There were some pretty crazy evenings," too. "Girls wouldn't show up because they were coked out," says Jacques Malignon. "Most survived but some went down. Some photographers went down, too." Adds Alex Chatelain, "Everyone was excessive, everyone was hyper. When they were late, they were very late." Bitten Knudsen, a model with a healthy appetite for drugs, "would come in four hours late, unwashed, dirty," Chatelain continues. "At times it was really, really impossible. I'd throw her out. She had this attitude: 'So, what?'"

"I did all that," confirmed Knudsen, a blue-eyed, blond Dane with fine features, and a smoldering attitude, who died in 2008. "Drugs was a real big part of fashion, especially fashion at the top. It got all-over crazy, all the time. With some photographers, it was the whole crew. With some, it was behind-the-scenes. With some, it was only after work."

But Knudsen didn't like the scene around Peppone: "They were bossing all the girls around, trying to sleep with them at night. Doors would be opened at night and guys would be there. Girls would cry. They'd put you in a car and tell you, you were working with Demarchelier. It disturbed me, being sent around like cattle."

The photographers had free reign. Kattan loved German shooter Chris von Wangenheim, whose vision "was all sex and no clothes," she says, "and every issue needed that spark. I knew to get the best from Chris, he could only work at night, so we worked from five to five." She also knew he was snorting cocaine. "Yeah, he had to get his inspiration going and it took a while to do it. It was a matter of understanding what it took to get them going." Generally speaking, Lizzette Kattan saw no evil: "I never wanted to be involved with the girls. I made it clear I didn't want to babysit. I didn't want to know." But there were nervous breakdowns "every day," she admits. "Those girls were very, very young."

There were exceptions to the ruling insanity besides Elgort. Model Juli Foster worked in Rome for *Bazaar* with photographer Albert Watson, who insisted on "no drugs, no drinking, and he took most of my best photos," she said. "He was very strict. You had to be in bed on time and look good." But ten years after quitting a nine-year-long modeling career in 1985, Foster admitted, "It's surprising I'm still alive. I fell into the drug culture. You'd go to work and there'd be a dish of cocaine there with most of the photographers I worked with. I'd go out dancing and go straight to work. Albert used to preach to me, 'What are you doing with your life?'" Then she'd go back to work and do more cocaine.

Chapter 32

SHOCK EFFECTS

Drug and sex insanity wasn't only a by-product of Italian fashion. And as Tina Bossidy demonstrated at *Oui*, fashion photographers didn't only find homes in high-fashion magazines. Dark flowers also bloomed in a venue as unlikely as the sew-at-home magazine *Vogue Patterns*. In 1975, Marc Balet, an architecture student, scouted locations for Bossidy and *Oui* in Rome and worked as a translator on a Helmut Newton shoot in England with the Italian actress Dalila Di Lazzaro. "Wow, what's this world about?" he remembers thinking after watching Newton, who had a toothache and was cranky, drive Di Lazzaro crazy. "She was lying on a board with her head down and her feet up, saying, 'Could you ask him if I can get up? I'm going to faint.' Helmut would not relent. I'd say, 'He's sorry,' but of course he wasn't sorry at all." Balet was nonetheless enchanted by the "mix of fashion and a macabre sensibility" that Bossidy had engineered. "Helmut realized he could get that into mass magazines. Nobody turns away from that opportunity."

Shortly after his return to the States, Balet was hired as the art director of *Vogue Patterns*. (Though it carried *Vogue*'s name, the magazine, first sold to Butterick Patterns in 1961, was then owned by the American Can conglomerate.) "It was a catalog operation," says Balet, "but with the best photographers and models in the world: Elgort, Watson, Demarchelier, Chatelain, Malignon, François Lamy." Balet sent them all over the world and, back in New York, fed them "the best drugs in town," he admits. "When I got the job, I had a big office with a studio next door. They said, 'How do you like to work?' 'I work on glass.' They got me a huge glass table. I did it so I could chop up the coke, snort, and jump on the phone with Bryan Bantry."

The photographers adored Balet. "Why not take a drugged-out holiday in Bali?" he says. "The clothes were good enough. I knew dealers. It

was a huge party. Albert Watson did not indulge. Everybody else was in on it. We were banned by Pan Am," which had flown his shoot teams around for free thanks to their tenuous *Vogue* connection, "because of the insanity on airplanes. It was fun times, man. But it was a business, too. They always brought back the pictures."

Balet was closest to Chris von Wangenheim, one of the photographers who fed cocaine to Juli Foster. Born in Germany in 1942, Wangenheim was from a minor German noble family, the son of a cavalry officer who'd won a gold medal riding in the 1936 Berlin Olympics; he was later taken prisoner on the Russian front while fighting for the Nazis and committed suicide in 1953 while still in captivity. Horses and equestrian gear would later figure in his son's work.

Chris started taking pictures after his father died and came to America at twenty-three to be a photographer, assisting *Bazaar*'s Jimmy Moore before opening his own studio. In 1969, he went to Italy and started working for its *Bazaar*. "I worked with shock effects, which do not have any photographic value, but extended my visual boundaries," he said. In the seventies, he started shooting for the various *Vogue*s and married a model. They had a daughter five years later.

Chris's father had been a *Freiherr*, or baron, and Wangenheim used the title himself, but he was really more "a martinet," says fashion editor Ila Stanger. "He could drive you crazy. You never knew how he'd treat people." That had been the case since he was eleven and shot a photograph of his mother over her strenuous objections. "I realized that getting my picture was more important to me than the discomfort of someone not understanding," he said.

He began taking advertising pictures for Christian Dior: images of beautiful women shooting a .38 caliber handgun, riding an inflatable shark, or being bitten by a Doberman, accompanied by copy lines such as "Explosive is your Dior," "Fairplay is your Dior," and "Fetching is your Dior." They reflected the hedonistic mood of his adopted hometown, New York, in the seventies. "The violence is in our culture, so why shouldn't it be in our pictures?" he asked.

He was often compared to Helmut Newton, whom he'd met and befriended. "He was infatuated with Newton," says hairstylist-turned-

photographer Hamid Bechiri, who worked with them both, "but he didn't have the talent. Helmut was a fucking star, a god. Chris was just a photographer." His adoration of Newton was "obvious," says Jade Hobson, "but Chris put his own spin on it," adding menace to Newton's eroticism. And unlike Newton, who seems to have been a pure voyeur, Wangenheim participated in the lifestyle he portrayed in his photographs. Early in his career, his day job had yet to be overshadowed by night games. But at the end of the seventies, Wangenheim pushed the limits, burning the candle at both ends. "He used to make us do shots for *Vogue* at night on a treadmill in high heels with a wind machine in our faces. He was crazy," says Juli Foster. "He was so loaded."

Though she'd been warned he was difficult, Sara Foley-Anderson worshipped Wangenheim from the moment she met him, a few years after joining *Vogue* in 1973. By 1976, she was working on shoots, mostly propping, finding whatever was needed to realize a photographer's visions. When Wangenheim wanted a photo of an elegant leg in high heels, kicking in a TV screen, "I was throwing the glass, thank you," Foley says.

One night at 1:00 a.m., "we'd done Christie Brinkley naked on a horse"—a photograph shot in the service elevator at 100 Fifth where Wangenheim, too, had a studio—"and then we start a shoe picture with a Doberman," Foley says. The dog on the set was a performer who'd been taught to "talk" by flapping its jaws. But it looked mean. Wangenheim considered the Doberman "a very erotic dog." The model was wearing a Geoffrey Beene dress, straight off the runway. The dog was coaxed with bits of steak to wrap his mouth around the model's ankle. "He doesn't look angry enough," Wangenheim told the trainer, who wrapped a towel around his hand and got the creature riled up, "and everyone is saying, 'Beautiful,' and all of a sudden the dog grabs the dress and literally rips it off," Foley recalls. "I freaked. I was supposed to bring the dress back."

In those years decadent Manhattan came to a head, too, and Wangenheim was an eager and willing participant in its rites and rituals. "Chris was really into S and M and bondage," says his assistant Rob Penner. "He had a secret love of that world." Only it wasn't so secret. "He would talk about it a lot. He went to underground clubs. He'd do tests with girls tied up, in leather, with boots up to their crotches."

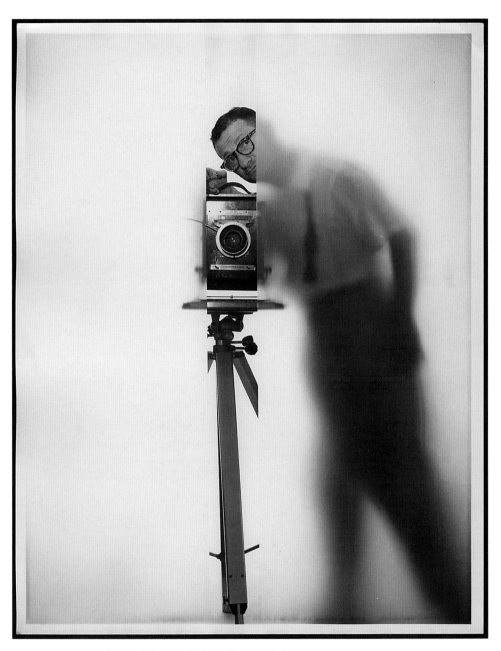

Erwin Blumenfeld, self-portrait (ERWIN BLUMENFELD,
COURTESY OF THE ESTATE OF ERWIN BLUMENFELD)

Carmel Snow (front row, *left*) with columnist Eugenia Sheppard
at Christian Dior's last couture collection, 1957
(© GLEB DERUJINSKY 2015)

Alexey Brodovitch
(BENEDICT J. FERNANDEZ)

Alexander Liberman in 1946, the year he
arrived in America (ASSOCIATED PRESS)

Melvin Sokolsky, self-portrait with Simone d'Aillencourt
(MELVIN SOKOLSKY)

Above: Diana Vreeland (*center*) with Pauline Trigère and
Nancy White, in hat and gloves, in 1964 (ASSOCIATED PRESS)
Below: Marvin Israel (with glasses, at *left*) at the Paris Couture,
1962 (JERRY SCHATZBERG)

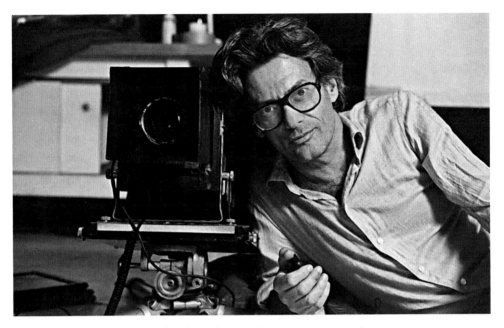

Richard Avedon, 1978 (ADRIAN PANARO)

Jerry Schatzberg, 1964 (TERENCE DONOVAN © JERRY SCHATZBERG)

David Bailey and Terence Donovan on the roof of Jerry Schatzberg's
New York studio, 1964 (JERRY SCHATZBERG)

Brian Duffy, 1977 (JERRY SCHATZBERG)

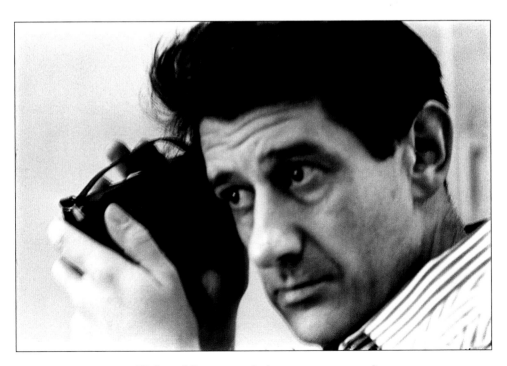

Helmut Newton, 1962 (JERRY SCHATZBERG)

Bert Stern (IRVING PENN)

Bill King with Erica Crome, London 1967 (BARNEY BOSSHART)

Counterclockwise from front: Mike Reinhardt, Janice Dickinson, Gilles Bensimon, and Pierre Houlés, Carnegie Hall, New York (MIKE REINHARDT)

Regis Pagniez (MICHAEL GROSS) Anthony Mazzola (MICHAEL GROSS)

Patrick Demarchelier (MIKE REINHARDT)

Bonnie Pfeifer and Arthur Elgort, 1975 (ARTHUR ELGORT)

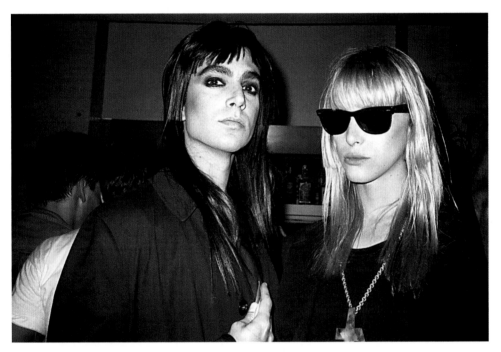

Steven Meisel and Teri Toye, 1984 (PATRICK MCMULLAN)

Fabien Baron (FABIEN BARON)

Franca Sozzani (ASSOCIATED PRESS)

Liz Tilberis (MICHAEL GROSS)

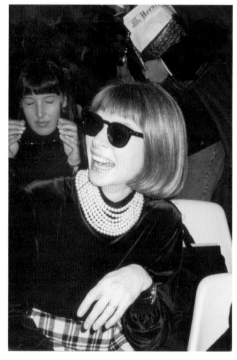

Anna Wintour (MICHAEL GROSS)

Bruce Weber (MICHAEL MURPHY)

Terry and Bob Richardson, 1996 (ROXANNE LOWIT)

Penner saw Wangenheim as a groundbreaking photographer, a Helmut Newton protégé whose work, though derivative, had "a unique interpretation. It was the time of Studio 54, cross-dressing, gay sex clubs, experimentation. People were pushing to the edge, and Chris was showing it in a very creative, compositional, gestural way."

Penner recalls conflicts with editors who hired Wangenheim precisely because his work pushed the limits, then worried when they got what they wished for. "He loved to shock," says Penner. "He always wanted to get a girl to show her breasts. The quicker he could get her clothes off, the better. It wasn't about clothing. He wants two girls making love and the clothes on a hanger to the side. Like Bourdin, the clothes were a prop. It was about the ambience and the aesthetic."

Wangenheim would search for locations with a dedication equal to Turbeville's, but with a very different goal in mind. "He found unusual places all the time," says Penner, recalling a fur shoot in the cold room NASA used to test space suits. "It didn't matter if it made sense. It was shocking and unique. He wanted to be different from everyone else. *Vogue* pretty much let him do what he wanted to do. The magazines were competing, so they wanted pages that made the magazines jump off the shelves."

Sara Foley found the chain-link fence and the AstroTurf that appear in Wangenheim's famous 1978 nude photographs of the drug-addicted bisexual model Gia Carangi, which were taken after a winter-coat session for *Vogue* was completed. By 3:00 a.m., Carangi's hands were bleeding from "climbing up and down the fence," Foley says. Then, the beautiful makeup artist Sandy Linter took off her clothes and faced Carangi through the fence, and Wangenheim, in heaven, snapped away. Gia later admitted she "fell crazy in love" with Linter that night, and rumors of a lesbian affair ran like wildfire through the gossipy world of fashion. Wangenheim was the one who'd scored, though: not a single shred of clothing was in the resulting pictures, only body heat.

Foley was excited by those photos, too—and proud to have played a part in them: "I wouldn't say it was twisted as much as of the time."

As the eighties began, Chris von Wangenheim's star went into eclipse, though he was only thirty-eight years old. He and his wife, Regine, broke up and were fighting an "ugly divorce," says his nephew Burkhardt von Wan-

genheim. She'd always "had her own life," says Penner. And "it was no secret he had a number of mistresses. He was a photographer."

He'd lost advertising accounts, too, such as Versace and Dior to Richard Avedon, reportedly because of a growing cocaine habit that saw him kicked to the curb even by the notoriously louche crew at Italian *Bazaar*. "There was not a lot of coke at first," says Penner, "but after a year, he was doing it before jobs, doing it in the middle of jobs. It was very much part of his life. He was also a wine enthusiast, without a doubt an alcoholic, a bottle a day if not more." Wangenheim stayed in control while working, "but after hours he got a little crazy," Penner says.

Then came a shift in the prevailing winds of fashion against his brand of kinky chic. Three years earlier, his handgun Dior ad was pulled from magazines after the Son of Sam mass murders. "Violence in fashion is over," he told *American Photo* magazine. "At the time it seemed worthwhile to make a statement about it. Now, advertising is going through a very conservative period."

Like so many photographers before him, he decided it was time to publish a book. He summoned Marc Balet to his studio, where he had spread a hundred pictures on a table. "I saw a Polaroid of a girl I knew he was fucking in a tight dress with an amazing ass, walking away from the camera in an empty ballroom, slugging champagne," says Balet. "And I looked and I looked and I swept all the other pictures on the floor. They scatter everywhere." Wangenheim was horrified. Had Balet lost his mind?

"They looked too Helmut-y," says Balet. He wasn't even interested in the famous Dior photos. "Chris had more to say than that. I wanted him to have his own image, to lose forever that image of him with Helmut." Balet suggested a book that Wangenheim would have to shoot almost from scratch, called *Women Alone*. "Start here," Balet said, pointing at the Polaroid. One day not long after that, Wangenheim told Balet he was going away on a job. In fact, "he went off on a tryst," Balet says. Late in 1980, he'd spotted Marie-Christine Starfield at a SoHo gallery. She was in mourning for a husband who'd just died. "I wasn't paying attention," she says, but a mutual friend told her, "Chris flashed on you." A week later, a whole gang went to the Mudd Club after a dinner party. Marie-Christine was upset, so Wangenheim took her outside to comfort her. Back in the club, she went to the

bathroom "and ended up falling apart again," she says. When she emerged, he was gone, but the bartender waved her over and handed her a note with his name, address, and phone number.

A dinner followed. "At the end of the evening, Chris looked at me and signaled, 'Come up with me,' and that was the beginning of our relationship," Starfield says. "I didn't know who he was. He wanted to take pictures of me. I couldn't care less. He mentioned to me, 'You know, I'm really good at what I do.' He was very humble and unpretentious. I knew famous artists. I'm not impressed with it. But he showed me a *Playboy* with [his photo of] Raquel Welch [on the cover], and I realized he had to be very good at what he does."

Marie-Christine shared everything with him—even S&M: "We went through using the paraphernalia in pictures and in life. He liked the leather. It's fun. It's fun to have role play. We were not hurting each other. The violence was a representation of something he found beautiful. He wasn't sadistic. It's the look of it."

In March 1981, he took her to Saint Martin. On their sixth day on the island, they had dinner and, while driving back to their hotel, crashed into a light pole. Six days later, Marie-Christine came out of a coma in a hospital. Chris had been declared dead on arrival there. Marie-Christine, who was incorrectly described in the local newspaper as his wife, had also suffered a broken leg. After a month in the hospital, she learned that his wife, Regine, in the meantime "took everything," she says, speaking of Wangenheim's archives and belongings. "I was not going to fight at that point. I didn't want to scare [their daughter] Christine. I loved her."

For more than three decades, Wangenheim's photographs and his legacy were in limbo. His not-quite-ex "never wanted to do anything," thinks Marie-Christine. "I don't know if it was about me. She didn't like Chris." But Regine was still his wife, and under the terms of his will she got $50,000 outright and half of the rest of his estate, which was valued at almost $325,000. Daughter Christine got the rest—and finally allowed a book of his photographs to be published in fall 2015. It includes an image of Marie-Christine, but ends with two pictures of daughter Christine at her mother's feet.

EXPOSING HIMSELF

Gilles Bensimon lived with the stylist Douce de Andia for eight years through the end of the seventies. Rich and happy-go-lucky, he was like the little brother of the other Frenchies. They sometimes even called him Little Ben. But finally, he started acting like a fashion photographer. It was as if he'd just discovered his sexuality and felt compelled to show it off. Another set of rumors started then; the worst have him regularly exposing himself to models. "You know, those are models talking," says Uli Rose, "but I wouldn't put it past him. Gilles comes up with the craziest shit."

Mike Reinhardt thinks the ill-endowed Pierre Houlès started the weenie-wagger rumors. "There was an incident. I think it happened in the Bahamas," Reinhardt says. "But I don't know if that's true. I do not believe he was regularly exposing himself. But Pierre was always impressed with his endowment and was always talking about it."

Gilles wasn't only showing it off. "He was cruising the girls a lot, but a lovely, simple guy," says Stephane Lanson, then a model agent. "From some of my models I heard he was quite nice in bed. Very well equipped. And a fabulous photographer."

Bensimon doesn't broadcast his conquests but acknowledges them when asked: "The girls liked me. I liked them, too." A story went around Paris that he broke up with de Andia after he bedded the Southern beauty Rosemary McGrotha, who went on to play a female president in a famous series of Donna Karan ads.

"That's not true," McGrotha says, almost shrieking. Though they worked together when she was nineteen and just starting out, he put her on an *Elle* cover that launched her career, and she admits, "I may have had a crush

on him," they were never lovers. But at that moment, Bensimon's romantic focus abruptly turned to models.

Just like Pascha, Douce de Andia betrays no bitterness and points out that she helped Bensimon a lot: "He began to be a great photographer with me. I worked a lot with him." She knew he liked models. "A lot. It's normal. But I was very happy with Gilles. At the end, it was not so good for many reasons. We finished our story together. I met another man. A happy end, you know? It's important to say that." Their breakup coincided with a new beginning for Bensimon, the launch of an American edition of *Elle*.

Regis Pagniez was working in the art department of *Marie Claire*, a Paris fashion magazine, when he met Daniel Filipacchi, who was then a radio deejay. In 1960, he recruited Pagniez to help launch a pop magazine. Over the next two decades, Pagniez ran the ever-expanding, centralized art department of a growing Filipacchi empire, directing visual magazines such as *Photo* and *Lui*. At each, he tended to favor a single photographer. "Regis doesn't like to speak to a lot of people," says Anne-Marie Périer, once the editor of French *Elle*, whose brother Jean-Marie shot for Pagniez.

In 1978, in partnership with *Rolling Stone* founder, Jann Wenner, Filipacchi and Pagniez moved to New York to relaunch the moribund *Look*, where Stanley Kubrick and Bert Stern once worked. "We had difficulties," Pagniez admits. "I didn't understand at that time how to do an American magazine. It was not a failure. We sold seven hundred thousand copies of the last two or three issues." Nonetheless, Filipacchi decided to pull the plug after losing about $10 million. The experience rankled.

In 1980, Jean-Luc Lagardère, whose Matra conglomerate manufactured everything from arms to automobiles and owned the radio station where Filipacchi had been a deejay, bought Hachette, the fading, family-owned French magazine company that published *Elle*. Lagardère asked Filipacchi to be his partner, running all their magazines. *Elle* "was in very bad shape," says Pagniez. "We had to put *Elle* on track. It took four year, but it start really quickly." Now, along with Oliviero Toscani and Marc Hispard, Gilles became a member of the *Elle* inner circle gathered around Pagniez.

In 1983, Bloomingdale's was planning a promotion called Fête de France and asked *Elle* to produce an English-language magazine for the event.

Hachette printed an extra one hundred thousand copies for newsstand sales. When it did well, two more biannual American issues were produced by the *Elle* team in France. Then, in partnership with Rupert Murdoch, Filipacchi sent Pagniez to New York to begin publishing *Elle* monthly.

Pagniez had decided that it would be a purely visual, pure fashion magazine, without the news stories or lifestyle features that fill out its French parent. But he immediately faced a problem; after seeing the byline of Bill King, one of *Vogue*'s top photographers, in *Elle*'s first issues, executives at Condé Nast made it clear to its photographers that if they worked for *Elle*, they would no longer be in *Vogue*. That ban has continued for years.

In 1984, Gilles went to Tahiti for French *Elle* to take pictures of a nineteen-year-old, six-foot-tall Australian named Elle Macpherson. She'd been forced on him by one of French *Elle*'s fashion editors, but something clicked and he followed her back to New York. "She was really cool and Douce drive me nuts at the same time," he says. "I tried to fix it with Douce, but she was a nightmare, so I said, 'Okay, I'll go back to this thing in New York.'" Macpherson says the "little photographer from French *Elle*" romanced her for six months.

"She was a great girl—always ready for anything," Gilles says of Elle, the model. Like all his other women, she says he taught her a lot. She convinced him to stay in America "because she wanted her career in America," says Pagniez. Bensimon decided to stay three years. Briefly, he switched to Condé Nast. "But the first story he do was a big flop," Pagniez says, laughing. "I thought Gilles will call me, and Gilles called me." He wanted to come home and be an *Elle* photographer again. "Like he was," says Pagniez, "like he is." He emerged as *Elle*'s chief photographer. "He was the only person I could call every day," says Pagniez. "His thing was *Elle*. He was born with *Elle*. And at that point, it was very important for the magazine to have its own style."

Bensimon's pictures cemented Macpherson's fame. They got married. "People thought I owned the magazine," Bensimon says. "That it was named after my wife. There were many, many, many stories." Nobody knew the big one. It was *Elle* vs. Elle. Bensimon was spending more time with Pagniez than with his wife. The two Frenchmen shared the same tastes, lived in the same building in Greenwich Village, ate breakfast together every morning, rode to the office in the same car, and talked on the phone when they

weren't together. "We grew up in the same way, we have the same Catholic school, we even have the same teacher," Bensimon says. "It was painful for Elle because I was always with Regis. I think we fell in love with each other."

Bensimon also fell in love with *Elle*, the magazine: "I got excited. Right away, I realize the possibilities. I'd always dreamed of being an art director, to have a magazine. Always, from the beginning, I was thinking, 'I want to decide.'"

By 1987, *Elle*'s circulation had hit 782,000 copies a month, an increase of 300 percent in three years. The magazine won two National Magazine Awards that year—for design and general excellence. Hachette's June 1988 purchase of Diamandis Magazines for $712 million, and its buyout that September of Murdoch's stake in *Elle* for $157 million, added a big debt burden. But the magazine was a juggernaut, with fifteen international editions by the end of 1989. Its unprecedented success also had an unintended consequence, toppling both the Queen of Fashion and the long-reigning King of Fashion Photography.

Chapter 34

STOP AND STARE

Richard Avedon's last *Vogue* fashion portfolio—mostly studio shots of Paris couture—occupied twenty-two pages in the October 1984 issue. His concept was to pair sedate location pictures with minimal styling on pages facing color studio photos with extravagant clothing, hair, and makeup. At a lunch at Closerie de Lilas, Grace Mirabella and Polly Mellen worried the idea wouldn't work, and Avedon, "in the nicest way possible, said, 'Fine, I'll pack and head back to New York,'" says J. P. Masclet, who'd been hired to assist him. "I don't think he really cared. It was my way or the highway. They backed down completely and he shot it the way he wanted."

Still, Avedon's fashion photography had suffered. Much of it was banal, such as the catalogs he shot for Bloomingdale's.* Some was more memorable for its ubiquity (his print ad campaigns for the brash Italian designer Gianni Versace, which continued for years) or its cockeyed ambition (the series of playful TV and print ads he concocted with Doon Arbus in 1982 for the Christian Dior brand, which aped and mocked the popular evening soap operas *Dallas* and *Dynasty*, telling the story of a fictional Dior family). But Avedon could still blaze new paths.

His most influential fashion accomplishments in those years were other television commercials. In the early seventies, just after the death of Coco Chanel, her company, which was privately owned by a Swiss family, hired Avedon to direct television commercials and print ads starring David Bai-

*Guy Bourdin had made a splash with a sexually charged 1976 Bloomie's lingerie catalog called *Sighs and Whispers*. Mailed out free to store customers at the time, it now fetches hundreds of dollars a copy at auction.

ley's wife, Catherine Deneuve, then barely known in America. She'd refused to even discuss posing for the brand until Avedon had a letter slipped under her hotel-room door, explaining that the company wanted her and her alone. Deneuve didn't like that Chanel herself had cozied up to the Nazis in Paris during World War II, but neither had Avedon, who'd contrived to photograph Chanel in 1948 beneath a poster referring to Adolf Hitler. And Avedon promised Deneuve the campaign, written by Arbus, would be like no other. "She finally said yes, and it was his first successful commercial," says Nick la Micela, who worked at Chanel's agency.

Avedon also directed and starred in a series of exquisitely silly ads, rarely seen in America, for Jun Ropé, a Japanese fashion brand, which featured models such as Veruschka, Anjelica Huston, Jean Shrimpton, and Lauren Hutton, and real fashion stylists, gently mocking their own world. He did something similar, but with far more impact, for the American designer Calvin Klein, beginning in 1980. His first Calvin ad, starring fifteen-year-old actress/model Brooke Shields, opens with the camera lovingly climbing one denim-clad leg, then revealing the rest of her, knees spread wide and crotch on display, as she whistles "Oh My Darling, Clementine." Then, she looks up and intones the memorable lines "Want to know what comes between me and my Calvins? Nothing."

Klein had been doing significant advertising since 1978. A year earlier, he'd licensed his name to an apparel manufacturer for a jeans line. Though he'd made jeans before that, they were quite high priced, and he wanted to compete in the new category called status jeans. At first, Klein worked with an ad agency called Epstein Raboy, which bought a billboard in Times Square to announce the launch of the new Calvin Klein jeans; Charles Tracy's photograph of model Patti Hansen on her hands and knees, flaunting her splendid rear end in skintight jeans and a silk blouse, caused a sensation. Sales of the jeans exploded, and Klein's advertising budget did, too, growing from $4 million a year to $22 million in the mideighties.

In 1979, Klein moved his business to the boutique ad agency Scali, McCabe, Sloves, a "hot shop" that produced a pool of television commercials for the jeans line that debuted on the Academy Awards show the following spring. But Klein didn't like the ads, so late in 1980, he poached Sca-

li's account supervisor, and Rochelle Udell, the art director who'd worked at *Vogue* through most of the seventies, to start an in-house ad agency he named CRK, his initials. "He wanted breakthrough, out-of-the-box advertising," says a Calvin Klein employee of that time. "He wanted controversial press-generating creative." Klein also chose and worked one-on-one with Avedon and Arbus. Avedon had shot Shields for *Vogue* and suggested her as the model.

The spots that resulted were ripe with sexual innuendo: "I've got seven Calvins in my closet, and if they could talk, I'd be ruined," Shields says in another. In a third, she says, "Reading is to the mind what Calvins are to the body." Depending upon the source, Klein paid Shields between $500,000 and $800,000. It was also reported that he bought her an $80,000 horse. Arbus was reportedly paid $100,000. Avedon's compensation went unrecorded. Klein and his jeans licensee reportedly bought more than $5 million of airtime. The CBS affiliate in Los Angeles banned four of the spots. Feminists were outraged. "Mission accomplished," says the Calvin Klein executive. Klein emerged as the category leader, selling 2 million pairs of jeans a month.

A second cycle of thirteen similarly silly yet provocative Avedon-Arbus-Calvin ads debuted on the 1983 Oscar broadcast. They starred young actresses and models including Martha Plimpton, Shari Belafonte, Lauren Helm, and Andie MacDowell, spouting seemingly spontaneous, solipsistic pseudo-profundities, ostensibly reflecting both the girls' personalities and the lifestyle aspirations of their target audience, eighteen- to forty-nine-year-olds in urban markets who wanted more from life than a pair of Levi's. As arresting as a car crash, the ads were milestones in the history of image marketing, selling a mood and an ideal. The products being sold, while seemingly secondary, were actually tools that let consumers feel part of a particular fantasy. Specifically, Avedon and Klein were telling viewers that if they bought a pair of the jeans, they, too, would be sexy and glamorous. Designed to provoke, with their emphasis on blatant teenage sexuality, they demanded you stop and stare and helped turn Calvin into a cultural icon, one unafraid to reflect the world as he saw it, even if the sights and sounds actually came from Avedon and Arbus.

Just as famous, if not quite as controversial, was Avedon's 1981 portrait of

the young actress Nastassja Kinski lying naked on a cement floor wrapped in and being kissed by a huge snake. Avedon later described the shoot as "fashion hell," despite the absence of any clothing whatsoever. "The snake kissed her with his tongue and Dick got the picture and I was crying," stylist Polly Mellen recalled. "Nothing you planned could equal the random accident," said Avedon. After its appearance in *Vogue* that October, Avedon made the image into a poster and sold 2 million copies.

In 1988, Anna Wintour, newly installed as the latest editor of *Vogue*, rejected the photograph he'd taken for her first cover—replacing it with a photograph of a model wearing a couture jacket and Guess? jeans, taken outdoors for the inside of the magazine by the up-and-coming German shooter Peter Lindbergh. Tellingly, the editor on the sitting was Carlyne Cerf de Dudzeele, a flamboyant Frenchwoman who'd joined *Vogue* in 1985 after a decade at French *Elle* and was known for the sort of mash-ups of street and couture style that would have flummoxed the hat-and-glove-wearing fashion editors of the past. Wintour clearly relished her break-the-mold mission.

Wintour wasn't alone in thinking that Avedon had fallen out of fashion. "The magazines got tired [of his covers] and started rejecting them," says Wynn Dan, then an art director at *Mademoiselle*. According to Vince Aletti's semiofficial history, Avedon "cancelled his [Condé Nast] contract, collected the rest of the money due to him, and walked away." In that 1992 interview, Avedon gave a more expansive version of what happened. Particulars about his deal with Condé Nast had become a topic of gossip and a point of contention inside the company. "Word went around what I was being paid," he said. "And it was more than the editor of *Mademoiselle* was making." The editor of *Mademoiselle* was married to the powerful editor of *GQ*, Art Cooper. "Things got really ugly with the Coopers," Avedon said.

Then, "Anna Wintour came in and I went right down, as I did with Grace, and said, 'Welcome, tell me what you want.' I had six or seven months left on my contract. I did some cover tries right away. I engraved one. It was changed at the last minute, which was okay. I began to . . ." Avedon paused and started again. "I was having . . ." He paused again. "She didn't want that cover. I worked on other covers. She didn't use them. Believe me, I didn't need another cover of *Vogue*. I didn't feel defined by *Vogue* covers."

They were shot according to a market-tested formula that then mandated big heads, eyes looking at the camera, a tight crop.

Si Newhouse called Avedon and asked him to lunch at the Grill Room of the Four Seasons, Manhattan's power lunchroom. "As I was leaving [home], I got a phone call from Jann Wenner [the founder and owner of *Rolling Stone*]. 'I hear you're kicked out of *Vogue*.' I figured, that's what Si wants. I called my lawyer. I'd never had a problem, so I didn't know what was in my contract. The money was guaranteed." At lunch, Avedon asked to get business out of the way first.

Newhouse, who speaks softly and slowly, often seeming to stutter, started to say that some of his magazine editors were . . . "Si, they want other photographers," Avedon interrupted. "He said, 'Well, so to speak.' I said, 'Fine, if they want me, I'm there.' I never heard from Anna Wintour again." His studio had a telephone known as the *Vogue* phone, "a hotline to Alex," says Julie Britt. "He took the *Vogue* phone out."

Avedon was likely relieved. "He saw the mass consumption of derivative work," says Simone Colina, a stylist who worked with him in those years. "Beauty was starting to elude him. He was totally losing his passion for fashion. He'd never had a conundrum before Anna. It was never 'I'm Richard Avedon.' But suddenly it was 'Huh? I invented this and now you're telling me it's over?' He always looked abstractly, and things became less abstract. It was product."

Even the models were product. Forced to shoot supermodels for Versace, Avedon had his crew pour a bucket of water on Kate Moss "to separate her from her image," Colina says. At another Versace shoot, an uppity supermodel tried to instruct him how to light her. After he balked at taking her directions, she scrawled "Asshole" on the dressing room mirror as she left his townhouse. No one had ever treated Avedon like that. Clearly, it was time for a change.

That summer, Tina Brown, the editor of *Vanity Fair* and a bitter corporate rival of Wintour's, was shifted to the top spot at the *New Yorker*, and in December 1992 she engineered Avedon's triumphal return to Condé Nast as the magazine's first staff photographer. Mostly, he did portraits, not fashion, but in 1995, he shot one of his favorite Versace models, Nadja Auermann, posing with a skeleton, in an elaborate macabre fairy-tale fashion

portfolio, and the work played on his familiar themes: mortality and the thin line between beauty and darkness. "The fear of death has always been strong in me," Avedon had said. "This is what's underneath the beautiful skin in all of us."

According to a press release from the Gagosian Gallery, which would later represent his work, the *New Yorker* pictures "established new historical benchmarks" by "combining design, choreography, acute compositional awareness, and sheer verve." At the time, they were perceived as a commentary on Avedon's disillusionment with fashion. Beautiful on the surface, eerily evocative just beneath it, they also marked the last gasp of his career in fashion.

Richard Avedon died with his boots on, of a cerebral hemorrhage at age eighty-one in 2004, while on an assignment in Texas for the *New Yorker*. He was working on another portfolio, tentatively entitled "Democracy," about presidential-election-year politics. A brief *New Yorker* obituary described it as nothing less than "a survey of America." He hadn't lost his grand ambition.

China Machado had seen Avedon just before his trip, and "he told me he was going to die," she says. But that didn't mean he was going to stop working or planning his next portrait session. "He called me that morning," says the photographic impresario Lawrence Schiller, who'd met Avedon while mounting his Marilyn Monroe show. "The word was out that I knew Charles Manson. He asked about photographing him. That afternoon, I heard he'd died."

The *New Yorker* obituary continued, "He was getting ready to take one more portrait when life fled from him. If to know him was to feel in the presence of the sun, to look back on his life is to see that what we really experienced was the track of a comet: breaking barriers between spheres, shattering fixed orbits, bringing joy and amazement and portents of change to those looking on below, and coming to rest at last in earth, still fully alight."

Those words, penned by a close friend, reveal Avedon controlling his own narrative even in death. Which was hardly surprising given its complex, insecure, but acutely self-aware subject, one who'd once admitted, "The minute you pick up a camera you begin to lie—or to tell your own truth."

Chapter 35

IT GETS REPETITIVE

In the wake of *Elle*'s tremendous success in the late eighties, its editors came and went. Though media watchers would continue to obsess over fashion magazine editors, *Elle*'s success was the first sign that their marketplace power was waning. Regis Pagniez and Gilles Bensimon, however, seemed to be omnipotent and forever. Editors only had sovereignty over the front of *Elle*; the central features section was off-limits. The first editor lasted one issue, the second, six months. Number three lasted two years. Her five successors lasted nine months, three years, two and a half, one and a half, and one and a half years, respectively. *Elle*'s text, such as it was, was scorned. "The look of the magazine was easy for me, but the text in English is not my thing, like you can heard," Pagniez says.

Pagniez brooked no arguments from women; at night, he was often seen with girls. Fashion editors came and went, too, sometimes dramatically. Upon the departure of one, a gossip item blamed the "tyrannical" Pagniez and Bensimon. "Gilles runs the place," an anonymous source said. Photographers sniped, too. Pagniez acknowledges what they said at the time: by the late eighties, Bensimon had become so integral to *Elle* that no one could compete with him. And when they tried, he pushed back. "Gilles, evil Gilles, got jealous and tried to get rid of him," stylist Jane Hsiang says of Bill King.

"I knew something was wrong," Pagniez admits. "Gilles made too many pictures. But it was easier for me." Bensimon's pictures didn't do it for the fashion set, but they made money on newsstands. Other photographers say *Elle* ran photos by Bensimon, credited to others, even dead people. Detractors say he did it for his ego, or his pocketbook. But it's possible he was simply trying to give the impression that others shot for *Elle*, too. "People think

we don't want other photographers," Bensimon would say in 2000. "We are starving for photographers."

In the early nineties, a recession set in, advertising revenues declined, and *Elle's* fortunes fell with them. Ad pages, revenues, and profits tumbled. Filipacchi put David Pecker, a number cruncher, in charge. "*Elle* was an island," Pecker says. "That's the way Regis wanted it." Pecker began pressing Pagniez to change *Elle*. Some think Pecker was also working on Bensimon. If Pagniez wouldn't play nice with touchy advertisers, someone had to.

Gilles stepped up to the plate. By 1992, *Elle* had not only recovered, but surpassed Tony Mazzola's *Harper's Bazaar* to become the number two American fashion magazine, and Bensimon was rewarded. Hachette rented him a downtown studio, helped finance a house in the Hamptons, and gave him the title of creative director. "So many large expenditures," Pecker says, "all paid back. He built relationships. He stood by his word. He made a statement." He was Pecker's big, swinging dick.

Meantime, Elle Macpherson was in demand—in February 1989, she appeared on the cover of *Sports Illustrated's* twenty-fifth anniversary swimsuit issue. Gilles was usually in the office, or else away on shoots. "We become hard to fit with each other," he says. She says *Elle* was a cross she had to bear. "I couldn't work for anybody else."

Then Gilles found another big, busty model, Rachel Williams, whom he repeatedly featured in *Elle*. Macpherson won't comment on reports from the time that she called Bensimon's hotel room on a location shoot—and left him after Williams answered the phone. "We were already split," says Bensimon. "We had already decided to live a different life."

"He had a midlife crisis, what can I tell you?" Macpherson says of their 1990 separation. "Whatever happened after that is his business. I have fantastic memories. We're not not friends."

And her ex's equipment? "All I can say is, my memory is . . . clouded."

Rachel Williams dumped Bensimon in mid-1991. "Gilles was madly in love with Rachel," says Mike Reinhardt. "When they broke up, he was just crushed." For a year, Gilles wrote to Williams almost every day, imploring her to come back. She'd become a star, too, but he says she wasn't happy: "It was complicated. Sometimes an instant success kills you because you expect

it to continue, but it doesn't. When she was not working, she was staying at home, not eating, not listening to music, not watching TV, naked with two cats in the dark. It broke my heart."

Then he met Kelly Killoren on a go-see. The big-boned Midwest blonde had been modeling from the time she was fifteen. Her agent told her to keep her distance, but she couldn't. "I knew who he was dating by the covers," she says. They spoke on the phone all the time, and he would take her for rides on his motorcycle in Paris and invite her skiing every Christmas. They dated for five years before they were married at the home of hairdresser Frédéric Fekkai. "With Kelly, I am more light, more myself," Bensimon said while still married.

She said, "I don't want to get into details, but he was alluring. He'd endured while others fell by the wayside. He's not a player. He's stable, grounded, encouraging." She didn't worry about his reputation. "He loves women. Why do you think the dynamic works so well at *Elle*?" She recalled how he cooked for her every night while she studied for a degree at Columbia. "He says the only thing that's important to him is his family." And then she started to cry.

The marriage seemed to be the end of Bensimon's midlife model-go-round. "We've all done that," says Reinhardt (whom model Bonnie Pfeifer memorably describes as "a turnstile"). "The models are great and all that, but once you've been around it thirty years, it gets repetitive."

Meantime, Regis Pagniez dropped from view. He took a leave of absence for treatment of prostate cancer, and in his absence Bensimon tasted life as *Elle*'s top frog. When Pagniez returned, "He wanted like it was in the past," Bensimon says. "I took a low profile." But David Pecker was impressed by what he'd seen, so after Pagniez inevitably clashed with editor in chief number ten, a former *Vogue* editor, and she was replaced in 1996, Bensimon's star rose again. He'd taken up Pecker's challenge to be more "connected to what was happening in fashion," he says. He moved from freelancer to profit-sharing employee, became a regular at fashion shows, and began running meetings of the fashion staff. Tales of terrorized fashion girls soon leaked out. Bensimon insisted, "I keep my opinions to myself because I don't wear dresses. I listen. I try to understand why they like that so much."

In 1997, Daniel Filipacchi sold his shares in Hachette, and Pagniez found

himself "naked," he says. Then something happened that upset him terribly. "I don't know if he wanted to stay, but he quit," Bensimon says. Pecker says nothing to allay the impression that he pitted protégé against mentor. "As Gilles took on more and more, Regis wanted to do less," Pecker says. "People create something and then want it to fail when they're not around anymore. I don't think he expected Gilles to do as well as he did."

Friends said Pagniez was angry at his protégé—but he denied it. "I have nothing against him. I left him a very good tool. But this is past. I stop to think about magazine. I think it was a little too long for me. Now, I don't care. I don't look at magazines."

Bensimon was rewarded with Pagniez's title, but not his power; editor in chief number eleven reported to a Pecker deputy. Then, less than a year later, Pecker quit, too. Bensimon still did as he liked. "The essential nature of Gilles Bensimon in the *Elle* DNA is not overlooked," said Pecker's replacement, Jack Kliger.

Kelly Bensimon briefly left Gilles in 1999, but they reconciled and stayed together another seven years. After they split, Kelly appeared on *The Real Housewives of New York City*, though she was no longer a wife. Gilles was linked to several models, Pablo Picasso's granddaughter Diana, and a Belgian countess. Bensimon was also divorced from *Elle* magazine and replaced two years after he and Kelly split. Robbie Myers finally ran her magazine. "I never asked to be director of a magazine," Bensimon said at the time. "I was only photography director. The first day I got the position . . . I go, 'Oh, my gosh, that's a mistake.'" In 2011, he sued *Elle* to recover negatives he believed the magazine had lost, a dispute later settled confidentially. Thereafter, he stayed out of the news, although he still shoots glamorous, sexy pictures—and in spring 2016, even appeared in French *Elle*.

Once something or someone becomes fashionable, fashion, inevitably, seeks the next fashion. Gilles Bensimon had fallen out of fashion, but he waved that away with Gallic *froideur*: "I can't even remember why I stopped working with them. I think they just wanted something different." He left just in time; the magazine business, already troubled, was about to be savaged by new realities.

Part 5

DOMINATION

I never spent my career thinking, "I've got to work for a fashion magazine."

—BRUCE WEBER

Chapter 36

"WHEN YOU'RE YOUNG, YOU'RE GOLD"

In summer 1985, Bruce Weber, a thirty-nine-year-old photographer best known for homoerotic fashion imagery, began a shoot for British Mohair, the marketing arm of a cooperative of Angora-goat breeders, at 7:00 a.m., on the grounds of his home in Bellport, New York. By ten, five nude bodies crawled over each other on a couch covered with the client's fabric. Five nude babies, that is. Five mothers stood behind the sofa, distracting the crying infants with bottles and toys. Weber crouched before the babies, moving them in and out of the shot like a basketball manager.

At one thirty, several vans headed to a second location. There, the setup featured a bare-chested seventeen-year-old male model, his hips and legs swaddled in mohair. Weber moved him from a barn to a tree and had the fabric soaked as he searched for his shot.

Behind the photographer, Mohair's British adman, Vernon Stratton, began to fret: "I'm very nervous on this shot. I can't make up my mind about men identifying with this. He takes millions of pictures, and you just need one, so you have to keep quiet and wait to the end. One thing about Bruce Weber pictures, they're always memorable. When the committee sees it . . ." Stratton raised his eyebrows. "At the moment, it's completely wrong for what the fabric is. Mind you, I'm not looking down the camera." Between frames, the model hung from a tree trunk, a mohair-clad Tarzan. Weber begged him to freeze and shot till the model literally dropped. Stratton was ecstatic. The copy for the ad, he explained, would be "'Back to nature.' This is fine, fantastic, superb," he exulted. "That's the thing about waiting."

"I'm on," said Elisabetta Ramella, the model for the third shot at 4:00 p.m.

as Weber's team tromped out into a field. "Did you bring the bug spray?" someone asked as Ramella stripped behind a blanket. Wrapped in a sarong of fabric, she lay on the ground. By 5:00 p.m., the light was softening. Ramella's eyelids were fluttering as she tired. Weber stood her up. She complained of bugs biting her bare feet. "We'll do this quickly," Weber promised, then let Didier Malige, his hairstylist, spend long minutes arranging three more bolts of fabric as towering turbans on the model's head. As Weber's stylist, Grace Coddington, on loan from her latest job as fashion director of British *Vogue*, pulled the sarong down to nearly uncover one of Ramella's breasts, a blush crossed the model's blue-veined, white skin. She clutched prickly branches to her bare décolleté.

"This is fine," said Vernon Stratton. "It's always easier with women's clothes."

At 6:00 p.m. Ramella began to grimace. Bites six inches in diameter had popped up on her skin. At six ten, Weber rubbed his eyes and, eleven hours after he began, put down his camera.

The whole side of his face had been rubbed raw.

On the surface, Bruce Weber was as goofy, friendly, and unglamorous as the pack of golden retrievers who were always around him and appeared annually on his holiday cards. Large and round and friendly as a big old dog himself, always lightly bearded with a classic bandanna knotted over his head, Weber emerged as the quintessential photographer of his time, the medium, if not the message maker, for the two best-known fashion designers of the day, the battling Bronx-born boy wonders, Ralph Lauren and Calvin Klein. Weber was a shaman who made misty moments and sexual fantasies into memorable selling propositions.

Weber's most influential work was for brands, not magazines, a result of a stark decline in the creativity of the fashion publications that had long been the Medicis of the fashion picture, nurturing photographers and bringing them to prominence. Lauren and Klein were leading a revolution in which designers, flush with cash from the sale of commodities such as jeans and polo shirts, took the lead in taking photography to parts unknown.

Most photographers excelled at either stillness (Penn) or motion (Avedon); Weber was comfortable with both. His genius was his ability to portray images as opposite as Dionysus and Apollo, punk rock and country

music. For Lauren, Weber's work crossbred the nostalgic and the modern, idealizing Americana and evoking its white Anglo-Saxon Protestant past, but replacing its distancing Puritan legacy with a tangible yearning for a sexualized ideal that was both accessible and out of reach. "All Bruce had to do was pinch it and it jumped," says model agent Frances Grill. For Klein, Weber shot pictures that alternately evoked classical ideals of physical beauty and the quintessentially of-the-moment chaos of the era's no-holds-barred libertinism. For both, he did something previously unimaginable in fashion photographs, portraying women as paragons of strength and men as sexual objects. For Klein, he'd even placed a young man on a pedestal.

Weber's specialty, and what brought him to prominence, was photographing "suggestive men," said Milton Glaser, the art director, with "an erotic undertow," according to Condé Nast's Alex Liberman. Weber's vision didn't treat male models like the props they'd been in the past, when "real men" didn't buy fashion magazines, men's fashion photography was an industry stepchild, and as the late designer Perry Ellis put it, "male models had an effeminate flair."

Weber convinced "extraordinary American men with exquisite bodies" to pose for him, Ellis continued. "True men in every sense of the word." He did it by being utterly unthreatening, in his infectious way. He confides easily and draws out those he's with. His friendliness seems natural, heartfelt. But, he'll admit, "You have to be manipulative, to be a photographer, to get results." Equally crucial to Weber's success was that he caught the zeitgeist on the fly. Weber's pictures "were saying, 'Change!'" says Grill. "Of course there were social messages."

By any standard Weber was already a great success. His advertising day rate was then $10,000; he was soon to have museum shows in Italy, Switzerland, and France and was about to publish his second book; and private sales of pictures had earned him over $150,000 in the prior year. He was thought to earn between $1 million and $2 million a year.

He spent some of it on collections of photographs, vintage cars, and grand real estate: a sprawling loft overlooking the Hudson River in New York's Tribeca district; a compound in Bellport, Long Island, a summer community popular with fashion types; and Longwood, an eleven-acre, eighteen-building camp reachable only by boat on Spitfire Lake in the Ad-

irondack Forest Preserve. Longwood, a property with great patrician provenance, was built at the turn of the twentieth century for Standard oilman George S. Brewster. Weber shared these residences with his agent, Nan Bush. Though it was as liberal as any existing subculture, the fashion world, fully cognizant of Weber's obsession with male sexuality, wondered what that was about.

Weber's professional secret seemed simple. By making men protagonists in the foreground of his photos, by giving them character and sexuality, by placing them in poses traditionally associated with women, and by sometimes photographing them with short-haired girls wearing popular man-tailored styles, Weber confronted traditional mass-market stereotypes of sexual roles and encouraged their evolution. Ironically he did that by objectifying men. But Weber's ambitions went beyond that. His work also reflected the ego and id of the baby boom, then the primary buyers of fashion products, capturing both its yippie-era sexual pioneering and its yuppie longing for perfectly edited lives.

Over the years, Weber worked for a stunning array of top designers from the avant-garde Azzedine Alaïa to the nouveaux riches favorite Gianni Versace (another brand that leaned on homoerotic imagery) to staid establishment brands such as Chanel, Neiman Marcus, and Valentino. "He's given each one a distant mythic image that's either beautiful or scary," said Barbara Lippert, an advertising critic. Either way, he'd snared the fleeting attention of a media-soaked generation, inventing better visual mousetraps with stunning rapidity and fecundity. But Weber was "not content," said another designer client, Jeffrey Banks. Weber fought endless battles for creative control; as he'd unhappily point out at every turn, clients had been killing his work, or choosing (in his view) to use the wrong pictures, since the day he picked up a camera. Even his best clients—Lauren and Klein—could drive him crazy. "'This is too Calvin. This is too Ralph.' They'll throw away what a team has done!" he'd shout, saying their criticism made him "crazy in the head."

In the early years of the eighties, life had changed entirely—and not for the better—for many peers of Weber's age. Drugs had stolen lives and livelihoods, and not just in the fashion trade. And an epidemic first recognized in 1981, when it was referred to as gay cancer, and given the name AIDS (or acquired immune deficiency syndrome) in September 1982, had already af-

fected thousands, hitting particularly hard in the fashion community, where homosexuality had long been accepted, even celebrated. By 1985, AIDS had reached every region of the world, the actor Rock Hudson had given it a celebrity face, and more than fifteen thousand cases had been reported, causing more than twelve thousand deaths.

Weber not only believed that the fashion industry's acceptance of different lifestyles needed to spread widely and quickly, he had embraced the role of educator through his pictures. Though he never discussed his own sexuality, Weber was determined to confront people's prejudices and fears and nudge them past embarrassment into acceptance of the whole spectrum of sexual preference.

The walls of his homes were lined with his photography collection. Every surface was covered with photo books. He openly admitted a debt to photographers who'd come before him, speaking of his love for August Sander and Jacques Lartigue; heroic shooters such as Alexander Rodchenko and Leni Riefenstahl; glamour photographers such as George Hurrell, Andre de Dienes, and Roger Corbeau; and fashion lensmen such as Horst and Hoyningen-Huené. "A lot of people have taken great men's pictures," Weber says. "Huené's pictures of Horst are amazing. August Sander's photographs of young actors and actresses in the Berlin Ensemble are amazingly avant-garde. The Man Ray photograph of Cocteau. I hardly think I was revolutionary."

Yet he was neither a copyist nor a mere update. "I was just photographing them the way I felt about them," Weber says. But Alex Liberman saw that Weber's vision was something new and different. "The fashion photograph is evolving," said the editorial director of Condé Nast, and Weber "may be one of the first to have sensed it." As clothing grew simpler and less important, the human factor, the narrative, the social message, "became dominant," Liberman continued, "and there, Bruce is quite unique in daring to portray a reality that is seldom seen in fashion magazines."

That British Mohair shoot was a typical day for Weber, who was renowned among his clients for shooting ten thousand frames to fill a few magazine pages or to create an ad campaign. "You'd get a shopping bag of three thousand chromes when all you wanted was one picture," says art director Nick la Micela.

Weber was as notorious a control freak as any of the greats who'd come before him. The difference was, he had Nan Bush running interference. "I have to see if they really want his involvement," she says of her client-screening procedure. "If they just want him to knock off a picture they've seen somewhere, I know it's the wrong job for us." He'll turn down work if he doesn't like the client, if they've already picked a location or models he doesn't like, if he is unsure of the idea motivating a shoot, or if it changes too much beforehand. He's even threatened to walk off sets when his control was questioned. "Most people don't like to have two very strong, opinionated people like Nan and myself involved in their work," Weber admits.

While he discusses approaches and models with his clients, he says, "We never get specific." He lets his shoots take their own shape, trying to capture fantasies on film, "and sometimes they're not mine." The Mohair session "was no more planned than that we would drape people in fabric," Grace Coddington explained. "What happened after that was anyone's guess."

Like Arthur Elgort, Weber is intrigued by unposed, unplanned moments. To maximize possibility, he treats his models and stylists like family, traveling with them, eating together, soliciting their ideas, waiting for telling moments he can pin to a page like a butterfly. "There's a bit of voyeuristic qualities in any photographer," Weber says. There is empathy, too. "He gets into my head," said Jeffrey Banks. "His style was very similar to what I believed in," said Ralph Lauren. "I never liked real fashion. My thing is much more earthy and natural and rugged looking, and that was Bruce's feeling." "We understand each other," agreed Calvin Klein. "It starts with that and ends up with a photograph. There's always trust and a sense of freedom. There's a tremendous amount of planning that goes into it, but then hopefully it goes far beyond what we planned."

How did Bruce Weber manage to channel the inner souls of so many finicky fashion clients? Fashion is "completely schizophrenic," Weber says. "I was used to that kind of emotion." The source of Weber's chameleonlike empathy lies in Greensburg, a small farming and coal-mining town outside Pittsburgh. His father, a furniture businessman, came from a large, poor Jewish family and Bruce's mother from a wealthy one. His parents lived a life filled with heavy drinking, extramarital affairs, and constant travel. Bruce would be left alone with a maid or with his grandparents, who lived nearby,

for months at a time, while his parents went off to resorts such as Capri. "People always say, 'This parent is really out of it, this parent's really drinking a lot, this parent's sleeping around a lot. It's really bad for the kids.' But in another way," Weber says, "it gives you a toughness that makes you survive. It made [me and my sister] immediately sophisticated."

But their lives were anything but stable. "It was a really wacko existence," he says. Which he feels was good preparation for a fashion photographer's life. His parents "went through a crazy period where once every three or four months, they wanted to get a divorce. My mother would pull me out of school and rush off to Palm Beach. So the only normal life I knew was with my grandparents, and they were very strict."

He endlessly studied family snapshots, including many of his mother's wealthy family. A great-great-uncle had come to America from Germany with Carl Laemmle, a founder of Universal Pictures, and Bruce's maternal grandmother shopped for clothes in Paris and wore Chanel and Schiaparelli. He had pictures of them all as well as of his parents, "this whole record of their romance together in pictures." He fantasized an ideal adolescence he never had—romantic images he later plundered for his Ralph Lauren ads. He was obsessed with style from an early age. "My mother dressed very well and my dad had a real beautiful sense of style. I never really think of clothes as fashion. I think of them as something that's just a part of being."

His real life wasn't glamorous. "I was like this weird kid. I was really skinny. I wasn't very attractive. I was incredibly shy, wasn't a jock. I was left alone and my whole life became picture books and art books and magazines. I was a little boy looking at *Vogue*. I studied painting, took piano lessons. You weren't considered a real man unless you played football, and obviously, I wasn't playing football."

He sometimes took pictures of his family with an Argus instamatic camera, but "I never wanted to be a photographer. I wanted to be a cowboy movie actor. I was into Clint Eastwood." Years later, he named a dog Rowdy after Eastwood's character in the TV series *Rawhide*, which debuted when Weber was thirteen.

At sixteen, Weber was sent to the Hun School in Princeton, New Jersey. "My parents were really flipping out and my granddad really wanted to send me. If you were a total fuckup and you got thrown out of a great boarding

school, you went to the Hun School. I was totally frightened to death. But I knew that in a crazy way, I would find a different family."

After two uneventful years at Denison University, and a stint in summer stock at the Bucks County Playhouse, Weber transferred to New York University to study theater and art in 1966 and went a bit off the rails. "I really wasn't happy. I had no social life. I wanted to get out and get attention. My parents immediately sent me to see a psychiatrist, and I'd go to this drug rehabilitation place down in the East Village," not because he was doing drugs, he says, but rather, because he liked the company. "It gave me a way to open up, to continue growing up and getting away from my family."

He was in a "James Dean period," he says, hanging around with theater people, and "interesting people who didn't amount to anything, but were just like lushes, or whatever," some of them on New York's then-still-deeply-closeted gay scene. Among them was the composer Stephen Sondheim, "a really good friend of mine," who "got me through five very difficult years of my life."

Weber's father cut him off for reasons he doesn't specify. "I had to pay my rent. I had to feed my dog." Yet that summer, Weber spent his last money on two weeks in the US Virgin Islands. When he came back, "all tan and really thin," but broke, he decided to try to earn money modeling. He thinks it was Sondheim who introduced him to Roddy McDowall, the actor and photographer, who took his test photos. "All that craziness adds up to at least a look," Weber says, laughing.

Chuck Gnys, a theater director and, later, talent manager, once told him, "Bruce, when you first came to New York and walked into a room, there wasn't a person who didn't gasp at the way you looked." Obsessed with appearance, Weber was thrilled to hear it. "I leaned over and kissed him," he says. "That was the kind of attention that I never got." A saying he often repeats is "When you're young, you're gold." To Donald Sterzin, an art director friend, it was the key to Weber's success as a photographer. At age twenty, a man's look "all comes together, flawless and shining," Sterzin said. "Bruce has a knack for capturing that magic year of their lives."

Weber says he was a terrible model, incapable of being prompt or attentive to his craft. "I didn't have the looks, I didn't have a dedication. I wasn't pulled together enough." But his year of modeling turned out to be magic

for him. He was photographed by Francesco Scavullo, Saul Leiter—"this strange, sensitive man" who took photos that "were so beautiful"—and Art Kane, who shot Weber in Coney Island for an Arrow shirts ad that never ran, "with food dripping all over the shirts." Weber was most impressed by Sante Forlano, who'd shot for *Glamour* and *Vogue*. "He wore these wild kimonos and tons of jewelry and he'd just be totally insane. He really made me look like a movie star, and I thought, 'God, that's really incredible. Can I do that for somebody else?'" Though Weber was still taking film to drugstores for processing, "I started to feel like I wanted to be a photographer."

By 1969 Weber was in Paris, trying to get "as far away from my family as possible, and away from all my psychiatrists and doctors," and "do it. You really had to pay your dues by going to Paris in those years." Other photographers told him to "find a beautiful young model, make sure she's a top model, have an affair with her, and you'll work all the time, and I just knew that I might be like that for five years, but I'd never be able to continue." Weber was a different breed, thinking, "Why can't men have pictures like women do, that they can look back on when they're older and say, 'Hey, I wasn't so bad, was I?' I wanted women to have the chance to see a guy like that, too, to fantasize a little bit. I mean, how many years did I dream about that picture of Elizabeth Taylor from *Suddenly, Last Summer* in that see-through bathing suit?"

Weber had two friends in Paris, a model and a film student, and whoever had money would pay rent for all three. He'd go to see Peter Knapp at *Elle*, "but none of the magazines would ever give me a job." Photographers from New York would visit and buy him dinner, "but they never really wanted to help me. I was photographing a lot of men. That was really frightening to them." Ultimately, to eat, he was reduced to sitting in the lobbies of the Ritz and Crillon hotels, chatting up tourists so they would invite him to dinner and perhaps take pity on him and give him money. "Nothing weird ever happened," he says, but "I sort of knew what it was like to be somewhat of a hustler."

After a year, his sister, who worked in the music business, visited with a band called War, and he shot them in concert and then came back to New York, where he started shooting "overweight record-company executives" at press parties and rock musicians "who could hardly stand up and I had two

seconds to do it in," taking head shots for actors, and testing models. Lisa Taylor was one of those. "He wasn't Bruce Weber yet," she says. "He was just loving photographing. I loved him, adored him. He was so good with people. He'd talk to you and get to know you and it would be about you."

He first shot fashion for a trade magazine, *Menswear*, in 1973, on Mike Edwards, a model who would later romance Elvis Presley's widow, Priscilla. Weber felt instantly attracted to him and saw in his own yearning a way to differentiate himself from other photographers by shooting through the lens of his sexual and emotional attraction. He wanted anyone seeing his pictures "to get the romance of a guy," he says. "It was a means to an end," to get attention, he admits. "But it seems like a really stupid way of going about it. A very certain kind of picture was all that was accepted. It isn't like now, where you can open up a magazine and see a lot of expressions."

Harry Coulianos, the flamboyant art director of the then-gaycentric *GQ*, loved the Mike Edwards photos—"the first positive reaction I got to any of my men's pictures," says Weber—and assigned him to shoot some tennis players on an indoor court. Weber hated the results, and when Coulianos insisted on running them, Weber insisted in turn that they appear without a credit. Coulianos found Weber's attitude "incredibly abrasive" and refused to work with him again. "So I was thrown back into the rock-and-roll scene," even briefly touring with Frank Zappa and the Mothers of Invention.

Meantime, though, he'd attracted the attention of some powerful players in the photographic world. Miki Denhof gave him a small job at *Glamour*, and Irving Penn's agent helped Weber put together a portfolio of samples and showed it to potential clients, including Bea Feitler, who'd become the founding art director of *Ms.* magazine. "She didn't care about how you worked or what kind of tear sheets you had," says Weber. She was interested in "what you want to do tomorrow, not what you did yesterday." She tutored him, showing him photos by Diane Arbus, Bill Brandt, and Jacques Henri Lartigue, and assigned him to photograph the film editor Dede Allen, whom he shot barefoot in a tailored black dress and pearls at a Moviola "with tons and tons of film all over the place," Weber remembers. Feitler "really woke me up and gave me a lot of strength to continue being a fighter, because she was."

Around the same time, Weber met Nan Bush, who'd run Francesco Scavullo's photo studio in the late 1960s. They "slowly became friends," and she

would lend him money to buy film. By 1973, she'd become his agent, and he'd moved into her tiny East Fifties walk-up apartment. But despite the odd jobs she found for him—ads for $2,500, photos for a catalog house that paid $750 a day, and magazine work for $200–$250 a page plus expenses— he'd begun to despair of ever having a career.

In desperation, he called Richard Avedon, who'd also shot him in his modeling days. He showed Avedon his portraits of jazz musicians and was advised to seek out Lisette Model, a Brodovitch-trained photographer, who was teaching at the New School for Social Research. That reminded Weber of an encounter two years earlier with the fashion-photographer-turned-artist Diane Arbus. After she ascertained that he wasn't a groupie and, despite his tan, wasn't a rich kid, either, Arbus spent several mornings talking to him on the phone, and he shyly showed her photos he'd taken of a gypsy couple he'd met in Central Park. He shot them "almost making love," he recalls, "in this loft with twenty-five birds." Arbus had also told him to study with Model.

Model was delighted by Weber's first photographs, taken for her seminar, of an impoverished imperial Russian princess who "lived in this funny old apartment," Weber recalls, "with thirtysome cats." He photographed her in bed with them. But Model hated his next assignment, "all very good-looking girls and guys," he remembers. "You didn't take any chances!" she scolded him. So for his third try, he photographed a once-beautiful bouncer-bartender-hustler with a "Charles Atlas man kind of body," who'd had four face-lifts, seeking to look like Marilyn Monroe.

"I really wanted to win Lisette's respect back," Weber says, "so I went to his apartment. He was always trying to commit suicide, and there were bloodstains all over the place. I did pictures of him posing with all the photographs that had ever been taken of him, lying in dirty underwear and his bathrobe. His bed hadn't been made in weeks and the sheets had a grayness to them."

"Is this guy still alive?" Model asked. "He looks like he's about to kill himself. Bruce, you took the chance. You really did it."

Years later, he could still quote her verbatim: "She'd say, 'You've got to photograph a tree when it's living, when it's first planted, when it's dying or it's in a storm. A tree is a special thing. Don't make it like a Hallmark

greeting card.'" Before long he had his first gallery show, in May 1974, of photographs of the losers in Miss Body Beautiful and Mr. Teenage America contests. "More than anything," he says, Model "gave anybody who studied with her the courage to really confront."

Weber began to gain momentum. In 1976, Andrea Quinn Robinson gave him a job at *Seventeen*—one of his first times shooting women's beauty—and found him "agreeable but strong about how he felt. I drove him crazy. I'd say, 'Bruce, I'm going to get fired for this picture.' He was always game for doing the unusual." On a subsequent trip to Puerto Rico, they tore up bed-sheets and tied rags in the models' hair. At the time, that was bold.

Bush sent Weber's portfolio to Kezia Keeble, a Nashville debutante who'd started her career in fashion at *Glamour*, then worked as Diana Vreeland's assistant and a fashion editor at *Vogue*, and was dabbling in fashion publicity while serving as the freelance fashion editor of *Esquire*. Keeble offered Weber an assignment shooting back-to-school clothes on non-models, a requirement at *Esquire* then, and one Weber eagerly embraced; the "effeminate flair" that prevailed in a world where macho Marlboro Men were, quietly, gay had no visual appeal to him. Weber also embraced several of Keeble's choices of amateurs, all of whom had recently graduated from college. One was Paul Cavaco, a waiter at a nearby branch of Brew Burger, and Keeble's boyfriend.

The shortish, bespectacled Cavaco was "what every kid's best friend looked like in school," Weber says. Cavaco was also a natural fashion stylist, and after that first shoot, Weber told Keeble her boyfriend was "really good at this," Cavaco remembers. "I'd watched Kezia do it, so I kind of knew what to do." Styling was just then emerging as a new freelance fashion profession and attracting magazine editors who wanted both more freedom and more money at a time when advertisers were increasingly calling the tune at glossies.

Magazines and fashion were becoming ever more boring and conservative during the economically troubled years of Jimmy Carter's presidency—and creative fashion folk felt stifled. "People were doing very creative things in other areas like advertising and avant-garde magazines," says Barbara Dente, who'd worked at Nancy White's *Bazaar* and Marc Balet's *Vogue Patterns* before turning independent. "All they wanted you to do was be creative.

They'd send a suitcase [of new clothes] and say, 'Do what you want.'" Sometimes they weren't even paid. "We did it for the creative experience," Dente says. "The photographers had their costs paid, but I never got a dime."

Keeble and Cavaco were living together when they met Weber. They would soon marry, and the trio grew close enough that when Keeble got pregnant, Weber was the first friend they told. The three were always looking for ways to work together. Weber would shoot press kits for Keeble and little ads for her clients. "Every time she got a job, she'd say, 'Let's use Bruce,'" recalls Cavaco. Weber would do the same for them. Keeble was "very much of the school of the photographer," Cavaco says. "She wanted him to take *his* pictures," and Weber adored that.

"At the same time, maybe out of desperation," says Weber, "*GQ* said, 'Let's give Bruce a few things to do.'" Dente was sometimes hired to style women's clothes for the men's magazine. "No one was on my case that 'You have to show this dress,'" she says. Weber was a perfect partner for the new stylist elite—and for Donald Sterzin, who worked at *GQ*. Sterzin and Weber turned their backs on modeling-agency men and started cruising college towns for those flawless and shining twenty-year-olds of their dreams. "It's interesting," said the late model Ingo Thouret, "that the gay models" of the era "appeared totally straight," so their pictures would appeal to straight men, while Sterzin and Weber "mainly hired straight models, but the photographs have a gay appeal."

Over the next four years, they would transform *GQ*, dragging it out of its closeted us-against-them Boys-in-the-Band beginnings into a nirvana where "gay men and the gay sensibility didn't need to be ghettoized" and "hetero college boys," as *GQ* itself would later put it, "stumbled into stardom as gay icons." One of the old-school gay male models who were thus usurped would later describe a silent confrontation while posing for Weber. The photographer wanted him to look away from the lens, but he stared straight into it instead, he said, to deliver the message "I know who you are." Weber, he felt sure, was a new kind of fashion voyeur, one who used his camera to possess unattainable men.

In 1978, not long after shooting a photograph of Ralph Lauren's family, Weber was hired to shoot a promotional brochure for the designer. That same year, working with Keeble and Cavaco, Weber made his debut

in the *SoHo Weekly News*, a local paper for what was then an emerging artist's neighborhood, featuring a twelve-year-old Brooke Shields wearing menswear. "It really looked different from what was happening," says Annie Flanders, the paper's style editor. It would be five more years before the world caught up with androgyny and cross-dressing.

For his second *SoHo* spread, Weber recruited New Jersey surfers as models—and struck a nerve that's still vibrating. Over the next four years, his photos filled *GQ*, as Weber and Sterzin, who replaced Coulianos as art director in 1980, scoured America, combing its schoolyards, picking through college yearbooks and team photos, hanging around gyms and sports fields, even crouching in dunes with binoculars, trying to spot new faces on the beaches of California, Hawaii, and Florida. Everyone around Weber joined the act. "Our phone bills," Nan Bush said at the time, "are not to be believed."

Their most famous discovery was a water-polo player from Pepperdine University named Jeff Aquilon, who'd appeared at an open casting call for a Weber shoot with a black eye and a bandaged broken nose. The first photos Weber took of him, in 1978, shot by the pool at director George Cukor's house in the Hollywood Hills, didn't appear for years, Weber says, because they were "pretty much aggressive." *GQ*'s editors "were really frightened of seeing men's skin. Pushing the sleeves up was an amazing adventure. Opening two buttons? 'Aren't we getting a little wild?'" At *SoHo Weekly News*, Flanders wasn't as inhibited. She encouraged Weber, Keeble, and Cavaco to go "overboard to excite," she says, and flew Aquilon to New York, where Weber shot him lying on an unmade bed with his hands stuck deep in a pair of Calvin Klein tighty-whities, a come-hither look on this face—and created a sensation. Editors at *GQ* warned Weber they were so tasteless, he'd never work again. "At the time, *GQ* was doing pictures of men in string bikinis, but the reaction was just so horrendous," says Weber. "I'm sure I didn't work for *Glamour* for a long time because of that." Kezia Keeble more presciently proclaimed those pictures "the start of everything!"

Before the Jeff Aquilon photos were even released, Weber was onto bigger things. "It all sort of happened at exactly the same time," he says. He'd met

with Calvin Klein, shown him the photos of Aquilon, and won jobs shooting press photos in Palm Beach, images for Klein's men's jeans, one of which became another billboard in Times Square, and finally, a sprawling fashion portfolio that resulted from a 1979 shoot in Santa Fe that included items from all of Klein's many product lines. Klein decided to combine them into a twenty-seven-page "statement of what Calvin Klein was all about," he said. Faster than you can say Bronx rivals, Ralph Lauren hired Weber to do something similar.

European fabric manufacturers such as Peppone Della Schiava were the first to use ad portfolios, called groupage, highlighting fashions by the different designers who used their wares. With Weber, Lauren and Klein refined groupage into a new kind of advertising, buying consecutive magazine pages to keep their images consistent no matter what was being advertised. They sought to reclaim creative control from magazine editors and retail advertisers, who'd previously used the designers' garments to tell the stories *they* chose, sometimes mixing and matching wares from several labels. Thanks to Weber, Lauren and Klein's images were individually tuned and pitched. Thanks to Klein and Lauren, Weber's photographs were given display that was unprecedented, particularly for a photographer so young. Imitations quickly began creeping into advertising for other clothing lines, and the concept of lifestyle advertising traveled far beyond fashion.

None of it would have mattered had Weber not pushed the envelope. Provocation got attention, which created authority, said the graphic designer Milton Glaser: "The worst thing is to be overlooked." Love him or hate him, you couldn't overlook Weber. "There is a liberation of attitude, a liberation of behavior in society," said Alex Liberman. "He reflects that and maybe helped initiate it." Calvin Klein's ads were particularly controversial. "I don't set out to upset people," Klein said at the time. "That's not my aim. My aim is to stimulate and excite. What I've come to realize is that everyone doesn't see the same thing. People were upset by what I do."

Weber's commitment to risk put him at odds with many fashion magazines. For a time, British *Vogue*, which had published some of his most evocative photos, tributes to artist Georgia O'Keeffe, photographer Edward Weston, and author Willa Cather, could no longer entice Weber to work. Weber's photos were "killed constantly," fashion editor Grace Coddington

said. But they sometimes seemed designed to provoke that reaction. Many of the best pictures in a series of marines on shore leave in Waikiki, shot for *L'Uomo Vogue*, were rejected and appeared instead in 1982 in *Details*, a then-new avant-garde magazine founded by Annie Flanders, and in Weber's first, eponymous photo book a year later.

After Condé Nast bought *GQ* in 1979 and it was repositioned as a more conservative magazine, Weber stopped working there, too. Four years later, *GQ* got a new editor, Art Cooper, a journeyman who'd worked at *Newsweek*, *Penthouse*, and *Family Weekly*. He openly admitted that the magazine had been perceived by advertisers as oriented toward homosexuals, and he re-oriented it as a more macho general-interest magazine with a fashion component, but Alexander Liberman dismissed the theory that it had turned antigay. Rather, he said, it was just promoting the fashion business. "Is Michelangelo's *David* a homosexual sculpture?" he asked. "Ralph Lauren and Calvin Klein sell images. Magazines fundamentally sell garments. This is where we have trouble with Bruce. The store or the manufacturer wants its garments to be bought. He gets the aura, but where is the merchandise in a Bruce Weber photo? Bruce wants to make a woman look like a truck driver's moll. It doesn't work. I think he despises fashion. Every time we've tried a sitting, there's been a distortion. He is fortunate he has income from advertising sources who accept the outer limits of his urges."

Chapter 37

"A DESIRE TO LIVE WILDLY"

Times had changed in so many ways, though it wasn't always apparent. Avedon, Penn, Newton, and Bourdin were still taking pictures, Gilles Bensimon was about to take over *Elle*, and Patrick Demarchelier was emerging as a star at the international *Vogue*s. The production of fashion imagery had been transformed into a growth industry as the garment trade spread in a thousand directions, designers embraced mass-market products, and their coffers swelled with profits that let them expand out of their native markets, broadcasting their messages around the world. There was more than enough work, and so much money being thrown around, photographers didn't need to seek new creative frontiers because fashion's boundaries were growing so fast, just keeping up was a challenge.

Guy Bourdin continued to do work of distinction. "It was always all night long and very creative," says Bonnie Pfeifer. "I never knew what the heck was going on, but the pictures were always great." But what the writer Anthony Haden-Guest described as Bourdin's "impenetrable strangeness" and "morbidity" began to overwhelm him in the eighties. He was "a little bit twisted," says J. P. Masclet, who assisted him after Bourdin's return from a six-month career pause Masclet describes as "a bit of a burnout."

Bourdin could be generous and charming, Masclet continues, but would also consult an astrologer daily and would send models and stylists home if he'd been warned off their signs that day. "I was told to be aware that he was a bit of a sadist. He was a very, very difficult man to work for."

In 1981, Bourdin's second wife, Sybille Danner, the model he'd taken up with more than a decade earlier, committed suicide. Bourdin's son, who discovered her body, was shipped off to boarding school. A year later, Haden-Guest reported, Bourdin was thrown in jail after tearing off his

clothes in a French tax office and calling the officials there Nazis. Why was he losing his grip? Fashion, Haden-Guest suggested, "had fallen out of love with photographs that hinted at decadence, ambiguous sex and female frailty."

Sybille's death was the start of a decade-long decline that saw Bourdin cut off relations with family and friends and suffer professional setbacks. He was repeating himself, and so was *Vogue* Paris, his primary editorial outlet, which, by the mideighties, was derided in avant-garde fashion circles as *Vogue* Putain, a magazine for prostitutes and women who dressed like them. "He slowed down a magazine," the photographer Wayne Maser observed. "Your eyeballs would hurt."

Bourdin seemed determined to erase himself, too, "adamantly" refusing to give interviews or publish books, says Masclet, to sell prints to collectors or, in one notable case in 1985, accept the Grand Prix National de la Photographie, a prize (accompanied by $9,000) previously awarded to such eminences as Brassaï, Henri Cartier-Bresson, André Kertész, and Robert Doisneau. "I think Guy liked doing the work, liked that it was disposable, and didn't feel it was great art," says Masclet.

In 1988, Bourdin developed debilitating stomach pains that were diagnosed the next year as cancer. He died two years later at sixty-two, leaving behind a big tax bill, an archive stuffed in bags and cardboard boxes, and an estate dispute pitting his son against his common-law wife. Another ten years passed before his son was able to publish a book of his father's work.

—⚬⚬⚬—

In 1981, at age sixty-one, Helmut Newton moved from Paris to a condominium in Monte Carlo. It was an unlikely home for an icon of fashion, "the fucking dodgiest apartment you've ever seen," says Paul Sinclaire, who had it photographed for *House & Garden* magazine. "A brown Naugahyde sofa, doilies and maple furniture, a big TV with a vase on top with plastic mums, but behind it, one of his Charlotte Rampling portraits. It was like visiting somebody's aunt in Coney Island."

Junie and Helmie, as the Newtons called each other, spent winters at the Chateau Marmont in West Hollywood. Both their adopted hometowns

were places where he could indulge his tastes for near-plastic beauty and upper-class decadence. "It's a world I know well and I feel at home in, so why bother to search further?" Newton asked Peter Adam, a German-born biographer and documentarian, who considered him "deliciously vulgar, earthy and elegant." Thanks to the success of *White Women* and succeeding books, Newton was a living legend, "the top Teutonic," says Masclet, who also assisted him. Unlike Bourdin, he accepted prestigious awards, exploited his archives by publishing often, regularly mounted gallery shows and massive retrospective exhibitions, and continued to shoot for magazines and for himself. "He was a complex man, but very straightforward," says Masclet. "He knew exactly what he wanted." Where Bruce Weber would shoot hundreds of rolls of film, "Helmut hated editing and shot a half a roll, a roll, max," says Masclet. "His reputation was such that subjects put themselves in a Helmut frame of mind, so they were primed to be Newton photographs."

Clients liked him, too. "Helmut was a crazy man," says art director Nick la Micela. "He was hard to control, but he liked money. He'd shoot anywhere if the money was right. He'd always try to sneak something exotic in, though, and I had to bring him back. They're like wild horses and it was my ass if it didn't work." But la Micela appreciated Newton's sense of humor, which "you'd never expect from a German. He once called me and said he was going to a sex-toy shop. 'Can I bring you a blowup doll?' He'd dress as a nun and his wife would shoot him. He'd dress in drag in World War One outfits. I saw humor in the most exotic, erotic pictures he shot."

Newton kept going, laughing all the way, until the day he died early in 2004 after crashing his Cadillac into a wall outside the Chateau Marmont garage. Friends believed he'd had another heart attack. His last story for American *Vogue*, published posthumously that March, opened with a two-page spread of the bathing-suit-clad model Daria Werbowy resting not quite peacefully on a bed of nails.

Chris von Wangenheim died by misadventure, Guy Bourdin and Helmut Newton of natural causes. Tall, blond, and lately bearded, with his quiet demeanor, Bill King would symbolize his era—unwillingly—as the most famous fashion photographer to die of AIDS. His work has since been almost forgotten, his closest friends believe, because his heirs couldn't accept his lifestyle and challenged his will, taking his most significant asset, his pic-

tures, away from the only people who cared about their maker and his visual legacy despite his myriad character flaws.

Many photographers compartmentalize their lives. King made compartmentalization his second art form. For years, he'd lived two lives. "It may have always been there, but it became evident in the late seventies," says fashion editor Betty Ann Grund. "He'd go to the Anvil and they'd have to carry him home." Or, he'd be found high on coke, crawling through the aisles of a gay porno movie theater or tied up in Central Park.

By day, he had his pristine studio and his white-coated assistants, his wind machine, squirt guns, and white seamless paper, and he attracted models who could act and celebrities who glittered and took pictures of them gesturing, jumping, laughing, and screaming and generally seeming as happy, excited, and beautiful as anyone else on earth. Bill King's pictures were a party you longed to join.

King's nights seemed the same. After its opening in April 1977, he was a fixture at the disco Studio 54, where his favorite models, girls such as Janice Dickinson and Ashley Richardson, were superstars, and a closeted gay man could let loose among like-minded friends. "The mouthwatering, handsome, narcissistic people were chasing one sensation after another, living in a permanent adolescence," wrote the BBC's Peter Adam, another promiscuous gay man, who met and befriended King. "There was sex everywhere, in the seats, in the aisles, in the lavatory . . . anonymous wild sex. . . . It was not only the homosexual community that had gone crazy, drunk with a desire to live wildly. . . . It was like an enormous comedy of manners being acted out in public. . . . Everybody was a part of the 'famous for one night' generation."

Adam and King shared private jets and expensive meals with the "brazen, stylish, sometimes vulgar" fashion set, Adam wrote in a memoir. "Bill basically despised this world of insubstantial and shifting characters, jetsam and flotsam of a trendy tide, but he was fascinated by it." Adam gained access to King's private studio office, "shared only with a few friends" who were allowed to see the nudes he shot on his own time, "pictures of rare strength and singular vision," and agreed to help him author a book including his photos and life story, but King could never focus on it.

"His fortune and success were often overshadowed by melancholia and doubts, which he drowned in an excess of temptations," Adam wrote. "Un-

derneath the unassuming exterior lay many passions and curiosities. Bill loved danger and used to say: 'I work hard and I play hard.' He was the entrance to a darker life, to evenings with Robert Mapplethorpe, visits to apartments filled with strange characters selling drugs and sex. If I know much about the horrors of drugs and the destruction they do, I know it through him, watching him 'crashing' at my doorstep." Only later would Adam decide that King was engaged in a "mad dance of death."

In 1980, King had been lured to *Vogue*, where he became more than ever the go-to photographer for models seeking exciting pictures. "He was wild," said the model Bitten Knudsen. "He was obviously gay, but he had relationships with certain models because he'd get turned on to them. He was one of the best photographers ever. It was all about energy. He never hired anybody who wasn't great. He wanted models who would go a step further."

That his pictures resembled Avedons, but without subtext or depth, was a plus in the Mirabella years. So celebrities were among King's greatest acolytes; his kinetic images (he'd started shooting covers for *Rolling Stone* in 1975) glorified theirs, making them glow with magnetic force. Bill King's career was a party you wanted to join, too.

His assistants had a different view. "He was definitely on fire," says Kevin Hatt, who joined the studio in the mideighties and lasted six months, "which seemed like a year. Every day was a twelve-hour day for fifty dollars a day. Once you burned out, you got kicked out." But before that, Hatt got an education, doing three or four jobs a day. "It was not a relaxed place to work. It was very particular, very tense, and Bill created that. The set was always quiet. You'd be standing around waiting for him." His first assistant would shoot tests and bring him Polaroids until he approved of the lighting. Then, with a nod, he'd set things in motion, the studio lights would snap off, the fans would come on, and with "motions, gestures, nervousness, tension," Hatt says, King and the camera assistant behind him, handing him cameras and checking settings, would "try to find and capture chaos." Behind King's back, the assistants called his studio the Wild Kingdom.

"He got a real kick out of those pictures of people going wild," says the model Shelley Smith. "Every picture was wildly energetic, and he got his kicks almost out of exhausting you. It wasn't the picture; it was watching you get exhausted. It had some strange undertones. It's pretty wild that he had

that much control. There was some pathology there with women, but I have to say, he was always wonderful with me. He played with those who would play with him."

After hours, King's binges grew wilder and longer and his games even more dangerous as his star rose in fashion's insecure firmament. "It was a lot of things," says editor Betty Ann Grund. "Money. Success. Why not?" King felt abandoned by his family and found a new one in the night scene, where gays were not only out of the closet and accepted but, suddenly, leading the pack. Grund saw parallels between his two lives: "The whole thing was obsessive whether it was one behavior or the other." By day, "he'd order white button-downs and boxers by the dozen out of Brooks Brothers and put all the boys [in his studio] in them." Off-hours, he'd shovel drugs into himself with equal immoderation. King and Grund shared a house in the Hamptons one summer; he had both ice cream and drugs delivered and "we'd stay up two nights" and consume them all, she says. Once, he gave Grund's daughter quaaludes. "She'd bury them in the sand," says Grund. "She wanted to make sure he didn't get hurt."

King sometimes seemed to be wishing for that, with his compulsive participation in S&M scenes. His boyfriend David Hartman "got very upset by it," but King didn't care. "The drugs let Bill not care about his neuroses," says Grund. "But he thought he could reach the heights and it would be marvelous." He was as insecure as he was successful. "He questioned his talent. He'd say always, 'Is it good enough? Will they call me again?'"

Many of King's nights ended in "personal" photo sessions. Some were comparatively chaste, often black-and-white nudes, shot for that book King never published. He kept the nudes stacked on shelves in his private studio room. But he had other, ruder photos, too, such as those he is reported to have taken one night in the disco Hurrah of one of the era's top faces, a blond poster girl for wholesome California pulchritude. Those pictures have been whispered about for years and called the tip of an iceberg of homemade porn, albeit shot by a professional. It's unclear how many such pictures King actually took. But multiple sources report the existence of this one set of sex-session images.

Betty Ann Grund describes being at the scene, even though "I tried not to be around," she says. "I hadn't planned to be there." The session began

in Hurrah's bathroom and continued in a limousine, and among the male participants was an owner of the club, who was gay, one of King's cocaine dealers, and would later die of AIDS. "There was a lot of coke," says Grund. "They probably took other things, too. [The model] didn't know what she was doing, she was so out of it. Bill was egging them on. She was doing a lot of advertising then, and I thought, 'If anyone ever sees these, she's finished.' But there was no getting her out of the situation. I didn't want to get in the middle of it. And I don't think it was the only time." Grund went home that night before the picture taking ended. "I saw enough. I wasn't interested."

While King's "personal" photos were an open secret among his intimates, these pictures were the best known, because at least one of them was stolen by an assistant. "We got Roy Cohn," the pit-bull attorney who was also a closeted gay and a Studio 54 habitué, and "the guy brought it back immediately," says John Turner, who'd joined King's operation as an assistant a few years earlier and saw the stolen picture when it was recovered. "She's sitting on two sinks with dicks in both hands. It was so beautiful." As to the others, "Who is in those pictures?" asks his close friend the stylist Jane Hsiang. "Everyone and no one. Strangers, somebody famous, hustlers, someone trying to hustle the hustler. It was the times. We all did that. We've all done worse." On one occasion, Turner stumbled into an orgy at King's big, early-American-antiques-filled one-bedroom apartment at One Fifth Avenue. "A lot of beautiful male models," he says, "most of them straight, so fucked-up, everyone eating each other and all being videotaped. Several days later, one of them came to the studio and wanted the tape. He threatened Bill. I had him wait outside. Bill didn't want to destroy it. I said to him, 'This isn't important to you, but it's his career.'" With King's reluctant consent, Turner took the tape, pulled it from its cassette, and cut it up as the model watched.

King loved to take photos of escorts and boys he met prowling bars and clubs. "He'd go on a binge," Turner says, and bring them back to the studio, where they'd have sex and he'd take Polaroids. He'd also shoot Kodachrome photos and send the film out for processing, bundled with his daytime work. When the transparencies came back the next morning, "he wouldn't look at them," Turner says. "He'd have me or an assistant cut them with scissors. He just wanted to shoot it." Finally, Turner insisted King buy

a shredder. It came in handy. "Models would call, men, women, didn't matter," says Turner, "and want to know" about pictures they'd allowed to be taken. "Honey, they're shredded," he would assure them. Today, he adds that usually the private porno wasn't high quality: "He shot stoned all the time. They were drug-fueled" photos of people "having fun naked. I wasn't impressed. They weren't amazing."

King's motive was unclear. British fashion editor Erica Crome has said she believed he did it for blackmail. "It means I have one over on them," King told her, referring specifically to his bathroom session with that one model. No matter how big she got—and she was plenty big already—she'd be available to him, he explained. Studio assistant Chuck Zuretti agrees: "It was a power thing. He had the goods. He had those kind of thoughts sometimes." But that doesn't explain the photos of random pickups and hustlers. Betty Ann Grund feels the "personal" photos were just an extreme expression of a trait common to many photographers' characters: "Part of his life was voyeurism. It gave him a kick and a thrill." To Jane Hsiang, it "was his nature."

John Turner had started his career as an assistant to Francesco Scavullo and Irving Penn. He'd won Penn's affection, he says, when the *Vogue* master was shooting a still life of a lobster that wouldn't hold still, even after being coated in mortician's wax. Turner melted the wax off with a hair dryer and "stuck a hanger up its ass," he says. "Mr. Penn seemed very pleased." Turner went on to work on Penn's Clinique shoots. "They were so simple," Turner says, recalling the time Penn shot a still life of a toothbrush in a glass against a Formica background. The idea was to make the cosmetics look like medical products without making medical claims for their efficacy. Penn's pristine vision was the perfect medium for that message. "I pushed the toothbrush a little," Turner says. "Click. He got it. And he got paid ten thousand dollars. I saw the invoice."

Turner really wanted to work for Bill King, whom he considered the most important fashion shooter. But he didn't recognize King the day he rode the elevator to Penn's studio at 100 Fifth with "a shaggy-ass guy with an earring and a bicycle," he says. Once King ascertained he was an assistant, he asked Turner to help out on a shoot for *Esquire*. But on the appointed day, King made himself scarce, and when one of his subjects threatened to leave, Turner found King in his office "catatonic, facing a wall, staring."

"Bill?" Turner said. "Snap out of it." When King didn't, Turner took King's glasses off and "slapped him really hard. He came out of it and never mentioned it again." After the day's shoot, he asked Turner to run his studio for him. "It was ragamuffin at first," says Turner, who painted the place, and is one of several King employees who claim to have come up with the idea of having everyone but King dressed in lab coats.

In the early eighties, the intensity of King's quest for kicks and thrills increased geometrically. At the end of 1980, Erica Crome came to New York on a visit and stayed at his apartment at One Fifth, even though someone at his studio had tried to head her off, saying King had the flu. "I didn't know it was code," she says. On her second day there, King bought her an escort and couldn't understand when she spurned his gift. King's housekeeper complained to her about serving dinner parties where naked young men crouched under the table.

King's father appeared one day. "He was a tall, very good-looking man," Crome says. "Well-groomed. An American archetype. He was clearly disappointed with Bill's lifestyle. He told me I was Bill's only decent friend and asked if we might get married, which was borderline hilarious." In the mid-seventies, when King's beloved mother had died, his father had discarded ten years' worth of photographs stored in their house and reportedly confessed to a studio staffer that he'd hated their "homoerotic content." Yet he still loaned his son money. They would never reconcile, but neither would they cut each other off.

King "wasn't the same person" he'd been in the sixties, Crome says. "I had no idea he'd become this other person . . . obsessed with drugs." He gave her a bag of cocaine "to mind," she says. "I put it in a perfume box." Later, he went looking for it when she wasn't there. "He destroyed furniture, shredded it." On her return, she poured the coke down the toilet. "Which might not have been the most sensible thing to do." King's angry reaction convinced her he needed "to be away from bad influences. I know! The seaside!"

She bought them tickets to Key West and offered him a week's vacation. But when they got there, he disappeared. "I didn't realize that for him Key West was the equivalent of a sweetie factory for a child. He was out of his head on coke. The hotel complained about noise. They couldn't get into his room." Thirty-five years later, Crome can't recall how she contacted King's

father, but he arranged to send a plane to an air base near Miami to "fly him out and put him in rehab," she says. Neither can she recall how she convinced a woman "whose husband Bill had seduced" to help get him there. Crome never saw King again.

Some friends felt that King's increasing drug use was a reaction to the loss of people close to him. The first to die was his mother, the only member of his family who he felt supported him, says Jane Hsiang, "which is rather classic in a homosexual artist's life. He spoke quite a bit about how his mother was moved by talent. He tried to buy her a wig when she had cancer," and she died shortly before Hsiang met King in 1976.

Then, in 1982, Bea Feitler died of cancer, too. Around that time, John Turner quit his job. He'd seen a lot in a few years. Early in his tenure, King was booked to shoot Jaclyn Smith of TV's *Charlie's Angels* for a Max Factor cosmetics ad, but *he* failed to show up. Turner found him at home, in his bedroom with a supermodel who later married a rock star. "She came out, completely nude in a pillbox hat," Turner remembers. "Want some lines?" she asked him. He looked past her. King was naked, on his back in bed, with his legs over his head. Turner insists he saw King's "sphincter reaching out and chewing coke. That's how he liked it, not dust, rocks. He'd stick rocks up his ass. His eyes were black saucers. I went back to the studio. I said he'd hurt his hand and couldn't shoot for a couple days. Jaclyn was lovely. It was never discussed again. Everything was cool." Turner learned to predict when King would go off on a binge, but "there was nothing I could do." So Turner had a necklace made for King engraved with Turner's name and phone number and began carrying a beeper and hundreds of dollars in cash—all in case of emergency. He was regularly summoned to get King out of fixes he'd got into and sometimes stayed at One Fifth to try "to make sure he didn't leave the apartment, if I could, until he got over it."

King's behavior was also troubling on location trips. "He was really going over the edge," says Betty Ann Grund, who realized the debilitated photographer needed more help than the one assistant he'd brought to Paris on a shoot could give and called upon an experienced one. Chuck Zuretti, who'd assisted Guy Le Baube and Rico Puhlmann, was in Paris. King offered Zuretti a Concorde flight home if he would stay in Paris a few days to help.

"Bill was using quite a bit of stuff," Zuretti says. "He was incapable, freaking out. He couldn't look through the camera. I ended up shooting it for him." Zuretti's pictures appeared with a Bill King credit. But a few months later, after a few less dramatic trips and King's switch to *Vogue*, it happened again on a shoot for *L'Uomo Vogue* in Rio de Janeiro during Carnival. On the Sunday before the trip, Zuretti went to 100 Fifth to pick up King's cameras, and another assistant handed him a bottle of Advil, saying King was suffering headaches. Zuretti looked inside and discovered it was full of quaaludes. It was the first thing King asked for when Zuretti arrived in Brazil, and he threw the bottle at King. "Don't you ever make me your mule again," he screamed.

Then, King "scored a lot of drugs" and, one night, woke Zuretti at 3:00 a.m., demanding he bring him some film. "I put on a robe and knocked on his door." King answered it, nude, with an erection aided by a cock ring. "There were two guys doing acrobatics on the bed," Zuretti says. "He wanted to take pictures."

King's editor was horrified when King disappeared for the next two days, "locking the door in the hotel and going crazy on drugs. I was banging on the door, almost crying. 'Just tell me. Five hours? Tomorrow? Tell me *something*.'" Finally, after many hours, King opened the door, "half-naked and completely bizarre," she continues. "He was alone. He wanted more drugs. He had them but he didn't want to snort them. He asked me to blow it into an opening you have in your body with a straw."

Once again, Zuretti says, he took the pictures and, that time, got credit for them, too. Meantime, King got beaten up and his cameras were stolen. En route home, Zuretti dragged him into an airport bathroom and demanded he empty his pockets. Several bags of coke went down the toilet. The editor is both philosophical and forgiving about the experience: "It's important that you have the right to live the way you want." Photographers like King "have to be admired, they have special antennae. They are the history of the moment."

After King sneaked an eighth of an ounce of cocaine into a suitcase before Turner carried it across a border, he quit his job. They didn't speak again for years. King finally called him in 1983, the year after Bea Feitler

died, waking him at 3:00 a.m. "I knew when Bill was on coke," Turner says. "He was coming down. He said he couldn't get to his coke." Turner took a cab to 100 Fifth, unlocked the door with a key he'd kept, and found King and the fashion designer Clovis Ruffin naked, tied up on the floor, covered in melted candle wax. A trick they'd picked up was passed out near them. King had managed to free a hand to make a call for help.

"It was as if I'd been there yesterday," Turner says. He woke up the trick, helped him off the floor, gave him $100, took him downstairs, and poured his limp form into a taxi. "Don't tell him where he came from," Turner ordered the driver, "but take him wherever he wants."

Two weeks later, Turner got a $10,000 check in the mail from King, with a note begging him to come back to work. It was August and King was leaving for his annual vacation in the south of France. While he was gone, Turner cleaned house at the studio. It, at least, was still running well. Even when King wasn't there, clients were put at ease by the scale and professionalism of the operation. King was another story. He'd become ever more obsessive, and his night games had driven boyfriend David Hartman to despair. "Bill wouldn't return his calls," says Turner. "I'd say, 'Bill loves you. He asked me to call. They're just tricks.'"

In the mideighties, Turner decided he needed to hire "a companion, someone to take care of Bill on a personal level." He went to Ben Fernandez, who taught photography at Parsons, and "asked for an effeminate blond boy with wispy blond hair who looked like a character in the gay hard-core sex films directed by William Higgins," a pioneer of what was known as California-look pornography, says a King studio staffer. That was King's favorite look.

"I saw Stewart Shining and he was perfect," says Turner, whose interview with the young South Dakota–raised photography student was interrupted by a phone call from King, who was watching from his office next door. "You have to hire him," King whispered. Shining accepted a salaried position and an offer of lessons in being an assistant. "It had nothing to do with photography," insists the staffer. "Bill fell madly in love." Several studio employees were struck by Shining's beauty. David Hartman was still King's boyfriend, but Bill's adoration of Shining became obvious as time went on, and "David

tolerated the situation," says a friend who asks to be anonymous. "It was a little tricky," John Turner adds.*

King wouldn't let Shining in the studio for a year, but they went to parties and movies together, which was good news for John Turner. "He wasn't on my back anymore," Turner says. "It was nice to see him happy." After a year, Shining insisted that he either be allowed to work in the studio or get a raise. King chose a raise, but Turner insisted, "You have to teach him." King was nervous the first day Shining entered the studio, but allowed Turner to position him on the big old fan he used to make wind. But the fan was leaking oil, and when Shining tried to correct the problem, the motor started spewing smoke, right into the face of the subject du jour, Lee Radziwill. "She was not happy," says Turner.

Nonetheless, Shining got a second chance. But the fan still wasn't working right, and King turned to grab it, accidentally stuck his middle finger into the blades, and almost chopped it off. Turner sprang into action, wrapped King's hand, stuck it into a bowl of ice, and rushed him to the emergency room. When King reacted badly to the first doctor who appeared, Turner says he found another, rushed King to his office, offered every patient in the waiting room a color television if they'd let King jump the queue, and somehow got "his finger glued back on." It was the end of July, so Turner sent King to Cannes to recuperate, shipping his favorite mattress ahead of him, and "hired two hookers he used as beards to fly over with him" to cook for him and Shining. A month later, King was healed and shooting for a new client, the luxury clothing and equestrian brand, Hermès.

By then, King's behavior had got even more dangerous, his risk taking fueled by a gusher of money. He was shooting covers for *Vanity Fair*, which had been revived by Si Newhouse and transformed by Tina Brown into the hottest general-interest monthly magazine in the land. King was making $500,000 a year, charging $40,000 for an advertising job.

In 1984, King hired Jane Hsiang as a freelance advertising stylist. There was rarely a dull moment. "When the models got tired, he'd say, 'Jane, go to

*Shining, now a working beauty photographer, the president of ACRIA, and a trustee of the Robert Mapplethorpe Foundation, declined numerous requests for an interview.

the fan,' and I'd spritz cold water," she says. Once, he built a pool in his studio so a model in a bathing suit made of Du Pont fiber could swim with sea lions. Hsiang was charged with finding a pair. When they arrived, King was aghast. "Ohmigod, they're the wrong color," he told her. "They're brown, I wanted gray." Hsiang burst into tears. King admitted he was kidding. "Who else could get seals but you?" They grew close, and along with Shining, Hsiang crossed over into King's personal life. He let his family think she was his girlfriend. But she knew where to draw a line: "I drink, I take coke, but come midnight, I go home."

<p style="text-align:center">⸎</p>

King's studio "was a machine," says Hilmar Meyer-Bosse, an assistant for two years in the mideighties, with shoots every day and editing on Saturdays. Clients "knew they'd get technically perfect shots," Meyer-Bosse continues. "He was competing with Avedon and Penn. He was second or third." Turner adds, "It was easy for him." Which made it all the more vital that he create obstacles for himself. The frequency of his binges increased. "Every other month," Turner reports, King would disappear for a week or two.

King was in his studio late one night, at the tail end of a ten-day cocaine binge, when he called a rehab hotline, begging for help. The counselor who volunteered, a former club habitué who asks for anonymity, arrived alone and found King with "the largest bowl of coke I've ever seen in my life." Though the counselor wanted to help, he was terrified. "The coke-sex energy was unbelievably wild. It overwhelmed me. It was sex, sex, sex. I was nearly clean. I called *my* sponsor and she said, 'Get out!' I said, 'I have to help him,' and she said, 'No, you don't. Get out!' I learned a lesson: don't go alone. By the way, he was not unattractive."

King's behavior could be extreme at work, too. All concerned say an oft-told tale about a baby's being dropped by his favorite model, Ashley Richardson, at a shoot for the children's clothing line Petit Bateau was untrue and propagated by a makeup artist King had fired. "You know how our business is," says Hsiang. "He wasn't that nice, but he didn't do those horrible things." But cameras were thrown regularly. "When the camera was empty, he'd throw it in the air," says his assistant Chuck Zuretti. "It was like the out-

field in baseball. You had to catch the camera. One time I let it bounce and quietly walked over and said, 'If you don't respect the equipment, you don't respect the job. Stop the bullshit.' He liked it. Maybe I was the first assistant to talk back to him."

But sometimes, he wasn't just playing. "He smashed a lot of Hassel-blads," says Betty Ann Grund. "He'd throw them at me," says John Turner. "I'd duck. He took his frustration out on me? Fine." They could always buy another one. That was far better than when he traded cameras for drugs.

THE GRIM SPECTER

In 1985, Robert Mapplethorpe photographed Bill King wearing aviator glasses, a black leather jacket, and a hoodie. Shot in profile, eyes hooded, he seems beautiful and serene. But that image, the one most people have seen, was cropped, says Turner. In the original, King had a bouquet of dildos in his lap. He was also "stoned out of his mind." By then, he had another reason to obliterate his capacity to reason. That spring his boyfriend, David Hartman, had fallen ill and was in and out of the hospital in succeeding months with pneumonia. He would die of AIDS the following July. "Bill would photograph his progress as he got iller and iller," says Hilmar Meyer-Bosse.

AIDS was then still new. But the disease had already taken a tragic toll and would continue to devastate the fashion industry. Over a quarter century, it would take photographers Robert Mapplethorpe, David Seidner, Barry McKinley, and Herb Ritts; *GQ*'s Jack Haber and Donald Sterzin; the designers Chester Weinberg, Patrick Kelly, Angel Estrada, Clovis Ruffin, Willi Smith, Tommy Nutter, and Halston; Perry Ellis and two presidents of his label, Laughlin Barker and Robert McDonald; Giorgio Armani's business partner Sergio Galeotti; illustrator Antonio Lopez and his partner Juan Ramos; the fashion icon Tina Chow; countless hair and makeup artists, including Way Bandy; models Joe Macdonald and Gia Carangi; and Kezia Keeble's fourth husband, the fashion publicist John Duka. In many cases, the cause of death was concealed.

Until 1986, the grim specter of AIDS was rarely even discussed. "Nobody wanted to talk about it," remembers stylist Julie Britt. "Girls refused to work with people. You had to get okays for hair and makeup. Before that, we were all one big family. The loss of talent changed the industry." For years, merely saying *AIDS* aloud was taboo, which kept many from understanding

what the disease was and how it was transmitted, and some, like King, from changing behavior that had once been seen as liberating or merely licentious. By 1987, King's nighttime habits would generally be considered high risk and potentially deadly. By then, it was too late for him.

Shortly after David Hartman's diagnosis, King asked John Turner to join him when he went to get a blood test that counted T cells, then the most effective screening for AIDS. "He wouldn't go unless we had tests together," Turner says. Afterward, a worried King kept interrupting shoots to ask if Turner had got results. Finally a call came. "I was fine," Turner says, but the doctor asked to speak to King personally. When he heard that, "Bill turned white," Turner says; he knew what it meant. Bill's T-cell count was low, making it quite likely he was infected. For a while, King was in denial and kept playing; he bought a special rectal antibacterial cream in Europe and "used it all the time on his rear," says Turner, who found it and threw it away.

Reality dawned slowly. In July 1985, just a few days after he learned of his low T-cell count, King and John Turner hired Denise Collin as the studio's new bookkeeper. King's appearance at her interview was a clear warning. "I was looking at two of the largest coke rings crusted around that man's nostrils," she says. "It was shocking. His eyes were completely dilated. He was visibly stoned." Collin's first day at work, Ashley Richardson wandered topless into the small room where Collin sat and "squished" her "humongous breasts" against a glass window that looked into King's lair as he laughed hysterically. The next day, Polly Mellen made an assistant cry when a hat got crumpled.

Collin's first job was to "devise ways to meet his expectations" so King could continue to fly to Paris on the supersonic Concorde, buy expensive antiques, and pay studio rent that had gone from $11,000 to $18,000 a month. "He'd take personal money out of the company," she says. "I got him to stop just writing checks for cash. He was trying to blow the smoke away and see [with] some clarity. He was scared."

He dialed back on his bingeing, "tried to boost his immune system" by going on a macrobiotic diet, and, wrote the journalist Stephen Fried, sought out "herbalists, spiritualists, hypnotists, [and] ecstasy therapists," all to no avail. The disease was relentless. But it was never discussed outside the tight circle of his closest associates. Hilmar Meyer-Bosse thought "he was

old-fashioned and would never admit openly the obvious," that he was gay. So confessing that he'd contracted AIDS was out of the question. "He was ashamed," says Hsiang, "which was sad, but that was the times." Fairly soon, though, he "cleaned up his act," Meyer-Bosse thought, and became "very focused on his work."

Collin was the last to join the tight circle around the ailing King. "He talked to each of us separately as to our loyalties, and we all kept our word," she says. Their first job, keeping his illness secret, was relatively easy. King never showed any symptoms. "I never saw Bill sick, even at the end," says Meyer-Bosse.

In July 1986, King signed his last will, but remained in denial. The next month, he was in England, working with an architect to remodel his studio, a job that began that fall. He didn't have enough money to pay for it, so he took out a loan. The makeover stalled in early 1987 until Jane Hsiang lent the corporation $50,000. "He didn't want to admit what was going to happen," says Denise Collin. "He wanted to keep face."

In a deposition given after King's death, John Turner revealed that King had continued to take cocaine after his diagnosis, until early in 1987, when he gave it up, but then found a new drug of choice, codeine; he told Turner he was addicted to it. That March, King came down with pneumonia and was in Beth Israel Hospital for three weeks. Recuperating afterward in Florida, he discussed his finances with his team and considered selling his apartment and declaring bankruptcy, but delayed a decision. Back at work by May, he did shoots in Bermuda for Paris *Vogue* and *Mademoiselle* and several advertising jobs. In June, he shot furs for American *Vogue* with Polly Mellen on Martha's Vineyard, but felt weak and came down with chicken pox, which landed him back in the hospital and then required twenty-four-hour private-duty nurses back at One Fifth to administer IV drugs. After he was back on his feet, he continued shooting, even making a TV commercial for Lancôme, though he scheduled rest days in between jobs. Denise Collin would don rubber gloves and wipe pus from his eyes so he could focus his cameras. "It was the saddest thing," she says. "He really, really, really wanted to just go on, so instead of compartmentalizing, he had to ask for help. He had to be more human."

He was still tied to his father, sister, and an aunt, though no one was

allowed to tell them he was ill, and Turner would later insist in a deposition that King wanted no part of them. "His family didn't understand," says Hsiang, who bought Christmas presents for his sister and "cooked all his Thanksgiving dinners," she says. "I'd see them, the family. Not my kind of people. You know how snobbish [fashion people] are. They were totally embarrassing because they were very limited people. They couldn't see his greatness. But you can't blame them. They're from a different world. The fashion world is so peculiar to real people. They're intimidated by us."

Hsiang and Shining took care of King and watched him grow introspective. "One day he said, 'Gee, if I wasn't so nuts, maybe this wouldn't have happened, maybe I'd have lived longer,'" Hsiang recalls. "I said, 'If not for your insane half, you wouldn't be Bill King.'"

Hilmar Meyer-Bosse's last sessions with King were from July 20 until August 2, 1987, in Paris. They shot ads for Enrico Coveri for several days, then spent a few more working for Paris *Vogue* with the models Linda Evangelista, Naomi Campbell, Famke Janssen, and Marpessa Hennink. Afterward, exhausted, King left for a spa, Évian-les-Bains, with Shining, "and I never saw him again," Meyer-Bosse says. There, King had a seizure—he'd developed brain lesions—and was hospitalized in Paris before returning to Évian to recover. Meantime, the studio renovation stopped again due to lack of funds, and the IRS threatened to seize its accounts. King agreed to rent the space to others and to sell One Fifth, which quickly found a buyer. "He would have done anything to keep the studio," said Turner.

Late in August, King had another seizure and was again rushed to the hospital in Paris. He returned to America in September, but only after Hsiang and Shining convinced reluctant airline employees to let him board a plane. After a weekend at home, he again entered Beth Israel. Meantime, many suppliers were refusing to do business with his studio. In meetings with his longtime accountant and a new lawyer, Turner pleaded by phone with King to let his family in on his secret, but he refused. King did order the sale of his antiques to keep the studio alive. Midmonth, his team was at the studio when King's aunt and father rang the bell. They'd heard he was in the hospital, but no one would tell them where. "They'd call and I'd hang up," says Jane Hsiang.

Refused entry, the relatives demanded John Turner come downstairs. He

told them King was at his latest rented country house in Bedford, New York. A day later, King called his aunt from the hospital and repeated the lie. By October, the money had run out and King's accountant had okayed a raid on Turner's and Collin's pension accounts to pay bills. That month, King's studio landlord decided to apply the studio's security deposit to overdue rent and cancel his lease.

On November 19, 1987, Bill King died in Jane Hsiang's arms. He left his personal clothing and effects to Stewart Shining, whom he considered his next of kin, as much a son at that point as a boyfriend, his property to Hugh Hardy, a British decorator, and five- and low-six-figure sums to his sister, an aunt, a niece, and a nephew. He willed his pictures to a nonprofit organization dedicated to promoting his work and to nurturing photographic excellence. It was never formed. It's unclear if King even had enough cash left to fund his $350,000 in direct bequests.

King's family soon charged that those closest to him—Hardy, Shining, Collin, and Turner—had taken financial advantage of him and stolen from the estate, and a battle followed in Surrogate's Court. "They thought if we were lying about [King's dying], we must also be taking his vast fortune," says Collin, "but there was no fortune." So the fight was mostly about the rights to King's pictures—and John Turner says he forced a settlement. Cleaning out the studio, he'd found a few images that had fallen behind the shredder, "selfies of naked boys fucking him," he says. "I copied them and faxed them to [the family's] attorney and that was the end of that."

John Turner says Shining has the original transparencies of about two dozen of King's finest photographs, "picked out by Bill and given to him for safekeeping." The rest were turned over to his sister and effectively disappeared; they've never been seen since, leaving King's reputation in limbo. Or, Janet King McClelland would have it, in tatters. She blames that on people speaking ill of her brother. "It's very hurtful," she says.

William King Sr. "dogged me," says Denise Collin, who twice met him in cafés. "He was just beside himself with grief. He wanted to know if Bill was really gay. I had to tell him yes."

No one knows for sure what happened to those other pictures, the ones that gave Bill King his risqué reputation. But Denise Collin acknowledges what King's family implied in their court filings, that Stewart Shining took

them when he emptied King's safe-deposit box in a bank branch near the studio just before King's death.* Shining then refused to say what had been in it, or in about seventy-five boxes he removed from the studio and King's residences. When the family finally won the right to break into the safe-deposit box, it was empty.

Jane Hsiang, who has remained close to Shining, isn't surprised that he won't revisit the Bill King story: "He doesn't want to dig all that up." And those pictures? "They're gone, I'm positive."

Collin says she was in the bank with Shining and saw some of the missing photos of "a lot of people . . . in compromising positions. It's one or two files. It's orgies, absolutely, with notable people," both gay and straight. "Bi. You name it. I can't even begin. You know some of the people who were his friends. Assume many, not all, were in pictures they never wanted to go anywhere." Where are they now? "They may not be where I think they are, but I know where they went. I doubt [Shining] disposed of them." She considers them valuable documents—and good photographs, too: "What's hurtful to some is beautiful to others." She doesn't believe anyone will ever be hurt by them, though, as she's convinced they'll never emerge. But she savors that King always "loved a good piece of drama," and the open questions about those pictures will ensure his last one will play forever.

*King had added Shining as a signatory four days after his last hospitalization.

"What I want to say"

One way to rein in a feisty and creative photographer was to remind him (yes, alas, generally a him) he was expendable. Bruce Weber's influence touched every corner of fashion but was most visible in the ad campaigns that launched Guess?, another jeans line. Wayne Maser's photos for Guess? combined elements of Weber's work for both Ralph Lauren and Calvin Klein. Klein would eventually hire Maser, to annoy Weber, Maser thinks. Alex Liberman used Maser in a similar fashion, giving him *Vogue* assignments "to punish everybody else," he says. Tellingly, Maser's photographs had a distinct *Elle* feel.

Shortly after his first Guess? ads appeared, Maser was summoned by both *Glamour* and *Vogue*. He worked with Jade Hobson and Christy Turlington on his first *Vogue* shoot, which made it deceptively easy, he thinks, because "I looked through the lens and realized, they do it for you. She looked like a *Vogue* model." Liberman promptly "offered me a studio," Maser says. "I didn't want one. But I got a contract within months."

Soon, Calvin Klein called and hired Maser to shoot ads with the models Josie Borain and Yasmin Le Bon. Borain didn't get along with Bruce Weber, so hiring a different lensman to shoot her was a good idea. But Maser believes he was hired "to punish Bruce" after Weber had a fight with Klein. "Bruce would turn in three-hundred-thousand-dollar bills. I'd do it for one hundred thousand dollars," Maser says. The same went for the late Gianni Versace, who "hired me to smack Avedon," Maser thinks.

Briefly, Maser was shooting "forty or fifty pages in some issues" of *Vogue*, between his editorial and advertising work, but he had a drinking problem. "I was too fucked-up, incredibly insecure, making too much cash, getting too much work, and not understanding how to make it work. Fashion photography is more about your relationships with people than the final product."

Maser also had an image problem, with people calling him a Bruce Weber copyist. "A *bad* copy," the art director George Lois told *Newsweek*. Maser insists, "I was only copying Brigitte Bardot pictures," but that sort of press didn't help him stay on an even keel. A girlfriend, model Lara Harris, raised the drinking issue with him "and he dealt with it," getting sober at the end of the decade, she says. "I saw him reinvent himself with sobriety." Then, Maser teamed up with an art director who gave him a fresh outlook— and did the same for fashion photography.

The son of a Parisian art director and graphic artist, Fabien Baron grew up surrounded by publications and was studying applied arts at age sixteen when he assisted a runway photographer at an Yves Saint Laurent fashion show. "Wow!" Baron remembers. "I was blown away. That's what I wanted to do."

He began assisting his father on freelance design jobs and quit high school to work on a series of little publications, sometimes with his father or friends of his. After a brief trip to New York, Baron decided that in Paris he'd always be his father's son, so he made a portfolio, crossed the Atlantic with $300 in his pocket, and started making the rounds. A friend won him entrée to Alex Liberman, "the big cheese," he says. "This was my chance." Liberman installed him first at *Self*, and then at *GQ*, as an associate art director, "the little guy, listening like crazy," Baron says. "Everything Liberman said was right. He was very practical. If he didn't like a picture, he'd cut a head off or tilt it."

When Baron announced he was going to a start-up, *New York Woman*, Liberman offered him a position at *Vogue*, "but I wanted my own thing," he says. *Vogue*, in the waning days of the Mirabella regime, looked boring. He'd been watching several young editors in Europe taking liberties with fashion at magazines such as *Jill*, which published eleven issues in France between 1983 and 1985, and *Lei* and *Per Lui*, feisty products of Italian Condé Nast, then edited by Franca Sozzani, one of two chic, wealthy, and well-educated Italian sisters.

Baron wanted to emulate them, "to do really forward fashion." To be an art director, even at a new magazine, was "a calculated step up," he says, as it let him hire "the European cool people," photographers such as Peter Lindbergh, Max Vadukul, and Jean-Baptiste Mondino, give some of them their

first American exposure, and gain notice for himself. Baron met Lara Harris when he put her on the cover of *New York Woman*. Around the same time, a *Vogue Italia* stylist, Sciascia Gambaccini, was on a shoot with another photographer when American *Vogue* called to say Maser needed her to release a hold on model Cindy Crawford so Maser could work with her. She thought, "Who the fuck is Wayne Maser?"

Gambaccini's new boss was Franca Sozzani, who'd become *Vogue Italia*'s editor in 1988 and hired Baron as its art director. Back in Milan, they told Gambaccini they'd just met Maser and wanted her to work with him. Maser and Baron, en route to their first shoot together in Deauville, compared notes on their respective divorces, the former's just concluded, the latter's just beginning. Gambaccini and Baron had recently got involved, and they all became close friends.

In 1987, Bruce Weber spread his wings, releasing his first film, *Broken Noses*, about a young boxer he'd met four years earlier while scouting athletes for his Olympics photos. He put him on the cover of *Per Lui*'s all-Weber issue in 1985, then used him in Calvin Klein ads, including one that sandwiched a topless Josie Borain between him and another young man. Weber had already finished a second film, *Let's Get Lost*, a documentary portrait of the jazz trumpeter and heroin addict Chet Baker, a very different sort of male icon. It would be nominated for an Academy Award in 1988. More films and monographs would follow, but like Richard Avedon, Weber stayed in fashion and used it to finance his sprawling operation.

Weber's relationships with his two most important fashion clients, Ralph Lauren and Calvin Klein, both wound down in the next few years. In the late eighties, Donald Sterzin joined Lauren's ad agency, but after Sterzin's 1992 death from AIDS at age forty-two, Weber had issues with the brand, chafing at the micromanagement of Lauren's creative team. Some also wondered if Lauren chafed at how much credit Weber was given for defining Lauren's visual image.

Lauren acknowledged in a 1985 interview that they sometimes clashed: "I work with him and love what he does. He's in love with everything he shot. I have to select my look as I see it. I want to know exactly what he loves and why, [but] I don't just take those things. They may be great for what [Bruce wants] to say, but they're not what I want to say."

Regardless, they not only continued collaborating, but kept innovating. In 1994, Weber introduced Lauren to Tyson Beckford, a stunning African-American male model, whom Lauren used to advertise a new line of performance sports clothing, rebooting his white-bread image with a single image. In March 1995, Beckford signed an exclusive contract with Polo Ralph Lauren.

Weber disliked Lauren's ad agency, which typically presented finished layouts filled with "swipes," inspirational photos borrowed from earlier ad campaigns or from other brands or photographers, and he would typically nod and smile at the agency meetings and then shoot his own way, but the implied lack of trust nagged at him. When Lauren's son David was put in charge of the brand's advertising, marketing, and corporate communications in 2008, the creative partnership ended. "David wanted his own people," says a Weber associate. "He wanted to put his stamp on the advertising," and Weber stopped shooting Lauren's clothing and image ads for years, though he continued to work for the designer's licensed fragrance line. But the ties between the masters of Americana in fashion and photography proved durable. In 2014, Lauren again asked Weber to shoot images to launch Polo Fifth Avenue, a new flagship store.

Weber's relationship with Calvin Klein's brand ended long before the designer sold his company to a garment conglomerate and stepped down from his role as its designer in 2003. Though their names were indelibly linked in the public's mind due to the provocative potency of Weber's Calvin Klein imagery in the mideighties—Weber's photograph of Olympic pole-vaulter Tom Hintnaus in Klein's tighty-whities against a whitewashed phallic pillar on the Greek island of Santorini, for example—the two rarely maintained the sort of exclusive relationship the photographer had long enjoyed with Lauren, as Klein's Wayne Maser moment demonstrated. Klein always played the field, at least a little, so Weber had usually shared the work with the likes of Avedon and Penn.

The first sign of trouble in the Klein-Weber relationship came after Klein signed model Christy Turlington to an exclusive contract in 1988. Weber, who wasn't consulted, didn't like Turlington. "If you don't consult with the photographer, you don't have a happy photographer," says the Weber associate. Still, Weber and Klein raised the bar in fashion advertis-

ing one last time in fall 1991, producing a 116-page stand-alone magazine full of fashion pictures that was bundled with *Vanity Fair* and mailed to its subscribers at a cost of $1 million—but the consensus was that it didn't sell clothes. The next year, Klein changed his image—and his photographer—using French Mobster Patrick Demarchelier to shoot the young model Kate Moss as a stand-in for a new generation of fashion consumers, and the younger Steven Meisel to shoot Lisa Taylor, who emerged from retirement to represent Klein's expensive Collection line. But the cause of the break with Weber was another series of ads released just after Klein's company, $62 million in debt from the repurchase of its jeans license, was rescued from its financial dilemma by Klein's friend the music and film mogul David Geffen, who bought that debt in May 1992.

Three months earlier, Weber had shot an entire issue of *Interview* that showed a young white hip-hop star, "Marky Mark" Wahlberg, on the cover and in a spread that included pictures of the future film star with his underwear waistline visible above his pants. That fall, Calvin Klein's underwear ads featured Wahlberg in poses quite similar to those he'd struck for Weber, but the advertising photos were taken by Herb Ritts, another photographer sometimes considered a Weber copyist, and one whose work also had a strong homoerotic flavor. Weber and Nan Bush believed, true or not, it was Geffen's idea to copy Weber's photographs.

Those photos added fuel to Weber's sense of grievance as, a year earlier, Ritts had won the job of making a television commercial for a Klein fragrance called Escape after Weber shot print ads for it. Weber had shot earlier commercials for Escape and a predecessor, Eternity, and Weber believed Klein had withheld praise for them until several friends, Geffen among them, said they approved. When Weber submitted his latest photos for Escape, Klein "wasn't as responsive as he should have been," says a member of the photographer's inner circle, "and then he sent Herb Bruce's pictures and Herb copied them. It turned Bruce off. He said, 'I've had it,' and they never worked together again."

Weber didn't lack for work. In 1996, he shot an entire issue of *L'Uomo Vogue* in Vietnam. "Kate Moss in a rice paddy in a ball gown is as mad as any of Diana Vreeland's exotic fantasies," wrote photography critic Vince Aletti. Then, in 1997, Weber staged a retrospective show of his fashion work and

celebrity portraits at the National Portrait Gallery in London. Simultaneously, a London gallery showed a group of hand-tinted Weber photographs focusing on the body of a sixteen-year-old professional wrestler from an eccentric book and movie project Weber called *Chop Suey*.

Weber seemed more comfortable with himself by then. Once, he'd left it to observers to speculate on his intentions, imagining his photos were inspired by everything from base voyeurism to a more mundane longing to be part of "some high-school in-crowd," Weber finally felt free enough to admit, or at least verbalize, his obsessions, telling *American Photo* he was increasingly focused on "catching a kid at that really vulnerable time when he's becoming a man . . . how you come to terms with who you are."

By then he'd published eleven books and released six films. A seventh, a docu-portrait of Robert Mitchum, was in the works. And he'd become mainstream, or so it seemed from the reviews of the London show. The *Financial Times* said his work contained "nothing remotely shocking," was sometimes self-indulgent, and that he'd been "eclipsed" by younger, edgier fashion talents. Apparently that critic hadn't noticed Weber's forty pages of photos of Kate Moss, Lucie de la Falaise, and Marianne Faithfull in the latest issue of *W*.

As if in response, Weber doubled down on his preoccupations with sex and youth. He started working for Abercrombie & Fitch, an old-line outfitter of WASP adventurers then being retrofitted, under the aegis of an outspokenly gay executive, Mike Jeffries, as a hip retailer for college kids. Weber's partner in crime at A&F was Sam Shahid, whom Weber had first worked with at Calvin Klein. Shahid came up with the idea of a quarterly magazine—later dubbed a magalog—for the brand, filled with photos by Weber and cheeky articles aimed at hormonal college students; it debuted in spring 1997. Over the next half dozen years, the magazine—aimed at the young and featuring hard, young, seminude bodies splayed in sexually suggestive poses and situations—would be acclaimed, engender criticism, and become increasingly suggestive, likely to ensure A&F was not eclipsed by other brands.

As he'd done for years, Weber took a traveling-circus approach to Abercrombie shoots, envisioning them as movie sets. "We had acting classes, great acting teachers, a dance class for everybody, so they weren't just sitting

around thinking about their careers," he says. "There was a bonding like people have on a football team or in a boot camp."

Like Weber's photos, the quarterly's written content was nothing new, but seemed calculated to outrage some who worried about its corruptible target market. In 1988, Mothers Against Drunk Driving protested a spread of mixed-drink recipes. In 1999, an A&F "sexpert" offered advice on giving oral sex in movie theaters. In summer 2001, a group of concerned Christians called the magazine's photos exploitive, and the National Organization for Women protested its promotion of unrealistic body types. That fall's issue featured photos of nude women supposedly inspired by Katharine Hepburn, whom it described as a collegiate skinny-dipper. The next issue was canceled in the wake of the September 11 attack on New York's World Trade Center, but even then, Shahid and Weber didn't back down, and at the end of 2003, A&F released its most outrageous quarterly yet, one with a group-sex theme.

At the shoot for that issue, Weber predicted, "This will never happen again." When it was released, more protests erupted; Abercrombie withdrew it and canceled the next issue, though it was already on press. Shahid and Weber continued working on ads and magazines for the label, but it was in decline; Abercrombie's moment of influence was passing, and their work no longer provoked.

For Weber, it was all replay, anyway. "Jeffries says, 'Hey, do whatever you want, I don't care about the clothes; as far as I'm concerned, they don't need to wear anything,'" Weber recalls. "These are all sort of red lights to me, because I think they do care about the clothes, but they don't want to seem too square and they think that's what I want to hear. Then all of a sudden, they start asking questions. 'We want to be on the nose about stuff.' Pictures don't grow from that. If your heart is in the right place, you just do it. Sam Shahid fought for us. But they were very middle of America." Which made Weber feel rebellious and left him as tongue-tied as one of the teenagers he was shooting. "So I'm doing something maybe I shouldn't be doing, because they don't understand me anymore," he sputters. "And the people who are hiring you, they're saying, 'Why are we doing that?' When it's successful, they're happy. But when it's not, who do they blame? They blame the photographer." In fact, they blamed the boss,

too. By the end of 2014, Mike Jeffries was gone. Weber and Shahid's contracts were allowed to expire.

By then, Weber had found a new client willing to push people's buttons. In 2011, Dennis Freedman, the longtime art director of *W*, which had morphed over its thirty-nine years of existence from a folded social gossip broadsheet to an oversize magazine bursting with the latest in fashion photography, joined Barneys New York, the avant-garde department store, as its creative director.

Three years later, in January 2014, it released a suite of Weber's photographs in its seasonal catalog and ads. Titled "Brothers, Sisters, Sons & Daughters," it featured an international cast of seventeen transgender individuals—people who'd consciously chosen to change their gender identity—ranging in age from their teens to thirtysomethings, wearing the latest clothes from Barneys. Freedman believed that despite American society's strides forward in its views toward gays and lesbians, the transgender community was still lagging behind.

Freedman and Weber had been working together since doing an award-winning shoot for *W* in 1997, inspired by their mutual admiration for the writer Eudora Welty. When Freedman conceived of the transgender campaign, he says, "There was no question there was only one photographer who could find the humanity in it, and that was Bruce. I called and there wasn't a second's pause."

Barneys had been casting the shoot for months. Weber dedicated a week to talking to the models, "developing relationships," Freedman says. "It was classic Bruce." He also made five films to accompany his photographs. "There was not a big budget and films are very expensive," Freedman says, "especially the way Bruce does them. He put the films ahead of financial gain. He knew we could make a difference."

Though fashion folk had sporadically played the transgender card, never before had a business like Barneys taken such a stand. Just when it seemed no social boundaries were left to cross, Weber had found another and done it with both beauty and empathy. "It's the best thing he's ever done," raved stylist Tina Bossidy. "It's such a big deal. It's the only territory that hasn't been raked over yet."

Bruce Weber says his experiments in film refreshed him, taught him, and

"really opened me up a lot. I just feel lucky that I'm still healthy enough that I can get up and work and photograph." Asked what jobs in the last two decades inspired him the most, he sounds just like the younger man who insisted on pursuing his own vision, even if it meant walking away from paychecks. He also sounded like someone who'd adapted smoothly to a world in which big money backs big brands and works hand in hand with the machinery of fashion to sell a vast array of products.

Weber was working on both a book and a film in 2008, he says, when *Vogue Italia*'s editor, Franca Sozzani, called and suggested he shoot for Moncler, a five-decade-old manufacturer of down jackets. Remo Ruffini, the company's chairman and creative director, then cohosted a dinner in Miami with Sozzani to celebrate a special issue of *L'Uomo Vogue* featuring about a hundred pages shot by Weber, celebrating life in that city. Weber had owned a home in nearby Golden Beach for many years.

In an interview before the party, Sozzani said she no longer thought of her publication as a fashion magazine. "I don't think you sell clothes through a [fashion] credit," she said. "I think that you go through an image, that you sell a dream, and [then] the clothes." She claimed she cared more about ideas and concepts than celebrities and selling magazines, even though she'd put the actor Javier Bardem on her cover to illustrate "the heart of Miami." In saying that, she was bucking the fashion industry's tide, just as Weber would soon do with his Moncler ads. Both editor and photographer are exceptions to fashion's ruling protocols in the twenty-first century.

Sozzani promised Weber that he could do whatever he wanted if he accepted the Moncler assignment. Normally, he says, such a promise makes him want "to go and hide" because it's so rarely true. When Sozzani added, "You can photograph your dog," Weber, whose golden retrievers are something akin to his and Nan Bush's children, was tempted. It turned out there *was* a condition: the notoriously camera-shy Weber had to include a self-portrait, but when Moncler agreed to a condition in return—to make a $140,000 donation to Green Chimneys, a charity chosen by Weber that provides animal therapy to young people—"I thought, 'Wow, these are people who stand by their word,'" Weber says. "So I ended up photographing my dogs."

Weber didn't only photograph his dogs, he shot them swimming with

down coats in their mouths and wearing them in the rain. He also shot a group of bare-chested men rolling a giant ball of down coats up a mountain of gravel, and he made himself almost invisible in his self-portrait, which showed him in bed, covered with cameras, a down coat hanging on the headboard. "You've got to look pretty hard to find me in the picture," he says. Working with Moncler "was an incredible collaboration with people who really trusted me." He continued to shoot Moncler ads for years.

Though he's been shooting pictures for forty years, five times longer than Alexey Brodovitch's use-by date for fashion photographers, Bruce Weber's career seems far from over. As long as he still feels the need to lash out when someone kills his photos and is thrilled to be trusted, he is likely to continue. Taking pictures, practicing his art, is his life—and he's managed to blend the personal and commercial so well, the division has become meaningless. So it seems somehow appropriate, in the tortured logic of fashion magazines, that after an increasingly ill and disengaged Alexander Liberman was effectively retired from Condé Nast early in 1994 (relinquishing his title of editorial director for the essentially honorary one of deputy chairman), he reached out to Weber.

A few months earlier, Liberman had bought a penthouse in Miami, and at the end of his life he spent considerable time there. One of the ways he occupied his time was to call Weber, "and we'd have these amazing conversations," Weber says. Despite their past differences over his refusal to bend to the art director's will, Weber decided Liberman was attracted to him much as Weber's parents were drawn to his older sister, who "was always wild," he says, "and my parents would complain, but I could see how much love they had for her. I learned a bit from that, and I just felt like I was going to be myself. I never spent my career thinking, 'I've got to work for a fashion magazine.'"

Liberman had had a second heart attack in February 1991, further weakening a body already ravaged by cancer and diabetes. It couldn't have helped that his beloved wife, Tatiana, was also in and out of the hospital with kidney failure and would die that spring. Like a failing parent moving close to a child, he would soon relocate to an apartment on the East River in the same cooperative apartment complex where Si Newhouse lived. Confined to a

wheelchair and attended by his third wife, who'd entered his life as Tatiana's nurse, Liberman would die in Miami in fall 1999. Liberman's replacement, a thirty-five-year-old Briton named James Truman, was an editor, not an art director, and both of his subsequent replacements were editors, too. The age of the omnipotent art director ended with Liberman, who'd already signed the death warrant for the "noble" fashion magazines he'd championed. "It's hard to compete with Bruce Weber's photographic layouts for Calvin," he'd said a few years earlier. "Magazines are a rearguard action."

But before his death, Liberman would sometimes ask Weber how he was doing, and as is his wont, Weber would complain about the latest unsympathetic art director, the latest story or campaign some wretch had ruined. "He was very simpatico," says Weber. "He agreed with me that it was better to stay who you are than give in to giving it all up and selling yourself down the river." That's what Liberman had done at Condé Nast, and in retirement, or at least when talking to Weber, he appeared to have regrets. "Look at his book," Weber says, referring to *The Artist in His Studio*, Liberman's 1960 volume of photographs and intimate conversations with painters and sculptors. "It's really a book about love and desire"—for the artist's life that eluded Liberman. "And that's why that book is so good."

And what about Weber and love and desire? Does he, as so many think, find love through the lens of his camera? "That's a good question that you could ask a lot of photographers," he says. "I don't really know and I don't really think I care to know. I kind of like it that I'm discovering what the feeling is each time I do it. It's so fulfilling, because it's different all the time. But I think that's so private. I just think that there are certain things that can't be answered in life. And that's one of them."

Part 6

DISRUPTION

If you throw a pig an apple, he'll run with it.

—RICHARD AVEDON

Chapter 40

"EVERY MOTHER'S NIGHTMARE"

As the nineties dawned, fashion raised its hem, revealing its transformation from an elite preoccupation to a mass-market production. The change was first obvious at the biannual fashion shows, where teams from major magazines such as *Harper's Bazaar* and *Vogue* grew from three or four to eight, ten, and more, and instead of one or two television cameras appearing, if any, there were as many as twenty. Not only did the shows seem to be on steroids, so did the entire business. Outrageous display became the new normal as the egos of designers, models, editors, stylists, and fashion publicists and journalists inflated like Thanksgiving Day parade balloons.

This was especially curious because fashion itself was in the doldrums. Designer Karl Lagerfeld had recently spun the syndrome as "the fashion of no fashion." The void had been filled by supermodels, a cadre of Glamazons with compelling personalities who were promoted by modeling agencies and taken up by image-conscious designers such as Lagerfeld in Paris, Gianni Versace in Milan, and Isaac Mizrahi in New York. But no one played a larger role in their celebrity than a photographer who would soon loom larger and soar higher than his peers and remain aloft for more than two decades, Steven Meisel.

Shortly after launching Bruce Weber, the signature photographer of the eighties, Annie Flanders and Kezia Keeble were the midwives at the birth of Meisel. Like Weber, Meisel was a gay man with a strong, well-connected mother figure beside him—only unlike Weber, Meisel would quickly drop her and cut his own swath through the fashion demimonde. Still, just as big-bucks advertisers such as Ralph and Calvin had elbowed fashion editors

aside, pioneering stylists such as Keeble and Cavaco and agents such as Nan Bush and Frances Grill sensed that times had changed and started competing with art directors as visual tastemakers and nurturers of photographers.

Grill was a rarity who began as a photographer's agent, became an agent for models, but played as profound a role in shaping fin de siècle fashion photography as any magazine employee or advertiser. The daughter of a longshoreman, she moved from Brooklyn, where she was born, to Manhattan's SoHo after college. One day, sheltered under an awning in a rainstorm, she chatted up the man next to her, Alberto Rizzo. He said he was a photographer. Without pause, Grill said, "I'm a photographers' agent." Grill and a friend promptly opened an agency and picked up Jeanloup Sieff as their second client. Over the years Grill would rep photographers on both sides of the Atlantic, including Frank Horvat, Lillian Bassman, Otto Stupakoff, and Oliviero Toscani.

In 1979, Annie Flanders introduced Grill to Meisel. A dark-skinned man-child with straight, long, thick black hair and piercing eyes, Meisel had been addicted to fashion magazines since his childhood in Fresh Meadows, Queens; his mother let him skip school to read hers the moment they arrived. By the sixth grade, he was collecting model composites, cards that typically showed three or four photos of a model along with vital statistics such as weight, height, clothing size, and eye and hair color. Meisel scrutinized them the way other little boys looked at *Playboy*s and baseball box scores.

In school, he studied fashion illustration, but found classes boring and left before graduating to get a job as an illustrator at *Women's Wear Daily*. Fashion was his passion: "It was part of me. I didn't have to think about it." He already had a fashionable uniform he wore every day: black faux motorcycle boots, black pants, a black coat, and a headband or a denim hat. His other passion was music; a grandfather had been a songwriter, his mother a singer, and his father worked in the record business. "My grandparents knew Tony Bennett, Sinatra, Peggy Lee, that era," he says. "I would meet the Beatles or the Stones." By 1977, the twenty-three-year-old was a star himself, both in *WWD*'s art department and in New York City's punk and gay clubs. Among his best friends were the punk-rock poet Patti Smith's piano player, Richard Sohl, a childhood friend from Queens (whose nickname DNV derived from the book and film *Death in Venice*, about a homosexual obsession); Stephen

Sprouse, an assistant to the designer Halston; and a transgendered girl from Iowa who called herself Teri Toye.

Meisel and Sohl had been haunting gay bars since junior high, says Gabriel Rotello, a nightlife entrepreneur who met them in the midseventies. "They both had real wild streaks and wanted to be where the action was. Richard would entertain us with stories about coming into the city on the subway, changing into rouge and heels, prancing around Manhattan, washing it off, and going home. Steven was not that way at all. He was very reticent." But they shared a conspiratorial streak and a secret language rife with nicknames and veiled put-downs. "I found them a little scary," says Rotello. Adds Annie Flanders, "They sat on the sidelines and observed." Voyeurs.

Like Weber, Meisel was committed to gaining acceptance for what he called the "queer sensibility." His relationship with Toye was an early public expression of that; they would later announce their engagement as a prank to celebrate a nightclub opening. "They were so enigmatic," says Helen Murray, a former fashion editor and agent. "The coolest of the cool, threateningly cool. They walked around like every mother's nightmare." But oddly, Murray adds, "They were cleaner than the guys working for Bear Stearns."

In the late seventies, Meisel began toying with photography and, after standing in for a friend who taught illustration at the Parsons School of Design, was allowed to take a photo course free and began shooting for *WWD*. "He was very focused, very ambitious," says Kenneth Paul Block, a senior illustrator at the fashion newspaper. "It was perfectly clear he had no desire to go on being an illustrator in a world in which illustration was dying." He was also ambitious for material things. Block and Meisel would walk around Greenwich Village, and Block would point out houses he liked. "I don't care," Meisel said. "I want to live on Park Avenue or Fifth Avenue." He would end up with a grand apartment on Park Avenue *and* a gated midcentury Modern home in Trousdale Estates in Los Angeles with a kidney-shaped swimming pool and sweeping views (which he would sell for $11.36 million in April 2014).

Meisel started out testing young models such as Phoebe Cates, who would later become an actress. "He was just different and playful," she says. She and her sister Jo "were girls from Park Avenue. He was our first grown-up friend, our introduction to the Village. He was the first man we'd met with really long hair who was into dressing us up." Thanks to Cates,

Meisel won an assignment from *Seventeen* magazine. "He had one camera," says *Seventeen* art director Tamara Schneider. "His mother took messages for him. But he had good design sense and a definite style." Annie Flanders saw that first effort and offered more work. "I've got to practice a couple more years," he demurred. "C'mon, shoot for us," Flanders countered. His first job for the *SoHo News* tackled plastic clothing.

At the time, Frances Grill's most important photographer client, Toscani, "was giving everyone trouble," Flanders says. "She was desperate for someone who could shoot like Toscani. I said, 'I found who you're looking for.'" Grill says, "I was looking for playfulness, for fun, and one day into Carnegie Hall walked this guy with his hair under a hat." He "technically knew nothing, but he showed a very special, individual flair. He had an eye for fashion and a fantasy and used his camera to transform everything into that fantasy."

Grill worked a few blocks from Keeble and Cavaco's apartment-office and took a carousel of Meisel's slides to them for their opinion. "The pictures were so adorable," Cavaco says. Keeble got Meisel several small jobs, and then, when she was hired to produce covers for *Self*, a new Condé Nast magazine about women's health, she got him in the door and, says Cavaco, "he started to do covers on, like, his second try, which is unusual for a starting photographer."

It was a coup for Keeble and a coup de foudre for fashion. Meisel's knowledge and photographic memory of sixties fashion photographs inspired him to take pictures that harkened back to the genre's glory days. They were past, but he made the work seem urgent again. That brought him attention both good and bad. For years, he'd be derided by many as a plagiarist. "He tacked my pictures to the wall and said, 'C'mon, let's go shopping,'" Richard Avedon later charged. "They'd look at the pictures for a movement, a gesture. If you throw a pig an apple, he'll run with it."

Years later, Meisel worked often with Madonna and shot photos of her inspired by Bert Stern's "Last Sitting" with Marilyn Monroe. Stern had met Meisel at Mel Sokolsky's studio when the former was still a fashion-struck preteen and the latter was shooting Twiggy. Years later, Stern would threaten to sue Meisel for copying him, but after meeting with lawyers representing Meisel and Madonna, Stern "kind of let it drop," he said. "I know for a fact they had the book at the studio, literally going through it copying pictures.

His early stuff was Avedon-ish. Then, he went through other photographers. It's very inventive, very clever. It's almost a style [itself]. We live in an age of nostalgia. But his [appropriation] is very extreme." Meisel even aped Stern's obsessive music-playing, though without a jukebox. "He'd play a track over and over and over," says J. P. Masclet, who assisted Meisel. "No matter what you were doing, you'd have to go to the player again. I can't begin to tell you how many times I heard 'Beat It.'"

But Meisel was more than a skilled postmodernist playing cut and paste. "He didn't know much about photography, but his illustrator's eye was sensational," Masclet says. "He applied his sensibility to photography, but he needed assistants to fill in the blanks. He'd come in with tear sheets and ask assistants to duplicate the light. He wanted to understand light and then do his own thing. He was learning on the job." Keeble master-minded his on-the-job training. "He absolutely knew nothing," says another assistant she hired for him. "I'd do all the lighting, I'd shoot the Polaroids. He gave no direction. He'd sit in the corner. He'd look, and either he would shoot it or Kezia would. The guy had a dream come true. Every one of us who busted his ass watched him have everything handed to him." But that happened for a reason. "He drew with his camera," Grill says. "He re-created faces."

At the time, Grill was helping out a friend at a failing modeling agency, and Meisel, who'd recently moved to Manhattan, shot test photos for them. "They didn't think his pictures were any good," says Grill's son and partner, Joey. "She said, 'If you think that, I'm out of here.'" When the agency folded soon thereafter, several male models asked Grill to represent them, and she stopped representing photographers and opened a modeling agency of her own in summer 1980. She called it Click. Bruce Weber's association with it was strong; he, Donald Sterzin, and Grill were "simultaneously doing the same thing," says Joey Grill. "They're scouting beaches, we're scouting la-crosse teams, looking for people who could model but hadn't. We were all on the same page about where fashion was going and willing to try different images." Men's fashion was finally going to matter.

Rumor had it that Weber was backing Grill's agency. In fact, it was the much younger Meisel who wanted to be part of it, somehow. He shared the same viewpoint, and at first Grill was willing to entertain the notion of him

as a photographer-partner. She loved his sense of humor. "Even the way he wore black was humorous," she says. "Something's torn, something's hanging, something's old. It's so untogether, it doesn't feel forbidding." She called him Mary Mary Quite Contrary.

But someone privy to their conversations says they had a falling-out when Meisel insisted that his therapist get a cut of the Click deal, too. Asked why they parted company, Frances Grill gets gnomic: "He is fashion. He moves on. That's fashion. It changes as fast as you think you've got it. That's how Steven is. He moved on. We didn't have an ongoing connection after that." But the person privy to their talks elaborates: Meisel's therapist "was a religious Jew and Frances thought, 'This is where Steven got his look.' But she also thought his therapist was a thief, manipulating Steven. He claimed Steven couldn't operate without him, but Frances didn't want him, so they went their separate ways."

Meisel next approached Nan Bush, but she was already representing Weber. Seeing Meisel's talent, but wanting to keep her client list small, Bush gave him some names, and he signed with a firm that represented photographers, stylists, art directors, and even copywriters. "Steven clicked the shutter, they managed him and marketed him as an incredibly cutting-edge cool person," says Helen Murray.

Before long Steven Meisel was working regularly for *Mademoiselle* and *Lei*. *Mademoiselle*'s editor, Amy Levin, looked askance at Meisel's appearance. "He wore eye makeup and no lipstick," says one of her editors. "A wig. A raincoat because he thinks he has fat thighs. You get very hardened to what people look like. At least he was clean." But as fast as he'd appeared at *Mademoiselle*, he disappeared. "Alex [Liberman] had his eye on him," says the editor. "*Vogue* plucked him."

Not everyone admired him. Oliviero Toscani called him a rephotographer, "but the fact is, a page by Steven Meisel had a signature," says Grill. "I didn't need to look for a credit." And if elements of that signature were Richard Avedon's, Meisel had made the right choice, thinks Ruth Ansel: "Why not go for the master?" The line between plagiarism and inspiration is fine, but it's a distinction with a difference in fashion where line-for-line knockoffs are the coin of the realm. Meisel was fashion's first advocate of sampling, the postmodern tool of choice.

One of the first editors Meisel worked with at *Vogue* was Andrea Quinn Robinson. He cited chapter and verse on "everything about me that had ever been printed," she says, and blew her away. He also blew her away with his look: kohl eyes and a skirt over pants. And then, there was the style of his photographs, starkly different from the look of the times epitomized by Arthur Elgort. "He really brought an illustrator's point of view," says Robinson. "He was very aware of the human form, the way artists are. Keen awareness of anatomy forces a more posed, formal picture." Robinson watched in awe as Meisel grew confident. "He was a maestro," she says of shoots where loud music played and he silently directed his models, commanding them through force of personality to match a look, a pose. "I remember thinking, 'Is this too much for *Vogue*?'"

In 1982, *Vogue* offered Meisel a complex, time-consuming shoot of clothes from all the international ready-to-wear collections, and he wavered. "I had to fire him so he could get going on his photo career," says his boss at *WWD*, art director James Spina. Meisel worked with the flamboyant editor Carlyne Cerf de Dudzeele, and their collaboration would continue through the supermodel era and beyond. Meisel got a $60,000 annual guarantee from Condé Nast.

In 1984, with Kezia Keeble's connivance, Meisel caused an uproar when he named Teri Toye Girl of the Year at a meeting of the Fashion Group, a trade association. Their black-clad cabal imploded under the weight of the ensuing attention. Only Meisel survived and prospered. Sprouse had a brief moment in the sun but couldn't stay in business and died at fifty of heart failure. Toye moved back to the Midwest. Keeble divorced Cavaco and married a *New York Times* fashion columnist named John Duka, and the unlikely ménage à trois founded Keeble Cavaco & Duka, a public relations and fashion-event management company that survived as KCD, even after Keeble died of cancer and Duka of AIDS, and Cavaco sold the company and went to work for a series of fashion magazines.

"People like to assign credit—who made a career," says Cavaco of Keeble, Weber, and Meisel. "We all helped each other. The fact that our careers moved forward was the fallout of the love of working together. There's a way they see the world, a way they see a picture, that's very similar even if, stylistically, their manner of working is different. They have an ability to see the next thing, and they're not afraid of it."

Cavaco ping-ponged among them for years. "Being on a set with them is the funniest," he says. "I could sometimes not believe I was laughing so hard. They see everything. Their observations are hilarious, and that sympathy makes their pictures beautiful. You feel cherished, so you do great work."

In the mideighties, Steven Meisel began working for both Italian and American *Vogue*. But often, his pictures were discarded. "He was ahead of his time, and that scared people," says an editor who was there. "Carlyne [Cerf] and Steven were after aggressive, contemporary images that were against everything *Vogue* stood for under Grace Mirabella," says a prominent art director. By 1987, "Steven's name was never brought up with any enthusiasm. They never gave him anything big." Even when his photos did run, he was upset about the way they were used and about editors hanging over his shoulder, demanding to see film before he was satisfied with his edit. "He wanted the freedom Bruce Weber had, and people wouldn't give it to him," says Annie Flanders.

"He began getting difficult," reports a Condé Nast editor. "At *Mademoiselle*, the art director had let him review his layouts. At *Vogue*, he had to do as he was told. He was not happy. He got frustrated" and began holding on to his film until the last moment, "hatching the pictures," the editor says. Eventually, he started turning over one frame per page of a planned layout. Liberman grew furious. "*Vogue* is not a photography magazine," he said. Grace Mirabella acknowledges the creative differences, but offers no details. "It's like clothes I don't like," she says. "I just decide I don't remember. Not that he's not strong and interesting. But I wanted a direction he didn't want, and I have trouble doing things halfway."

Meisel wasn't the only newcomer to Condé Nast whom Mirabella didn't like. The mideighties were treacherous times; *Vogue* was in a crisis, alarmed at the success of the upstart *Elle*. "Grace and Alex had established a vocabulary," says a Condé Nast art director of the time. "As much as they wanted to hear about new people, they didn't want to have to deal with their development, which means you have problems, failures, egos. *Elle* caused scurrying, whispering, worrying. Why was a giant worried about this irritant? They'd lost focus. Something terrible and terrifying was happening, and they just didn't know what to do." Then, the future arrived.

Chapter 41

"A FASHION MUSICAL"

Anna Wintour's journey to the top of fashion's pyramid is well chronicled. The daughter of an American mother and a newspaper editor from London's Fleet Street, she had what she describes as "a totally undistinguished academic career" and started her real one as a fashion assistant at British *Harper's Bazaar* in 1970. "By the time I left," five years later, she's said, "I'd risen to the heights of deputy fashion editor."

In 1976, Carrie Donovan hired her to work at *Bazaar*, but she was quickly fired for "not understanding American fashion," and she admitted, "They were probably right." Wintour joined *Viva*, an ill-fated women's magazine, until it went out of business, and then *New York* magazine, where Alex Liberman noticed and started courting her to work for Grace Mirabella. "He can be very seductive," Wintour said later, and in 1983, he hooked her with an offer of a new title, creative director, and a vague mandate to collaborate with Mirabella on the magazine's visuals. They didn't hit it off—and no wonder. At their first meeting, Wintour famously made it clear she was gunning for Mirabella's job. Her relationship with Liberman was another story. "I learned more from him than I can imagine," she said around that time. "He's always right."

A year later, Beatrix Miller retired from British *Vogue* after twenty-two years at its helm, and Wintour was offered her job by the head of Condé Nast's international division. It had been her childhood ambition, and feeling underused at *Vogue*, she accepted. So even though she'd established a life with a husband and newborn in New York, and Liberman didn't want her to go, Wintour moved to London, took over a staff that was "nervous and apprehensive," she's said, and turned an eccentric, whimsical magazine into a glossy, Liberman-style frock-selling machine. "Whimsy was disappearing," she said. "I was coming from an American *Vogue* point of view and I certainly brought that to England."

Six months into the job, her fashion director, Grace Coddington, quit and moved to America to join Calvin Klein's design studio. Coddington's departure fed red meat to a British media pack that had shoveled abuse on Wintour from day one, even though Coddington was quickly replaced by Elizabeth Tilberis, a prematurely gray-haired sittings editor with a jolly, friendly outward demeanor and a core of tempered steel.

Wintour never expected to stay in London. "One was always aware it wasn't going to be forever," she said. But her departure came "a little sooner than originally expected." By early 1987, she was pregnant again and rumored to be restless and talking to *Harper's Bazaar*. That summer, Tilberis announced she was leaving, to join Ralph Lauren in New York. Alex Liberman stoked the fire when he told a *New York Times* reporter Wintour might return to America "within a certain period of time." The day that appeared in print, he called the reporter. "Dear friend," he said, using a phrase that signaled quiet fury, "it seems we have gotten me into some trouble. Now, how are we going to get me out of it?"

Si Newhouse did that for him, flying to London to offer Wintour just what Liberman had implied—and later that summer, after giving birth to her second child, she returned to New York, but not to take over American *Vogue*. Newhouse "said quite firmly that *Vogue* was not available," Wintour recalled. Instead, she replaced the editor of Condé Nast's home-design magazine *House & Garden* (he left for Hearst). Tilberis was convinced to stay at British *Vogue* and replace her. Wintour's magazine was renamed *HG* and given a stiff dose of chic, leading wags to nickname it *House & Garment*. It was generally reviled, but Liberman and Si Newhouse were nonetheless impressed with Wintour.

Elle's sudden ascent caused panic—and a series of abrupt personnel shifts—at Condé Nast. The most significant was a change at the top of *Vogue*. As with Diana Vreeland, Newhouse and Liberman had tried for several years to nudge Grace Mirabella to alter her course, see that times had changed, and confront the French usurper; Wintour's 1983 stint at *Vogue* may have been their first glancing attempt to do that. Wintour was front and center when they confronted the problem head-on in spring 1988, moving her into Grace Mirabella's job so abruptly that *Vogue*'s editor learned the

news from her husband, who'd heard it announced on television by the gossip columnist Liz Smith.*

American *Vogue* and Steven Meisel had already broken up. "All of a sudden," says a fashion editor, "Steven was not on the schedule." The exact circumstances of the breach are unknown, but news of it spread through the industry and, paradoxically, raised Meisel's profile higher because "Steven didn't care," says Helen Murray. "He wasn't scared of them."

The photographer had problems with advertising clients, too. He did his first big jobs in Europe, where designers "were more avant-garde than magazines," says Jade Hobson. Yet Rei Kawakubo killed a campaign Meisel shot for her Comme des Garçons line after he wrapped the models' faces in bandages and shot them on a conveyor belt. "Occasionally, I get to do what I want," he complained to *Photo District News* in 1987. But just as often, he didn't. "He was supposed to shoot an Alaïa campaign," a Condé Nast editor says. "He put the sexiest women's clothes in the world on boys. He's very provocative. Very self-destructive. But Steven also has taste, and it's hard to have taste in this business."

Refusing to accommodate American *Vogue* was a considerable gamble. "He went out on a limb, but it really paid off for him," says a stylist he's worked with. Luckily, Meisel had a friend in Franca Sozzani. Frances Grill's client Oliviero Toscani had been the main photographer at *Lei* before Sozzani took it over in 1980, and when he left the magazine on her ascendance, she found new shooters, among them Peter Lindbergh, Paolo Roversi, Herb Ritts, Max Vadukul, and Meisel.

Bruce Weber was also a Sozzani mainstay, but Meisel was clearly her favorite. He "was just beginning," says Sozzani, "he didn't have so many pictures, but he had a way to explain what he wanted and I was fascinated by somebody who was so full of ideas, so full of energy. He's the only photographer I know who *loves* fashion. The only one. It is very unusual to see beautiful fashion with

*One further anti-*Elle* gambit failed. Gilles Bensimon says *Vogue* tried to hire him in 1990, offering him $1 million to jump ship. He asked Alex Liberman if Anna Wintour knew about the offer, and Liberman said she didn't. Bensimon turned down a Condé Nast contract, he says, because "she got rid of Avedon in one month. She could get rid of me in a week!"

a beautiful image and beautiful girls. He searches for beauty. He finds a girl, an attitude, a dress, and puts it all together. He's never satisfied. He's a photographer and a stylist at the same time." Meisel became Sozzani's Richard Avedon. But she didn't think him any more of a copyist than Weber. "People said Bruce was copying [Edward] Weston," Sozzani says. "Of course you get inspiration. But if it was so easy, why somebody else didn't do it?" Meisel's first *Lei* sitting, of young brides, appeared in June 1980, and he worked for Sozzani "almost every month after," she says. His shoots were "always completely different." Sozzani's photographers were fanatically loyal to her. She gave them "incredible freedom," beautiful, almost copy-free layouts, and a regular showcase where, says Helen Murray, "a photographer could really strut his stuff." After Sozzani moved to *Vogue Italia*, it became "the ultimate showcase" for fashion photography. Sozzani's secret, says a top photographer's rep who prefers to remain anonymous, is that "she's a little bit lazy. She lets a photographer like Bruce or Steven do everything if they do all the arranging. She'll send the clothes, you send the layouts. So she gets something nobody else has. If she has to, she'll say, 'You really have to show this.' A brilliant editor will pick out clothes the photographer will like *and* they really have to show."

The timing of her move was great for Meisel, who'd just broken up with *Vogue* in America. "They considered him too avant-garde," says Sozzani. "In a country as huge as America, of course you have to be careful about the kind of women you represent. In Italy, we have so many fashion magazines" that hers could afford to showcase "the quality and the dream." So as soon as she knew she had the new job, "I flew to New York," she says, and offered Meisel "the cover and the main story every month." *Vogue Italia* would publish pictures Americans considered peculiar and self-indulgent.

Meisel had a good relationship with Sozzani's art director, Fabien Baron, too. "Fabien and Franca were an incredible moment," says a top art director. "Everyone here was scrambling for focus while Europe was stretching the imagination, bringing the sexual underground overground." Because Sozzani's magazine sells less than a tenth the number of copies of its American sister, she could let Meisel take chances. "Nobody can understand," she said with a chuckle. "Condé Nast has given me freedom. I give him freedom." Jimmy Moffat, his agent, thought Meisel gave Sozzani something, too: "Steven gives her, her magazine basically. She appreciates it and lets us

send layouts. There's lots of magazines in New York where that relationship doesn't exist and can't exist, and we don't work for those magazines." Meisel's relationship with Sozzani and *Vogue Italia* continues to this day, though he now only shoots every other cover for *Vogue Italia*.

Meisel kept working with Baron after the latter left *Vogue Italia* in 1988 to move to the United States and open a design studio. With Baron, too, Meisel could do things his way. "Before that, I was just pleasing each magazine and I wasn't happy," he said. His income quadrupled thanks to campaigns for Italian designers such as Valentino, making him even happier. He'd bring a private chef to shoots and brag that he'd made more than $30,000 a day shooting ads, "just for walking in the door."

One door he didn't like walking into—initially, at least—was Anna Wintour's at American *Vogue*. He needed attention. Under the gun to compete with *Elle*, she couldn't give it. He needed time. She didn't have it. She didn't like him much, either. "Steven cops attitude, he doesn't listen, he has no respect," said a *Vogue* editor.

Meisel didn't like her, either. When Wintour suggested Meisel for sittings, he'd decline. "Anna Wintour comes in and destroys the magazine," said Meisel's makeup man Kevyn Aucoin. "He was appalled by her lack of style and her dictum that ugly no style is style. She had a deliberate approach to fashion. She wanted the magazine to be more accessible, to be *Elle*, to sell more. She sacrificed quality for that."

By 1990, Wintour and Meisel were taking potshots at each other in the press. Only one of his stories had run the previous year, and he'd canceled his Condé Nast contract. "There's just not much discussion with him," Wintour told *WWD*. Meisel responded that although "editors scream and carry on," he was opposed to "kissing ass" and being "taken advantage of." Says a top rep, "He ran around saying how much he hated Anna." Not long afterward, he did work for Condé Nast's new beauty magazine, *Allure*, but that didn't last. "Certain photographers forget they are working for a publication with a purpose," said Liberman. "He resented, again, the art director. At a certain point, the needs of the publication have to supersede. I'm too old to pull my punches."

Liberman no longer felt the need to cultivate talent as Alexey Brodovitch had, and he'd squelch it if need be. He hadn't killed Meisel, but the photographer was grievously wounded. Friends worried aloud that he was "depressed

like crazy," developing an ulcer and unable to work. "It just gets so tiresome," he complained. "What I need is freedom."

Like Bruce Weber, Steven Meisel sometimes found freedom shooting ads. One of the most photographer-friendly advertisers was Barneys New York, which had "a rich history of advertising," says Gene Pressman, a grandson of the namesake of what started as a discount men's clothing store and became a premier retailer of avant-garde fashion. Since the seventies, it had hired top advertising professionals to produce clever print and television ads. Then, it hired art director Marc Balet as creative director and advertising executive Neil Kraft as the store's chief marketing executive. "Gene said yes to just about everything," says Kraft, so Balet hired young photographers such as David Seidner and Meisel, who was still so ill prepared, the store had to rent cameras for him. "We ended up in the business of discovering people," says Kraft, who recalls Meisel as a tiny guy who didn't talk much, let his agent speak for him, banned Kraft from his set, and blasted "Gimme Some Lovin'" by the Spencer Davis Group "over and over" at earsplitting volume as he shot hidden behind screens.

Kraft stayed at Barneys through 1991, then went to Calvin Klein, which also hired Fabien Baron to reboot CRK Advertising. In turn, Pressman hired Ronnie Cooke, the senior fashion editor of *Details*, until then America's flagship avant-garde style magazine. The fashion media's game of musical chairs had grown more frantic; Cooke had been *Details'* senior fashion editor until Si Newhouse bought it for Condé Nast and replaced editor Annie Flanders with a former rock journalist, James Truman, who would later replace Alexander Liberman as the company's top editorial executive.

Kraft and Balet brought the Barneys image into the fashion present; Ronnie Cooke shoved it hard into the future with "an original idea of what Barneys was that was very different from the department-store mentality," she says. Its recalibrated image was designed "to stand up against designer brands." Using Steven Meisel and the latest generation of supermodels was one way to do that. Cooke had him shoot Linda Evangelista kissing a monkey, and posing as Lucille Ball with male celebrities, "fun humorous images," Cooke says. "It's a fashion musical, the models become characters."

But then, fashion changed and photography had to follow. "It's a whole language that changes," says Cooke. "I was expected to do that." To demon-

strate that the store was making a clear break with fashion's past, Cooke hired Corinne Day, a photographer who had just emerged from the nursery of Great Britain's ever-evolving youth and street culture. Ever since World War II, it had been a crucible in which music and fashion mixed and spawned cults that spread around the world.

Day was the child of a bank robber and a brothel madam, a former model who'd decided to pursue photography, begun testing in Milan, then returned to her native London. Her break came when she stumbled on a photo of a girl as short and waifish as Day was in what was called the "maybe" drawer at a London modeling agency, the drawer where likely rejects were tucked away. It was 1989. Christy Turlington, Linda Evangelista, Cindy Crawford, and Tatjana Patitz were about to appear on the cover of British *Vogue* in a photo by Peter Lindbergh that would consecrate the so-called supermodel phenomenon. But that meant fashion would soon need something new, and Day discovered it while looking for a girl who would pose for her for free. The girl in the photo was Kate Moss. She would become Day's muse, and several new British magazines would become the vehicles through which she and several other neophyte shooters would change the vocabulary of fashion imagery.

Two independent magazines had been launched in London in 1980 and by mid-decade gained enough traction that Alexander Liberman kept copies on his usually bare desk. The *Face* was created by Nick Logan, a former editor of *New Musical Express*, a publication for pop music fans. Terry Jones, who'd been the art director of British *Vogue* in the seventies, invented *i-D* as a new kind of fashion magazine. Both reflected the mood of London's streets in the years just after punk rock, when style and design replaced unfocused anger as the primary vehicle of personal expression for the chaos of cults that had replaced the monolithic youth culture of the sixties. "The change was in attitude as much as anything," says Jones, who'd fought the formal structures of fashion that ruled at *Vogue*. "My preference was for energy and attitude," he says. "I pushed for an element of fun. The idea [of *i-D*] was to infiltrate the mainstream with a wider vision."

"It all changed in the space of three months," says Dylan Jones (no relation), who joined *i-D* in 1983 and became its editor the next year. A new generation of photographers "reached critical mass by 1985." Day, Nigel Shafran, Nick Knight (who doubled as *i-D*'s photo editor), David Sims,

Craig McDean, Glen Luchford, Stéphane Sednaoui, and Juergen Teller each had a distinct style. "They came from different planets," says Dylan Jones. "Idiosyncrasy became your forte."

The *Face* and *i-D* also championed stylists. They "had no need to reflect designer fashion," says Phil Bicker, who joined the former as photo editor in 1987. Both magazines reflected the streets and their subjects, rather than the commercial dictates of designers and retailers. *i-D* filled its fashion pages with "straight-ups," photos of people with natural style, found on the streets and shot against walls. The *Face* did "unheard of" things such as mixing athletic clothes, Jamaican influences, and Armani, Bicker continues. "It was very out there" but also something "we could relate to."

Arriving at the *Face*, Bicker vowed to nurture new photographers: "Magazines looked to control situations and issued directives everyone would follow. Our idea was the opposite. I wanted to give them a platform." At first, "the world didn't get it" and other magazines "ridiculed it, like, 'What the fuck?'" But then, Corinne Day and Kate Moss came along "and changed things. People stood up and noticed," and soon enough, "they embraced it and made it fashion."

Day came to see Bicker with a few photos of a girl on a street that he thought he recognized. Day had "grown up a couple of miles from me," he says, "we had shared points of reference," and the girl in the photos, Moss, "embodied them." Best of all from Bicker's point of view, "she wasn't Linda, Christy, Tatjana, or Cindy. She was all the things the *Face* was." Initially, Bicker hired Moss, but not Day, for a cover shoot. Then, realizing his mistake, he assigned Day to shoot the model again. Day cooked up an idea with a stylist out of clubland named Melanie Ward to shoot Moss, unadorned, unpolished, and relentlessly anti-glam, on a beach, just having fun. Day asked the sixteen-year-old to doff her top and bare her breasts. "And she remained topless for the next twenty years," says Bicker, who put a shot from the session on the cover of the issue.

When the photos were published in a July 1990 spread, "everyone thought it wasn't styled, it was Kate," says Bicker. "It wasn't. It was set up and staged and redone even though Corinne wanted to suggest it was all spontaneous and real. Really, it was clever and calculating, but the added bonus

was, Kate was real, she was genuine." And thanks to Day, Ward, and Bicker, she became the face of the nineties and its offbeat style and the last great fashion model to emerge on film.

Soon, Moss moved in with Day and her boyfriend and started seeing another young model-turned-photographer, Mario Sorrenti. Sorrenti's posing career had faltered, as Day's had, when he was judged too short as he aged, so he learned to use a Hasselblad. Once he was linked to Moss, his profile rose sharply.

Chapter 42

"YOU KNOW IT'S WAR?"

London was a step ahead, but things had been changing in New York, too. The supermodel moment ran its course; Meisel emerged unscathed. "Steven was Steven before them," says Franca Sozzani. "Now people realize. He made them personalities, not anymore models. They had something. He found it. They trusted him. They played with him and gave him the opportunity to cut their hair, take off their eyebrows. He's never satisfied." So, in 1989, in his most influential move yet, Meisel revived then-forty-six-year-old Lauren Hutton's modeling career in a series of ads for Barneys New York. Before and since, he brought back other sixties and seventies faces such as Peggy Moffitt (who famously posed for her husband, William Claxton, in designer Rudi Gernreich's scandalous monokini in 1964), Veruschka, Donna Mitchell, Wallis Franken, and Lisa Taylor. Meisel's recognition of the beauty of older women won him tremendous—and well-deserved—acclaim.

But still, he was dissatisfied when an interviewer came calling late in 1990: "I'm not having as much fun as I would like to or that I used to. I'm sort of in a transitional period in my life because I don't go out and do drugs and fuck all night long anymore, yet I'm not quite ready for dinner parties." Twenty-five years later, he would still be shooting regularly, working, apparently happily, and raking in big bucks as one of the half dozen most sought-after shooters of fashion advertising. But first, he had to get past one last defining career moment, when he finally put his bad-boy past behind him, accepted the compromises demanded by maturity, and made his peace with the commercial demands of his profession. It was set in motion by the last great upheaval in the fashion-magazine business.

In 1991, the Hearst Corporation approached Liz Tilberis of British *Vogue* about replacing Anthony Mazzola at the helm of *Harper's Bazaar*. That June,

Condé Nast (which had already bought Tilberis a house in London) gave her a substantial raise, and she promised to stay, but in the fall, the talks with Hearst resumed, and the following January she announced she was moving to New York to take over *Bazaar*. She'd already begun assembling the team she hoped would return it to glory, and some kind of parity with her former boss Wintour's *Vogue*. Photographers would be her special forces.

Meantime, Fabien Baron had tired of the grind of constant flying back and forth from New York, where he still worked for Barneys and other clients, to Milan, where he spent about a week a month at *Vogue Italia*, and decided to quit and open a New York design studio with his wife, Sciascia Gambaccini. Baron's next high-profile job was art-directing *Sex*, a porn-ish photo-book collaboration between Madonna and Steven Meisel. Baron was laying it out when Patrick Demarchelier called. "I think there's a magazine," Baron remembers him mumbling. "No magazine is interesting," Baron replied. "The only one I can imagine doing is *Harper's Bazaar*, and it needs a total redo." Demarchelier chuckled. "It's *Bazaar*," he said. "Let's do it. You have to meet Liz. She wants the best magazine in the world."

Baron's response was prescient: "You know it's war with Condé Nast, don't you?" Demarchelier did know; he'd been shooting *Vogue*'s covers, and the loss of his services would be devastating.

Tilberis and Baron met, and she told him she had a contract and was ready to sign it, but wanted the security of knowing who would be beside her. Hearst had promised her the resources to build a world-class team. "Of course, Condé Nast will play hardball," Tilberis acknowledged. "I will, too."

Baron brought a list of photographers to their second sit-down. "We need Meisel, Demarchelier, and Lindbergh," he told her, as well as some younger photographers, and the stylist-editors Gambaccini, Tonne Goodman, and Paul Cavaco.* "She goes tick, tick, tick," Baron says. They got them all, except Meisel, but he was reportedly interested and kept the fashion world guessing for months before spurning *Bazaar*. "We were a single hair away," Baron thinks.

*Grace Coddington, who'd left Calvin Klein to join Anna Wintour's team, turned down her old friend Tilberis's offer of a job at *Bazaar*. She would go into semiretirement at age seventy-four, in 2016.

The battle for Meisel was fierce. "We really wanted Steven back," says a *Vogue* editor. How did they get him when so many of his collaborators had signed up with *Bazaar*? Condé Nast executives made their position abundantly clear: Thanks to his unprecedented exposure in *Vogue Italia*, and Franca Sozzani's abiding loyalty, he'd won advertising jobs worth millions. If he signed with Hearst, that work might melt away. "It was Italian *Vogue*, his relationship with Franca, that killed it," Baron says.

"Italy is a little world," a photo agent said at the time. "Advertisers often come to an editor and ask who they should use if they want a new look. Franca is very friendly with a lot of advertisers. She would say, 'Steven is perfect' and in a sense act as his agent. It's something she believes in. But the Italians are so crazy. One minute to the next, everything changes. It's just in their nature. Certain people would be influenced. And if Steven had gone to *Bazaar*, she probably wouldn't have recommended him anymore. Condé Nast is that powerful."

Franca Sozzani insisted that wasn't true. "That's not my style," she said before Meisel made his choice. "It would be stupid to say, 'I believed for twelve years and now he's bad.'" What if he went to *Bazaar*? "Maybe I'd cry," said Sozzani. "I'd fight till the end." But her feelings were hurt. "I find Steven Meisel myself," she railed, her voice rising. "It's true they are trying to get Steven. It's good to try and get the best, but I supported him when he wasn't Steven Meisel. There are two photographers I love, Steven Meisel and Bruce Weber. I took a lot of risks with both. It's too obvious to choose what someone else has chosen. Find some new photographers! I want to be out of this shit gossip that's around!"

The specifics of the negotiation that followed have never been revealed. "He asked to keep Franca" and work for American *Bazaar*, said the head of a big Italian fashion brand. That wasn't going to fly. A stylist close to Meisel told a reporter that it was tragic "the greatest fashion photographer has no regular American outlet." He clearly wanted one. Condé Nast got the message and made Meisel an offer he couldn't refuse: $2 million to stay with Sozzani and return to American *Vogue*. Within a few months, he was not only back in its pages, but up to his old tricks, too. "We didn't see that film for two weeks after he shot it," a *Vogue* editor confided.

Compromises were apparently made all around. "Many things are forgiven

because he's so good," said Alex Liberman, who correctly predicted that "Complications will progressively iron themselves out through the success of what he's doing." Though they were never as close as he was with Sozzani, Meisel and Wintour's collaboration would continue for more than two dozen years.

The loss of Meisel turned out not to matter much for Tilberis's *Bazaar*. Her first cover, featuring Linda Evangelista photographed by Demarchelier, with a simple headline announcing a new Era of Elegance, was a strongly graphic sensation. The new *Bazaar* immediately won National Magazine Awards for photography and design, and in 1994, Tilberis would be named editor of the year by *Advertising Age*. But in a dreadful twist of fate, she'd been diagnosed with ovarian cancer just a few months earlier, and though she fought the disease heroically and remained a much-admired figure, her staff would be drained by a slow but steady attrition of talent. Demarchelier and Lindbergh remained for years, but *Bazaar* never caught up to Wintour's *Vogue* in either circulation or advertising pages. When Tilberis died at fifty-one in 1999, she left behind a magazine far stronger than the one she'd inherited, but one that would never again generate the excitement that greeted her first few issues.*

Many said the new *Bazaar* harkened back to the days of Alexey Brodovitch, but Fabien Baron wasn't among them. "I didn't know the guy," says Baron, who'd worked for the trade's other influential Russian, Liberman. "When I arrived, I told myself, 'Be careful. You can't go into the archive.' I remembered, but I didn't want to be influenced by looking. Because it was strong, people called it Brodovitch." Baron places himself "smack in the middle" between Liberman, the frustrated artist consumed with commerce, and Brodovitch, who made commercial design his art.

Elizabeth Tilberis's brief tenure at *Bazaar* was the last great magazine moment in the heyday of fashion photography. She and Baron gave shooters such as Lindbergh and Demarchelier a platform for some of their best work ever. For Demarchelier particularly, Steven Meisel's decision to stay at *Vogue*

*After Tilberis was replaced by journalist Kate Betts, most recently the fashion news director at *Vogue*, Fabien Baron left the magazine. He joined Paris *Vogue* in 2003, not long after the stylist-turned-editor Carine Roitfeld took charge of it. He then left to take over *Interview*. After two years at *Bazaar*, Betts was replaced by another British editor, Glenda Bailey, who has held the post ever since.

was a life-altering event. Long a journeyman, he was propelled into the top ranks of photographers by Tilberis's and Baron's imprimatur. Demarchelier was remarkable because he had no recognizable style or signature of his own; what he had was extraordinary competence and the ability to deliver whatever a client, be it a magazine or an advertiser, desired. Among other things, that made him the go-to photographer for reshoots, when a first attempt at getting a picture had failed and no time was left to experiment. Though he remained a lothario—in 2007, he tried to kiss a model he was shooting at the pool of the Beverly Hills Hotel and she pushed him in, fully clothed, with cameras hanging around his neck—his reputation was as a consummate professional. "He could do everything, anything," says model Bonnie Pfeifer. "Not anybody can do that."

Baron had first worked with Demarchelier on a bathing suit issue at *GQ*, and they began a long collaboration. "He's an amazing photographer because it doesn't show," says the art director. "Things fall into place. He doesn't suffer, he doesn't sweat it. You feel, 'This is easy, we'll be out of here fast.' The minute he looks at a girl, he knows exactly where to put the light, what lens to use, what height and what angle. That's sixty-five percent of the job." The rest is interpersonal. "He puts his subjects in the position of feeling so confident, he gets amazing things." How? "He does nothing. He lets things happen, he lets people be themselves, and *clack-clack-clack*, the picture. I've seen what pain other photographers go through to get a picture Patrick can do in two minutes." Finally, Baron compares Demarchelier to a chef. "If you ensure that the environment, the idea, the casting, the clothing, the colors, are great, he'll make the most amazing meal." Left unsaid is what happens when not all those elements are on the counter.

Baron kept his design studio open when he went to *Harper's Bazaar*; unlike journalists, many fashion photographers, editors, and art directors work for both fashion magazines and the designers whom they cover and who advertise in them. "Those days of isolation" were over, Tilberis said at the time. "You have to be out there as a business." The synergy helped all concerned, even if it further eroded already porous ethical boundaries.

At the time, Calvin Klein was "very stuck doing things the way he always had," says Neil Kraft, but Klein's business troubles in the early nineties "opened his eyes. . . . Calvin was sick of the Bruce Weber thing and realized

there wasn't enough separation between him and Ralph."* Separately, Kraft and Baron both take credit for what happened next. Kraft says he mocked up a new collection ad with an image of the French singer Vanessa Paradis, and Klein wanted her as his next contract face. But she'd just signed to model for Chanel and said no, so Kraft called Patrick Demarchelier because Kraft wanted to work with someone "easier" than Steven Meisel. "The rap on Patrick is he doesn't pay attention, but he does. He looks half-asleep but he really concentrates when he's working," and when Kraft asked the "no-drama" photographer to suggest a new face for Calvin's campaign, he mumbled, "Kate Moss. *Fantastique*. I just shot her for *Bazaar*."

Baron says he was looking for a campaign to do with Demarchelier, and they "took Kate to Calvin" after they all did a shoot for the first issue of Tilberis's *Bazaar*. "As we were looking at the pictures, we said, 'What about Kate? She looks a bit birdlike like Vanessa.'" They brought her to Klein's office, put her in his jeans, and asked her to sit on the floor. "Calvin is open-mouthed," Baron recalls. "'Great, great, perfect,' and he's falling in love on the spot, and we went to the studio and took a picture."† Demarchelier was rewarded for his find with more Calvin Klein ads, notably shots of Christy Turlington in Klein's underwear.

Moss had come to New York with Mario Sorrenti. "Part of my plan for *Bazaar* was to give younger photographers contracts to make them feel important," says Baron. "Then on top of that, I make them discovered for advertising. Sorrenti, David Sims, and Craig McDean"—all products of the new generation in London—"I gave each a different campaign so they became blue-chip very fast. I wanted them to work with the big girls for *Bazaar* and with cooler people for ads. Sims said, 'Linda [Evangelista] has nothing to do with me.' I said, 'Do it.' It made the big girls look cool and the young photographers look established."

Baron suggested Sorrenti and Moss shoot the next Calvin Klein jeans and Obsession fragrance ads together. "They're in love," Baron told Klein. "Send

*Weber's "gay under- and overtones" weren't "working as well by then," Kraft says. "He takes ten thousand pictures, five thousand of guys without clothes, and the rest is editing."
†In an odd parallel, Moss would soon start dating the actor Johnny Depp, but would eventually be replaced in his affections by Vanessa Paradis.

them on vacation. No hair, no makeup. Let them do what they want. That's what it means to be obsessed." And Baron said to Sorrenti, "Show me how obsessed you are." Baron recalls Neil Kraft's reaction: "You're fucking crazy."

Kraft insisted on monitoring the shoot after Sorrenti "hadn't shot anything after three days," Kraft says. "Mario said, 'We're chillin'.' I was apoplectic. I spent the next three days getting them to take pictures." Baron was unimpressed with the results: "Nothing was used, not a piece of film." He says he encouraged Sorrenti to keep shooting. "It was Mario's third job!" Finally, a photo resulted of Moss prone "on that cheap sofa," Baron says, recalling, "You can feel the obsession. Calvin loved those pictures. They ran everywhere, over and over, for twelve or fifteen years."

Some of Klein's Moss ads (which also included topless couple shots by Herb Ritts with the model straddling Marky Mark Wahlberg) were controversial. A year later, images of Moss on New York bus shelters and phone kiosks in Calvin underwear ads were tagged by graffiti writers—presumed to have feminist leanings—with "Feed me." Within fashion, Klein and Fabien Baron were accused of being overly inspired by the work of Corinne Day with ads that were "louche and dishabille, a cultivated concoction of glamour and grime," wrote the author Maureen Callahan.

Not long after Klein first met Moss, Corinne Day had *her* big breakthrough when she was hired by Barneys New York. At the same time, the young designer Marc Jacobs showed a notorious collection for Perry Ellis based on the Generation X thrift-shop-bred fashion style propagated in preceding years by the *Face*, *i-D*, and postpunk bands from Seattle such as Nirvana and Pearl Jam. Dubbed grunge, the collection was greeted with contempt by most runway watchers, who were then overwhelmingly from an older generation. Suzy Menkes, the fashion critic for the *International Herald Tribune*, even handed out hospital-green pinback badges with the slogan "Grunge is Ghastly." Jacobs was fired from his job. But this watershed moment foretold a generational change in fashion and the embrace of a new aesthetic. The supermodels were already peaking and would soon be replaced by a pack of newcomers dubbed waifs, led by Moss. Jacobs would go on to his own label and two decades of considerable influence. Until that moment, their challenge had been issued from the fringe. But as with so many youth-bred movements of the past, it was on the cusp of mainstream assimilation.

"We were literally just getting dressed to go out and photograph each other," says Caryn Franklin, who bought her first copy of *i-D* as a design student and became its fashion editor in the mideighties. She thinks of the magazine as "the Facebook of its day," but also as "the antithesis of everything" and aimed at people "who looked and sounded different. It was all about personal identity, standing for something and communicating it by making yourself highly visible. We'd never heard the word *brand*."

Franklin saw the photographers she worked with as pioneers, but watched with dismay as some quickly became "thoughtless facilitators of a brand message that was tasteless." As their careers progressed, "I didn't see individuality. I saw the hypersexualization and infantilization of women and gender stereotyping, and nobody could get the energy up to complain. These creatives were giving a voice to something with its own energy—work that had a diary feeling, a hard-copy Facebook—that the corporate world bought into. Calvin Klein recognized that self-disclosure and the pretense of an artisanal approach had a cool factor. You can't decide to be cool, but you can be attracted to it. So all designers had to go to London and hang out, and they saw the photographers who we featured and realized that to revitalize their offerings, they needed our attitude because they had none. So they appropriated London."

Ronnie Cooke followed *i-D* and the *Face* and spotted Corinne Day's photos. Cooke found them a perfect fit with the evolving fashion image of Barneys and brought Day in for a meeting. "She came with her grandmother, not an agent," Cooke marvels. Gene Pressman was dubious. "I said I really believed this was the future," Cooke continues. "We needed to go antifashion."

Cooke and Day became fast friends, talking on the phone regularly as Cooke introduced her to the gritty documentary photographers Nan Goldin and Larry Clark, "and to the idea of art photographers being relevant to fashion," Cooke continues. "We straddled the fence between fashion and art. It's pretentious to say, but we mirrored pop culture, we reflected New York, we were ironic, it was entertainment, it was something different. I had no one saying no, so I was interested in what hadn't been done." Corinne Day was that. "The work was very personal," Cooke says. "The hard thing was, she'd only photographed things she found in vintage stores. She didn't do

credits. We had to pick clothes that worked with her voice yet represented Barneys. It took two months of talking and talking and talking—for a very minimal thing."

Sadly, Day's Barneys ads—collected in a booklet of images floating on matte white paper—may have been the high point of her career. Though she was bitter that Calvin Klein had booked Moss without her, the duo subsequently shot a British *Vogue* lingerie spread together "and it just about killed Corinne's career," Maureen Callahan reported. The slice-of-life photos accentuated Moss's gaunt frame and were assailed as perverted, freakish, and squalid. Moss was advised to stay away from Day, who rationalized the loss by saying that once the model realized she was beautiful, she lost her appeal. Moss went on to have one of the longest and most resilient careers in modeling, despite regular dips in the pool of tabloid scandal. Day wasn't so lucky.

"Corinne was made with her anger and destroyed partly by her anger," says Ronnie Cooke.* "She shouldn't have done campaigns. She was so difficult. She was unmanageable, out there. If you said black, she'd do white. We got along, but I'd say, 'I'll smash your camera on your head if you don't start taking pictures.'"

In the next few years, others would imitate and exploit Day's visual signature while she pulled away from fashion, instead pursuing a London grunge band and photographing its members and entourage. In 1996, she had a seizure while shooting them and was diagnosed with a brain tumor. Upon her release from the hospital, Day began taking heroin, a habit that spread widely among the young in the fashion world in the midnineties.

Ever ready to apply a label, fashion dubbed *that* trend *Heroin Chic*.

*Cooke subsequently worked briefly for Calvin Klein, then moved to London, where she married Condé Nast International's chairman and CEO, Jonathan Newhouse, a cousin of Si Newhouse's, and opened a luxury-fashion advertising agency.

Chapter 43

"TO CREATE SENSATION"

It's generally thought that Steven Meisel rarely, if ever, took drugs, but he did take cues from the rising grunge culture, and in summer 1995 he and the rest of Calvin Klein's creative team paid dearly for that. While using him at Barneys, and working with him regularly at *Vogue Italia*, Fabien Baron fell head over heels in love with Meisel's photography. "He can do it all," Baron raves twenty-plus years later. "He's an encyclopedia of fashion. He knows everything and everybody. He's an archetypal fashion photographer, the king; he knows hair, makeup, styling, clothing, better than anyone. He's got it all down and there's a mystique about the guy." Baron also admired Bruce Weber, but for different reasons. "He's a king as well, but of American culture. He owns the American lifestyle. I don't think he's a fashion photographer; he's a chronicler of Americana, and he's totally obsessed with people. He searches people's souls. Meisel is obsessed with fashion. He is fashion. It's very different."

Baron was in awe of Meisel's technique: "He builds a picture a piece at a time. The girl gets dressed, has hair and makeup, then he works with a pose, stops, and studies it very carefully. He'll remove objects from the background, then put the girl back on the set. Now, change her hair. It's too flat. Make it bigger. Lower the powder. Give it more shine. He directs to perfection. Twist the pinkie. Grab the chair more delicately. Lift the index finger. Almost ready. See that fold in the dress? We don't want that. Put the light back on. Click. We have it. Next! Fucking thirty years of working with him and I've learned, when he says move this way, it's better."

Though the art director says Meisel "was able to remove himself from Avedon" by the time they met, Avedon's graphic group portraits from the late sixties and early seventies inspired one of their first collaborations for

Calvin Klein, a 1994 series of ads and commercials for the ck one fragrance that included both models, among them Kate Moss, and "a bunch of people on a white background, so they are who they are," Baron says.

The next year, after Meisel did a shoot for *L'Uomo Vogue*, seemingly inspired by the aesthetic of seventies porn sets—complete with cheesy wood-paneling and toxic-colored carpets—featuring boys seemingly in their teens dressed only in underwear, Klein and Baron cooked up a similar campaign for the ck clothing line, of transit, print, and TV advertising aimed at young fashion customers.

"At that time, I was really into David Sims, a young, reality-based photographer," Baron says. "I wanted things to be so real it felt off the mark. I had a great sense of wanting to be in your face, and I came up with the idea of castings. Every time I did a casting, the people would come in and be so fucking awkward, and then they'd go away and you'd never see them again. The moment was so vulnerable. So I said, let's do a casting as if it was for a sex movie, but take pictures of it. We started casting kids who looked cool. Not on a set, in a room just for them, something cheap and common—and then they realized, 'Oh, there's a camera.' Of course, I was looking to create controversy. I liked the idea of putting these kids on the spot, so we made a list of questions and had a guy from a porn channel come interview them."

Aspirants were first gathered in a room together, then called onto Meisel's closed set, one at a time. "They stood against a wall and a camera was rolling," Baron continues. "They came on the plateau and, bang, took it on the face. 'So how old are you? What do you like to do? What are you wearing? Oh, jeans? Can you lower them for us? That's a nice T-shirt. Can you tear it for us? You're an actress? Have you ever done sex on film? What do you do when you're alone in a room? You march?' 'No, I mosh.' 'What's that? Can you show us?' We put them on the spot and we're filming everything." Then they were sent back to the room with the other models, ensuring "the next would be even more nervous," says Baron. "And that was the commercial."

Calvin Klein was used to controversy, but even he was taken aback by the reaction. Though the team knew what they'd done was "borderline," Baron says, they were sure "it was nothing major, but then [someone] realized one kid was seventeen." A few television stations rejected the ads, and after

they'd run for just one day, word got out and critics pounced, denouncing the ads as kiddie porn. Within two weeks, despite Klein's feeble protest that he was being misunderstood, the campaign was killed. In September, the FBI announced it was looking into the affair; it cleared Klein two months later. "It was not fun, it was intense," says Baron, who departed.

A few years later, Klein's basement porn campaign would win first place on an *Adweek* list of the "most offensive, most tasteless and downright dumbest ads" of the preceding decade. Nonetheless, Klein doubled down in 1999 with a campaign showing children dancing in underwear on a sofa; it, too, was quickly withdrawn. After Klein and his business partner began exploring a sale of their company the next year, he stopped pushing advertising hot buttons. Three years later, the company was sold, Klein stepped back from designing, and the career of one of fashion imagery's great patrons came to an end.

In years to come, Steven Meisel would do his best to take on Klein's title of fashion's provocateur-in-chief. His laissez-passer from Franca Sozzani and *Vogue Italia* let him cross the traditional boundaries of good taste and explore realms of socio-cultural expression in a way not seen since Avedon's portraits of upper-class anomie and Andy Warhol's Factory set.

The fun began in 2005 with a story called "Makeover Madness," mocking the craze for plastic surgery, Botox, and liposuction. In September 2006, a portfolio called "State of Emergency" showed a model being stopped and frisked by police, a pretty face jammed against a car windshield, a body being thrown to the street next to a spilled Starbucks coffee cup, a blonde in a bra being wanded at a TSA checkpoint, and a model on her knees in front of a cop with a billy club and another with a barking dog. Where Chris von Wangenheim's similar photo portrayed chic menace, Meisel's version was a slick cartoon, undermining its presumable intention: commentary on the post-9/11 police state.

The next year, Meisel took on rehab culture with pictures of out-of-control models, one with legs splayed wide in a limousine, another shaving her head à la Britney Spears, and, presumably later, committed and strapped down to a hospital bed, engaged in talk therapy, plunged into bathtubs, throwing fruit around, doing yoga buck naked, and just looking like models, albeit under lock and key. "Girls treat rehab like a spa, which I thought was funny," Sozzani told a reporter.

That fall, *Vogue Italia*'s dynamic duo took on the occupation of Iraq in a spread called "Make Love Not War," which showed bare-chested models cavorting with similarly exposed soldiers in desert tents, fighting them on sandy ground, arm wrestling, and lying in what appears to be precoital expectation and postcoital bliss—a typical desert-warfare maneuver. England's liberal *Guardian* newspaper called them "the most nauseatingly tasteless fashion pictures ever."

A 2012 spread entitled "Haute Mess," featuring models wearing brightly colored, determinedly trashy clothing, multicolored hair weaves studded with candy-bar logos, exaggerated makeup and false finger- and toenails, attracted accusations of racism, despite the fact that Meisel and Sozzani had, four years earlier, collaborated on a "Black Issue," featuring only black women. And the *Deepwater Horizon* oil spill inspired a twenty-four-page 2013 spread called "Water & Oil," which turned model Kristen McMenamy into an oiled-up and endangered loon bird on a despoiled shoreline.

What did Meisel think he was up to? He'd answered in a rare interview in 2009: "Clothes are such shit now. We've become a world of H&M. . . . You have to be eye-catching because there are so many images out there. You are inundated all the time, whether it's on TV or the Internet, buses, bus stops, taxis, or billboards. I guess the only way to get people's attention is by trying to do something outrageous."

A few years earlier, in February 1997, Calvin Klein's kiddie-porn ads were still on people's minds when the last great controversy engendered by twentieth-century fashion photography burst into view. When Mario Sorrenti's younger brother, Davide, who was starting his own career behind the camera, died after an apparently accidental overdose of heroin and Percocet, the fashion business was castigated for its embrace of heroin chic. Though the term actually predated its fashion moment, it came into vogue alongside Corinne Day and Kate Moss in 1994 and became a big stick hitting the garment trade in 1996 when presidential candidate Bob Dole lashed out against the fashion and entertainment industries for promoting drug use. Three months after Sorrenti's death, the term landed on the *New York Times*' front page, and a day later, President Bill Clinton—who'd previously called out Calvin Klein's porn-chic ads—picked up the cudgel. "The glorification of heroin is not creative, it's destructive," Clinton said.

Though she came from the culture that put heroin chic on the public agenda, Caryn Franklin was appalled by it. "Self-disclosure, in order to create sensation, became more and more dramatic and personalized for shock value," she says. "There are certain things you *don't* tell people. Heroin chic was the exposure of the psyche as dark and grim as it gets, but fashion mistakenly thought it had currency" and revealed its "inability to recognize the boundaries of what is distasteful. Fashion invested it with the cool factor and that's entirely irresponsible. At that point the fashion message was appropriated by brands and huge corporations looking to engage through shock tactics and not from a position of integrity. The photographs were no longer personal statements made for a small, niche market. Mass media widely broadcast to willing consumers who've agreed to follow fashion is a different matter, so fashion should care where it leads."

Whether fashion cared is open for debate. But it promptly turned its back on heroin chic. In a follow-up to its front-page article, the *Times* presciently predicted that fashion photography would return to its traditional tools: glamour, sex, and fabulous elegance. "Fashion is based on a whole series of quick about-turns, going against everything that's there," said Nick Knight, the photographer who briefly served as the photo editor of *i-D* in 1990, before starting to take pictures again for British *Vogue* in 1993. "There's no point in doing anything that exists already. So the only way for me to get back into fashion was to have a mainstream vehicle for my work." His comeback shoot was called "Glam Is Back" and plundered the work of Helmut Newton and Guy Bourdin, even using Newton's ring light. "It hit a note just at the right moment," Knight continued. "All of a sudden makeup and hair products started selling again. It was such a pro-fashion-industry step." Says Phil Bicker, "It was a real statement: we want to take control again."

Then, a moribund Italian label, Gucci, hired a new creative director, Dawn Mello, and in 1990 she brought in a new designer, Tom Ford. Four years later, he hired Mario Testino, a charming and socially smooth Peruvian photographer based in London, to shoot the revived brand's advertising. Testino had been working with a half-French former model and stylist, Carine Roitfeld, for years, and the ads they made for Gucci, which revived and updated the expensive and hard-edged eroticism of the Studio 54 era, made fashion folk feel good about themselves again. In 1999, Calvin Klein

hired them to create a campaign, and two years later, their conquest of fashion was affirmed when Roitfeld was named editor of Paris *Vogue*.

Ironically, the return of glamour opened the way for another wave of down-market innovation. Just after Knight's *Vogue* debut, another fringe fashion fanzine appeared in London, beginning its life in poster form. Phil Poynter moved to London in 1992 at eighteen after growing up reading the *Face* and *i-D* and spending a summer assisting a photographer from his hometown named Marcus Piggott. London's economy was depressed at the time, creating "an open playing field for people without a place to express themselves," Poynter says. He met Jefferson Hack and a photographer named Rankin Waddell in a West London bar late that year, and they "had the idea of starting a magazine together," he says, after Rankin (as he is known) published one called *Eat Me* using the resources of a student union publication he edited. "He'd photographed London's coolest people naked and published it without the student union knowing," Poynter says. "We realized, we can do this."

"We felt quite young and like no one would ever employ us," says Katie Grand, then a fashion student and Rankin's girlfriend. "We were really ambitious but we had no strategy, no logic. We thought we could be the next *i-D*. We were the next generation." Their magazine, *Dazed & Confused*, was first published sporadically, "whenever we could afford to," Poynter says. "We ran clubs to fund it. Our aim was to give ourselves and our friends a place to produce and publish work."

Dazed & Confused had no plan, but it had a motivating principle based on collaboration, with its journalists, stylists, and photographers working together to realize "concepts rather than straightforward pictures," says Grand. Adds Poynter, "It wasn't about a girl in a dress or a fashion movement, which all those guys, Fabien, Mario, and Corinne, did brilliantly. It was about an idea that wasn't directly related to clothing or selling a lifestyle."

They put Grand's upstairs neighbors, Piggott and Mert Alas, a stylist, together and created a fashion photography team. Like Grand, they were "interested in challenging images," she says. "It did feel like we were heavily referencing Bourdin and Newton as a reaction to David Sims, Corinne, and Craig McDean. Mert and Marcus would never let it go. We could've plundered Bourdin until the cows came home."

By the late nineties, the *Dazed & Confused* photographers were winning high-profile advertising assignments, just as the *i-D* crew had a few years earlier. Simultaneously, digital photography was moving slowly but steadily into the mainstream. Though Photoshop software for manipulating images had first been sold in 1987, the photographic team of Inez and Vinoodh began using it to manipulate fashion images only in 1994, and the first digital cameras designed for professionals were introduced in 1995. It would be eleven more years before Nikon would discontinue most of its film cameras. In the meantime, the avant-garde of fashion imagery embraced digital, and inevitably it conquered the business. By 2002, *Dazed & Confused*, with its focus on hyperreal, conceptual images, would find itself in the digital vanguard. "Photograph a girl and drop in a background!" says Poynter, who became a full-time photographer himself.

Chapter 44

"ALL YOU SEE ARE HANDBAGS"

The fashion-image business had split in two at the turn of the millennium. On one side were the star photographers *Women's Wear Daily* had once dubbed the Supersnappers: Meisel, Weber, Demarchelier. On the other were those it memorably described as Whippersnappers—younger (and less expensive) talents such as Steven Klein, Dewey Nicks, the Sorrentis, and Corinne Day—who worked for "little magazines like *Purple* and *Self Service*" that "started as art projects and grew into an underground labor of love," says an even younger photographer, Cedric Buchet. He started at *Dazed & Confused* and soon found himself shooting for *Vogue*s and *Elle*, but "at the time, it was cooler to do the really cool ones and everyone gets to be creative, and you know what? The big magazines didn't pay either."

The advent of digital photography encouraged the collaborative spirit championed by *Dazed & Confused*. Where photographers could once exclude editors or clients as they tested film and lights, send them home while film was being processed, enjoy the thrill (or suffer the agony) of discovering what they'd shot when it emerged from the lab, and then choose which images they'd share, now the shutter clicks and an image instantly appears on a screen that everyone in the studio can see, critique, accept, or reject. More crucially, perhaps, digital photography transformed the art into a new kind of computer-generated illustration. "It is generally understood that you can only photograph what you can see," Robin Derrick, the former creative director of British *Vogue*, wrote in his introduction to a book of digital fashion photographs. "Digital technology means this is no longer the case. . . .

Pictures can be seamlessly altered, blended and mixed together. . . . Extraordinary mind games are being played."

"Photography is now a huge industry," says Ronnie Cooke Newhouse. "You have eighteen to twenty people on a set, the photo team, the digital team, the behind-the-scenes video team, the in-house retouchers before the proper retouchers, and you're doing it all at the same time. It's a different kind of creativity. But it's no less creative."

To many, the advent of digital photography marked the end of an era in fashion photography. "It's perfectly beautiful if you call that beautiful, which I don't," sniffs Denis Piel, a *Vogue* shooter from the nineties. "It's not sexy. It's plastic. It's not appealing." Melvin Sokolsky considers digital "hugely important," but don't take that as a compliment: "Every schmuck on the street with an iPhone is taking pictures of themselves, and it can't come out bad because there are apps to fix everything. The tools have become more important than the idea." Sokolsky says he cares about "a person's vision, not the mechanics of photography. Photoshop can make you proficient; it can't make you see." Digital "is a fantastic fucking tool, but it's being used wrong." Fashion magazines are "laughable," he concludes. "The girls are so retouched it's not a photo, it's an illustration."

Many photographers, such as Steven Meisel, accepted the inevitable and changed with the times. "He mastered it early and never made his work look digital," says Ronnie Cooke Newhouse. Bruce Weber, on the other hand, never bothered: "I don't use digital; I still shoot film. It's the way I started. It's what I'm most comfortable with. I like film. I like the way it feels when you load it. I buy my friends old cameras like Rolleiflexes and Leicas."

The advent of digital coincided with a turning point in fashion. "Stores were merging, discounters were rising, magazines were growing troubled, there were fewer places for new photographers to work," says Joey Grill. "Where you used to get five days to shoot a story, you got three. The bean counters at all levels were getting more power than the creatives. The business affairs offices of magazines were clamping down on creative excesses, and certain photographers were able to deliver campaigns and images that sold merchandise. They understood how to sell."

At the same time, a handful of luxury companies such as LVMH (the

initials stand for Louis Vuitton–Möet Hennessy), Richemont, and Kering began expanding, swooping up fashion, jewelry, watch, luggage, textile, and spirits brands, and flexing their muscles in the marketplace and the media in a way only a handful of supersuccessful designer firms such as Giorgio Armani and Polo Ralph Lauren had been able to do before, demanding and receiving favorable coverage from fashion magazines. The breakdown of the traditional lines between editorial and advertising pages became so extreme that at times the same photographers shot the same garments in the same settings and on the same models for both editorial and advertising pages that ran in the same magazines. Reporting the truth about image merchants had never been a high priority for fashion magazines; in this new environment, it became impossible. Naked emperors cowed trembling editors desperate to hold on to their jobs.

Carine Roitfeld left French *Vogue* after a decade to start her own niche magazine. "Ten years, it was a hell of a lot of fun, but toward the end, it unfortunately got less and less fun," Roitfeld said. "It's all about money, results, and big business. . . . Today's fashions don't let people dream as much as they used to. . . . If you look at advertisements these days, all you see are handbags."

Creative directors held on to their jobs by becoming ever more conservative. "You have to use Lindbergh or Demarchelier, a known quantity," says Neil Kraft, "because the clients have so much money riding on a shoot, it's unkillable. It's a function of working for companies rather than individuals of vision." Magazines had problems of their own, unrelated to fashion. The rapid rise of the Internet in the midnineties; increased paper, printing, and mailing costs; and shrinking advertising revenue squeezed the life out of them and caused editors to turn their attention away from journalism and toward brand management. The failure of grunge to capture the imagination of traditional fashion consumers meant that the pretty waifs and wan, unmemorable blondes who followed the supermodels onto fashion runways and in photo studios would have a particularly short moment in the sun. Since they no longer sold magazines in sufficient numbers to satisfy the bean counters, by the end of the decade they'd mostly been replaced by celebrity faces. Oprah Winfrey became a newsstand sensation. *InStyle*, a celebrity-fashion hybrid, was the "hot book" of the moment. The

red carpets at entertainment industry events became (and remain) more important than runways as venues for the promotion of fashion products. Fashion shows became celebrity petting zoos.

The merger of fashion and entertainment was sealed in the late nineties, says former model and journalist Dana Thomas, author of *Deluxe: How Luxury Lost Its Luster*, when Bernard Arnault, the CEO, chairman, and owner of LVMH, installed young designers atop many of his labels: Alexander McQueen at Givenchy, John Galliano at Christian Dior, Marc Jacobs at Louis Vuitton, Michael Kors at Céline, and Narciso Rodriguez at Loewe. "Their mandate was not to make clothing, but to make noise," Thomas says. By dressing celebrities and putting them in ads, in magazines, and in the front rows of their shows, the brands would "sell high-profit items—bags, perfume, sunglasses, scarves—many of them covered in logos. During the dot-com boom, the middle-market consumer emerged. They had money and spent it on themselves—not couture or prêt-à-porter, but Gucci shoes, Chanel sunglasses, Dior handbags, Hermès scarves. Those items were cash cows."

Problem was, the arrival of celebrity diminished creativity in fashion photography. "Models don't outshine the products," says Thomas. Celebrities were products themselves and came complete with "reams of people, contracts and riders. They're really high-maintenance and it became really tricky. They want to appeal to the middle-market consumer as well. Photographers' hands were tied. Their pictures had to jibe with the celebrity's image. There was major retouching. It was embarrassing. It wasn't photography anymore. It was computer-generated imagery. Everything got homogenized and sanitized and it sucked the soul out of fashion photography."

Fashion's morph into entertainment had other repercussions. Trends, too, became commoditized. True luxury goods were cheapened both literally and figuratively; prices rose and quality fell; aspirational goods spread far and wide; less expensive diffusion lines and secondary labels gained in popularity, diluting designer exclusivity; and "fast fashion" brands from Abercrombie & Fitch to Zara grew in importance, attracting consumers by offering dozens of wear-it-twice fashion items for the price of a single luxe-label investment piece.

The dot-com crash early in the twenty-first century made fashion's image-mongers tighten their belts even more. As income disparity rose in

the years that followed, fashion consumers became ever more stratified. That opened up opportunities for niche magazines, but forced those with large circulations to think even harder about "packaging" their editorial "content" to both pander to lowest-common-denominator readers and reflect the values and serve the needs of advertisers. "Intensely image-conscious companies, public or otherwise, are so intent on controlling how they're perceived, advertising has simply become too safe," Lisa Lockwood wrote in *WWD*. "And safe equates with boring."

Aside from the three superstar survivors, Demarchelier, Weber, and Meisel, a few photographers prospered in the new environment, none more so than Carine Roitfeld's favored lensman, Mario Testino. SuperMario, as he is sometimes called, started his career—after several years of hard partying in his hometown of Lima, Peru—by moving to London, studying photography, and becoming an assistant. A chance encounter with a British *Vogue* stylist led to his first fashion assignment. Grounded both by a conventional Catholic upbringing and a long-term relationship with his Brazilian business and life partner, Jan Olesen, Testino became a master of the politics of fashion (clicking the portraits link on mariotestino.com brings up a shot of him photographing the all-powerful Anna Wintour, the only person besides the late Princess of Wales with a dedicated page of portraits on the site). "He yes'ed everyone and gave them what they wanted," says the owner of a top modeling agency. Testino also embraced the role of court photographer of the new fashionable society, the royals, actors and musicians, designers, artists, and business folk—performers all—who make up today's commerce-driven simulacrum of A-list society.

Testino is represented by his brother Giovanni, whose firm, Art Partner, has become a force in fashion photography, representing, among others, Terry Richardson, Mario Sorrenti, Mert Alas and Marcus Piggot, Cedric Buchet, Steven Klein, and Glen Luchford, as well as some of fashion's top stylists. "Fashion photography became portraiture, and the person who put [sic] that is Mario, my brother," Giovanni says. "You can't see fashion today without seeing a celebrity—who did that? I don't know if he did, but we were there. We started to be bored of models and started to shoot incredible people." It all made Mario Testino as much a celebrity as his subjects. "You can't be a fashion photographer today without being comfortable in

the spotlight," his brother concludes. And they can't just be photographers anymore; they have to manage their own brands and social media empires, just like the very latest crop of celebrity models, Internet-savvy beauties like Kendall Jenner, Karlie Kloss, Gigi Hadid, and Cara Delavigne.

Not all photographers could adapt. By the late nineties, Corinne Day was deeply involved with her druggy musical set, which she was chronicling for a Nan Goldin–ish book, *Diary*, published late in 2000. But it hit after its style and subject matter had fallen out of fashion—which ironically sent the ailing Day, who'd had cancer surgery that slowed but didn't stop the disease, back to the fashion world seeking assignments few wanted to give her. As Day's illness accelerated, Kate Moss reappeared to support her first champion and raise funds for her care. Day also changed her style in jobs for British *Vogue*, Hermès, and Cacharel. "Almost overnight, rawness was replaced with refinement," the *Independent* commented in her obituary. "It was a natural evolution." But her last-minute pivot couldn't halt the inevitable or alter the legacy based in her groundbreaking photos of the nineties.

Corinne Day died at forty-eight in summer 2010. Kate Moss, by then a multimillionaire, attended the funeral, held in the backyard of Day's rented cottage in Denham, Buckinghamshire. "What I found interesting was to capture people's most intimate moments," Day once said. "And sometimes intimacy is sad." Day's unrelenting honesty could be seen as the antithesis of fashion—which lies for a living. But fashion's capacity to adapt to, and even celebrate, a vision such as hers was a clear demonstration of its plasticity and an unexpected underlying generosity.

RETURN TO TERRYTOWN

Terry is my revenge.

—BOB RICHARDSON

Rockville Centre isn't a fashionable place. A landlocked suburban village situated just above the south shore of Long Island in the heart of Nassau County, it is a forty-five-minute commute by train to New York City, but a world away from the vibrant metropolis. It is also the site of the sixth-largest Roman Catholic archdiocese in the United States, supported by a large, vital Irish Catholic population.

Terry Richardson's photographer father, Bob, was born in Brooklyn in 1928, the son of an Abercrombie & Fitch executive, but he, his parents, and five siblings moved to Rockville Centre, where Bob attended the St. Agnes Cathedral School, which he recalled as a *Lord of the Flies*–like breeding ground for menacing bullies. An older brother was an athlete, while Bob favored artistic pursuits after his parents gave him a painting set and easel one Christmas. Bob was also bisexual; he discovered that at age thirteen, when he got his first blow job from a man and never went to confession again.

Richardson transferred to South Side, a public high school, in ninth grade, stopped painting, and decided he'd become a designer of everything from cars to clothing. Richardson was scorned by his classmates when he started taking drawing classes at Manhattan's Art Students League, but he'd seen that escape from suburbia was an option. "Being an outsider—a maverick—a rebel—became my life," he wrote years later in a series of autobiographical sketches. He recalled losing his virginity at seventeen in a "fast and furious" gang bang.

As World War II was ending, Richardson enrolled in—and flunked out of—the Parsons School of Design, then switched to a graphic design program at the Pratt Institute. He earned spare cash designing fabrics and spent it wooing his sweetheart. In 1950, he was drafted and sent to Korea, then won a discharge, claiming to be gay. Back at home, he married his girlfriend and childhood sweetheart at St. Agnes Cathedral ("two young adults making a serious mistake"), moved to Greenwich Village, and worked as a textile designer ("the worst designer in the world"), an illustrator, and a Bloomingdale's window dresser. He developed mental health problems, tried suicide (the first of four attempts), and was committed to Bellevue Hospital.

At various times, Richardson said several of his siblings had serious mental issues, that he was diagnosed as a paranoid schizophrenic in 1950 and again in the late sixties, and that he suffered memory lapses, blaming them on electroshock treatments. He also claimed that he discovered his wife had a drinking problem and divorced her while she was pregnant with their daughter.

In the midfifties, Richardson went to California, where "a friend gave me a Rolleiflex," he recalled. "He told me I had no patience but I could paint with the camera and get done in five one-hundredths of a second" what might take a painter days to accomplish. When Richardson saw his first picture—of a café table with a bottle of red wine and a burning cigarette in an ashtray—"I knew he was right," Richardson said.

He returned to New York, where he got a job assisting photographer Richard Heimann, husband of the model Carmen Dell'Orefice, and learned darkroom and lighting techniques. He said both that he got fired and that he quit ("I told him to go fuck himself," he wrote. "I had learned all I needed to know"). He'd decided to become a fashion photographer himself, even though "I hated fashion," because "I liked photographing women." He wasn't in it for conquest, though; he wanted to be an artist.

He met a stage actress, dancer, and amateur photographer, Norma Kessler, who was working in the chorus at the Copacabana and dating jazz musician Gerry Mulligan; she'd become Richardson's second wife and regular stylist. "When he got an assignment, they would discuss it all night," their son, Terry, recalled years later. "He would bounce everything off her. They'd just drink wine and smoke a joint and he would be, like, 'How do I do this

story?'" Norma took Bob to museums, foreign films, and downtown parties. She reinvented him visually, too, swapping button-down shirts and loafers for cowboy hats and scarves.

If anything got him going, it was *Harper's Bazaar*. "It was the greatest magazine in the world," and through it, he thought, he could "create my own style." Marvin Israel had just become the magazine's art director, and "I decided I had to seduce him," Richardson remembered. He'd met models through Heimann, among them Mary Jane Russell, Dovima, and China Machado, who posed for him in bed with a boyfriend. Richardson showed Israel that photo, and "he threw it across the room and said, 'Why do I need you?' He asked me to photograph my own life."

"That really clicked for my dad," Terry Richardson said. "It's basically making every image you do a self-portrait. . . . That's why I think so many of my dad's pictures are so emotionally intense. The mood is so heavy you can feel it. . . . It's about my father's true feelings."

Bob returned with a photo of another model "lying on a couch in tears, talking to a psychiatrist," he said. Israel approved and, quite unexpectedly, offered him an assignment for a special section conceived to attract children's fashion ads. Richardson took two kids to Coney Island and shot them sitting on rocks, smoking Lucky Strike cigarettes in the rain, which won him his first location trip with "an editor as crazy as you are," Israel told him. The ill-fated trip to Spain with Deborah Turbeville was designed to yield six pages. "I ended up with fourteen," Richardson boasted, as well as a scandal. "We battled our way across Spain," he recalled with pleasure. *Bazaar* "didn't get any ads," he adds, "because the pictures were so weird." But Israel kept giving him assignments.

Richardson was sure Richard Avedon was watching: "When I started at *Bazaar*, Avedon almost had a nervous breakdown. I knew the only way I could succeed was to give him one. He was out to eliminate me if he could. He'd see my prints, and the next day he'd do the same picture." One day, the buzzer went off at the Richardsons' apartment-studio on West Fifty-Eighth Street and "upstairs come China and Dick, both drunk as skunks. I knew he had to get bombed to confront me. He said he wanted to see the studio where all these wonderful pictures were taken."

Judgmental, ambitious, competitive, and hypercritical, Richardson wasn't

easy to deal with. "I never did anything more than try to take beautiful pictures, but it was my way or no way," he said. "I'd ask art directors, 'Why did you hire me?' 'I love your work.' 'Then sit down and be quiet.' I was way ahead of them and I knew they'd never catch up. It was not my job to educate them."

Of his penchant for shooting out the open doors of helicopters while an assistant held his belt from behind, he said, "Danger fascinated me." That applied to professional relationships, too. He proudly recalled ruining clothes by shooting them underwater off Acapulco, and throwing fashion editors off sets, giving *them* nervous breakdowns. "I'm told you're a genius, but I don't see it," Charles Revson, owner of Revlon, told him. "Get your eyes examined," Richardson snapped.

In 1965, he met his muse, model Donna Mitchell, and formed a personal and professional partnership; they were both committed to pushing the limits of the acceptable. "We caused one scandal after another," Richardson said proudly, "all planned and rehearsed. I could have told her to jump off a building and fly and she would have done it, but there was only going to be one take. We had more pictures killed than any photographer in the history of photography." Richardson blamed the sex in his images: "There was no sex before the early sixties. There were models who looked like they had zippers on their pussies, rigid girls with long necks, beautiful posture and no cunts." He vowed "to break that down."

Like Bert Stern's, Richardson's ambition sent him reeling into drug addiction. A year before he met Mitchell, a model introduced him to amphetamine-laced vitamin injections. "We'd get stoned and she'd give me a shot," he said. She took him to see the Dr. Feelgood Max Jacobson—"We called him Jake"—and Richardson became "one of his star patients," Richardson boasted. "I never thought about what I was doing. I only had time for ideas," and Dr. Jake's shots "forced my mind to go faster. He taught me to mainline and gave me the works"—prescriptions for hypodermic syringes.

After each injection, Richardson would stay awake two or three days. For three years, Jacobson steadily increased the doses. "I was black-and-blue from my knuckles to my shoulders," said Richardson, who also got shots in the back of his neck, between his ribs, and in his spine. He wasn't thinking about his career. "I never had a career," he claimed. "I never wanted a career.

My trouble was, I wanted to be great, a legend, not famous. Anyone can become famous. I worked myself into a state where, without speed, I wouldn't have been able to work."

Drugs also infiltrated his pictures—and he was convinced no one knew: "I'd photograph models smoking joints for Paris *Vogue* and *Bazaar* and they'd think it was cigarettes. They didn't understand the look, the scene. I was at least ten years ahead, feeling isolated and not understanding why people were so slow to realize that something was happening on the planet—not in the stupid little fashion business, but in the whole world." More than once, he jumped on a runway "and made a hasty exit" from a fashion show, he remembered. "It was so stupid and boring."

In the midsixties, just after he and his second wife had a son, Terry, Bob was hospitalized again. Manic, he'd gone to Jacobson for a shot and instead been given Thorazine, a tranquilizer. He wrecked his own studio and ended up in a straitjacket and a padded cell in the posh Payne Whitney psychiatric hospital.

Drugs weren't his only problem. He'd begun to hate the work. "When Marvin Israel was fired, it was all over," he said, because he was sure Bea Feitler and Ruth Ansel "weren't strong enough to cope with Nancy White." Richardson hated her, and the feeling was likely mutual. "They would have a shot set up, and my dad would shoot himself up with speed in another room, have the rush, walk out, shoot half a roll of film, and then disappear again," Terry was told. "He got into this whole star trip . . . did this whole performance. . . . That was his thing . . . doing a number on people."

"He was the most difficult human being," says fashion editor Barbara Slifka, though she adds, "We did some gorgeous pictures." They worked together until the day Richardson returned all the clothes *Bazaar* wanted him to shoot with a note to Nancy White. "He hated everyone, he hated us, he hated the work," says Slifka, "and that was the end of Bob Richardson and us."

"I felt American editors were very rude and disrespectful," Richardson explained. "I was changing the industry, and they fought me every step of the way. Diana Vreeland called me and said, 'Move to Paris, darling. They'll understand you.'" He did. Peter Knapp had left *Elle*, and Hélène Gordon-Lazareff asked Richardson if he'd become the magazine's art director and

take pictures, too. He said maybe and took an assignment that turned into "another scandal," he said. Shooting in the Camargue, his editor got "drunk as a skunk on scotch, from six a.m. on, and I didn't want to do what she wanted." So he walked out and went to work for Paris *Vogue*.

"The French put up with me," he said. "They called me the Beau Monstre. They published everything I gave them, let me do my own layouts, and treated me with utmost respect." He loved Paris, where the family lived in the sixteenth arrondissement, but after three years, a wrist-slashing suicide attempt, and yet another hospitalization, this time a sleeping cure for his drug addiction, they sailed home.

Bob and Norma moved with Terry, then four, into a penthouse in Greenwich Village, but their marriage was doomed when they started swinging—"going to parties and bringing people home," Bob wrote. Terry, who'd discovered his father after the Paris suicide try and for years had "visions of him in a room, all bloody," was aware of his parents' experiments. "My dad definitely was sleeping with models and . . . my mom had lovers," Terry said. "Group sex. They were experimenting with all that stuff. I remember my dad saying that after he tried to kill himself and he was in the hospital, my mom was fucking his assistant. I ended up working with that guy twenty years later."

Then, Bob, who was forty-two, met the eighteen-year-old Anjelica Huston. Her first exposure to fashion photography had come when Richard Avedon shot her family and asked to test the coltish teenager, though the experience "wasn't tremendously eventful," she says. "Dick liked the way I looked and wanted to see how it translated to the camera." It didn't; he told her mother her shoulders were too big. Later, the teenager would shoot with Frank Horvat, and David Bailey. "He called me Missy," Huston says. She found him funny but stolid and "didn't like him much," but she shot with him again. Despite Avedon's opinion, she'd become a model.

Just then, Huston's mother was killed in a car crash at age thirty-nine, and in spring 1969, Anjelica fled London for New York, where she'd been offered an understudy role on Broadway. Her childhood friend Joan Juliet Buck, the stylist sidekick of the early French Mob expatriates, took her in. "I was a supremely confident twenty-year-old," says Buck, "and I knew her inside out." So when Huston told Buck *Harper's Bazaar* wanted to shoot her, "I told them it had to be Bob Richardson," she says. "They were both dreamy,

intense, and poetic." Buck told Huston the same thing, showing her Richardson photos from Paris *Vogue* that looked like "a beautiful, dangerous foreign movie," Huston wrote in her first memoir.

When *Bazaar* called, "I wanted to photograph personalities," Richardson said, "so I figured I'd give them another shake. Anjelica walked through the door and it was love at first sight. I loved her. She had one of the most beautiful faces I'd ever seen." He showed up at her theater in his red Fiat and drove her to Jones Beach. Compared to Buck's friends in the French Mob, who "all wore Shetland sweaters and tight pants," Richardson "was the rock-and-roll photographer," Huston says. "Everyone else was . . . visually . . . I don't want to say they were Herman's Hermits, but Bob was Keith Richards, the dark prince." Their encounter on the beach was "a heart-expanding moment. It was a very powerful thing to work with Bob. His gaze was incredibly penetrating. He'd wait for the moment just before you thought, 'Whoa, dangerous,' then he'd lift the camera. It was always a rhythm as precise as music."

She doesn't remember when they became lovers, but soon "he implied that his life with Norma was over and not as a result of me." They smoked a joint in front of a mirror before they first made love. She considered it "almost an out-of-body experience. I felt we were the same animal, the same breed." He moved out of his penthouse, leaving Terry with Norma, and into a hotel, where Huston joined him after her play's run ended in Boston that summer.

"My mom pleaded with him not to leave, but he did anyway," Terry has said. "It's not that she was staying alone at home." He recalls Jimi Hendrix visiting shortly before his death in 1970 ("She'd say, 'Yeah, he was hung like this! Huge!'") and "seeing my mom making out with Kris Kristofferson on the fire escape." But Richardson's departure "destroyed" her.

Bob was in the room when Anjelica heard that Dick Avedon wanted to shoot her again—and over her lover's objections, she agreed. Then Diana Vreeland asked Avedon to take Huston to Ireland for a *Vogue* shoot. "He was trying to do Bob Richardson photos with the girl who'd become my lover, and he didn't know it," Richardson said. He followed her to Europe, professions of desire alternating with accusations she wanted to destroy him.

"He was very possessive and unbalanced," she says. "It was him against

the world. The black moods went on for days. I saw and experienced it, but I had no idea he was schizophrenic. They didn't call it bipolar in those days and I didn't know what it was. I was a fledgling waiting to be torn apart by cats, or picked up and nurtured, and when Bob was good, he could be enchanting, graceful, smart and funny. The camera was his eye. He taught me about being in front of them, how to move for them, how to establish a rhythm with a photographer, how to show yourself or clothes to the best advantage. But I lived in terror of him."

Back in their New York hotel room, she left for a television appearance without unpacking first, and he tore up her clothes and threw her jewelry out the window. She decided she'd hurt his feelings; she didn't know he terrorized everyone around him: "He'd allude to doing a number on somebody, and having experienced a few myself, I pitied anyone who stood in the line. But I was inside the box with him. I heard his version of things. No one said, 'Look, Bob is crazy.' Bob said, 'I'm not crazy. They're the crazy ones. They're the liars, not me.'

"I was young and gullible and scared of him. Fear is as violent as anything. You don't have to hit. Fear is where it starts. To live in fear is to be in a violent situation. Words, to me, can be violent." He alternated loving and manipulating her. She felt responsible for his "episodes," thought of him "as a wounded soul, and believed it was my mission to save him." She was still too young to understand that "I had mistaken Bob's need for dominance and control as love," she would write more than forty years later.

In 1970, Terry Richardson was five years old when his mother moved to Woodstock. Bob and Anjelica would take the bus so he could see his son, who describes himself as "a little rock-and-roll kid." His mother wanted to "be a hippie, grow out her armpit hair, get a job as a waitress in a health-food restaurant." He added, though, "There was the same shit going on. Total excess. People having affairs, sleeping around, drinking and taking lots of drugs." She took pictures of the rock musicians who lived nearby and, within a year, met a British guitarist and singer (and Bob Richardson look-alike) named Jackie Lomax. She married him and changed her name to Annie Lomax.

Terry suffered from what he's half joked were abandonment issues. Lomax and Terry's mother would go out and leave him home alone, "screaming in the fucking house," he recalled. "'No! Don't leave me! No! No!' I

would be fucking terrified. And this happened to me over and over again. I'd be hysterical, jumping at shadows, screaming and crying myself to sleep."

His father and Huston were often in Europe. "We started traveling," Bob said, "to London for *Vogue* and *Nova*, to Paris for *Vogue*, to Italy to work with Anna Piaggi [at *Arianna*]." They were doing "some remarkable shoots," Huston recalled, including one evoking the Nazi era and another, the Troubles in Ireland, but money was always tight and Huston wouldn't ask her father for help; she knew he wouldn't approve of Richardson and wanted her father to have no advantage over them. Making matters worse, all of Richardson's Nikons were stolen. So late in 1971, they moved to London. Terry recalled spending a summer there and waking up at noon to the sounds of their having sex. "And at night sometimes they'd leave me alone," he continued, "and I'd be shaking and staring at shadows. It was the same fucking thing that happened in Woodstock. I actually started shitting in my underwear."

Later, on a visit to Woodstock, Huston discussed that with his mother "right in front of me. Humiliated by two women. Emasculating little Terry. It was all pretty traumatic." Huston thought him "a solemn little kid," but also "a beautiful child." Albeit one who threw regular tantrums, turned violent, and started stealing.

Anjelica and Bob had moved back to New York, where she found her work had dried up. Only Avedon still booked her, infuriating Richardson. "Bob took it personally and that was a lot of his problem," she says. "It wasn't Dick booking the daughter of his friend. It was Dick intruding on Bob's territory. Ohmigod, they were territorial." Huston didn't share Richardson's concern about Avedon's copying him: "I didn't want to counter Bob on many things, but I didn't necessarily agree with that. I liked the way I looked in Dick's pictures. Bob was jealous. Dick, I'm sure, was trying to penetrate the secrets of Bob's cameras. But that doesn't have to be nasty competition. They were turned on to each other."* But Avedon was possessive, too. "Dick had stopped me from working with anyone else. I couldn't get a job. No one wanted to touch me. The only people who would work with me were Dick and Bob. Two extremes of the cream."

*Later, Richardson would admit, "Her best photographs were done by Dick Avedon—not me."

In the early seventies, Terry was moved to Sausalito, to England, back to Woodstock, and then, in 1974, to a Hollywood apartment. He had not one but two gypsy families. Torn between them, his violent behavior escalated, and his mother started sending him to a psychiatrist twice a week. Stability wasn't an option. Then, in 1975, when Terry was nine, he was waiting for her to pick him up after a shrink session when she was rear-ended on a freeway and ended up in a coma. Six months later, she came home in diapers with permanent brain damage. "Where's my mother?" Terry thought. She would recover, but only partly, and it took a long time. Meantime, Jackie Lomax lost his record deal, and the family went on welfare. Terry tried suicide by swallowing dozens of pills—it was his second attempt. His maternal grandmother took him in but couldn't control him. "He was running wild," Bob recalled.

In 1973, the *New York Times* called Bob Richardson for a front-page exposé of Dr. Jake—and he gave them a candid interview. He was in good company; the story revealed that over the years, Jacobson's patients had included the Kennedys, their family photographer Mark Shaw, Truman Capote, Emilio Pucci, and a pack of politicians, diplomats, and celebrities. The response to the story wasn't what Richardson expected: "I was threatened. I got calls from Hollywood." Huston got a call from her father, who flew to New York to meet Richardson for the first time. At the apartment he and Anjelica shared, John Huston invited them on a fishing trip to Cabo San Lucas. Anjelica worried it wasn't such a great idea.

As expected, the trip turned out badly. Richardson flung a bottle of tequila at Anjelica. He then harangued her all night before they flew to Los Angeles with her father and stepmother. At the luggage carousel, she informed Richardson she wouldn't be returning to New York with him. They never saw each other again. But she doesn't look on Richardson as a bad memory: "It's part of life, maybe not the easiest, but textural. All men can't be sugary. He had a lot of good in him, too. He was not an ordinary man."

Richardson went back to the Gramercy Park Hotel and back to work and still spent summers with his young son, including a location trip to Haiti where eleven-year-old Terry ended up in a shower with a model "with these big breasts and I remember having this really erotic experience with them." But Bob's demons were never far away. "He'd show up at four in the morning drunk, ranting and raving," Terry recalled.

Susan Forristal had met Richardson on her arrival in New York and had often modeled for him with Huston. "He was very concentrated," she says, "like a saluki dog. Everything was slow and dramatic. He had a superior air, always. But with Bob, I'd always look great, be well paid, and Anjelica would be there. You're with your girlfriend, making money." What could be better than that? But after the breakup with Huston, he changed. Forristal lived around the corner and would often see him "with his long, strange face, gray skin, gray hair, smoking, always lurking, cheeks always held in, an odd man. Anjelica leaving took away his credibility as a man."

"It was getting almost impossible to work," Richardson later wrote of the seventies. "My mind betrayed me. Dear God, what have I done? Please save me before it's too late—it was already too late." His career was on life support. "I went all the way up and all the way down. From working for everyone I went to working for no one because I'd become so short-tempered, you had to be very understanding and special to work with me."

The end of the seventies were a jumble for Richardson. He tried suicide again—slashing his wrists—and was put back on Thorazine after his parents brought him home to Rockville Centre to recover. One night he stripped naked in the street and started screaming. "It's amazing that no one stopped me," he wrote. He couldn't see through his viewfinder, couldn't focus his Nikon. "Looking at a contact sheet was tough." He even stopped smoking pot; drinking cheap wine was easier than dealing with dealers. Then, one summer, "[Terry] called from LA and told me he didn't want to come" for a visit, Bob later wrote. "What was left of me died."

Not long after that, walking down Fifth Avenue, broke and unable to look anyone in the eye, he took stock while fighting off the "constant electrical storm in my brain" and decided he had to flee again.* Borrowing $800 from his sister, he packed a Louis Vuitton suitcase with clothes, but left his cameras behind. His son thinks that like Brian Duffy he burned his photographic archive. "Finished as a photographer and finished as a man," Richardson wrote, "a one-way ticket to LA seemed the only answer." There, he pawned his last valuable possessions, drank away the proceeds, and ended up homeless, living on the beaches of Santa Monica and Venice. He remained

*Depending on the source, that was somewhere between 1978 and 1982.

there for several years, using survival skills he'd learned in Korea; panhandling to buy food, liquor, and drugs; getting arrested for ordering food in a coffee shop without the money to pay for it and for stealing a blanket when it got too cold to sleep outside. "Not once did I think about photography," he recalled. But after reading up on schizophrenia in the local library, and gaining a better understanding of his plight, he applied for unemployment and got jobs sorting and filing, and delivering flowers and packages, earning enough to buy a bus ticket to San Francisco.

In the mideighties, Annie Lomax was the only person who knew where Bob Richardson was—living in a single-room-occupancy hotel in that city's Chinatown, working as a telephone solicitor for the *San Francisco Chronicle* to earn money to pay for the one-course meals he cooked on a hot plate, and the red wine he drank, "just enough to mellow me out." Then, in late April 1989, Martin Harrison, a former assistant in *Vogue's* London studio who'd become an art historian and was researching a coffee-table book on fashion photography, turned up at Richardson's door.

"I had been looking for him for literally years and had asked dozens of people," Harrison recalls. "I had gone to LA because I had been told he'd been spotted there." Somehow, he got Richardson's phone number. "He never answered the phone, so I stalked the flophouse and asked a guy there to tell me which was Bob's room. I knocked, and while I was being kept on the threshold, Bob lit a Newport, which gave me seven minutes' cigarette time in which to talk my way in."

Richardson convinced himself that Dick Avedon was behind the visit. "Dick hardly needed to persuade me and couldn't coerce me, so that must have been a fantasy of Bob's," Harrison says. But that visit coincided with Richardson's recovery ("no more voices, no more hallucinations") and his purchase of a tiny point-and-shoot Ricoh in a local Macy's and may have helped restore his self-esteem. Regardless, the sleeping Beau Monstre stirred again and began shooting images of his adopted city's foggy streets at dawn.

———❦———

Some 375 miles to the south, Terry Richardson had been busy not growing up in the "Wild fucking West," he's said. Riding his bike or skateboard-

ing down Hollywood Boulevard, four blocks from the Lomax home, among "the runaways, the prostitutes, the drug dealers . . . cruising around at night, hanging out at head shops, playing pinball for hours and hours," the effectively motherless child was still a violent teenager, "always getting into fights," lighting fires, smashing things, and stealing, he told the fashion fanzine editor Olivier Zahm in a series of biographical interviews. He sneaked into the dirty movies that played on that seedy strip. "I was always really drawn to sex and violence. . . . I was a mess even before I started having sex! . . . I like emotional pain."

At twelve, he discovered drinking, drugs, and punk rock, a sound track to suit his psyche. He's said he saw *Rock 'n' Roll High School*, starring the Ramones, about fifty times in the summer of 1979, the last he spent in New York with his father. He was fourteen. But Bob and Terry remained connected. In another interview, Terry admitted, "I inherited all the schizophrenia, depression, anxieties, and a Napoléon complex, even though we're both six feet tall." So it's hardly surprising that father and son had a tumultuous relationship. "I tried to strangle him a few times," Terry once boasted. "All the classic father/son Greek mythology stuff."

Both have said that father moved in with son in Hollywood for several months before they argued and Terry told Bob "to get lost," in the latter's words. "I left my Louis Vuitton suitcase filled with all my nice warm clothes at his house and that was it. I see now that I had to follow this road into hell and go all the way through it." According to a 1995 profile in the *New Yorker* that Bob Richardson called "a hatchet job," the teenaged Terry later "arranged" an apartment for his father to move into, but he chose to leave again and subsequently became a sort of photographic hustler, "living with this millionaire who had this huge mansion in Beverly Hills," Terry said in a 1998 interview. "He would bring home young prostitutes and get my father to photograph them," until Bob got fed up and refused and the millionaire "had him thrown in jail."

Right after that, Bob moved to San Francisco, and Annie Lomax left her second husband and moved with Terry to Ojai, a hippie town like Woodstock, east of Santa Barbara. At first Terry hated it, but then realized that he was suddenly a big fish in a small pond "because I was from Hollywood," he's said. "I became the star of the school. . . . All of a sudden, I just blossomed."

He got a car (which he would run into an electric pole while high on pills and beer), started a punk band, took drugs of all sorts, including his first taste of heroin, was arrested at his mother's instigation after throwing a TV across a room, and "got into more trouble there than I did in Hollywood, because all you can do in small town America is drink and have sex. . . . The ultimate California dream: you're in high school, your crazy mother is freaking out, yelling and screaming, and you're punching holes in the wall."

Terry had started taking pictures as a teen, but when he showed them to Bob, "he discouraged me so bad that I threw away my camera" and didn't shoot again for years. But in the early nineties, he returned to photography, taking courses, assisting, and shooting. "He would send me his contact sheets," Bob wrote. "Editing them and mailing them from SF was not working. He moved up to SF where we would work every day for a long time. He is still the best and least grateful of my students." Terry initially disdained Bob's late-life choice of a point-and-shoot camera, insisting on a Nikon like the ones his father used to use. An editor who has seen both at work says they handle cameras exactly the same—cradling them lovingly in their hands like babies.

Clearly, Terry's feelings toward both his parents are complex. In his often lurid pictures, "there's a motif of childhood defiled," Benjamin Wallace wrote in the *New York* magazine profile approved by the damage-control public relations specialist Richardson hired when his career was threatened by accusations of sexual misconduct. "Using the title *Son of Bob* for a book containing pictures of his own feces cannot have been a simple homage. Dedicating [his second book] *Terryworld*, which includes an image of him flossing his teeth with the string of a still-inserted tampon, 'to my mom and dad' was surely an ambivalent tribute."

It took a year to create Terry's portfolio. Then he headed to New York and Bob followed, perhaps inspired by Martin Harrison's book, released in 1991—the first positive attention he'd got in ten years. Initially, Bob stayed "with a hostile Terry," he recalled. "Editing his work is what I have been assigned. One day he threw a metal chair at me, just missing my head. He ignores the fact that his father is still recovering."

Terry wasn't his only supporter. Donna Mitchell, who'd been shooting with Steven Meisel—whose work Bob detested—asked Meisel to help Bob

get a job teaching at the School of Visual Arts. Meisel, who collected the few Richardson prints that had survived the bonfire of his sanity, waited two months, annoying Richardson, but then made the call, and Richardson got a class to teach. Richard Avedon did the same at the International Center of Photography and introduced Richardson to Staley-Wise, the foremost fashion-photography gallery in Manhattan. "Thank God for Dick Avedon," Richardson later wrote, though in a 1994 interview, he still disdained Avedon.

"I was dead" was how Richardson introduced himself to that interviewer. "Everyone thought I was dead, which was exactly what I wanted them to think. It's how you keep a legend going." But he added, "It's outrageous that none of those people had a memorial for me." He was tall and missing teeth and bore scars physical as well as mental. He said he still smoked dope. He disdained the supermodels: "They have no idea of style, no idea of class. But what they lack in brains they make up for in tits." And he declared fashion photography a dying art: "They're in it for the money. They copy Avedon, me, Bruce, Helmut. Take a look at Steven Meisel's photographs and you'll understand exactly what happened. It isn't an age of mediocrity, it's a rage for mediocrity. Photographers who have no genius get along with everyone. One of their biggest talents is kissing ass, and if they feel guilty, then they buy a house or a car and it makes them feel better."

Bob and Terry began pitching themselves as a team, showing slides of both their work while a boom box played Nine Inch Nails. They completed a few magazine assignments, and Bob got an apartment on Hudson Street in the Village, though he couldn't always pay the rent. Terry started using a point-and-shoot camera. Bob wrote to *Vogue* and *Bazaar* and asked for work. "They ignored me," he recalled. "Where and how were these 'ladies' brought up?" Franca Sozzani and Fabien Baron gave him assignments and helped him win an ad campaign, but then, he charged, took his pages away and gave them to photographers "who kiss her ass." Richardson started calling the blond Sozzani "Goldilocks on Acid." He was back and he hadn't changed much.

Finally, Terry realized he had to break free and, when he was offered a fashion shoot for the music magazine *Vibe*, jettisoned his father, who vowed to never speak to him again. Clearly marked as his father's son, Terry was

determined to make his own mark, but couldn't cut his family ties. Eventually, Bob's radical mood swings and crazy threats alienated many who'd been inclined to help him, and he moved back to Venice, California. But Terry never gave up on him entirely, and when Bob penned "Outsider," his autobiography-in-fragments, in the early aughts, his son sought to get it published, to no avail.

By then, Terry had had some success and generated controversy Bob admired. When editors at *W* magazine decided Terry was an anti-Semite and dropped him after he exhibited photos in a gallery show of postpunks wearing swastikas, harkening back to his father's photo of Anjelica Huston on the edge of a bathtub occupied by a male model in a Nazi officer's hat, Bob noted that Terry's mother was Jewish and wondered, "How do these broads get their jobs?" After Terry went into rehab for heroin addiction in 2002, Bob wrote, "It's great to have a son whose photographs wow me—I teach him to use all of his suffering in his work the way all artists have—Terry is my revenge."

In 2005, at seventy-seven, Bob drove cross-country back to New York, taking pictures all the way. Toward the end of the sequence, he shot Coney Island's Cyclone and a sign on its boardwalk that said "shoot the freak." He planned to publish them in a book, but a few months after his return to New York, he died, apparently of natural causes. Few mourned the troubled genius. Terry finally got a book published two years later that included what little of Bob's archives remained, magazine tear sheets of more work, his autobiography, and those final pictures.

By then, Terry Richardson had established himself as a shooting star in his own right. His 1994 photos for *Vibe*—a black-and-white portfolio of images of street kids—were spotted by art director Phil Bicker, who suggested him to the streetwise London designer Katharine Hamnett for her next ad campaign. Richardson showed up with samples, "a bunch of personal pictures—people with their dicks out and all that," he said, and won the assignment. His first ads showed a girl on an unshaven guy's lap, her legs spread to show her underwear, framed by wisps of pubic hair, her fingers in the fellow's mouth, and another girl kneeling before a faceless man, her mouth slightly open, her fingers at his belt. The ads led to jobs for *i-D* and the *Face*. "We gave him his first proper magazine story," says *i-D*'s Terry Jones,

who'd worked with Bob Richardson years before. Jones thought Terry loved to push buttons and cross the line between risqué and risky. "There was always a point when I *wouldn't* encourage him." But his straight-up, seemingly spontaneous, and styleless documentary style—he often shot people against a wall—was a perfect fit for those magazines. He'd pulled off a neat trick: combining the antifashion attitude of Day and Sims with the glossy color, graphic punch, and transgressive sexuality of Newton and Bourdin.

Richardson quickly moved up the fashion food chain and began shooting for *Harper's Bazaar* in 1997. But despite entering the mainstream, working for advertisers such as Gucci and Sisley (for whom he shot a famous image of a model squirting milk from a cow's udder into her mouth), conquering various *Vogue*s beginning in the early aughts, and becoming the portraitist of choice for postgrunge celebrities such as Chloë Sevigny and Jared Leto, he kept one foot firmly planted on the fringe, doing more outré pictures for *Sleazenation*, *Self Service*, *Dazed & Confused*, *Numéro*, *Dutch*, and *Purple*, and his perviest work for himself.

His commercial images pushed the envelope; his personal work tore it to shreds. He seemed obsessed with sexual and scatological imagery, with fellatio, menstruation, and with his own penis, which he would regularly expose, both as a subject and to convince other subjects that they, too, could strip down and show their stuff. After all, Terry had got naked first—and that made it all right. Inevitably, some of those shoots turned sexual (or trisexual, as Richardson often described his father; Terry photographed all iterations of sexual activity), and Richardson's assistants would photograph the action when Terry and his tool were otherwise engaged. It was all in good fun! Uncle Terry said so!

He'd taken his father's lessons about image management to heart and promoted himself better than his old man. Where Bob had been prickly and uncooperative, Terry was friendly and collaborative. Where Bob was intimidating, Terry was comic. Where Bob gave a client one picture he'd chosen, Terry shot a million and let clients do the editing. It was easy to brush aside the topless models and choose the images that had his trademark insouciance and just enough rebellion to enhance his rep as a fashion Ramone.

Richardson created that image with his pictures and with the visual persona he'd adopted, but unlike Steven Meisel, he not only stuck to it, he pro-

moted it—putting pictures of himself with his goofy signatures wherever he could, not only in ads and magazine spreads, but on Terry T-shirts and (of course) condoms.* He also made it a thing to photograph models and celebrities in his glasses, giving the same double-thumbs-up sign he always used—reinforcing his image and subverting the concept of reflected glory because, after all, whose glory was it? It all made him a celebrity himself, and by 2013, the Year of Terry, he was reportedly charging advertising clients $160,000 a day, and making $58 million a year. That fall, though, a British teenager with no apparent connection to the fashion business posted a petition addressed to *Harper's Bazaar*'s latest editor, Glenda Bailey, on Change.org, asking that fashion brands and magazines stop hiring Richardson. As of summer 2015, she'd gathered more than thirty-five thousand signatures.

Richardson's appeal was—and remains—clear to Fabien Baron. "The subject matter of fashion has been used," he says. "There's too much of it. It's hard to find a niche. Terry is relevant because he takes throwaway pictures that match the throwaway qualities of today with digital and computers and Instagram. It's not a fashion picture, but Terry is now. He matches his time."

Neil Kraft says "a remarkable sameness" has crept into fashion photography today, despite the proliferation of niche magazines, blogs, websites, and Instagram and Pinterest pages. "There are too many outlets. A magazine page doesn't matter. Doing a shocking story in Italian *Vogue* and having everyone talk about it doesn't happen anymore." Terry Richardson made himself matter despite all that. "Terry is important because his pictures are dirty. He has no range but he does *a* picture really well."

Not everyone finds Richardson images shocking anymore, though. "How many years are we into the idea of the modern fashion photograph?" asks Ronnie Cooke Newhouse. "Almost sixty? We're jaded. We've seen so much, and with the Internet, nothing is left. It's harder and harder to create something new. What's new is that people aren't that interested. And in a funny way, we're not shockable anymore. Decapitated heads are the provoc-

*Early in 2016, Richardson posted photos of a baby shower celebrating the assistant who was pregnant with his twins on Instagram. The event featured penis-shaped lollipops, a cake decorated with an image of the assistant giving birth, and after-party gifts of condoms printed with a sonogram of the fetuses, captioned "cumming soon."

ative images of our time. Fashion can't compete. Even Terry Richardson's images don't shock. It's his behavior that's shocking."

Like his father, Terry had the flip side. As different as they were, both could be more than a little creepy. And finally, Terry's inner demons threatened his career and reputation, just as Bob's had ground his to dust. In 2004, a blast of publicity accompanied a gallery show of his personal pictures, and the publication of two books, one of them limited to his sexually themed work, called *Kibosh*. He clearly considered the triple play a career-defining event.

Of *Kibosh*, Richardson said, "This is my life's work . . . the most intimate part of me as a photographer. I believe that the phrase 'I would never ask anyone to do something that I myself would not do' from the introduction of this book shows the profound respect that I have for the people who collaborated in the realization of this work, which for me is so important. For the realization of *Kibosh* I stopped working, for months I dedicated myself entirely to collecting the photos and planning the layout."

The press generated by those events revealed just how powerful his demons were. In an interview, he admitted he was working out "lots of stuff" with the show and the books. "Like, this current show could be about my midlife crisis. Or it could be something to do with the fact that since I gave up drinking and taking drugs, I have to get high on sex and being an exhibitionist. Or maybe it's the psychological thing that I was a shy kid, and now I'm this powerful guy with his boner, dominating all these girls."

Through the nineties, Richardson had been a regular heroin user. In 1996, he married Nikki Uberti, a model he'd shot the year before for the cover of *i-D*. He told the *New York Observer* he was "high as a kite" when they were wed at City Hall. Six months later, they considered getting an annulment, but stayed together three years. Richardson says they were separated when she was diagnosed with breast cancer at twenty-nine, and though "she had been throwing me out forever," he wanted to stay, but "I was trying to get clean and I couldn't get clean and stay in that house. I would just wake up and start drinking and taking pills." In a short film she reportedly made about their breakup, Uberti (who later became a makeup artist and married actor Eddie Cahill) implied that he'd deserted her.

In his commercial work, Richardson was working with top models such as Stephanie Seymour, Angela Lindvall, Natalia Vodianova, and Stella Ten-

nant. He reportedly segued to dating another, Shalom Harlow, and later, Susan Eldridge, whom he'd shot for his long-running Sisley campaign. But simultaneously, it appears he was playing the field, or at least playing with and photographing some of the characters who passed through his studio. "I was single and I was going to explore sexuality," he admitted. He deemed these photo sessions "spontaneous sexscapades." England's *Observer* newspaper described the results as "self-made images of Terry thrusting, rucking, prodding, pumping and sometimes, grinning at the camera like a nerd let loose in porno heaven. . . . These photographs seem grounded in, at one extreme, adolescent fantasy gone mad, and, at the other, some darker personal demons: narcissism, obsession, compulsion, even addiction."

His addictions returned with a vengeance on Christmas Day 2001, three days after a breakup with a girlfriend, he told *Observer* reporter Sean O'Hagan. "I was at the bottom, man." Some friends found him comatose "and sent me off to rehab."*

The Deitch Projects show made Richardson famous and prompted a spate of press that treated Richardson's lurid outrages with jokes and ironic distance as if the writers were concerned with being deemed uncool if they so much as cocked an eyebrow.

Toward the end of one story, writer Phoebe Eaton revealed a Richardson "side project" called Breaking in the Carpet, a visual chronicle of his masturbating onto hotel-room carpets wherever he went. But as with Bill King before him, it was Richardson's personal behavior, not his smutty "personal" pictures, that would have career-threatening consequences.

The psychosexual revelations of *Terryworld* notwithstanding, Richardson's career blossomed in its wake, seeming to prove the old adage that any press is good press. He continued to work for many of the *Vogues*, added prestigious advertising clients, and even shot for the *New York Times* and photographed Senator Barack Obama for *Vibe* in 2007.† It would be five years before anyone spoke out against him, and even then he was only referred to obliquely as

*He reportedly stayed clean until 2008, when he relapsed.

†After Richardson posted those photos on his website in 2012, the website *Refinery29* published a list of other unlikely Richardson portrait subjects, which included such symbols of female empowerment as Gloria Steinem, Diane von Furstenberg, and Oprah Winfrey.

"one of the top names" in fashion photography when model Sena Cech described her encounter with him in a documentary on modeling made by Sara Ziff, a former roommate. Ziff was a crusader who would later form a non-profit to advocate for the majority of models who don't make a fortune. Cech, now retired and a single mother, confirms Richardson was the unnamed culprit who asked for and got a hand job from her at a shoot. "I wasn't trying to protect Terry," she says. "There were others like him, a population of similar men, so I wanted to include them."

Cech had been sent on a go-see for *Purple* magazine. She wanted to turn it down after seeing in the magazine Richardson's photos of his assistant, a girl, "and this fat, ugly-ass bald guy, and she was eating off his ass, and I was, like, 'No way!' But these *Purple* people were comfortable with whatever Terry wanted to do, and besides, it paid one hundred dollars, seventy-five dollars in my pocket [after agency commissions]," so she changed her mind and went. Richardson asked her to "do something a little sexy. 'Can you take off your clothes?' I have no problem being naked. And then the photographer gets naked, and I'm going, 'This is weird.'"

Cech thought the scene was gross, but did as she was told, though she later refused when Richardson offered to book her for the actual job. On camera, Cech told Ziff, "That was the end of the story." In fact, it wasn't— and what happened later was even more revealing of the morality-challenged zone in which Richardson operated and young models live.

Not long afterward, Cech was in Paris when she was booked for a shoot with Bon Marché "and he was the photographer," she reveals. She told her agent what had happened the last time, and they told her he'd said he was sorry and wanted to take her to dinner to apologize. The agent swore other people would be there, including a model friend of hers. "It's a classy client," the agent said. "Let's get back on track." Cech talked to the other girl and learned they'd reeled her in with the promise that Cech would be there, but she went to dinner anyway.

"I don't know how to explain this," she continues, laughing nervously. "He started kissing me, deep tongue, at the table in front of everyone." She asked herself how that had possibly happened and convinced herself the only explanation was that "he really likes you, and he's a big deal. I'd broken up with my boyfriend in New York, partly over the Terry thing. He dumped

me. I'd be crying and he'd be, 'What's up?'—and I couldn't tell him because I kind of cheated on him with the hand job. As soon as you lie, it's so easy to taint young love." In the back of her mind, she wondered if Richardson wanted to be her boyfriend. But after the Bon Marché shoot the next day, she never saw him again. "Men have done much, much much worse things to me, and I've done so many awful things, I had to forgive those people. I know guys so much fucking worse. He wanted to kiss me? Who cares? I'm not fighting those battles."

Others were willing, however. The next year, Rie Rasmussen had her moment in Paris with Richardson. Not long after that, Jamie Peck and Sarah Hilker, who'd met Richardson at the SuicideGirls casting, went public with their Terry stories—and more allegations followed, often including Richardson's studio manager, Seth Goldfarb; Terry's assistant Keiichi Nitta; and Leslie Lessin, a woman sometimes described as his talent coordinator, "or his pimp, if you will," says another former Richardson assistant. "Everyone was sober," Peck recalls. "They're just high on the fucked-up things they're doing. I think he replaced his heroin addiction with sex abuse. He gets off on the fact it exists in a legal gray area. But it's not an ethical gray area. This is a pattern of predatory behavior."

"I'm not someone who hates him," says the former assistant, a woman who worked for Richardson in the middle aughts. "I'm neutral." But her description of Richardson, his studio, and his talent isn't neutral at all. "He likes a cheap look," she says of his photos. And she makes him out to be a cheap hustler, in the dictionary sense of tawdry, sleazy, contemptible, and lacking in redeeming qualities.

The assistant—call her Penny—says shock value is Richardson's gold standard and complicity, willing or not, the key to method. Anyone who works for him ends up in photos, Penny says. "It's like a fraternity initiation. He wants you to get involved. Acts on camera are part of the deal," which is only part of the reason Penny asks to be anonymous. She also wants to continue to work in fashion and fears exposure will hurt her career.

Penny says Richardson "hated normal work—fashion, advertising." He liked celebrity shoots because "it's part of his fetish. He's obsessed with celebrity and notoriety, but he's the star of the show. He doesn't want to think he's famous because of his father. He's definitely insecure and narcissistic."

Terry's best days were "Terry shoots," she continues, when the downside was a lack of paying work, but the upside was that no celebrity handlers, art directors, or editors were around. They were "free-for-alls" starring "people who have no power. He uses who he is to get people to do things. They look for street people, scavenge sex ads, find people in 'Casual Encounters' on Craigslist. He'd meet them anywhere. He's a Lower East Side celebrity, so people volunteer. Sometimes they get paid, sometimes not. Sometimes they're models and he calls it a test. But he likes freaks more." Lessin is "the ringmaster," Penny says. "She calls beforehand and tells them what to wear but not what to expect. She makes everyone sign releases beforehand. That's one of the shadier things he does."

Terry shoots revisit favorite themes. "The same fetishes again and again," says Penny. "He always says he's not into porn, but he loves coming on girls," especially into their open eyes. "Anything perverse. He's supposedly straight, but on camera, he doesn't mind if guys do things to him."

Penny says some potential subjects walked out when propositioned. "He'd deal with it in different ways," ranging from acceptance to ridicule. "It's a game mentality. It seems innocent, and then you're in it, and are you going to back out? It's a freak show, a circus, yet it might be fun, but you'll probably regret it down the road. It's like a night out, but there are pictures."

Fashion photographers "don't get into it because they want to save the world," Penny concludes. "A lot of photographers do similar things—but not on camera."

Then came a time of trials for Richardson. His career had hit its highest heights ever and he could be found working with Miley Cyrus, Beyoncé, and Lady Gaga. But his mother had died in 2012, and his stepfather followed in 2013. As the storm of accusations swirled around him, his girlfriend, the political consultant Audrey Gelman, broke up with him. That's enough to whipsaw anyone.

Gelman never addressed her relationship with him. But she did go on Twitter that year to answer critics who'd condemned her friend Lena Dunham, who'd posed for Terry. Dunham "tried to see the good i saw in someone & we both have regrets," Gelman wrote.

To those who disdain Terry Richardson, the problem is clear. "Can one say dinosaur, deluded, manipulative, middle-aged sex predator, and fashion

photographer in one sentence? I just did," says Caryn Franklin, who became a TV host and fashion commentator after six years at *i-D*. "Fashion will pretend it's art instead of calling it what it really is: porno-objectification of women all stylishly dressed up as womenswear marketing. But then, women have gotten so used to seeing themselves with their legs wide open and their fannies hanging out, they have normalized it for themselves! What he does behind the scenes however is simply unethical."

Friends of Richardson's are quick to point out the complexity of his character. "He's a simple, soft-spoken, honest guy looking for normalcy and stability," says a woman who knows him well. "He's clever and aware of how he's perceived. We live in a puritanical society and you shouldn't be indicted for pushing boundaries." He's also determined, she continues, not to suffer the same fate his father did. After he cleaned up his act, he'd attend Alcoholics Anonymous meetings every day. "He worshipped his father and was so afraid he'd become him." Like several other women who've met Terry, this one thinks that beyond everything else he suffered, he was also abused as a child. "But he's not in touch with it, so he perpetrates it on others." In that, as well as in his reliving of his father's triumphs and traumas, he represents a classic case of repetition compulsion, which Sigmund Freud defined as "the desire to return to an earlier state of things."

Bob Richardson made it hard to pity him. His son strives to make it impossible. "He is really talented," the woman continues. "He can elicit life and energy like no else, but he's out of control." On the one hand, "he's desperate for attention, desperate for love, desperate for affirmation." On the other, "he needs to feel powerful, to dominate, to humiliate, and, uniquely, to photograph it."

Richardson would probably not agree, but his photographs capture the moment when an era of fashion photography ended. They represent a fashion culture—and perhaps the larger culture as well—that is so inured to shock, so numb to consequences, and so desperate to sell, it will burn down its own house just to get attention or, in the parlance of the day, attract eyeballs.

But that only means the glory days are over. Reinvention is fashion's prime directive, its raison d'être, its highest calling. So a world still hungry for inspiring, shocking, or just plain beautiful visuals will always seek what's next. It is the fashion photographer's job to find it.

ACKNOWLEDGMENTS

Focus is the product of thirty-plus years of reporting on fashion and fashion photography, so hundreds of people deserve thanks for contributing both to my education and to this book. Many were named in the acknowledgments in my 1995 book, *Model*, and I won't repeat that long list here, but this new book could not have been written without them. I should single out my oldest friend, Stephen Demorest, who first entered this very special world with me when we decided to write a series of mystery novels with a fashion-model detective named Temple Kent; Mary Michele Rutherfurd and Christine Mortimer Biddle, the first models I ever knew, both also lifelong friends; Jerry Schatzberg, the first fashion photographer I ever met; Anne Russell, who first hired me to write about the field for *Photo District News*; my editors at *Manhattan Inc.*, the *New York Times*, and *New York* magazine, who let me loose in that world; and Tina Brown, who published my brief interview with Steven Meisel and long profile of Bruce Weber in *Vanity Fair* and, at *Talk* magazine, assigned the (as it turned out, never published) profile of Gilles Bensimon that has now expanded into this book's pages on the French Mob.

I thank every person who contributed to those articles and gave interviews for this book. Most are cited in the text. I also thank those who gave assistance anonymously. I especially thank all the photographers who trusted me and spent so much time talking to me. I hope they find this book a worthy tribute.

For help with *Focus* that is not explicit in the preceding pages, thanks to A. Richard Golub, Adam Hutchins, Alan Kleinberg, Alexandra Pitz, Jacob Bernstein, Alida Morgan, Andrea Derujinksy, Helen Antonakakis, Barbara Camp, Brian Belfiglio, Siiri and Benedict J. Fernandez, Brian Hetherington, Eric Himmel, Burkhard von Wangenheim, Hannah Speller, Camilla Lowther, Malcolm Carfrae, Jennifer Crawford, Cynthia Cathcart, Christy Sadron, Eileen and Montgomery Brookfield, Varick Bacon, Frank and Remy Blumenfeld, Terry Gruber, Laura Harris, Nan Bush, Hillery Estis, Jaclyn Bashoff, Jeremy, Janet, and Susanna Chilnick, Jim Cornfield, Joshua Greene, Robin Morgan, Julie Britt, Kira Pollack, Kristoffer Tabori, Leslee Dart, Lisa Immordino and Alexander Vreeland, Mandi Lennard, Marisa and Palma Driscoll, Melissa Unger, Mary Foresta, Neil Selkirk, Nina Furia, Philippa Serline, Robin Morgan, Rosy Kalfus, Shannah Laumeister, Stephanie Rodriguez, Francesca Sorrenti, Tom Lisanti, Veruschka Baudo, Wynn Dan, Nicholas Coleridge, Faith Kates, Ivan Bart, Marek Milewicz, Iris Bianchi, Sandy Linter, Freddie Lieba, Marysia Woroniecka, Simone Colina, Andy Grundberg, Carol Halebian, Hugh Henry,

Marianne Houtenbos, David Netto, Kirsty Hume, Edie Locke, Fern Mallis, Andrea Sasso, Diane Schlanger, Barry Secunda, and Lynn St. John.

I also thank Denis Piel, Wayne Maser, Andrea Blanche, Pamela Hanson, Cedric Buchet, and Gosta and Pat Peterson, who gave extensive interviews that were not included for reasons of length and narrative velocity. Their stories and those of a number of other photographers can be found on my website, www.mgross .com, where I've also posted the source citations for *Focus*.

I did not include fashion pictures by the photographers who star in the book because reproduction in small size diminishes them, and because, in most cases, they are available in large-format photography books. Photographs by almost all of them (including Bill King, whose work has sadly been kept from wide distribution by his heirs) can be found on websites such as Pinterest and paperpursuits .com. I would have liked to include photographs by Richard Avedon, who shot portraits of many characters in this book, and who contributed several photographs to *Model*, but the Richard Avedon Foundation, run by Avedon's son and daughter-in-law, demands to review the written content of books in which his photos appear, and I was unwilling to agree to that condition. But I thank Nadia Charbit and Remy Blumenfeld, Andrea Derujinsky, Melvin Sokolsky, Shannah Laumeister, Erica Crome, Claude Guillaumin, Polly Mellen, Bruce Weber, Fabien Baron, and especially Mike Reinhardt and Jerry Schatzberg for helping me gather the portraits of key characters in the story that I chose to include instead.

I also thank Penelope Rowlands, Etheleen Staley and Takouhy Wise of the Staley-Wise Gallery, Lyssa Horn, and Liza Harrell-Edge at the Kellen Archives at the New School, and Dierdre Donohue at the International Center of Photography (ICP) for very special help. For additional research assistance, thanks to the all-knowing Patty Sicular, and to Blake Hunsicker, Amanda Zambito, Bernard Yenelouis, and Marusca Niccolini.

Very special thanks to my exceptional friends Brian Saltzman, Giorgio Guidotti, Lavinia and Ophelia Branca Snyder, Barry Kieselstein-Cord, Henry Lambert, Esteban Matiz, and Roy Kean.

Finally, I am especially indebted to my agent, Dan Strone of the Trident Media Group; to his assistant, Chelsea Grogan; to my incredibly devoted and talented editor, Leslie Meredith; and to Judith Curr, Paul Olsewski, Paul Dippolito, Sara DeLozier, Isolde Sauer, Martha Schwartz, Donna Loffredo, Betsy Bloom, Lisa Sciambra, Phil Pascuzzo, Jackie Jou, Kimberly Goldstein, Albert Tang, Jin Yu, and Tory Lowy at Atria Books; to Diane Mancher and James Walsh; and to my editors, Richard David Story and Heather Halberstadt, at *Departures*. And as always, thanks to my wife, Barbara, who spent the last twenty years trying to convince me to take a look at this subject through a different lens. I'm glad I finally listened.

BIBLIOGRAPHY

Adam, Peter. *Not Drowning but Waving*. London: André Deutsch, 1995.

Aletti, Vince. "Photoshop." *Village Voice*, August 13, 1996, 68.

Alexey Brodovitch and His Influence. Philadelphia: Philadelphia College of Art, 1972.

"Alexey Brodovitch Workshop Session Notes: Design Laboratory, 1964. Including a Biography of Alexey Brodovitch; also, Richard Avedon/Irving Penn Session." 1964.

Ansen, David. "Avedon." *Newsweek*, September 13, 1993, 48.

Arnold, Rebecca. "Heroin Chic." *Fashion Theory: The Journal of Dress, Body & Culture*, August 1999, 286.

Aronson, Harvey. "Stern: Or, How to Make Good in the Big City by Developing Some Very Glamorous Photos into a Beautiful Empire." *Newsday*, March 16, 1968, 10.

Avedon, Richard. "Borrowed Dogs." *Grand Street*, September 1987, 52–64.

———. *Evidence: 1944–1994*. New York: Random House, 1994.

———. "The Family 1976." *Rolling Stone*, October 21, 1976.

———. "My First Sale." *Famous Photographer's Magazine*, 1970, 6.

Avedon, Richard, and Judith Thurman. *Made in France*. San Francsico: Fraenkel Gallery, 2001.

Bailey, David, and Martin Harrison. *Shots of Style: Great Fashion Photographs Chosen by David Bailey*. London: Victoria and Albert Museum, 1985.

Baldwin, Neil. *Man Ray: American Artist*. New York: Clarkson N. Potter, 1988.

Battelle, Phyllis. " 'Scarecrows' Sell Clothes." *New York Journal-American*, February 20, 1957.

Beebe, John L. "This Is Sheepshead Bay." http://www.usmm.org/sheepsheadbay.html.

Behar, Henri, and Michel Guerrin. "Avedon." *Le Monde*, July 1, 1993, 25–27.

Bennetts, Leslie. "Fashion Comets." *Vanity Fair*, November 1990, 126–38.

Bert Stern: Original Mad Man. Directed by Shannah Laumeister. 2012.

Blumenfeld, Erwin. *Eye to I: The Autobiography of a Photographer*. London: Thames & Hudson, 1999.

"Book Ends." *New York Times Book Review*, December 5, 1976, 297.

Bosworth, Patricia. *Diane Arbus: A Biography.* New York: Alfred A. Knopf, 1984.

Bourdin, Guy, and Samuel Bourdin. *Exhibit A.* Boston: Bulfinch Press/Little Brown, 2001.

Brady, James. *Superchic.* Boston: Little, Brown, 1974.

Brustein, Robert. "Everybody Knows My Name." *New York Review of Books*, December 17, 1964.

Buchwald, Art. "The Horse-Faced Girl Comes to Paris." *New York Herald Tribune*, August 8, 1957.

————. "A Real Doctor's Dilemna." *Miami News*, October 9, 1960, 5B.

Bussard, Katherine A. *Unfamiliar Streets: The Photographs of Richard Avedon, Charles Moore, Martha Rosler, and Philip-Lorca diCorcia.* New Haven, CT: Yale University Press, 2014.

Callahan, Maureen. *Champagne Supernovas.* New York: Touchstone, 2014.

CECOM Historical Office. *Women in War—Toni Frissell and Janet Flanner.* November 2, 2011. http://cecomhistorian.armylive.dodlive.mil/2011/11/02/women-in-war-toni-frissell-and-janet-flanner/.

Chase, Edna Woolman, and Ilka Chase. *Always in Vogue.* Garden City, NY: Doubleday, 1954.

Christy, Marian. "The Fine Definition of Style." *Boston Globe*, March 12, 1976, 19.

————. "Self Determination Applies to Women, Too." *Boston Globe*, March 14, 1971, A-13.

Coddington, Grace, with Michael Roberts. *Grace: A Memoir.* New York: Random House, 2012.

Collins, Amy Fine. "Avedon." *Harper's Bazaar*, March 1994, 278–87.

Conant, Jennet. "Sexy Does It." *Newsweek*, September 15, 1986, 62.

Cornfield, Jim. *The Photo Illustration: Bert Stern.* Los Angeles: Alskog, 1974.

Cotton, Charlotte. *Imperfect Beauty: The Making of Contemporary Fashion Photographs.* London: V&A Publications, 2000.

Crawford, William. *The Keepers of Light: A History & Working Guide to Early Photographic Processes.* Dobbs Ferry, NY: Morgan & Morgan, 1979.

Curtis, Charlotte. "*Vogue, Bazaar* Are Changing in Own Ways." *New York Times*, June 27, 1971, 48.

Dahl-Wolfe, Louise. *A Photographer's Scrapbook.* New York: St. Martin's/Marek, 1984.

Daniel, Malcolm. *Edward J. Steichen (1879–1973): The Photo-Secession Years in Heilbrunn Timeline of Art History.* November 2010. http://www.metmuseum.org/toah/hd/stei/hd_stei.htm.

Davies, Lucy. "Martin Munkácsi: Father of Fashion Photography." *Telegraph*, July 3, 2011.

Davis, Deborah. *Party of the Century: The Fabulous Story of Truman Capote and His Black and White Ball.* Hoboken, NJ: John Wiley & Sons, 2006.

de Looz, Pierre Alexandre. "Who Is Steven Meisel?" *032c*, Winter 2008–9, 61–86.

Deposition of John Daniel Turner. 5295/87. Surrogate's Court New York County, April 12, 1988.

Dickinson, Janice. *No Lifeguard on Duty.* New York: Regan Books, 2002.

Di Grappa, Carol, ed. *Fashion: Theory.* New York: Lustrum Press, 1980.

Dillon, Brian. "Deborah Turbeville." *Frieze*, November–December 2006.

Dowd, Maureen. "Liberties; Plagues, Comets, Values." *New York Times*, July 28, 1996, 13.

Duffy, Brian. *Duffy . . . Photographer.* Suffolk, UK: Antique Collectors Club, 2011.

Duffy: The Man Who Shot the Sixties. Directed by Linda Brusasco. 2009.

du Plessix Gray, Francine. *Them: A Memoir of Parents.* New York: Penguin, 2005.

Dwight, Eleanor. *Diana Vreeland.* New York: HarperCollins, 2002.

Eaton, Phoebe. "Terry Richardson's Dark Room." *New York Observer*, September 20, 2004.

Ebin, Jon D. "A Master Teaches the Experts." *Photography*, January 1955, 50.

Eisner, Lisa, and Toman Alonso. "The Trouble with Bon." *New York Times Magazine*, February 12, 2006, 68.

Ellenzweig, Allen. *The Homoerotic Photograph.* New York: Columbia University Press, 1992.

Emerson, Gloria. "Avedon Photographs a Harsh Vietnam." *New York Times*, May 9, 1971, 52.

Ephron, Nora. "The Big Name Photographers: Bert Stern." *New York Post*, July 20, 1965.

———. "The Big Name Photographers: Richard Avedon." *New York Post*, July 19, 1965.

Esten, John. *Man Ray: Bazaar Years.* New York: Rizzoli, 1988.

Ewing, William A. *The Photographic Art of Hoyningen-Huené.* New York: Rizzoli, 1986.

Ewing, William A., and Marina Schinz. *Blumenfeld Photographs: A Passion for Beauty.* New York: Harry Abrams, 1996.

Felsenthal, Carol. *Citizen Newhouse: Portrait of a Media Merchant.* New York: Seven Stories Press, 1998.

Finke, Jack Anson. "Pro.Files: The Great Graphic Innovators." *U&lc*, March 1977.

Fraser, Kennedy. *On the Edge: Images from 100 Years of* Vogue. New York: Random House, 1992.

Fried, Stephen. "Fashion's Dark King." *Vanity Fair*, August 1994, 109–24.

———. *Thing of Beauty*. New York: Pocket Books, 1993.

Friedman, Bruce Jay. "The Imposing Proportions of Jean Shrimpton." *Esquire*, April 1965, 70–73.

Frissell, Toni. Untitled manuscript for an autobiography.

Garner, Philippe. "The Most Underrated Photographers of the Last 30 Years." *American Photos*, November/December 2006, 61, 89, 102.

Garrat, Sheryl. "I'm a Photography Junkie." *Observer*, September 3, 2000, 3.

Goldberg, Vicki. "The Hidden Versailles." *New York Times Magazine*, September 20, 1981, 15–19.

———. "Richard Avedon's Own True West." *New York*, September 16, 1985.

Gopnik, Adam. "Postscript: Richard Avedon." *New Yorker*, October 11, 2004.

Gross, Amy. "Turbeville: An Interview." *Vogue*, December 1981, 335.

Gross, Michael. "Madonna's Magician." *New York*, October 12, 1992, 28–36.

———. *Model: The Ugly Business of Beautful Women*. New York: William Morrow, 1995.

———. "New Fashion Ads: The Provocative Sells." *New York Times*, April 19, 1986, 52.

———. "Paris When It Dithers." *New York*, April 11, 1988, 35–38.

———. "Possession." *Manhattan Inc.*, June 1985, 92–95.

———. *Rogues' Gallery: The Secret History of the Moguls and the Money That Made the Metropolitan Museum*. New York: Broadway Books, 2009.

Grundberg, Andy. *Brodovitch*. New York: Harry N. Abrams, 1989.

Haden-Guest, Anthony. "The Return of Guy Bourdin." *New Yorker*, November 7, 1994, 136–46.

———. "Richard Avedon: The Big Apple's Big A." *Sunday Times Magazine*, September 26, 1993, 46, 49.

Halebian, Carol. "The Bert Stern Story." *Camera 35*, March 1979, 28–53.

Halpert, Peter Hay. "Bruce Weber: Photographer." *American Photo*, May/June 1998, 48.

Harrison, Martin. *Appearances: Fashion Photography Since 1945*. New York: Rizzoli, 1991.

Helburn, William. *Seventh and Madison*. London: Thames & Hudson, 2014.

Heller, Karen. "An *Elle* of a Life." *American Photographer*, April 1988, 34–45.

Hodenfield, Jan. "Richard Avedon: The Art of the Camera." *New York Post*, September 20, 1975, 20.

Holson, Laura M. "The Naughty Knave of Fashion's Court." *New York Times*, March 2, 2012.

Huston, Anjelica. *A Story Lately Told.* New York: Scribner, 2013.

Hyde, Nina. "Fashion Notes." *Washington Post*, October 1, 1978, F3.

The Image Makers: Deborah Turbeville. February 6, 2012. http://www.style.com/stylefile/2012/02/the-image-makers-deborah-turbeville/.

Jacobs, Laura. "Everyone Fell for Suzy." *Vanity Fair*, May 2006.

Jobey, Liz. "Last Tango in Paris." *Independent*, April 25, 1993.

Kamp, David. "It All Started Here." *GQ*, October 2007, 343–55.

Kazanjian, Dodie, and Calvin Tomkins. *Alex: The Life of Alexander Liberman.* New York: Alfred A. Knopf, 1995.

Kent, Allegra. *Once a Dancer . . .* New York: St. Martin's Press, 1997.

Klemesrud, Judy. "The Evening Hours." *New York Times*, November 5, 1982, B8.

Kramer, Hilton. "The Dubious Art of Fashion Photography." *New York Times*, December 28, 1975, 100.

Kronstadt, Sylvia. "Mad Men, Bad Women: A Summer in the '60s New York Ad World." *Kronstantinople*, March 2012. http://kronstantinople.blogspot.com/2012/03/mad-men-bad-women-my-summer-in-new-york.html.

LaBruce, Bruce. "Terry Richardson, 1998." *Index*, 1998. http://www.indexmagazine.com/interviews/terry_richardson.shtml.

Lerman, Leo. *The Grand Surprise: The Journals of Leo Lerman.* New York: Alfred A. Knopf, 2007.

Lipsky-Karasz, Elisa. "Memo Pad: Franca's Code." *WWD*, December 10, 2008, 3.

Lisanti, Tom. *Pamela Tiffin: Hollywood to Rome, 1961–1974.* Jefferson, NC: McFarland, 2015.

Livingston, Jane. *The New York School: Photographs, 1936–1963.* New York: Stewart, Tabori & Chang, 1992.

Lockwood, Lisa. "Fashion Advertising: Controversy—Where Has It Gone?" *WWD*, July 28, 2014.

"The Lowest Moments in Advertising." *Adweek*, June 9, 2003, 38.

Macintyre, Ben. "Every Picture Tells a Story." *Times* (London), March 18, 1995.

Madison, Jennifer. "She's a Politician; I'm a Stylist!" *Daily Mail*, April 13, 2011.

Maier, Thomas. *Newhouse: All the Glitter, Power, and Glory of America's Richest Media Empire and the Secretive Man Behind It.* New York: St. Martin's Press, 1994.

Man Ray: In Fashion. New York: International Center of Photography, 1990.

The Man Who Shot Beautiful Women: Erwin Blumenfeld. Directed by Nick Watson. 2013.

McClure, Richard. "Relentless Paeans to Perfection." *Financial Times*, November 17, 1997, 15.

McKenna, Kristine. "Beyond the Ads . . . Obsession." *Los Angeles Times*, May 26, 1991, C5.

Menkes, Suzy. "Dour Take on Fashion Photos." *International Herald Tribune*, May 4, 2004.

Michener, Charles. "The Avedon Look." *Newsweek*, October 16, 1978, 58.

Miller, Joshua L. "A Striking Addiction to Reality: Nothing Personal and the Legacy of the Photo-Text Genre." In *James Baldwin Now*, by Dwight A. McBride. New York: NYU Press, 1999, 346.

Mirabella, Grace. *In and Out of Vogue*. New York: Doubleday, 1995.

Morgan, Ted. " 'I'm the Biggest Model, Period.' " *New York Times Magazine*, August 17, 1975.

Muir, Robin. "All Is Finally Revealed." *Independent on Sunday*, March 31, 2002, 12.

Newton, Helmut. *Autobiography*. New York: Nan A. Talese/Doubleday, 2002.

O'Hagan, Sean. "Good Clean Fun?" *Guardian*, October 16, 2004.

Penn, Irving. *Passage*. New York: Alfred A. Knopf/Callaway, 1991.

Purcell, Kerry William. *Alexey Brodovitch*. London: Phaidon, 2002.

———. "Ballet." In *Ballet*, by Alexey Brodovitch. New York: Errata Editions, 2011.

Ray, Man. *Self Portrait*. Boston: New York Graphic Society Books, 1963.

Reed, Paula. *Fifty Fashion Looks That Changed the 1970s*. London: Conran Octopus, 2012.

Reichert, Tom. *The Erotic History of Advertising*. Amherst, NY: Prometheus, 2003.

Remington, R. Roger, and Barbara J. Hodik. *Nine Pioneers in American Graphic Design*. Cambridge, MA: MIT Press, 1989.

Rensberger, Boyce. "Amphetamines Used by a Physician to Lift Moods of Famous Patients." *New York Times*, December 1, 1972, 1.

———. "Two Doctors Here Known to Users as Sources of Amphetamines." *New York Times*, March 25, 1973, 48.

Reynolds, Charles. "Focus on Alexey Brodovitch." *Popular Photography*, December 1961, 80.

Richard Avedon: Darkness and Light. Directed by Helen Whitney. 2002.

Richardson, Bob. *Bob Richardson*. Bologna: Damiani, 2007.

Richardson, Terry. Damiani, 2004. https://www.damianieditore.com/en-US/product/69.

Rowlands, Penelope. *A Dash of Daring: Carmel Snow and Her Life in Fashion, Art, and Letters.* New York: Atria Books, 2005.

Sanders, Mark, Phil Poynter, and Robin Derrick. *The Impossible Image.* London: Phaidon Press, 2000.

Saner, Emine. "A Tasteless Line in Battledress from *Vogue.*" *Guardian*, September 24, 2007, 3.

Sargeant, Winthrop. "A Woman Entering a Taxi in the Rain." *New Yorker*, November 8, 1958, 49–84.

Seebohm, Caroline. *The Man Who Was Vogue: The Life and Times of Condé Nast.* New York: Viking Press, 1982.

"The Sexes: Really Socking It to Women." *Time*, February 7, 1977.

Sheppard, Eugenia. "Some People Say They're Crazy." *New York Post*, November 12, 1968.

Shrimpton, Jean. *An Autobiography.* London: Sphere Books, 1991.

Sischy, Ingrid. "Exposure." *New Yorker*, April 10, 1995, 45.

Snow, Carmel, with Mary Louise Aswell. *The World of Carmel Snow.* New York: McGraw-Hill, 1962.

Span, Paula. "Richard Avedon's Stark Faces of the West." *Washington Post*, October 29, 1985, C1–C2.

Squiers, Carol, and Vince Aletti. *Avedon Fashion, 1944–2000.* New York: Harry N. Abrams, 2009.

Steichen, Edward. *A Life in Photography.* London: W. H. Allen, 1963.

Steinbicker, Earl. *Assisting Avedon* (iTunes app). San Francisco: Sutro Media, 2012.

Stern, Bert. *Adventures.* Boston: Bulfinch Press, 1997.

Stopin, Raphaelle. "The Sky over Paris." In *Paris 1963/Paris 1965*, by Melvin Sokolsky. Los Angeles: Leafcar Editions, 2011.

style.com. *Voguepedia.* http://forums/thefashionspot.com.

Szarkowksi. *Irving Penn.* New York: Museum of Modern Art, 1984.

Taylor, Angela. "The Deborah Turbeville Look: Altering the Focus on Fashion." *New York Times*, January 24, 1977, 27.

Tourdjman, Georges, and Allan Porter. *Alexey Brodovitch: Grand Palais, Paris, 27 Octobre–29 Novembre 1982.* Paris: Ministère de la Culture, France, 1982.

Tungate, Mark. *Branded Beauty: How Marketing Changed the Way We Look.* London: Kogan Page, 2011.

Turbeville, Deborah. *The Fashion Pictures.* New York: Rizzoli, 2011.

Van Meter, Jonathan. "The Godfather." *Vogue*, May 2009, 192.

———. "Pretty Women." *Vogue*, October 1990, 346.

Vienne, Véronique. "Hélène Gordon-Lazareff: The Tsarina Who Was Elle." *Graphis*, July–August 1999.

Vreeland, Diana. *Memos: The Vogue Years.* New York: Rizzoli, 2013.

Walden, Celia. "Why Black Is 'the New Black.' " *Sunday Telegraph*, June 29, 2008, 22.

Wallace, Benjamin. "Terry Richardson Shot Himself." *New York*, June 16–29, 2014, 28–35, 130.

Wallach, Amei. "Richard Avedon Looks Straight at the Camera." *Los Angeles Times*, June 2, 1974, 16.

Warhol, Andy, and Pat Hackett. *POPism: The Warhol Sixties.* New York: Harcourt Brace Jovanovich, 1980.

Weinberg, Lauren. "Wunderkind." *Glass Archive*, July 4, 2014.

Wilson, Earl. "It Happened Last Night." *Newsday*, 1961, 6C.

Wolfe, Tom. "The Girl of the Year." *New York Herald Tribune Sunday Magazine*, December 6, 1964.

Woodward, Richard B. "Whither Fashion Photography?" *New York Times*, June 8, 1997, 55.

Zahm, Olivier. "Terry Richardson's Life Story—Episode 1." *Purple*, Fall–Winter 2008.

———. "Terry Richardson's Life Story—Episode 2." *Purple*, Spring–Summer 2009.

———. "Terry Richardson's Life Story—Episode 4." *Purple*, Spring–Summer 2010.

Zwingle, Erla. "Inside Advertising: Dior." *American Photo*, February 1981, 102–3.

INDEX

About the Author

Michael Gross is the author of *740 Park*; *Model: The Ugly Business of Beautiful Women*; *Rogues' Gallery*; *House of Outrageous Fortune*; and *Unreal Estate*. A contributing editor of *Departures*, he created the blog *Gripepad* and has written for the *New York Times*, *New York*, *Vanity Fair*, *Esquire*, *GQ*, *Cosmopolitan*, *Travel + Leisure*, *Tatler*, the *Daily Beast/Newsweek*, and many other publications.